STUDIES IN MODERNITY AND NATIONAL IDENTITY

Sibel Bozdoğan and Reşat Kasaba, Series Editors

STUDIES IN MODERNITY AND NATIONAL IDENTITY examine the relationships among modernity, the nation-state, and nationalism as these have evolved in the nineteenth and twentieth centuries. Titles in this interdisciplinary and transregional series also illuminate how the nation-state is being undermined by the forces of globalization, international migration, and electronic information flows, as well as resurgent ethnic and religious affiliations. These books highlight historical parallels and continuities while documenting the social, cultural, and spatial expressions through which modern national identities have been constructed, contested, and reinvented.

Modernism and Nation Building: Turkish Architectural Culture in the Early Republic by Sibel Bozdoğan

Chandigarh's Le Corbusier: The Struggle for Modernity in Postcolonial India by Vikramaditya Prakash

Islamist Mobilization in Turkey: A Study in Vernacular Politics by Jenny B. White

The Landscape of Stalinism: The Art and Ideology of Soviet Space edited by Evgeny Dobrenko and Eric Naiman

Architecture and Tourism in Italian Colonial Libya: An Ambivalent Modernism by Brian L. McLaren

Everyday Modernity in China edited by Madeleine Yue Dong and Joshua L. Goldstein

Empire, Architecture, and the City: French-Ottoman Encounters, 1830–1914 by Zeynep Çelik

Modernism and the Middle East: Architecture and Politics in the Twentieth Century edited by Sandy Isenstadt and Kishwar Rizvi

Empire, Architecture, and the City

FRENCH-OTTOMAN ENCOUNTERS, 1830–1914

ZEYNEP ÇELIK

UNIVERSITY OF WASHINGTON PRESS *Seattle & London*

This book is published with grants from the John Simon Guggenheim
Foundation; Ministry of Culture and Tourism of the Turkish Republic;
School of Architecture at the New Jersey Institute of Technology;
and the University Seminars at Columbia University.

This book is also supported by the University of Washington Press
Endowment in memory of Marsha L. Landolt (1948–2004),
Dean of the Graduate School and Vice Provost, University of Washington.

© 2008 by the
University of Washington Press
Printed in Canada
Designed by Ashley Saleeba
12 11 10 09 08 5 4 3 2 1

University of Washington Press
PO Box 50096, Seattle, WA 98145
www.washington.edu/uwpress

The paper used in this publication is acid-free
and 90 percent recycled from at least 50 percent
post-consumer waste. It meets the minimum
requirements of American National Standard for
Information Sciences—Permanence of Paper for
Printed Library Materials, ANSI Z39.48–1984.

LIBRARY OF CONGRESS
CATALOGING-IN-PUBLICATION DATA

Çelik, Zeynep.
Empire, architecture, and the city :
French-Ottoman encounters, 1830–1914 /
Zeynep Çelik.—
1st ed.
p. cm. — (Studies in modernity and
national identity)
Includes bibliographical references and index.
ISBN 978-0-295-98779-8 (hardcover : alk. paper)
1. Public spaces—Africa, North. 2. Public
spaces—Turkey. 3. Architecture, French—
Africa, North. 4. Architecture, Ottoman.
5. Architecture and state—Africa, North.
6. Architecture and state—Turkey. I. Title.
NA9053.S6C45 2008
720.956—dc22 2007053064

TO THE MEMORY OF MY PARENTS

CONTENTS

ACKNOWLEDGMENTS

THIS BOOK WAS MADE POSSIBLE WITH generous support from several institutions. I am grateful to fellowships from the John Simon Guggenheim Foundation and the American Council of Learned Societies, as well as a summer research grant from the National Endowment for the Humanities, a travel grant from the Council of American Overseas Research Centers, and a sabbatical leave from the New Jersey Institute of Technology. A visiting professorship at the École des Hautes Études en Sciences Sociales facilitated my research in Paris and provided a vibrant intellectual environment while I was conceptualizing the book. I owe much to the directors and staff of the following archives and libraries, who were accommodating, helpful, and efficient: the Prime Minister's Archives (Başbakanlık Osmanlı Arşivi), Istanbul University Central Library (İstanbul Üniversitesi Merkez Kütüphanesi), Atatürk Library, and the Archives of the Ottoman Bank (Osmanlı Bankası Arşivi) in Istanbul; Service Historique de Défense at the Château de Vincennes and Bibliothèque Nationale de France in Paris; Archives Nationales d'Outre-Mer in Aix-en-Provence; Archives Diplomatiques de Nantes; Getty Research Institute in Los Angeles; the libraries of the German Institute for Oriental Studies and the American University in Beirut; the library of the Institut Français du Proche-Orient in Damascus; Fine Arts Library at Harvard University; and the New York Public Library.

I presented my work-in-progress at the Columbia University Seminar on Ottoman and Turkish Studies and the Columbia University Seminar on The City, the Research Center of the Ottoman Bank in Istanbul, the School of Architecture at the University of Michigan (Ann Arbor), the History Department of the Université de Paris VII, the Orient Institut in Beirut, Institut de Recherche sur le Maghreb Contemporain in Tunis, the annual meeting of the Society of Architectural Historians of Australia and New Zealand in Fremantle, the University of Sydney, and the University of Queensland. The feedback I received on these occasions enabled me to rethink some key issues and ask further questions. During my research trips, I benefited from the hospitality and intellectual generosity of many colleagues. I am particularly thankful to George Arbid, Jean-Luc Arnaud, Serap Atassi-Khattab, Lorans Izabel Baruh, Aylin Beşiryan, Omar Carlier, Ali Djerbi, Sinan Hassan, Dalenda and Abdelhamid Largueche, Wolf-Dieter Lemke, Nabila Oulebsir, François Pouillon, Robert Saliba, Wa'el Samhouri, Jeff Spurr, Frances Terpak, and Stefan Weber.

I am fortunate to have friends and relatives who contributed to this book in many different ways, from reading the manuscript at its different stages of development and giving me their earnest opinions to the formulation of the title and transliterations from different languages: Janet Abu-Lughod, Seyla Benhabib, Sibel Bozdoğan, Christine Boyer, İbrahim and Sylvie Çelik, Julia Clancy-Smith, Etem Erol, Diane Favro, Geoffrey Fox, Alice Friedman, Ira Lapidus, Jayne Merkel, Guy Métraux, Elaine Klein Mokhtefi, Mokhtar Mokhtefi, Sarah Nelson, Uri Ram, Mary Roberts, Susan Slyomovics, Susana Torre, Suha Umur, and Ayşe Yönder. My arguments are interlaced with their thoughtful and pointed comments. All shortcomings are, of course, mine. I thank Kevin Field for drawing the maps with care and attention and Caecilia Pieri for sending me a rare plan of Baghdad at the last minute. Elif Özgen, my research assistant in Istanbul, played a crucial role during the research phase. A brilliant young scholar, knowledgeable, inquisitive, hardworking, responsible, and with a great sense of humor, Elif facilitated my work in every way possible: she read archival documents, combed through journals, selected images, and checked the corrections. I am most grateful to her for understanding what I wanted to do so well and for immersing herself in my research with great enthusiasm.

At the University of Washington Press, Michael Duckworth, my editor, was efficient, professional, and gracious. Mary Ribesky coordinated the production process with skill, wisdom, and good humor; Beth Fuget dealt with many administrative issues competently; Ashley Saleeba provided visual beauty with expert design; and Pamela Bruton copyedited the manuscript with meticulous attention and exemplary conscientiousness. This wonderful team made it a great pleasure to return to the publisher of my first book, *The Remaking of Istanbul*, after two decades.

As always, I relied on warm support and intellectual challenge from my home

front. My son, Ali Winston, was too engaged in his own writing projects to read the whole manuscript, but he was outspoken about the parts he did. My tireless and most faithful critic is my husband, Perry Winston, whose comments and queries spanned from the larger issues to minute details, extending our dinner conversations into unpredictable venues on the politics of architecture.

A NOTE ON
TRANSLITERATIONS AND DATES

I HAVE USED THE TRANSLITERATIONS
of Arabic names and places as they appear in the French and Ottoman documents. This means, for example, Bab el-Oued instead of Bab al-wad in the case of the former and Aziziye instead of Aziziyya in the latter. Nevertheless, there will be inconsistencies derived from the inconsistencies in the archival and published sources. Transliterations from Ottoman texts and rules of modern Turkish present further discrepancies; for example, Ahmed in Ottoman Turkish will be spelled Ahmet in modern Turkish. I kept standard uses of certain terms in English, such as Eid al-Fitr and Eid al-Adha.

In the Ottoman documents and publications, most dates are given in the *hijri* (lunar) calendar, but some are in the *mali* (fiscal). All dates are converted into the Gregorian calendar.

EMPIRE, ARCHITECTURE, AND THE CITY

INTRODUCTION

T

WO INTERTWINED THEMES DOMINATE the history of the nineteenth century: empire building and modernity. Modern empires derived much power from complex iconographies developed to define and disseminate official images. Among these "invented traditions," to use a memorable term coined by Eric Hobsbawm, public spaces occupied key positions and stood as metaphors for a modern order. They were conceived as stages that exhibited notions of power through permanent symbols; they accommodated public ceremonies; and they served as fields of action, where imperial agendas were played out and where citizens asserted their own voices. Arguing for the existence of a "connected world of empires" in which ideas, strategies, and technology traveled smoothly, this book studies the construction of public space in the French and Ottoman empires.[1] I trace the shaping of a universal imperial iconography through the physical transformations in the built environments, concentrating on infrastructure, street networks, urban squares and parks, and architecture. Situating the two empires in a comparative framework, and with a deep awareness of their unequal status in the nineteenth-century world order, I hope to show a broader picture of the cross-cultural exchanges. To expand conventional associations, I am inspired by Marshall Berman's "broad and open" definition of modernity, which argues for, among other issues, "a dialectical process" across physical and social space to reveal hitherto ignored links.[2]

The choice of my case studies moves the emphasis from the "centers" to the "peripheries." I acknowledge the undeniable significance of the capital cities as primary sites for expressing notions of empire but suggest that, to achieve a comprehensive understanding of imperial constructions, it is even more productive to look at the regions at the "margins" with different historic, social, and cultural characteristics. Imposing the presence of the empire and engraving its image with modern connotations presented heady challenges in these settings, and having to confront the regional specificities led to the adoption of transparent and direct practices. Accordingly, my case studies are drawn from the cities of the Maghrib under French colonial rule and the Ottoman Arab provinces. More specifically, the geographic area includes, in the French case, Algeria and Tunisia (the French domination of Morocco falls outside the chronological boundaries of this study) and, in the Ottoman case, the *vilayets* (provinces) of Syria, Beirut, Aleppo, Baghdad, Basra, Mosul, Hijaz, Yemen, and Tripoli (in Libya, hereafter Trablusgarb).[3] I chose not to include Egypt, as its ties to the Ottoman Empire (going back to 1517) became more and more tenuous after Muhammad Ali Pasha acquired a semiautonomous status for the area in 1805, which lasted until the British occupation in 1882. Relying on French and Italian expertise, Muhammad Ali initiated a series of military, economic, and administrative reforms, which were followed by legal, educational, and infrastructural ones under Khedive Ismail Pasha (1863–79), who was granted partial independence from the Ottoman Empire to conduct technical and economic programs with foreign powers. There is no doubt that situating Egypt's modernization in my framework would have raised further questions; however, my focus on empire building calls for its exclusion.

Although I return to Paris and Istanbul (and the communication between them) periodically, my inquiry embodies a web of cross-references among urban centers such as Algiers, Damascus, Constantine, Aleppo, Tunis, Beirut, and Trablusgarb. I cover the major cities of the region to some extent, but without giving them monographical depth—based on the argument that inclusion of a wide spectrum allows for a broader understanding of the making of public spaces and reveals the multiplicity of experiments and the variety of end products. My goal is twofold: to highlight the dominant tendencies and to make a case for specificities.

SHIFTING CONCEPTS, METHODOLOGICAL CHALLENGES

The French colonies of North Africa and the Ottoman Arab provinces allow for a meaningful comparative study for several historical reasons, primarily stemming from a shared language (Arabic) and religion (predominantly Muslim) that created a comparable social and cultural structure. Another critical factor is the pre-nineteenth-century history of the entire region, which had been under Ottoman rule since the sixteenth century. Modernization through (French) colonization or (Ottoman)

reform had to be implemented in response to an Ottoman environmental and institutional landscape already in place. A provocative parallel in the domination history of the two regions extends beyond the time bracket of my study: with the establishment of the French mandate after World War I, Syria and Lebanon experienced a similar passage from Ottoman to French rule as Algeria and Tunisia had done in the nineteenth century. This development makes my story of domination and its manifest forms of expression open-ended.

Methodologically, my choice to study these two regions in relation to each other promotes the reconsideration of the conventional bilateral axes of east–west and north–south that continue to dominate scholarly inquiry.[4] By showing a multidirectional communication pattern that dismantles the one-way vector of European influences on Ottoman modernizing reforms and the singular focus on France and the Maghrib during the colonial era, I hope to bring a new understanding to cross-cultural relations.[5] For example, one specific voyage of architectural ideas begins with the Ottoman capital of Istanbul looking to Haussmann's Paris for models of modernity. Right around the same time, in a project by prominent architect Eugène-Emmanuel Viollet-le-Duc, Paris turned to sixteenth-century Ottoman mosques of Istanbul to develop a monument in an *architecture parlante* in Algiers that was deemed suitable to visually summarize power relationships in the colony. Several decades later, elements from Viollet-le-Duc's commemorative design showed up in Damascus (after passing through Istanbul), this time to celebrate the opening of the Damascus–Mecca telegraph line, a symbol of technology in the service of Islam. This passage of ideas charts out an unexpected circulation of influences (see chapter 3).

Comparative history confronts at the outset the difficult issue of depicting the case studies. The role played by Ottomans in nineteenth-century empire building could be examined in relation to the Russian, Austro-Hungarian, Japanese, and British empires, each comparison provoking new questions. My focus on the Ottoman and French empires derives from an interest in issues of imperialism and colonialism and awareness of the close intellectual affinities between the Ottomans and the French. Comparative studies of modern empires have concentrated on Western empires (the British and the French are the leading examples), excluding, among others, the Ottoman Empire, which was not deemed to be at the same level of advancement. When the Ottoman Empire entered the broader discourse, attention commonly turned to its responses to European norms and models, with the clear implication that it occupied a lower status in the hierarchy. I argue for a two-way street between the French and Ottoman empires, if not with the same intensity of traffic in each direction. Even when there is no exhaustive textual documentation that maps the cross-cultural dialogues, tracing parallel developments reveals the existence of complex communication patterns, as in the use of urban forms and architecture as political tools.

Engaging in comparative history with only two case studies exposes the enterprise to the trap of bilateral constructions. In my attempt to avoid this, I was aided by the unequal status of the two empires and the source materials for each, conditions that prevented me from suggesting "balanced," "point-to-point" comparisons. Evident in the particular slants taken by the discussions in different parts of the book, this unevenness, which reminds us that history is uneven, emanates also from my decision to highlight certain themes or issues. Hence, for example, the emphasis on the transformations of urban fabrics in Algeria and Tunisia (chapter 2) is due to the wealth of source material, as well as my concern to introduce some of these important cities into the ever-growing discourse of colonial urbanism. The focus on Ottoman "race thinking" (epilogue) stems from the relatively unexplored nature of the topic, as opposed to the extensive literature on its French counterpart. The same reasoning colors other parts of the book: whenever I felt my research was opening new ground, I allowed it to take priority at the expense of evenly constructed exposés.

This study of empire building is from the "official" perspective, that of the French and the Ottoman states and elites. I focus on the vision from "above" of the struggle to control and unite the imperial territories by devising myriad mechanisms. My goal is to display a broad picture that will help develop an overall understanding of the process in both cases and in relation to each other and will underline the presence of multiple imperial modernities. Of course, center-periphery relations amounted to a lot more than that—as articulated by Jens Hanssen in his recent study of Beirut: "Within Ottoman center-periphery relations, imperial inspection and local self-representation merge Foucault's technologies of modern governmentality and epistemological power on the one hand, and the processes of adaptation, negotiation, experimentation, and contestation by those people subject to these imperial practices on the other."[6] I tell only the first part of the story, which is complex, multivalent, and contradictory in itself. The other part, the reception of the modernization projects by the peripheries, remains outside the boundaries of my book but has enjoyed some recent scrutiny, especially by historians of the late Ottoman Empire.[7] I see my book as a complement to their work, one that contributes to the drafting of a canvas on which the adaptations, experimentations, contestations, and negotiations may be cast.

Among the many themes that run through the book, two should be highlighted, as they set the broader parameters to my perspective in studying modern empires: communication and ordering. The different forms of communication, all intertwined, depended on modern technology: cartography, telegraph lines, postal service, rail and land roads, bridges, canals, ports, urban street networks, but also printed media, including periodicals, books, published laws and regulations, and, of course, photography. Linking modern communication's origins to the programs of the post-1789 French state, Armand Mattelart argued that it was a "project of mastering space"—a description that foregrounds its complex role in empire building.[8]

Communication also came to define the standard by which "civilization" was measured. In promoting rail and telegraph lines from the Ottoman Empire to India, William P. Andrew wrote in 1857: "The railway and telegraph are not only of incalculable value as political instruments, but they are the pioneers of enlightenment and advancement: it is theirs to span the gulf which separated barbarism from civilization."[9] The *Grand dictionnaire universel du XIX* siècle (begun in 1865) reiterated this sentiment: "the freest and most civilized nations . . . are also those that possess the best means of communication."[10] Maps were at the heart of the operation as "a projection of a rational system in which everything should communicate."[11]

Advances in communication technology served as indispensable tools for colonization. For example, the overhead telegraph lines installed in Algiers in 1842 (only five years after the invention of telegraphy) proved to be extremely useful during the colonization of the country.[12] Around the time of the occupation of Algeria, Michel Chevalier, a Saint-Simonian, had envisioned a "Mediterranean system" that would turn the basin into "the nuptial bed of the Orient and the Occident" in the form of a confederation bound together by modern communication. Colonization was essential to the realization of Chevalier's hierarchical utopia, with France at its pinnacle: "By the railway and steamships, and with the help of some other modern discoveries such as the telegraph, it will become easy to govern most of the continents that border the Mediterranean."[13] Chevalier's means of communication could be extended to include regularized urban public spaces, government offices where information was carefully categorized and filed, and the dissemination of ideas, including the power of communication itself, through modern media.

Communication not only was instrumental in empire building and colonization but also linked empires to each other. Consider the part played by telegraphy: without the 1,800 miles of lines that crossed the Asian territories of the Ottoman Empire, Britain could not have been connected to India. The urgency of efficient communication increased in the aftermath of the Indian mutiny in 1857—and explains the keen interest of British enterprises in developing the Ottoman lines.[14] A map of telegraph lines from 1874 shows the Ottomans' own dependence on other countries to reach its overseas provinces, among them Trablusgarb, which could be accessed only via Italy, in addition to the widespread distribution of the lines in the east and west (fig. I.1).

Ordering, documentation, classification, and filing of information, crucial to the controlling apparatus of a modern state, made their lasting mark on imperial space from macro- to microscale. In 1790, with the goal of replacing the former provinces of the Old Regime, characterized by intersecting administrative districts and judicial and religious units, with a unified set of administrative units, the French National Assembly divided France into eighty-three departments, which in turn were divided into districts and communes.[15] Eighty years later, the 1871 Ottoman Law on the General Administration of Provinces (İdare-yi Umumiye-yi Vilayet Nizamnamesi, based

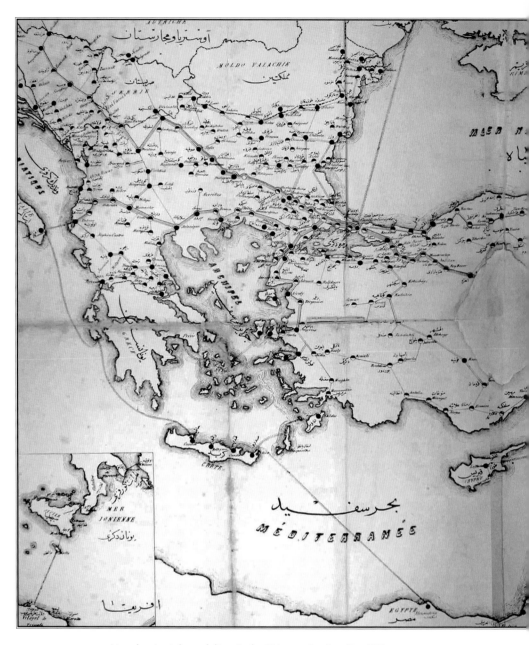

1.1 Map showing telegraph lines in the Ottoman Empire, 1874 (AK).

on an 1864 "vilayet law," or "law of provinces") established administrative divisions and uniform principles of management and reform that would be pursued throughout the empire. Modeled after the Code Napoléon, it reorganized the imperial territories into twenty-seven *vilayet*s (provinces), each governed by a *vali* (governor-general) appointed by the capital. *Vilayet*s were divided into *sancak*s (departments), each

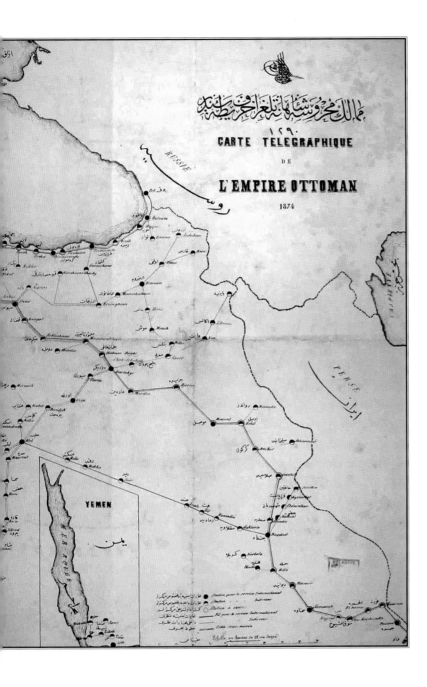

headed by a *mutasarrıf* (governor); then came *kaza*s (districts or *arrondissements*), under *kaymakam*s (undergovernors). The hierarchy continued down to the *karye*s (villages).[16] Upon his appointment as the governor of Syria in the 1870s, Midhat Pasha described the land division system in detail and identified the official administrator at every level, along the way revealing a hierarchical delegation of responsibility that would allow for complete control.[17] The importance placed by Midhat Pasha on this law testified to the urgency felt by the Ottoman state to unite the empire by

means of a shared, transparent administrative system. Speed and efficiency also marked the functioning of the modern state, inserting the element of "time discipline" into the general order. The opening and closing hours of offices, train and tram timetables, and school schedules all contributed to the management of time— the importance of which was proclaimed in public spaces in the form of large clock towers (see chapter 3).

The regularization of administrative and other institutions (e.g., educational ones) meant further transformations to the urban fabrics and cityscapes. The same laws and regulations on the opening of new streets and squares produced comparable modern fragments in dispersed cities of the empire. Government buildings, sheltering the shared modern bureaucracy, dotted the urban centers. The placement of memorial monuments followed similar principles, adding yet another spatial and visual level of uniformity. The mapping and repeating of a legible pattern hence promoted and made concrete the centralized control of the empire over its territories.

As a historian of built form, my approach centers on the physicality of architecture and cities. I analyze buildings, spaces, and spatial relationships, and considering them as social-political documents, I investigate their workings in the history of empire building. I am interested in multiple facets of modernity, cross-cultural communication patterns, the flexibility of the city as a stage for social and cultural transformations, the cohesive dimensions of public spaces to affect behavior patterns, their ability to adapt to new programs and needs, the potential of architecture to carry political messages, and the divergent meanings behind remarkably similar forms. The "tangible substance, the stuff of the city," that is, "the physical mass of marble, bricks, and mortar, steel and concrete, tarmac and rubble, metal conduits and rails," constitute my primary actors and documents.[18] Yet their stories need to be understood, triangulated, and contextualized by interdisciplinary research, borrowing methodologies and technologies from other fields, among them social and political history, art history, geography, and anthropology. Visual culture occupies a particularly important place in this study: photography plays a central role, linking sight, knowledge, and power especially after the mid–nineteenth century, and constructs bridges between the fractured pieces of data from different sources. With the boundaries between disciplines becoming blurrier, empirical research getting more cross-referential, and the material becoming richer but more elusive, the need to negotiate an increasingly complex terrain allows for new methodological experiments.

THE HISTORIC BACKGROUND: AN OUTLINE

The chronological bracket of this book extends from 1830 to 1914. Two important events of the 1830s were the French occupation of Algeria (1830) and the declaration of the Tanzimat Edict, also known as the Gülhane Edict (Gülhane hatt-ı şerifi, 1839),

by Sultan Abdülmecid, which opened the way to an extensive series of modernization programs known as Tanzimat (literally, "putting in order") reforms in the Ottoman Empire. The beginning of World War I signals the demise of the Ottoman Empire and complete French control of the Maghrib, including Morocco (which had become a protectorate in 1912). To provide a historic survey of this era (even a concise one) is beyond the scope of the current study, but a broad-brush reminder of the developments that are key to the themes of the book should help anchor my arguments to their complex background.

The invasion of Algeria by the French was instigated by the mythical *"coup d'éventail"* of 1827, that is, the dey (*dayı* in Turkish) of Algiers (Hussein Pasha) slapping the French ambassador on the face because of a financial disagreement. France reacted with a maritime blockade and, three years later, military invasion. Rationalized to local people as an operation "to chase the Turks, your tyrants," in order to help them to regain their country, the occupation led to the end of Ottoman rule (established in 1529) and withdrawal of the Ottoman elite to Istanbul. Nevertheless, it proved to be far from a smooth affair. Met by recurrent resistance from the early 1830s on, the French military administration took charge of all affairs of the colony, with the size of the army growing steadily. At the center of resistance was the legendary figure of Emir Abd el-Kader, who built a regular army and confronted the French troops for the first time in 1832 outside Oran. Until his final defeat by French forces in 1847, Abdel Kader fought many battles, which sometimes resulted in negotiations and peace treaties, only to be followed once again by armed conflict. The turbulent history of these years, accompanied by an initial ambivalence on the part of the French about the kind of rule they wanted to establish there, led to experiments that gave some power to Arab leaders in the countryside, while the French held on to Algiers, Oran, and Bône and their environs. However, the insurmountable conflicts always ended up in military confrontations, culminating in a long and often-atrocious war. The mass killings by the French army, including razing villages "to terrorize the tribes" and sending fumes into caves to asphyxiate people taking refuge there, provoked moral questions among the conquerors and raised doubts about the future character of French rule. One official commission was revolted by the violence exerted on local populations: "We have surpassed in barbarism the barbarians we were going to civilize." De Tocqueville agreed with this assessment in his famous 1847 report: "Everywhere, we took control of the revenues [of the *habous,* the religious foundations] by changing their former functions. We reduced the charitable establishments, abandoned the schools, dispersed the seminaries. Around us, lights have been turned off. . . . In short, we have rendered the Muslim society much more miserable, disorderly, ignorant, and barbarian than it had been before it got to know us."[19]

The wavering confidence in the legitimacy of the conquest, the uncertainties about the nature of French rule, and the violence of the era explain much about the urban

and architectural design decisions at the time. Another striking trait of the period was the army's direct involvement in all affairs of the colony—administrative, institutional, infrastructural, architectural, and cultural. Military officers conducted scholarly research on various aspects of Algeria, including its people and popular customs and traditions, documented it visually (with maps and drawings), and engaged in construction activities that transformed its cities. In short, the army was the main conduit of modernity in Algeria. A considerable number of visual and textual primary documents on which this study is based were created by military engineers (see especially chapter 2).

The military regime endured for four decades, with shifting policies toward the administration of the colony and control of the indigenous people. The Second Republic (1848–51) policy of assimilation declared Algeria an integral part of French territory and placed it under metropolitan law, ultimately calling for the abolition of precolonial administrative systems. The act of 9 December 1848 reorganized the colony into three *départments* according to the Code Napoléon (Algiers, Constantine, and Oran), which were further divided into districts (*arrondissements*) and communes— to be administered by prefects, subprefects, and mayors, respectively. This structure separated the military rule from the civilian one to some extent but relegated the territories formerly under the control of local leaders to the military. The creation of a Ministry of Algeria and the Colonies in 1858 affirmed the policy of centralization and emphasized its extension to Muslims, described as "an armed and inveterate nation that must be quenched by assimilation."[20]

In the 1860s, during the reign of Napoléon III (1852–71), a significant change occurred in the policies toward the "indigenous" people. Influenced by Saint-Simonian philosophy, the emperor advocated an association policy that was based on respect for Arab society and that called for its preservation. Declaring Algeria a *royaume arabe,* or Arab kingdom (and not a "colony"), he envisioned it as an extension of France where Arabs and Europeans lived and worked peacefully side by side, with technical expertise from the metropole supporting its development. Muslims would be declared French citizens but allowed to keep their religion; Islamic courts would be reestablished; public instruction would be developed and higher education institutes opened; and the "indigenous battalions" in the French army would be increased. Ch.-Robert Ageron, the prominent historian of Algeria, summarized the philosophy of the *royaume arabe* in three words: protection, reconciliation, and association.[21] Napoléon's initiative revived some of the precolonial educational establishments, for example, by reopening elementary Koranic schools. Nevertheless, by teaching Arabic in the morning and French in the afternoon, it was the "Arab-French" primary schools that truly represented the emperor's vision.

Not helped by a series of natural disasters (including a long drought, followed by a disastrous famine) and opposition from the settlers, Napoléon III's policies soon

were abandoned. However, his short-lived "Arab dream" had important consequences on architectural practices in North Africa. Valorizing Arab society and culture called for a scholarly appreciation of its artistic and architectural productions and cleared the way for their inclusion in the official "heritage" of the colony, next to works of antiquity. Their documentation, restoration, and preservation followed. Eventually, at the turn of the century, architects began integrating "Islamic" fragments into "European" buildings, contributing to the diversity of modernism (see chapter 4).

An insurrection a year after the shift to civilian rule in 1870 expressed the accumulated discontent of Muslims under French rule and their desire to gain independence; it was provoked by the results of the 1870 Prussian War and the regime change, which were deemed to testify to the weakness of the French state. The defeat of the insurgents translated to the victory of the settlers and led to the solidification of *Algérie française*. An official colonization policy invested large sums in the operation while conducting further expropriations—all facilitated by new laws and procedures. The subsequent fifty years witnessed an influx of colonists and the consolidation of the colonial power structure according, in general, to the policies established in the 1870s. Made possible by expropriations and the 1873 Law of the Settlers (revised in 1889), which abolished the holding of property by indigenous "collectives," special privileges granted to immigrants drew them in waves to the countryside. Between 1870 and 1900, settlers obtained three times more land than had been occupied in the previous decades, and the numbers of Europeans in the Algerian countryside increased to one-third of the total European population in Algeria. Urban areas displayed a similar pattern of development, but more intensively, attracting French administrative officers and merchants, as well as other Europeans. The "assimilation" policies continued to erase the precolonial institutions of Algerian society, including the justice and educational systems; the religious structure was also upset by the establishment of an official Muslim clergy—a concept foreign to Islam. The cities (and the countryside) reflected the transitions, absorbing the growing numbers of European residents and accommodating the amenities necessary for their lifestyles, against the background of the diminished presence of precolonial institutions (pl. 1).

During the first fifty years of the time period covered in this book (and since 1574), Tunisia was a province of the Ottoman Empire, with a semiautonomous political structure (*beylik*). According to Tanzimat agendas, the beys, most significantly Ahmed Bey (1837–55) and Muhammad Bey (1855–59), and Prime Minister Khayr al-Din (1873–77), engaged in a series of reforms, beginning with the military and extending to administration, finance, education, and urbanism. Aware of the "European progress in the field of civilization," as Khayr al-Din wrote in his political treatise *The Surest Path* (1867), Tunisia looked to Europe, especially France, but also to Istanbul

for models. Khayr al-Din explained Europe's advancement as based on science, deducing lessons for Tunisia to follow in order to reach the same goals, along the way endorsing the Ottoman Tanzimat reforms: "Europe has attained these ends and progress in the sciences and industries through *tanzimat* based on political justice, by smoothing the roads to wealth, and by extracting treasure of the earth."[22] Describing the "means of civilization" that enabled European countries to "achieve the development they sought," the governmental clerk Ahmad ibn Abi Diyaf highlighted infrastructure projects: steamships that eased "their paths at sea, . . . smooth roads, enabling carriages to reach all places, . . . a postal service to carry the letters that facilitate intercourse, . . . iron roads on which steam-powered carriages can speed," and "the transmission of information by a form of magnetism called the telegraph, which is among the wonders of the world."[23]

Both authors supported the Ottoman reform programs, and Khayr al-Din argued that implementing Tanzimat would ensure "growth and development in the provinces."[24] In 1857, Khayr al-Din played an instrumental role in the promulgation of Ahd al-Aman (the Fundamental Pact), a Tunisian charter based largely on Tanzimat principles. A municipal council was established in Tunis in 1858, only four years after the one in Istanbul. Its responsibilities included maintaining security, drafting and administering a budget, and serving the "public good" by overseeing the public spaces and water and sewage lines. A set of urban regulations, such as one on street cleaning, supported the municipality's tasks.[25] Echoing the initiatives to bring order to cities in the other Arab provinces at the time, the measures taken in Tunis affirmed its ties to the empire, and in all likelihood, they would have been followed by more extensive urban projects.

The French administration pursued a different approach to the colonization of Tunisia than they did in Algeria. The occupation forces in Tunisia in 1881 adapted the municipal institutions already in place in Tunis but employed a more aggressive approach to transforming the rest of the colony. Tunisia was considered, not as part of France, but rather a protectorate that reserved a symbolic sovereignty for the bey, who would have a say in the financial, judiciary, and administrative "reforms" deemed necessary by France. The goal was to append Tunisia to France without any financial burden to the metropole. The colony would thus be "reorganized, without costing the treasury anything." It was "rich enough that it only needed order and justice. Particular enterprises would take care of the rest, under the supervision of the bey, with some French agents and especially [the French] resident-general." Because of the development of French infrastructure projects in Tunisia since the 1840s, this was a predictable attitude. Barthélemy Saint-Hilaire, the minister of foreign affairs at the time, explained the situation: "Since 1847, we have established [in Tunisia] the postal service; . . . a telegraph service; . . . a railroad from the Algerian border to Tunis." Under the protectorate, the work would continue to bring "the benefits of civilization

that [the French] enjoyed."[26] Historian Abdallah Laroui has argued that Tunisia was not spared the shock of colonial intervention and that the policies privileged economic and legal violence.[27] The differences in the governing of Algeria and Tunisia resonated in the urban landscapes: the massive transportation projects and city building that occurred in Tunisia were consistently geared toward economic goals while continuing to etch the image of the empire. Leaving the existing cities untouched, the practical interventions appended vast patches of European-style settlements and structures to the built fabrics of Tunisia (see chapters 1 and 2).

As the French Empire was expanding, the Ottoman territories were shrinking: Greece gained its independence in 1829, followed by Bulgaria, Serbia, Romania, and Montenegro in 1877, in addition to the empire's loss of Algeria and Tunisia to France. In the second half of the nineteenth century, despite the dramatic shift in power to Britain, France, and (after 1870) Germany, the Ottoman Empire continued to play a crucial role, devising strategies of survival in response to the ever-growing pressure from expanding European powers. Its political independence allowed it to develop and pursue its own modernization programs, including cultural modernization— even though defining the notions of Ottoman sovereignty and modernity was a thorny affair in an age of European hegemony, as argued by Ussama Makdisi.[28]

Tanzimat reforms, key to Ottoman rejuvenation programs, marked, not a sharp break with the past, but a critical moment in a process that had started at the end of the eighteenth century. By crystallizing the agendas, they cleared the way for great transformations in the structure of the empire. One of the most important goals was centralization, which meant redefining the relationship between the center and the peripheries—as opposed to the historic decentralized administration, which maintained a distance between the two. In Makdisi's words, "Ottoman reformers sought to nationalize (Ottomanize) the empire and ultimately to absorb the margins into a cohesive and uniform Ottoman modernity."[29] A series of laws and regulations laid out the foundations of the integration of the empire. The 1869 citizenship law, pursuing the Tanzimat notion of political equality, dictated that people living in the empire were no longer subjects (*reaya*) but Ottoman citizens (*taba*). The Provincial Municipality Code (Vilayet Belediye Kanunu) of 1877 complemented the 1871 law on the provinces, mentioned above. It stipulated programs for urban reform that included the opening of new streets, paving, cleaning, and illumination of public spaces, supervision of construction and demolition, and matters related to public health and safety, as well as setting the conditions for forming municipal councils.[30] In short, a series of critical issues needed to be addressed in every province according to general criteria set in Istanbul. Around the turn of the century, İbrahim Pasha summarized the daunting tasks ahead of him as the governor of Trablusgarb: "The official administration must be governed with a severe discipline. . . . A reform program must be put into effect. The police must be reorganized. Education, public works, commerce,

and agriculture must be given new direction. All administration must be regularized and public order maintained. . . . Justice, discipline, [and] order must reign."[31]

Osman Nuri Pasha, the longtime governor of Hijaz and Yemen, listed six areas requiring attention in the provinces: "the establishment of administrative and political divisions," "the construction of government buildings and military establishments which would reflect the glory of the state," the foundation of law courts, "the spread of education and the procurement of progress in the trades and professions," an increase in revenues, and road construction.[32] Unlike the French practice in Algeria, where the army served as the main agent of modernity, the task was shouldered primarily by bureaucrats in the Ottoman Empire.

Scholars have recently begun to question the Tanzimat reforms from a historiographically unprecedented angle: whether the reforms gave birth to an Ottoman "colonialism" of sorts, an inquiry that makes sense given the "imperialist" character of the major nineteenth-century world powers.[33] This context, they argue, led the Ottoman elite to consider the imperial peripheries, and especially the Arab provinces, as "colonies" and to espouse colonialism with modernity (as in the French case).[34] An advanced center hence aimed to reform the backward peripheries. While the association has merit, the description of the late Ottoman Empire as a "colonial empire" would generate a serious confusion and conflate different economic, social, political, and ideological factors.[35] Well aware of this potentially reductive position, revisionist historians explore the differences between the colonialism of European powers and of Ottomans, underlining the four-centuries-long historic connections between the center and the Arab peripheries that had led to the creation of specific social, cultural, religious, and political networks.[36] They also propose more nuanced terms, such as Selim Deringil's "borrowed colonialism," which signifies "dip[ping] into a whole grab bag of concepts, methods, and tools of statecraft, prejudices and practices that had been filtered down the ages."[37] Makdisi chooses to use "Ottoman Orientalism" to explain the Ottoman representations of Arab provinces and Arabs in reference to European Orientalism, implying both an acceptance of the European discourse and resistance to it.[38] My study explores the entangled characteristics of Ottoman rule in the Arab peripheries along similar lines but relies on case studies drawn primarily from urban forms, architecture, and visual culture.

At the center of the critical debates of the post-Tanzimat era was the turn to the long-neglected Arab provinces (and Anatolia) for economic compensation and to create a new platform of social solidarity. Ahmed Cevdet Pasha, one of the main protagonists of the reform movement, articulated the rationale in 1878 in a memorandum to the sultan, in the aftermath of the short-lived constitutional regime (1876–78): "Because of the devastation of Rumelia, the revenues of the government have become reduced by nearly a half. In order to make up for this loss, the most important issue for us now is to render prosperous and increase the wealth of the Anatolian and Ara-

bic provinces. . . . The development of Syria [i.e., Damascus and its environs], Aleppo and Adana would turn this area into an Egypt. . . . This can be accomplished under the aegis of our sovereign."[39]

The same year, evaluating the mistakes made since the beginning of the reform era that had caused the secession movements and highly aware of the European role and interest in Ottoman territories, Midhat Pasha emphasized the importance of solidarity: "What ought to have been done at the outset when reforms were undertaken, would have been to group all these elements round a vivifying and regenerative principle which would have cemented their union; to create for these races a common country which would have rendered them insensible to suggestions from without. . . . if it is desired that serious reforms be carried out, . . . a fusion should be effected of the different races, and that out of this fusion should spring the progressive development of the populations, to whatever nationality and whatever religion they may belong."[40]

The lessons learned from earlier mistakes helped shape future agendas. Following Midhat Pasha's reasoning, even if it was too late to appeal to the people of the European provinces, Arabs could still be drawn into the empire and endowed with an Ottoman identity. The investment of the Ottoman state went beyond the regions specified by Ahmed Cevdet Pasha and reached the far-flung corners of the empire. While Syria always occupied the most privileged position, farther peripheries such as Yemen and Trablusgarb gained new attention due to their strategic locations at the borders. A good indication of the importance placed on the Arab provinces during the Abdülhamid era can be seen in the Ottoman state almanacs (*Salname-yi Devlet-i Aliye-yi Osmaniye*): the Arab provinces were placed in the front, with the European ones relegated to the end, the order reflecting the different salaries of the high officers and attesting to the emphasis placed on the appointment of the "most capable" governors to Syria, Hijaz, Baghdad, and so forth.[41]

Continuing to pursue the post-Tanzimat reform agendas, Abdülhamid II (1876–1908) brought an ideological twist to Ottomanism that valorized the institution of the caliphate. He placed a new emphasis on Islam and his religious role as the caliph and reoriented the focus of loyalty from the state to the sultan. As maintained by Hasan Kayalı, Abdülhamid's Islamism had developed in reaction to the European powers and was "the child of changing international and economic relations in Europe and the position that the Ottoman Empire acquired in the neoimperialist status quo."[42] Turning to the Arab provinces, it privileged them as the primary sites of investment. Cities testified to the shift and the scope of modernization; the enduring concreteness of their physicality served as reminders of the Hamidian era's predominant concerns. By the end of Ottoman rule, "the equipment of principal cities like Aleppo, Damascus, Beirut, and Jerusalem, with broad ways, modern buildings, electric lighting, tramways, and other convenient apparatus [had] made Syria as a

whole the most civilized province of Turkey at his [Abdülhamid's] day," according to a report from Great Britain's Foreign Office.[43] Historians have overlooked Ottoman modernity in Middle Eastern cities until very recently and have commonly associated the urban transformations with the European powers that dominated the region in the aftermath of World War I, continuing the colonial discourse.[44] My study aims to fill this gap.

RESEARCH MATERIALS: DIVERSE AND DISPERSED

This book synthesizes documentation that, although fragmented, incomplete, and inconsistent, is rich, provocative, and often untapped. The archival data, publications of the time, and visual materials raised many issues concerning their possible interpretations for the study of each empire, as well as for comparative analysis. While making it difficult to offer firm arguments and draw definitive conclusions, the ambiguities allowed me to ask charged questions. They should be evident to readers, as exemplified, for example, in my arguments on the connections between the old cities and the *extra-muros* new quarters in both empires, the development of "regional" architectural expressions for Ottoman Arab provinces and their relationship to the North African *"néo-Mauresque,"* and the affinities between the Ottoman and French visual discourses on race (chapters 2 and 5).

Differences in archives pose a great challenge to comparative studies. The French and the Ottoman archives I consulted presented two significant problem areas for my research: the classification of the documents and their contents. For example, the archives of the French army (Service Historique de la Défense, housed at the Château de Vincennes, Paris), which contain a wealth of textual and visual information on city-building activities in Algeria (under the category of Génie—the engineering works), are organized chronologically and according to region, allowing an understanding of transformation processes. The reports are accompanied by drawings that fill in the details not conveyed in words—such as the building-by-building demolition necessary to build a straight road through a city. Depending on the importance of an operation, as well as the negotiations involved, the number of documents can even be overwhelming. The Prime Minister's Archives (Başbakanlık Osmanlı Arşivi) in Istanbul do not have a similarly consolidated structure but are organized according to the nature of the matter reported, such as interior affairs (İrade-Dahiliye), or in specific collections, such as Abdülhamid's collection, originally stored at the Yıldız Palace (Yıldız). Data on city building in different provinces can be found under several classifications, turning the research into an arduous, if exciting, adventure with unexpected finds in unlikely places. With rare exceptions, drawings are stored separately and, aside from the annotations on them, are devoid of explanatory texts.

This brief account of archival differences should give some sense of the predica-

ments involved in comparing the French and Ottoman transformations to urban fabrics. To cite one specific case, the unequal treatment of the rue Nationale in Constantine and a comparable avenue in Aleppo, Hendek Caddesi (chapter 2), must be understood in reference to the archives. The imbalance applies to the entire chapter, signaling the archives as principal actors in the shaping of the book and the methodological flexibility that underlies comparative analyses. This explains to some degree the organization of each chapter as well (there are other considerations), sometimes integrating the two empires, sometimes giving them separate and parallel treatment.

Contemporary publications supplement and contextualize the material gleaned from the archives. The Ottoman *salnames*, almanacs for provinces, make up to some extent for the lack of systematic archival data. Published periodically and representing the viewpoint of the "center," they convey detailed information on multiple aspects of the provinces, including infrastructure projects, urban affairs, and construction of major buildings, as well as the peoples and their customs. In a uniform format that provides long lists of events, administrative units, committee members, and buildings (in addition to selective descriptive entries), the *salnames* themselves testify to the late-nineteenth-century Ottoman penchant for orderly documentation and classification to facilitate gaining and storing knowledge on all aspects of the empire. Compiled at intervals of several years, the *salnames* record the new developments and serve as measures for progress.

Periodicals proved to be especially useful, as they reported and interpreted the main operations. Furthermore, the extent of coverage served to informally rank the importance of projects. Illustrations provided a concrete level of reality, especially with the "documentary" power of photography. The Paris-based *L'illustration* was the nineteenth-century journal par excellence. It enjoyed a considerable circulation among the Ottoman elite and was accepted as the model for several leading periodicals. One, *Malumat* (Information), had a subtitle that flaunted the association: *L'illustration turque*. Arguably, the most important of such journals in the Ottoman Empire was the richly illustrated *Servet-i Fünun* (The Wealth of Sciences), which I used as one of my primary sources. *Servet-i Fünun* systematically reported on the Arab provinces, broadcasting their significance to the empire. Certain projects were spread over a long period, such as the construction of the Hijaz Railroad and the port of Beirut (chapter 1). Pursuing modern journalism, *Servet-i Fünun* sent reporters (with their cameras) to distant regions of the empire and published the articles they sent in installments: in 1312–13/1894–95, Ahmed İhsan toured Syria; in 1313–14/1895–96, Mehmed Tevfik went to Iraq and wrote detailed accounts of his observations of the land, settlements, people, and their habits and customs, illustrating them with the photographs he took (fig. I.2); in 1314/1896, the journal published the correspondence of Sadık Bey, traveling in the African Sahara (the province of Trablusgarb). In addition to these *seyyar memurlar* (traveling officers), *Servet-i Fünun* proudly

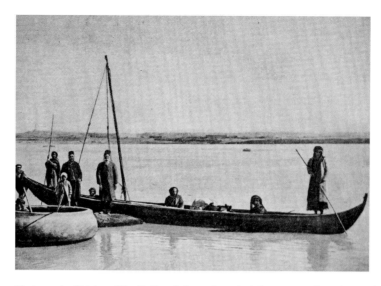

1.2 Photograph of Mehmed Tevfik (fourth figure from the left, wearing a fez), the traveling
reporter for the journal *Servet-i Fünun*, in Iraq (*Servet-i Fünun*, no. 336 [1313/1896]).

credited its photographers *en place*, such as Tevenet Efendi in Aleppo and Mehmed
Salih Efendi in Basra.[45]

Photography was invented at roughly the beginning of the chronological period
covered by my study and played an instrumental role in presenting the transforma-
tions discussed here. It was used in both empires as an effective tool to communicate
"real" knowledge on the "margins" (on historic and natural landscapes, the people,
and the curiosities) and to convey the nature of interventions to urban fabrics. Along
with the "official" photographic missions (famously, Félix-Jacques-Antoine Moulin's
eighteen-month expedition in Algeria in 1856–57 to "bring to France . . . precise doc-
uments on . . . our great colony" and Abdülhamid II's project to register all aspects
of his empire, resulting in a very rich and important collection), private photogra-
phers and studios mushroomed in urban centers.[46] Photography quickly turned
into an international business and developed lucrative commercial venues, among
them *cartes de visite* and postcards, in addition to publications of all sorts. Post-
cards brought an extraordinary scope and liveliness to visual culture by including
the new, the old, the spectacular, the ordinary, and the quotidian (the latter some-
times highly constructed). While all genres existed in both contexts, one aspect of
nineteenth-century Middle Eastern photography displays an idiosyncratic differ-
ence worth noticing: European and American photographers expressed no interest
in the Ottoman modernization of the land, while the photographers working for the
Ottoman state had to turn their lenses to the new projects to display the "advances."
It is because of this difference that the Abdülhamid collection, housed in Istanbul

University, occupies a unique place among other rich collections of Middle Eastern photography.[47]

During the time period covered in this book, certain literary genres, well established in Europe, were just emerging on the Ottoman scene. Highly relevant for my purposes is the travelogue, whose history in the Maghrib goes back to the early days of the occupation, with works such as Claude Antoine Rozet's *Voyage dans la régence d'Alger* (Paris: A. Bertrand, 1833) and Évariste Bavoux's *Alger: Voyage politique et descriptif dans le nord de l'Afrique* (Paris: Chez Brockhaus & Avenarius, 1841), producing a considerable collection over the decades and well into the twentieth century. Together with the proliferation of "scholarly" books that also began to appear in the 1830s and 1840s, for example, Adophe-Jules-César-Auguste Dureau de La Malle's *Constantine: Recueil des renseignements pour l'expédition ou l'établissement des français dans cette partie de l'Afrique septentrionale* (Paris: Librarie de Gide, 1837) and Camille Leynadier's *Histoire de l'Algérie française* (Paris: H. Morel, 1846), the publications on French North Africa coalesce into an impressive library. Ahmed Midhat, a prominent Ottoman intellectual and prolific writer who was well aware of the European travel literature, acknowledged the importance of the genre not only for gaining knowledge on different parts of the world but, even more importantly, as a useful tool in the service of "colonial enterprises."[48]

Ottoman publications on Arab provinces are few and far between. There are only a handful of travelogues (including some serialized in periodicals), and the names of their authors will become familiar to the readers of this book due to the inevitability of repeated references to their works: Mehmed Refik and Mehmed Behçet, Şerafettin Mağmumi, Mehmed Refed, Hakkı Bey [Babanzade], Cenab Şahabettin, and Ahmed Şerif. The sad state of literature on the Arab lands was bemoaned by Ahmed Şerif upon his visit to Damascus: as he felt lost and like a total stranger roaming the streets of the city, without any knowledge of the historic monuments, he could not but observe foreigners of both sexes going around "as though they were in their own countries," with guidebooks in their hands. Contrasting the knowledge they had on "our country" with "our ignorance and our obstinacy not to get to know our own country," he summed up the situation: "[T]hey had pages, volumes of information on Damascus. But what is written on the topic by us, in Turkish? How many volumes did we have on our own country?"[49]

There are other curious absences in late-nineteenth and early-twentieth-century Ottoman literature: Algeria and Tunisia. In the pages of *Servet-i Fünun*, which published pieces on all corners of the world, I have not come across any textual or visual reporting or commentary on the French projects in Algeria (there is an essay on an iron bridge in Constantine in *Revue technique d'Orient*; see chapter 1). Even the unique episode of technological exchange between French Algeria and the province of Trablusgarb in the 1860s (chapter 2) did not seem to have received coverage in the Ottoman press. Given the profound involvement in urban projects in France since

the Haussmannian operations in Paris (complete with rumors about the personal engagement of the prefect in Istanbul's remaking),[50] the silence on the massive transformations of Algerian cities that bore centuries-old Ottoman imprints is difficult to understand. There are a few glimpses of Tunisia under the French protectorate—for example, in an album in Abdülhamid's photography collection that includes photographs depicting recently opened avenues and new French buildings.[51] In a brief comparison with Trablusgarb, Ahmed Şerif commented that the minute the border was crossed from Tunisia into "our land," "all works of civilization [and] beauties of nature" disappeared. Tunisia was crisscrossed with "orderly roads, telegraph and telephone lines," all displaying a "civilized life."[52] Perhaps it was to avoid an unfavorable comparison that prevented the Ottomans from turning an eye to the French modernity in territories that had formed part of their empire not so long ago.

STRUCTURE OF THE BOOK

The book begins on the macroscale, with chapter 1 tracing the infrastructural networks that enabled efficient transportation over long distances: land roads, railroads, ports, and waterways. Their concerted development, based on the technological advances of the nineteenth century, united each empire and provided connections to the rest of the world. The infrastructure projects served many agendas, ranging from military to commercial and even ideological. The processes, policies, and often the intentions of the Ottoman and French empires in carrying out their respective projects display unique stories about the role of infrastructure in empire building in each context. Arguing for the merit of exploring their individual coherent processes, I broke chapter 1 into two main sections but discussed the two contexts in relation to each other, pointing to their intersections and divergences. The topics in other chapters yield to more intertwined discussions, and I structured each chapter according to the specific nature of the material.

From "mastering" expansive imperial lands with technology, in chapter 2 I turn to cities and analyze the interventions that changed the urban fabrics in unprecedented ways. Starting with the operations that cut straight arteries through the old tissue, I move to the implantation of European-style quarters adjacent to historic cores and to the creation of new towns. These major feats of planning and engineering were carefully delineated to evoke the idea of the empire and its modernity, while addressing practical concerns of growth and communication. An additional methodological challenge especially affected this chapter: the present-day status of many cities I consider after the even-greater twentieth-century transformations. In some cases (such as Burj Square in Beirut), the earlier fabric has been completely erased; in others (such as the Marja Square area of Damascus), the remaining fragments are so abstracted and isolated that they do not tell much about their history. To pursue my

inquiry, I first had to revert to archaeological research of sorts, reconstructing the urban landscapes with the help of historic plans and photographs.[53]

In chapter 3 I discuss the public square as an ultimate site of imperial expression, as evidenced by its setting, the buildings that define it, and the iconographically charged monuments that adorn it. With blatant associations to Europe, the public squares introduced a new type of urban space to the "Islamic" cities of the Middle East and North Africa and quite rapidly took on central roles. The public park, another urban type that called for the introduction of new social habits, is also examined in this chapter. In chapter 4 I look at the architecture of public monuments. The offices that harbored the imperial administrative apparatus (city halls, government palaces, post offices, police stations, and military structures) introduced new and secular monuments, designed according to European models but in a range of architectural expressions. Placed near each other, they created imperial enclaves of modernity. Other buildings, such as theaters, schools, and hospitals, complemented the image. In chapter 5 I examine a sample from the myriad public ceremonies that affirmed the empires in multiple ways. These ceremonies formed temporary components of the new public spaces and contributed to their memorability. In the epilogue I synthesize the themes of the book and examine again the attitudes of both empires toward their peripheries, from the perspectives of cultural difference, race, and civilizing mission. Drawing attention to the cross-cultural diffusion of such notions, my aim is to broaden and deepen the debate on the concepts of empire, modernity, and colonialism and argue for their further contextualization in reference to built forms and visual culture.

COLOR PLATES

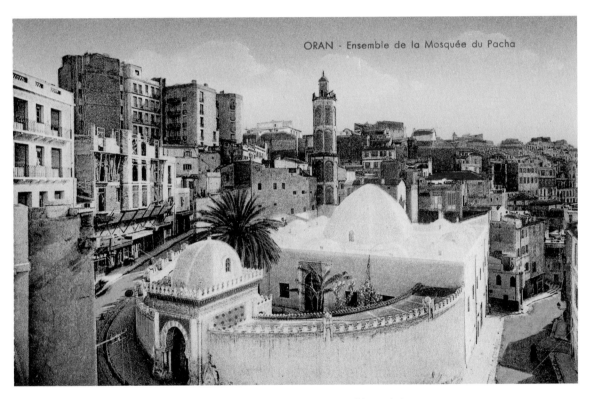

ORAN - Ensemble de la Mosquée du Pacha

PLATE 1 Oran, The Great Mosque (Mosque of the Pasha),
surrounded by colonial buildings, postcard (GRI).

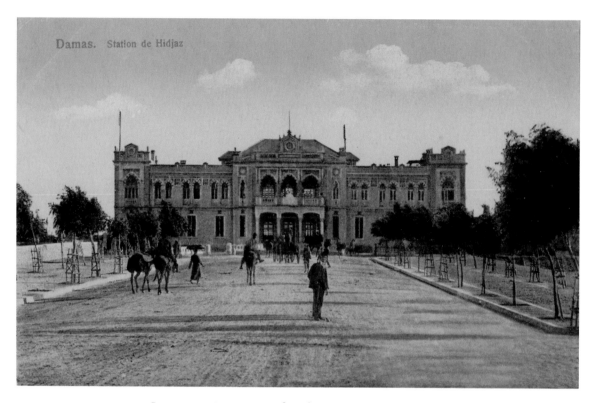

Damas. Station de Hidjaz

PLATE 2 Damascus, train station, view from the new avenue (postcard, OBA).

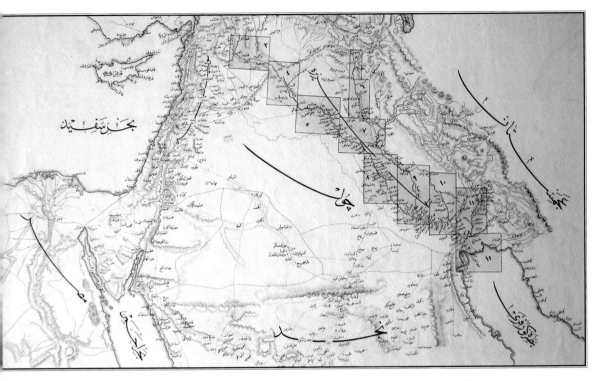

PLATE 3 Key map, showing towns and villages along the Tigris and Euphrates rivers (IÜMK 93163).

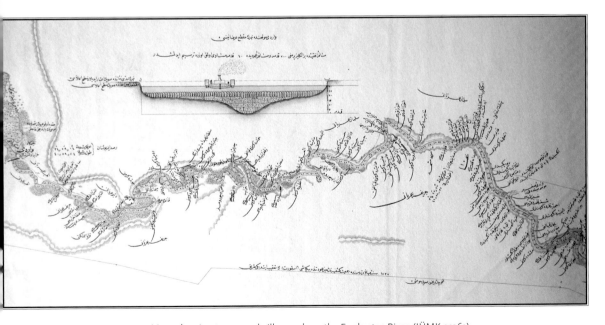

PLATE 4 Map, showing towns and villages along the Euphrates River (IÜMK 93163).

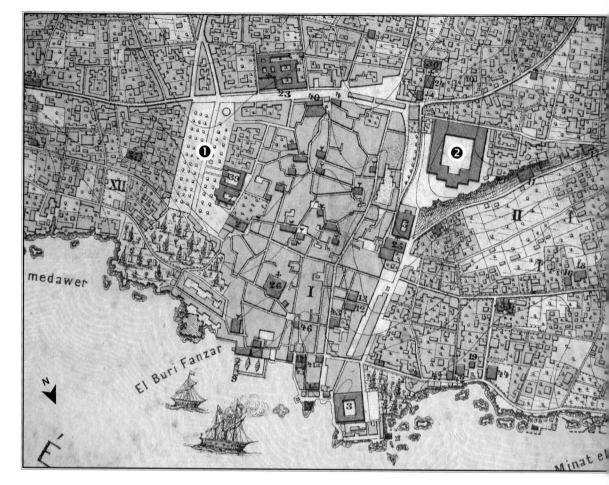

PLATE 5 Beirut, plan by Julius Löytved, 1876, detail (IÜMK 93158).
1. Future location of Sahat el-Burj. 2. Grand Sérail.

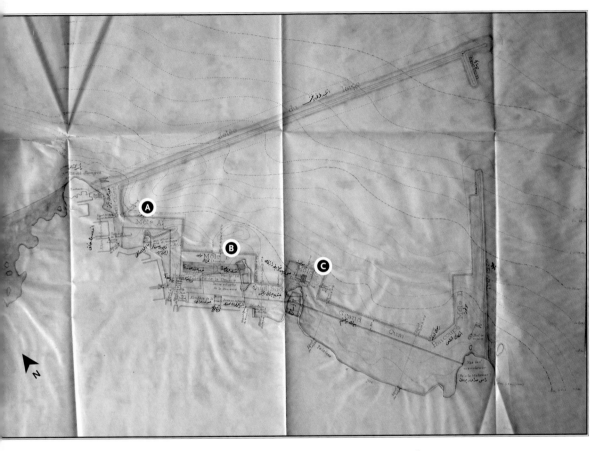

PLATE 6 Beirut, project for the construction of the port, 1888, plan (IÜMK 92301).

A, B, and C show the embankments.

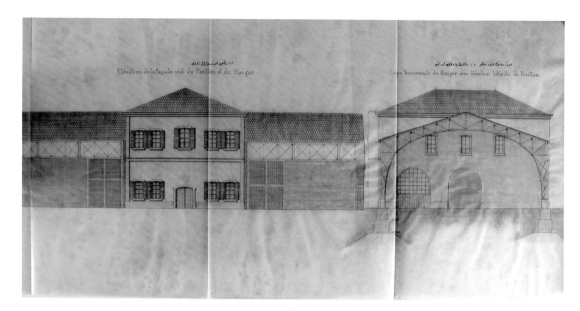

PLATE 7 Beirut, project for the construction of the port, 1888, elevations and sections (IÜMK 92301).

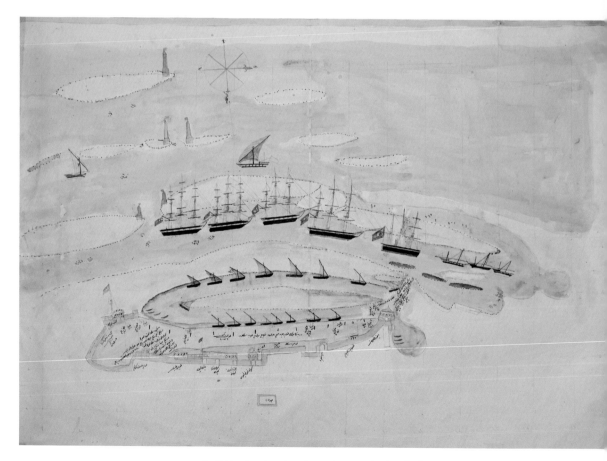

PLATE 8 Jidda, drawing that shows the outer harbor for larger ships
and the inner harbor for smaller ships (BOA, PPK 41/6).

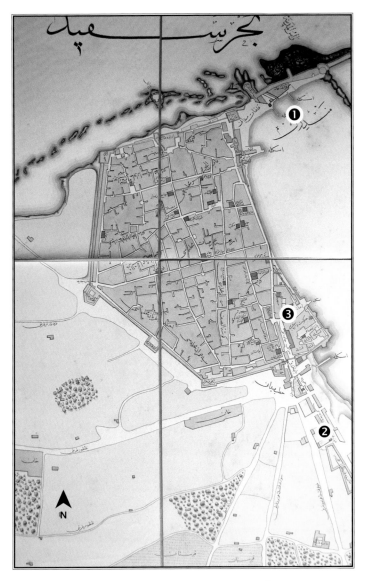

PLATE 9 Trablusgarb, plan of *intra muros*, 1883 (IÜMK 92310).
1. The quarantine zone. 2. Suq Aziziye. 3. Clock tower.

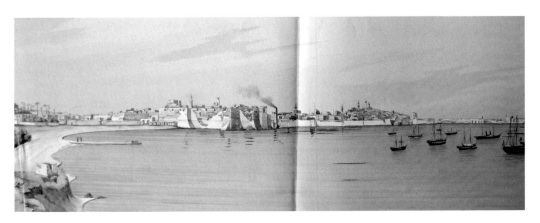

PLATE 10 Trablusgarb, view showing the walled city and the outskirts,
insert drawing of plan, 1883 (IÜMK 92310).

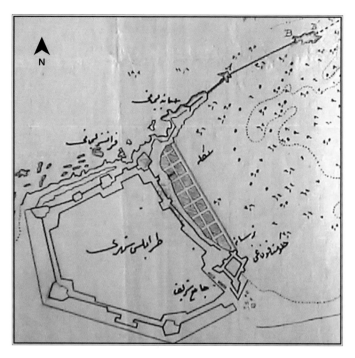

PLATE 11　Trablusgarb, project for the construction of the port, showing a new quarter to be built on fill (BOA, Y.EE 109/22).

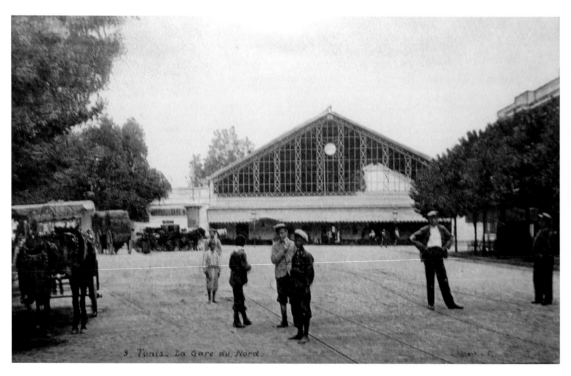

PLATE 12　Tunis, North Station (postcard, ADN).

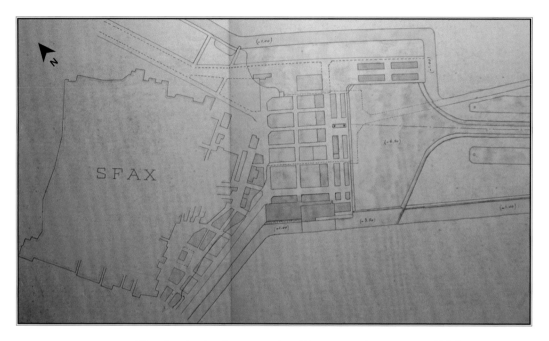

PLATE 13 Sfax, plan showing the construction of the port and the new quarter (ADN).

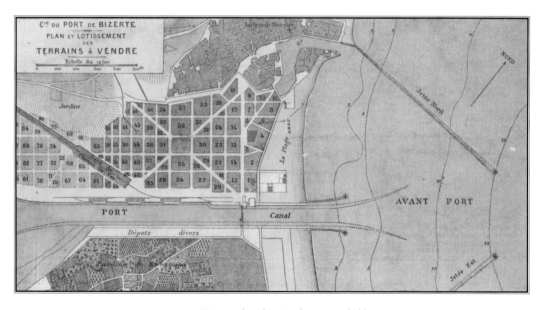

PLATE 14 Bizerte, plan showing the new and old towns
(*Le nouveau port de Bizerte: Bulletin de la Companie du Port de Bizerte* 1, no. 1 [14 July 1893], BNF).

PLATE 15 Algiers, plan, 1888 (Piesse, *Algérie et Tunisie*).

1. Place du Gouvernement. 2. Place Bresson. 3. Place Bugeaud. 4. Lycée Bugeaud. 5. Jardin Marengo.

PLATE 16 Damascus, plan, c. 1920 (Institut Français du Proche-Orient, Damascus).

1. Suq el-Hamidiye. 2. Suq Midhat Pasha. 3. Widened street leading to Bab-ı Tuma.

4. Widened street on the western boundary of the Jewish quarter. 5. Süleymaniye complex.

6. Marja Square. 7. Beirut Road. 8. Train Station.

9. Dervişiye Street. 10. Said Street. 11. Suq Ali Pasha.

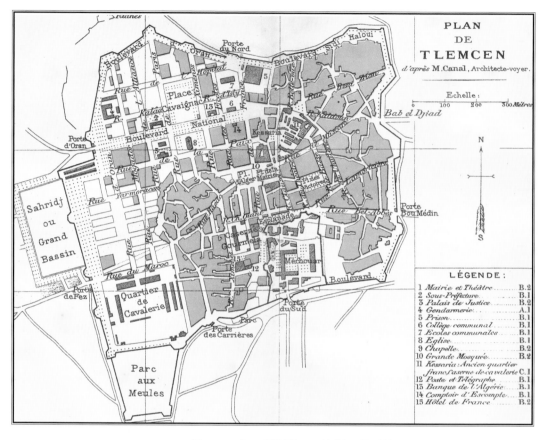

PLATE 17 Tlemcen, plan, 1888 (Piesse, *Algérie et Tunisie*).

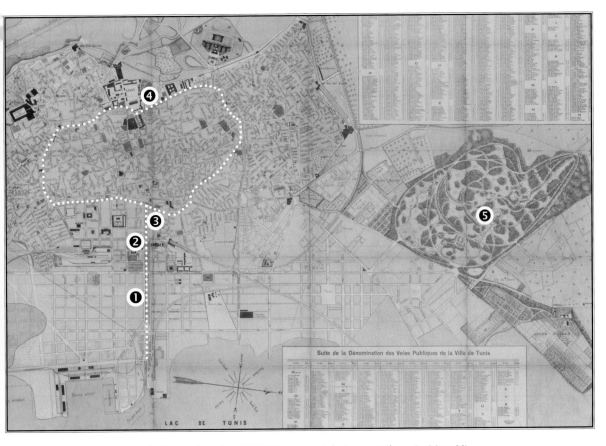

PLATE 18 Tunis, plan, 1899 (BNF, Département de Cartes et Plans, Ge AA 2066).
1. Avenue de la Marine (avenue Jules Ferry). 2. Avenue de France.
3. Porte de France. 4. Place de la Casbah. 5. Belvédère Park.
The route of the procession during the inauguration celebrations
for the new port is indicated by the dotted lines.

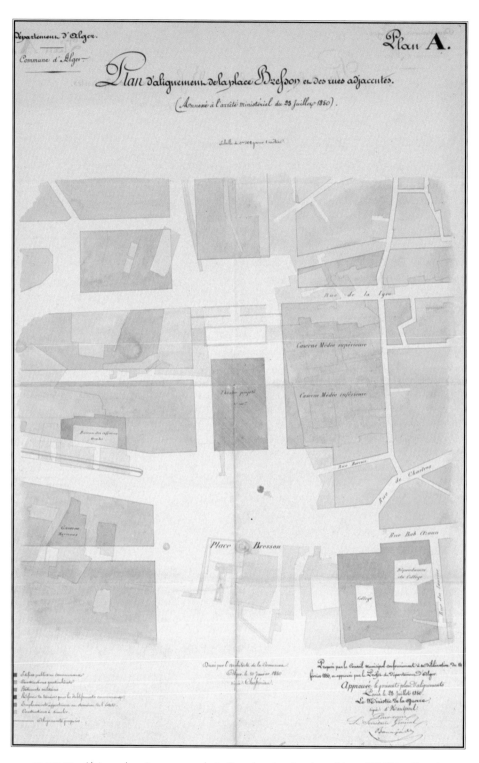

PLATE 19 Algiers, place Bresson, regularization plan showing demolitions (ANOM, 1 Pl 942).

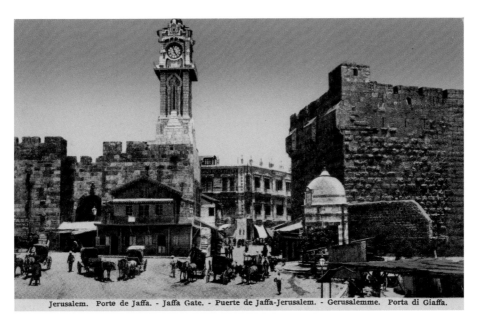

Jerusalem. Porte de Jaffa. - Jaffa Gate. - Puerte de Jaffa-Jerusalem. - Gerusalemme. Porta di Giaffa.

PLATE 20 Jerusalem, clock tower, with the memorial fountain for Abdülhamid II's twenty-fifth jubilee
on the right (postcard, Fine Arts Library, Harvard College Library).

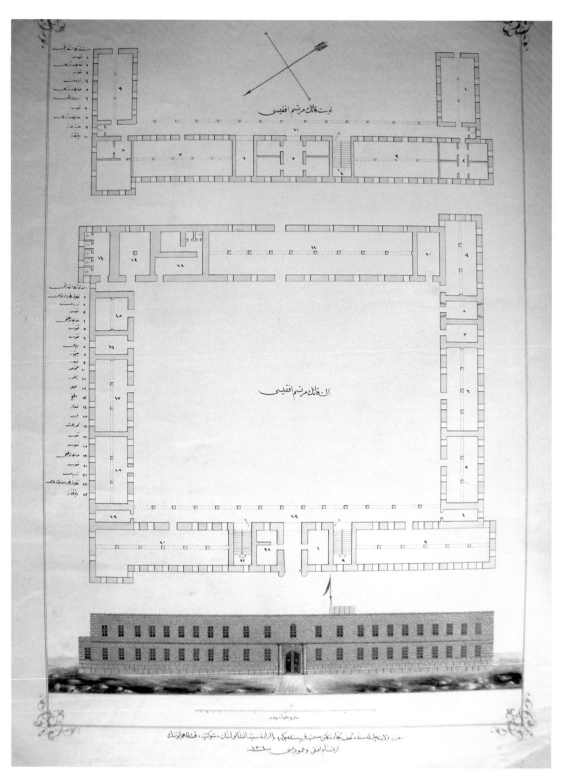

PLATE 21 Syria, "Şevkiye" military barracks, plans and façade, 1302/1885 (IÜMK 93137).

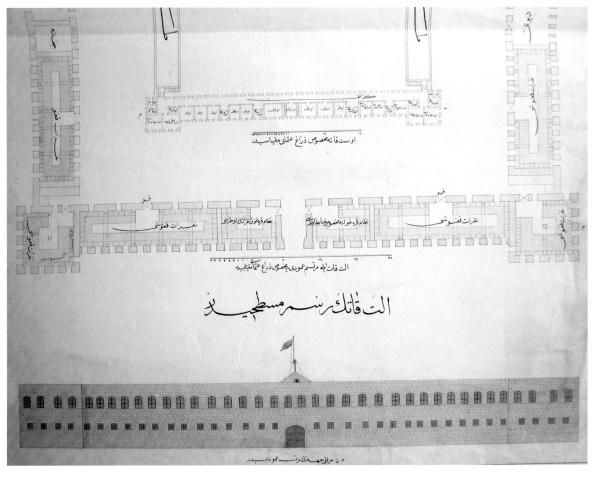

PLATE 22 Syria, "Hamidiye" military barracks, plan and façade (detail), 1302/1885 (IÜMK 93141).

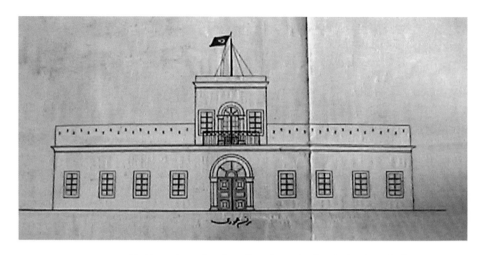

PLATE 23 Trablusgarb, project for military barracks, façade drawing, 1896
(BOA, Y.PRK.ASK 120/120).

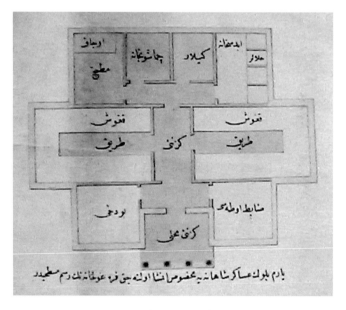

PLATE 24 Generic police station, plan (BOA, PPK 900).

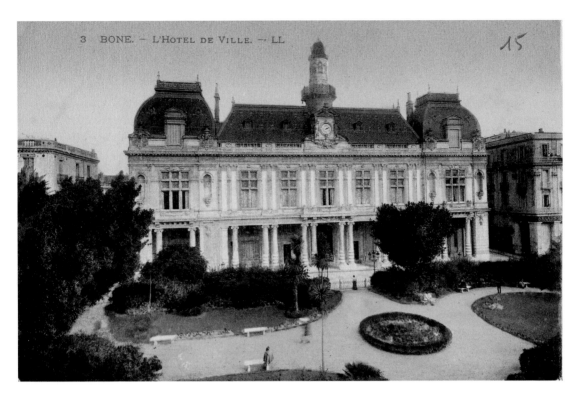

PLATE 25 Bône, town hall (postcard, GRI).

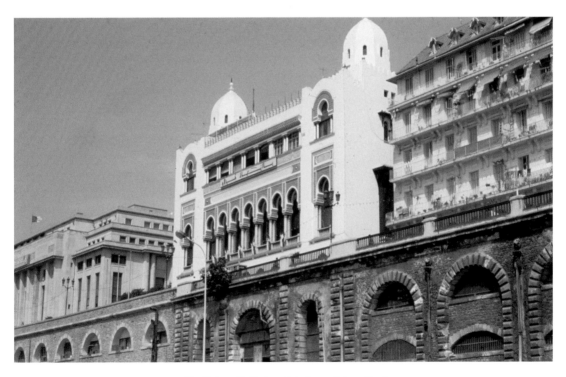

PLATE 26 Algiers, Préfecture (photograph by author).

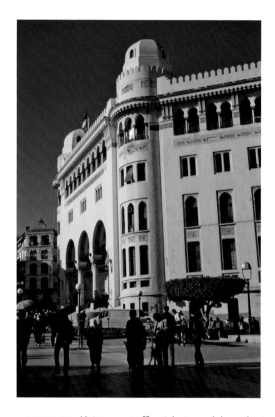

PLATE 27 Algiers, post office (photograph by author).

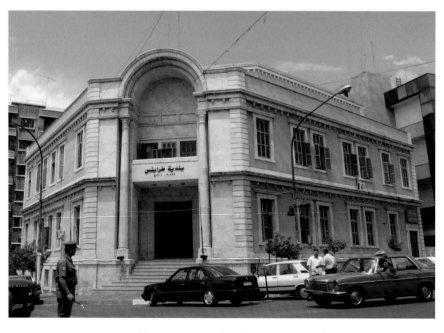

PLATE 28 Trablusşam, Municipal Building (photograph by author).

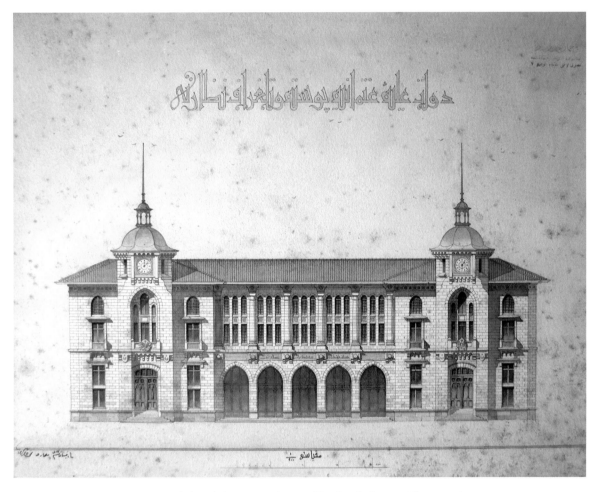

PLATE 29 Istanbul, Vedad Bey, Central Post Office, façade drawing (IÜMK 93112).

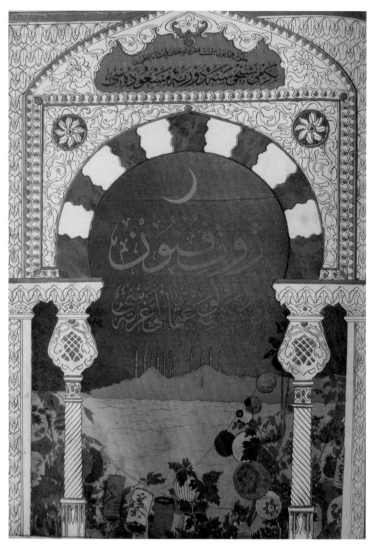

PLATE 30 *Servet-i Fünun*, special issue on Abdülhamid II's jubilee, cover
(*Servet-i Fünun*, no. 670 [1320/1904]).

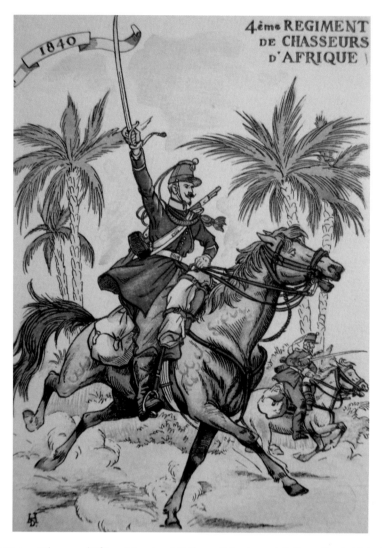

PLATE 31 "Chasseur d'Afrique" (postcard, Défense, Département de Terre, Fonds Michat).

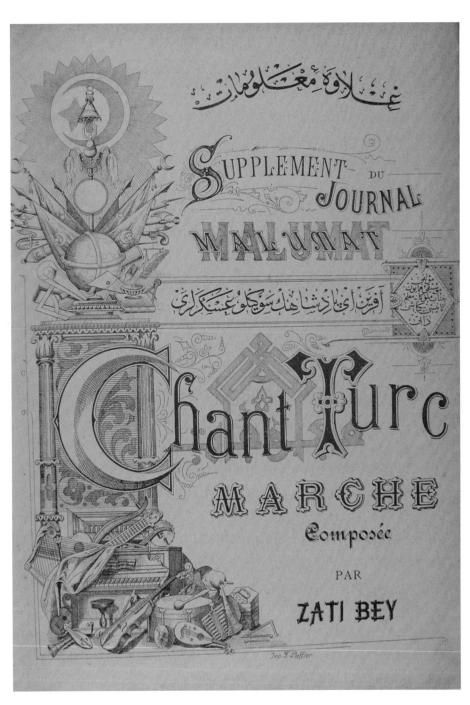

PLATE 32 Cover for "Chant Turc" (*Malumat*, no. 120 [1313/1898]).

PLATE 33 *Military Barracks in Bengazi*, perspective drawing, watercolor (IÜMK 93139).

1

IMPERIAL INFRASTRUCTURES

INFRASTRUCTURE PROJECTS, MODERN enterprises par excellence, differed in the Ottoman and French empires in terms of their goals. Military, economic, social, and ideological concerns were their common denominator, but the specific emphasis placed on each aspect gave each empire its own outlook and development process. An analytical overview of the aggressive engineering operations that irrevocably changed vast landscapes will reveal some of the most dynamic forces at work in empire building. It will also help clarify the meaning of "public works," which sectors of the "public" were targeted, and when and why, as well as the numerous power struggles, negotiations, and collaborations between political entities, international companies, and capitalist businesses.

A modern infrastructure that would connect all corners of the Ottoman Empire was at the heart of the post-Tanzimat reforms. To implement the programs on the broadest scale possible, the provinces had to be fully integrated into an efficient network, and the drive for administrative centralization necessitated linking them to the capital. The primary incentive for such projects was military and state control, to be followed by economic development. The establishment and operation of an evenly distributed network of state authority depended on the newest technology. The construction of land roads, railroads, ports, and telegraph lines (from 1853 on), the improvement of waterways, and the introduction of a postal system (with the first stamps

issued in 1862–63) were the major modernization projects. In addition, at the end of the nineteenth century, the Ottoman Empire launched an ideologically loaded railroad project that occupies a unique place in the history of modern transportation: the Hijaz Railroad was intended to connect Istanbul, Aleppo, Damascus, and Beirut to the holy cities of Mecca and Medina.

The French infrastructure projects in the Maghrib pursued more focused agendas. They first served the occupation, directly involving the army in the construction of an effective communication system. Maréchal Thomas-Robert Bugeaud, who served as the commander in chief of the army in Algeria (from 1840 on) and as governor-general (1845–47), described the army's dual function in Algeria at the outset of the conquest: "Our army is organized such that it is not only an army of warriors but also an army of workers. The army must be the first agent of colonization to employ; it is a sure means to dedicate to this oeuvre a high number of arms, vigorous and low-cost."[1] In Algeria, taking the Roman legions, the *"antiques dominateurs"* of Africa, as an example, the French soldiers shouldered the challenge of ensuring the "double interest of domination and colonization" by building an extensive road network. Against the background of Muslim "scorn" for civilization and its products, roads (the engineering feats of the French army) testified to the "superiority of France."[2] Two decades later, railroad construction in Algeria, undertaken by independent French companies, complemented the land roads and played a key role in the occupation.

As Algeria's status as a settler colony became firm, the next step was to develop the local economy and tap the natural resources. Without the rapid and efficient transportation of agricultural, industrial, and mining products, economic development could not be realized, settlers would not immigrate to work (and control) the land, and the goods could not be conveyed to the metropole. Explaining the importance of constructing railroads in Algeria to Napoléon III, Maréchal Jean-Baptiste-Philibert Vaillant situated them at the heart of the colonization project: "railroads should, in effect, be considered as one of the most powerful elements for the prosperity of our vast conquest."[3] Following the example of metropolitan France (and of North America), where "railroads, created by urban capital, went where the interests of capital and of urban industries took them, not where people actually lived," railroads had to precede the settlers.[4] In Tunisia, the economic drive dominated: the first rail lines linked the mines to the nearest ports, relegating the connections between the cities—a primary concern in Algeria—to later efforts.

Beyond their imperial mission, infrastructure projects played global roles. For example, India was connected to England by telegraph lines passing through the Ottoman Empire (see the introduction); the port of Beirut would become a crucial point for the Mediterranean trade; and the Hijaz Railroad (intended to connect to port cities on the Red Sea) would ease transportation for Muslim pilgrims from

other parts of the world. In the French case, the communication networks were to link the different colonies and consolidate the French presence in Africa. This rationale explains the priority given to the east–west railroad lines in the coastal region of Algeria at the expense of the north–south ones as early as the 1850s: the goal was to extend the railroad from Tunisia to Morocco.[5] Four decades later, with the expansion of the empire, the trans-Saharan connections gained importance, reflecting the growing imperial ambitions and the aim of unifying a territory stretching from Tunisia to Algeria, Senegal, and the Congo.[6] Infrastructure, linked to a rational exploitation of the lands and to the "civilizing mission," became the essence of the *mise-en-valeur* (development of the natural and human resources) of the colonies, as argued in an official document dating from 1902: "no material and moral progress is possible in our African colonies without railroads." Influenced by Saint-Simonian thought, Minister of Public Works Charles de Freycinet had argued a few years earlier that "civilization spreads and takes root along the paths of communication."[7]

The integrity of infrastructure projects within each empire, the priorities, the details of their designs, construction, and management, and the extent of their geographical scope call for their interconnected analysis. Although this chapter treats the two empires separately, cross-references will be made.

BUILDING AN OTTOMAN NETWORK: "STEPS TOWARD NOVELTY AND ORDER"

Land Roads: Regulating and Classifying the Imperial Geography

Laws and regulations, as with all Tanzimat reforms, systematized the construction of roads throughout the Ottoman Empire. The attempt to unify the operations rationally and expeditiously was enhanced by a simple road classification system. Each new regulation addressing the shortcomings of the previous one, a series of legal documents were developed in the 1860s to facilitate the mastering of the land. The first, dating from 1864 and titled the Regulation of Provinces (Vilayet Nizamnamesi), established the capital of each province as the seat of power, where the governor and other high bureaucrats, appointed by the sultan, would reside; it also set Istanbul's municipality as the model for all cities and towns of the empire. This was followed one year later by a regulation that stipulated the procedures for constructing roads and the rules for (corvée) employment.[8] The 1869 Regulation on Roads and Streets (Turuk ve Meabir Nizamnamesi) classified the imperial road system with the intention of expanding and regularizing the network. The first category (imperial roads, *sultani yollar*) consisted of roads leading to Istanbul, ports, and railroads; the second-

ary and tertiary roads linked the centers of provinces; and the last category encompassed roads between small towns and villages.[9]

The main dilemma in the execution of the infrastructure projects stemmed from the economic conditions of the empire, more specifically the bankruptcy of the state, which had led to the creation of the Public Debt Administration, giving European powers control over financial matters. Not having the resources to fund the ambitious projects, the Ottoman state was forced to sell concessions to foreign companies in order to consolidate its own imperial programs. European political and economic interests in the region responded enthusiastically, turning the history of infrastructure projects into a history of foreign enterprise in the Ottoman Empire. The story of the three-decades-long construction, operation, and maintenance of the Beirut–Damascus road, reduced to its bare essentials below, provides a glimpse into the fragmented processes and the labyrinthine interactions between the various actors, including their disappearance from one project and reappearance elsewhere.

Edmond de Perthuis, a Frenchman who would be engaged in several infrastructure ventures in the region, obtained the concession for the Beirut–Damascus road in 1859 and opened the road to traffic in 1863, cutting the travel time between the two cities from two days to twelve hours.[10] Perthuis's company held on to the transportation monopoly until 1892, when it was passed to another French company, one that had already acquired the rights to build a railroad between the two cities in 1891. Because the concession for rail lines between Damascus and Mezeirib was already in the hands of a Belgian company, negotiations led to the unification of the two companies. Ironically named Osmanlı Kumpanyası (the Ottoman Company), this new company demanded and was granted another concession to build a "large road" to Aleppo in the north.[11]

Despite the governing ambition to be comprehensive, the projects were not evenly distributed owing to the lack of centralized control as well as the piecemeal nature of the construction processes. Syria received the lion's share.[12] The increase was most impressive in Mount Lebanon: in comparison to the 60 kilometers of roads in 1860, the roadways stretched to 1,444 kilometers in 1914. Even more significantly, in addition to macadamized arteries between urban centers, the network included secondary roads that linked villages to highways.[13]

Providing access from the Mediterranean outlets to the main centers inland was of utmost urgency; in most cases, this meant the widening, fixing, and paving of the existing roads for carriage traffic. By the early twentieth century, Damascus was linked to Beirut and to Haifa (via Taberya and Nazaret), Aleppo to Trablusşam (via Homs and Hama), and Jaffa to Nablus and Jerusalem. The total length of the land roads at that time (including those under construction) was 910 kilometers 230 meters; 597 kilometers were open to transportation. For example, coaches (*dilijans*) that held

17 passengers and that were described as "European-style" by Şerafettin Mağmumi operated between Trablusşam and Homs (the road was opened in 1878) and between Beirut and Damascus (opened in 1860). Wagons were used to carry merchandise.[14]

Even in this privileged region of the empire, lack of maintenance was a nagging issue, and because of chronic neglect from the concessionaires and the inability of the government to control them effectively, the roads quickly ended up in a "ruinous" state.[15] In 1910, an editorial in the inaugural issue of *Revue technique d'Orient*, which reported on technical and industrial public works in the Ottoman Empire, described the neglected state of the roads, deficiencies in management, and absence of overall control. A major problem stemmed from not considering the larger picture: the pieces were parceled out so that the projects that the Ministry of Public Works in Istanbul ordered each province to undertake were independent of those in the neighboring provinces. Working against centralization policies, this situation led, for example, to the abrupt ending of a newly opened *"belle route"* at the boundary of a province. Recognizing the problem, the ministry granted an ambitious project of 10,000 kilometers of land road construction to a consortium of three French companies. Of the ten branches projected, two were in the Arab provinces: the Baghdad network and the Damascus–Jerusalem–Beirut road.[16]

Certain regions at the peripheries were ignored. Yemen is a glaring example. As officially acknowledged in 1895, roads were absent even in the most crucial region, that is, between Sana and its hinterland. Yet the state considered well-built roads indispensable for empire building, especially in critical areas like Yemen, which had been belatedly introduced to "a state of order" and "rules of civilization." To facilitate the broader mission, described in general terms as a "development project," a road between Sana and Hodeida, a "relatively important port," was imperative: it would integrate different modes of long-distance transportation while serving the local people, who had recently begun to engage in agriculture and commerce.[17] A French engineer was invited to Sana to devise a plan for the construction of highways in Yemen, but in the political turmoil that swept the province at the turn of the century and forced the Ottoman administration to focus solely on military control, the project was abandoned.[18]

The Railroad Network: Transporting Cereals, Soldiers, and Pilgrims

The energy devoted to railroads and the faith placed in them stand in significant contrast to the fragmented execution of land roads in the Ottoman Empire. Three major networks (with interconnections) were to cover the Arab provinces: the Syrian, Baghdad, and Hijaz railroads. For Tanzimat reformers, railroads charted the future of the empire, not only in unifying the land but also for strategic and economic reasons: easy transfer of troops would help combat the ever-increasing uprisings, and

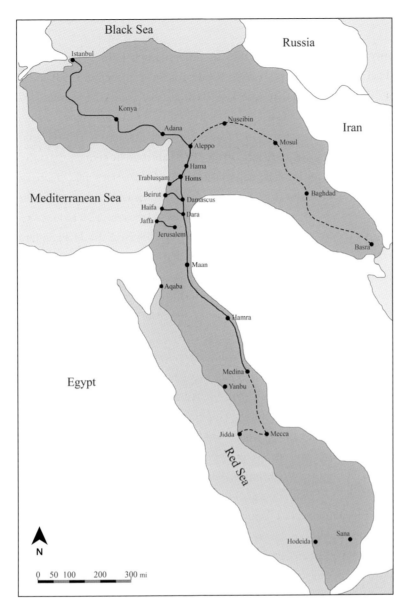

1.1 Map showing the railroads in the Ottoman Arab provinces, c. 1914

(drawing by Kevin Field); the dashed lines indicate the unrealized sections.

production would benefit from fast transportation.[19] Military control was as signifi-
cant as economic development, as underlined by Abdülhamid in his rationalization
of the Baghdad line: "The Baghdad railroad will revive the old trade route between
Europe and India. If this line is extended so that communication is established with
Syria and Beirut, and Alexandria and Haifa, a new trade route will emerge. This
route not only will bring great economic benefit to our empire but also will be very
important from the military point of view, as it will consolidate our power [in those
lands] (fig. 1.1)."[20]

The economic promise of railroads for the empire as a whole and for the regions they passed through was much discussed at the time. The following passage on the Haifa–Damascus line of the Syrian network from a 1908–9 *salname* clarifies the official perspective:

> The material benefits and welfare . . . are high for the people. Because the line passes through the most fertile valleys of Palestine, the development potential of these areas will increase in a short time . . . and it will constitute an export route for the produce cultivated by people in the Havran region, thereby leading to the accumulation of wealth and capital and, consequently and without any doubt, to the true advancement of agriculture and development. The lands that correspond to the Sublime Line's route after Dara may not be as fertile, but they are not deserts as assumed. They are uncultivated land and were once inhabited; they will show great development easily and in a short time thanks to the arrival of the railroad.[21]

Promotion of religious tourism, specifically access to the "Holy Land" for Christian pilgrims, constituted an important component of the economic program, and the need to connect the ports on the Mediterranean to the sacred sites spurred the construction of the Syrian network. The Hijaz Railroad, which led to Medina and Mecca and facilitated Muslim pilgrimage, accommodated political and ideological concerns above all but was also important militarily and economically.

With the exception of the Hijaz Railroad, the financially strained Ottoman state gave concessions to foreign companies to build and run the empire's railroads. This situation served the rampant capitalism and European economic and strategic interests in Ottoman lands. The British, the French, and the Germans fought over the concessions in order to expand their respective control over disparate parts of the empire. In the historic framework of world imperialism, it is not surprising that the history of railroads in the Ottoman Empire began with a British initiative (by Captain F. R. Chesney) in the 1830s and that the first line (between Izmir and Aydın in western Anatolia) was built by a British company that obtained a concession in 1857. The goal was to connect to India via the Persian Gulf and Aleppo.[22]

Rivalries between the European companies in the Ottoman Arab provinces constitute an intriguing episode in the history of imperialism. While unknotting the relationships among numerous companies is not the issue here, understanding the interactions and the scale of the operations casts light on the piecemeal nature of construction and operation, the troubled state of the Ottoman economy, and the limits of control exercised by the Ottoman administration over projects believed to be crucial for the broader Ottoman imperial project. Complicated by the sheer number of players involved, the railroads came relatively late to Syria and Palestine. The 75-kilometer line from Jaffa to Jerusalem, crucial for the pilgrim traffic to the Holy Land

and the economies of both cities, was realized only in 1892 by a French company. Nevertheless, this project, deemed profitable and ideologically and politically astute, had been on the table for over five decades—as testified by numerous unsuccessful British attempts to obtain concessions (dating from 1838, 1856, 1862, 1872, and 1880).[23] Yet the economic benefits were ill calculated, not taking into consideration the seasonal nature of pilgrim travel (and the small scale of merchandise transportation). The cost of the enterprise weighed so heavily on the company that the operation of the line had to be completely halted for a short period in 1894.[24]

The line between Damascus, Homs, and Hama was built in 1894 by another French company, which took the name of the Société Ottomane du Chemin de Fer Damas–Hama et Prolongements (DHP) in 1900; it was extended to Aleppo a year later. The same company constructed the 145-kilometer line between Damascus and Beirut in 1895, a difficult and expensive operation that involved crossing the Lebanon mountain range on necessarily narrow rails and the construction of numerous viaducts, bridges, and tunnels (figs. 1.2 and 1.3). The conditions made travel long and arduous.[25] The French were also in charge of the Damascus–Mezeirib line, which would connect Syria's "bread basket" (the Havran region) to Damascus, its trade center. As the construction that had begun in 1891 proceeded, its logical prolongation to Haifa gave way to disputes between the French and the English, the latter holding the right to build the Haifa–Damascus line, which would also cater to religious tourism. In effect, connecting Damascus to the Mediterranean via Haifa was more efficient than reaching Beirut, because the land to be crossed was geographically more conducive to "normal" rails (1.50 m wide). The company, called Syria Ottoman Railways and founded by Pelling (an Englishman) and Yusuf Elyos (a local entrepreneur), did not succeed in raising the required funds for the construction; by 1900 its total length stretched merely five kilometers. Finally, the government abolished the concession and integrated the Haifa–Damascus line into the Hijaz Railroad: it was completed in 1905. The execution of the Haifa–Akka line took longer and it opened to transportation in the early years of World War I. This line enjoyed only a short life, as the rails were removed so they could be reused in another branch of the Hijaz Railroad.[26]

The final link from inland to the coast was the 102-kilometer-long Trablusşam–Homs line, built in 1911 by the DHP. Due to its potential to bring the products of Aleppo and its hinterland to Trablusşam, it was meant to enhance the development of the latter, albeit at the expense of Beirut. Nevertheless, like the Haifa–Akka line, this one did not survive; its rails were demounted and transported to another branch of the Baghdad Railroad, to the south of Diyarbakır, during World War I.[27]

By 1914, Syria was crisscrossed by railroads. An inland north–south rail line, running parallel to the coast, led to Anatolia in the north and toward Arabia in the south. It was connected to Mediterranean ports at regular intervals. However, this rather-comprehensive web did not amount to an integrated system due to the incompatibil-

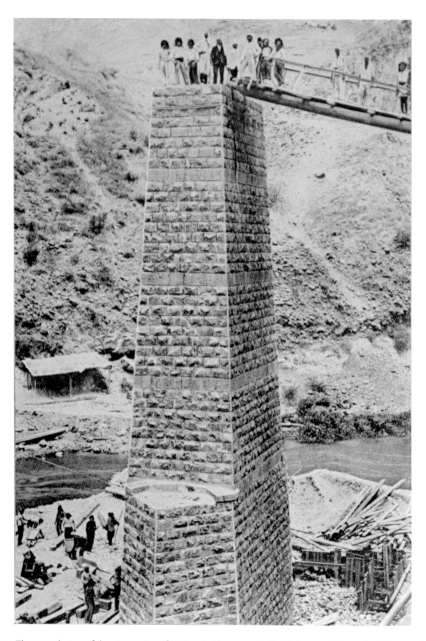

1.2 The completion of the stone pier of an iron bridge near Haifa (*Salname-yi Beyrut* [1326/1910–11]).

ity of the rails, which required transfers at their meeting points. For example, the Jaffa–Jerusalem and Beirut–Damascus–Mezeirib lines were narrow (1.00 m), whereas the Haifa–Damascus and Damascus–Aleppo lines were wide (1.50 m).[28] This lack of coordination could have been avoided by systematic and careful inspections of the regulations governing the concessions and was representative of the Ottoman government's failure to pursue its reform agendas in practice.

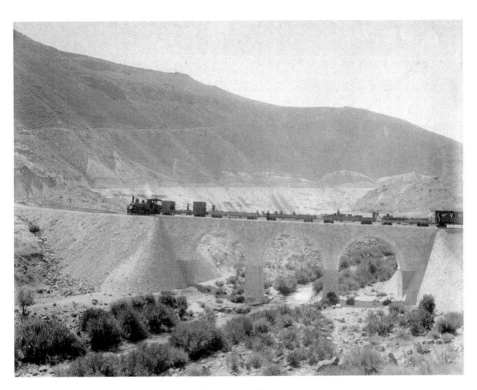

1.3 Hijaz Railroad, bridge (IÜMK, album 90606).

Reviewing the state of the railroads in Syria during World War I, Mehmed Refik and Mehmed Behçet, the authors of *Beyrut Vilayeti*, criticized the government policies from several perspectives. They maintained that the land and rail routes did not complement each other to benefit trade, but that the former were built simply following the latter's path. They argued that the railroads should pass through "important locations" and especially those that catered to trade; it was a death sentence to build them randomly in "deserts." Another issue was that some rail lines were single and some double and some were 1.50 meters wide, as in Europe, and some 1.00 meter wide. While the authors acknowledged the financial burden of constructing double lines on "normal"-width rails ("as in Europe"), they favored this choice because of its potential to increase trade. They reminded the government that, in issuing concessions, the "comfort and benefit" of the public should dominate all decisions and that good transportation enabled the economic well-being of the citizens. They advocated that, at the least, provisions could be made to expand the system to two lines in the future, and tunnels and bridges could be built on a larger scale.[29]

The initiative to link Anatolia to Baghdad for economic and military reasons went back to the reign of Sultan Abdülaziz in 1871 when the Ottoman government asked Wilhelm von Pressel, a German engineer, to develop a project. However, only a small

portion (between Istanbul and Izmit) was constructed in the next two years, and the condition of Ottoman finances led the government to abandon the idea of state-funded railroads.[30] The project was revived during Abdülhamid's reign, but now relegated as a concession. Beyond Ottoman agendas, a railroad that would connect Europe to the Persian Gulf had obvious appeal to European powers, making the rights over it a matter of rigorous competition, especially between Germany and Britain but also between Germany and France.[31] The German enterprise, represented by the Deutsche Bank, benefited from Emperor Wilhelm II's visit to the Ottoman Empire in 1898 (see chapter 5) and obtained, in addition to the concession for the Baghdad Railroad, the concession to build and run the ports of Baghdad and Basra. In accord with the growing rapprochement between the two countries, the Ottoman government increased the privileges given to Germans beyond the previous concessions to foreign companies; it granted the German Baghdad Railroad Company the authority to search for minerals and use the water resources along 20-meter-wide bands on both sides of the line, hence the right to exploit the untapped resources of the land. The Baghdad Railroad would lead from Ankara to Diyarbakır in southeastern Anatolia and then to Mosul, Baghdad, and Basra. This expansion of the project gave rise to complicated negotiations and revisions and ultimately obstructed the project's execution. Only the Anatolian sections were constructed by the outbreak of World War I.[32]

While it is beyond the goals of this book to engage in a detailed analysis of the conditions that governed the concessions, it is worthwhile to examine closely the regulations that bound one company, focusing on economic, military, technical, and cultural issues that demonstrate the intended scope of Ottoman control over foreign enterprise. The *actes* of the Railroad Company of Syria, which was responsible for the construction of the Damascus–Haifa line (1891), stipulated that the concessionaires had to build offices, free of charge, for imperial commissioners, customs inspectors and officers, postal services, and police, at locations indicated by the government; they also had to construct military barracks during time of war, as judged necessary by the state. In addition, the company had to establish a telegraph line along the entire length of the railroad; this line could not be used for private communication, including communication by the concessionaires. Antiquities and art objects found during construction had to be reported to the Ottoman administration, and a separate request had to be made to obtain authorization for archaeological research. With the exception of technical experts, the personnel would be selected from among Ottoman subjects, and the company had to employ some engineers who had graduated from the Ottoman military school of engineering (Hendese-yi Mülkiye); the employees would wear fezzes and uniforms devised by the imperial government; those in contact with the public should be able to speak Turkish as much as possible. Passenger cars should be in three classes, and special compartments should be

reserved for women in each class.[33] The document thus addressed issues considered urgent at the time, including the emphasis placed on antiquities and attempts to prevent them from being smuggled out of the empire (see chapter 5), as well as the drive to disseminate an Ottoman identity—in a manifestation of the integrated nature of various projects to modernize the empire.

The Hijaz Railroad: A Sacred Line

The Hijaz Railroad, announced by an imperial decree on 1 May 1900, which was the birthday of Abdülhamid II, occupies a unique place in the history of the late Ottoman Empire.[34] Connecting Damascus to Mecca and Medina, this "sacred line" (*hatt-ı mübareke*) was to be an exclusively Muslim enterprise: it would rely on Muslim funding, be planned by Muslim engineers, and be built by Muslim workers using local materials.[35] Non-Muslims and foreigners could not own or inhabit the land alongside it.[36] The Hijaz Railroad marked a break from the usual practices of railroad projects in Ottoman lands and was an attempt to make a statement about the identity of the empire, interweaving modernization with ideological and political agendas. Its ostensive raison d'être was religious: to make the pilgrimage to Mecca shorter, easier, and cheaper, in support of Abdülhamid's pan-Islamist policies. Unlike the other lines, the Hijaz Railroad did not have a convincing economic justification: it would serve only seasonal traffic and there was no agricultural production in the regions through which it ran. The Hijaz region had always been an economic burden on the Ottoman state, and its administrative and military expenses surpassed by far the only income from the province, that is, the customs tax from Jidda.[37] However, because of the British occupation of Egypt (1882) and, consequently, British control over the Suez Canal, the line had also acquired military and strategic significance. With the completion of the Hijaz Railroad, the Ottoman state could send troops directly to Arabia. Ottoman authority would be strengthened by a connection to Aqaba that would provide access to the Red Sea and by linking the Baghdad and Hijaz railroads (at Aleppo). These were serious political and military considerations that challenged the special status historically enjoyed by the emirs of Mecca, whose independence had increased by the turn of the century. The Hijaz Railroad formed the backbone of a policy designed to reestablish Ottoman control in the area—against persistent and effective British provocation.[38]

The idea for a railroad in Hijaz had been around since 1892, when a connection between Jidda and Mecca to ease the land travel of pilgrims arriving by sea was envisioned. Another proposal was to link Damascus to Mecca to strengthen Ottoman authority and to resist the growing impact of foreign powers in the Arabian Peninsula. In 1897, the Ottoman administration focused again on British activities in the region and agreed upon the need to construct a railroad from Damascus to the Suez

Canal (and also to link Damascus to Anatolia) to expand Ottoman political power and the state's ability to protect its territories. Meanwhile, an 1896 British project to undertake a "desert railroad" in Arabia was rejected as a result of an effective protest, initiated by Muhammed Inshallah, an Indian journalist. Engaging in a wide propaganda campaign through Muslim newspapers in different parts of the world, Inshallah appealed to the sultan to take on the project and turn it into a Muslim enterprise with funds exclusively from Muslims. Presumably on the success of Inshallah's campaign, the Ottoman state revisited the topic of the Hijaz Railroad in 1898.[39]

Funding for the Hijaz Railroad, starting with a generous sum from Abdülhamid, turned into a worldwide affair. The campaign promoted the project as the collective work of Muslims everywhere. Although donations from abroad amounted to only 9.5 percent of the total budget, they came from a vast area, including India, Egypt, Morocco, Algeria, Tunisia, Iran, Singapore, Russia, China, Java, and Trinidad. Muslims living in Europe, especially England and Germany, contributed as well. The Ottoman government capitalized on this diversity to accentuate the ideological importance of the project and its relevance to the greater world of Islam, while searching for additional donations from within the empire and abroad and taking other measures to finance construction. The latter included loans from Ziraat Bankası (the Agricultural Bank), a new tax on the salaries of state officers (at first all, but after 1902 only Muslims), a yearly tax on every Muslim family, concessions from certain mines, and income collected from sales of postcards, stamps, and animal skins collected after Eid al-Adha (Kurban Bayramı).[40] In short, all subjects in the empire paid for the Hijaz Railroad.

The administrative apparatus of the Hijaz Railroad was carefully crafted to carry out its ideological mission and to enable centralized control, while running the operations effectively at the local level. The symbolic associations of the project that linked it to the idea of the empire and the sultan himself, as well as its grandiose scale and much-sought worldwide visibility, necessitated a layered structure consisting of two bodies: a High Commission in Istanbul and a local commission in Damascus. The former, composed of leading Ottoman statesmen, underlined its imperial prominence. The fact that all decisions were subject to Abdülhamid's final approval reinforced the project's esteemed status. The High Commission drafted the overall strategy on issues related to the budget, allocation of funds, employment policies, importation of materials, commissioning of contracts, and negotiations with companies that already held railroad concessions. The Damascus commission, whose members were selected by the sultan himself (which reiterated the importance of the project on the local level), was responsible for the execution of plans and projects. The High Commission contracted an Ottoman engineer, Hacı Muhtar Bey, to develop the initial project and propose a route based on his study of the region's topography.

Technical problems plagued the project and caused significant delays, sometimes

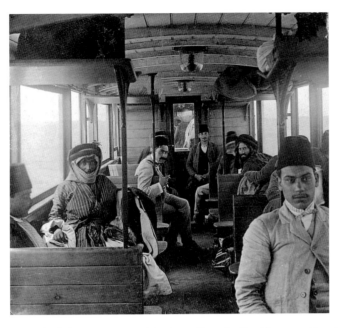

1.4 Hijaz Railroad, third-class carriage, 1908 (Dr. Jean-Alexandre Otrakji, www.mideastimage.com).

necessitating reconstruction to correct mistakes. The High Commission and the sultan thus found themselves forced to employ foreign engineers with expertise in railroad construction. In December 1900, the appointment of Heinrich August Meissner, a German engineer who had already worked for railroads in the empire and who knew Turkish, attested to the growing rapprochement between the two countries. By 1904, 12 German engineers were working on the project; the number of foreign technicians had increased to 20. Nevertheless, the sultan's insistence on the employment of Ottoman engineers produced results not typical of other infrastructure companies operating in the empire: in 1904, 17 Ottoman engineers (some graduates of the Hendese-yi Mülkiye and others educated in European schools) worked on the Mecca line. As they gained experience, they assumed key positions among the technical cadres and in the administration of the Hijaz Railroad.[41]

In its special issue on the Hijaz Railroad, published two years and five months after construction began, *Servet-i Fünun* described it as a system of two lines. The first ran between Damascus and Dara; out of its total projected length of 123 kilometers, 70 kilometers and a number of "small and large bridges" had been completed, with an accompanying telegraph line. The second line, from Dara to Medina, would ultimately total 1,560 kilometers; rails had been laid for 94 kilometers.[42] In 1903 the line reached Amman, and by 1904 it had stretched to Maan. The Dara–Haifa line was incorporated into the project and finished in 1905, establishing a link to the Mediterranean. The line reached Medina in 1908, reducing the travel time between Damascus and Medina from 40 to 3 days (fig. 1.4).[43]

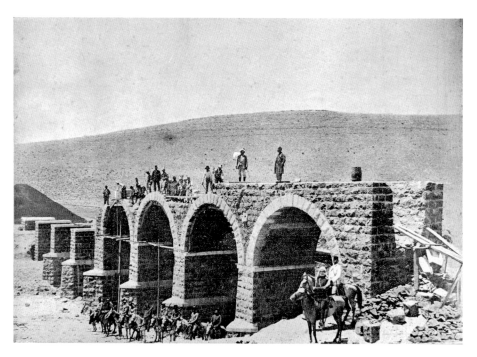

1.5 Hijaz Railroad, bridge (*Servet-i Fünun*, nos. 593–94 [1318/1902]).

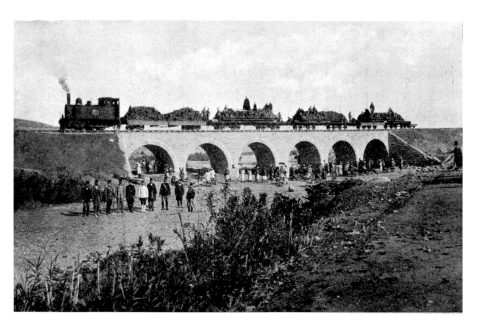

1.6 Hijaz Railroad, bridge (*Servet-i Fünun*, no. 607 [1319/1903]).

The status of the Hijaz Railroad was unequaled among other construction projects of the post-Tanzimat period. Its progress was extensively recorded and disseminated by photographs. Images of the railway and the accompanying structures were

collected in albums (see fig. 1.3).[44] The Ottoman press systematically published news (visual and textual) from the construction sites, keeping the public informed at every stage of the process. The statement made in the special issue of *Servet-i Fünun* that the progress of the project could be observed by "viewing our pictures" extended to the history of the entire operation.[45] Issue by issue, the journal reported in photographs the points reached, the bridges and tunnels begun and completed, the trenches dug, the materials transported, and the inaugural ceremonies performed. Over time, these accumulated into a visual history of the Hijaz Railroad, with the picture captions constituting the only textual information (figs. 1.5 and 1.6).[46] Browsing several issues of *Servet-i Fünun* from 1903 conveys the scope and detail of the photographic reporting: bridges along the Haifa and Maan branches, an interior view of a railcar transported to Damascus by boat from Istanbul, opening ceremonies of the Damascus–Maan branch featuring the "honored committee" from Istanbul posing with notables and Bedouins from the region and the army band playing, new rail construction, and even tents of workers (who were "imperial soldiers").[47] The photographic survey thus highlighted different aspects of the project: technical, scientific, social, political, and, above all, imperial. The Hijaz Railroad encapsulated the totality of Hamidian ambitions.

The Hijaz Railroad was never finished. Three crucial connections remained unachieved: Maan–Aqaba, Medina–Mecca, and Mecca–Jidda, the latter two especially important for pilgrimage and without which the promise to the Muslim world could not be entirely fulfilled. The failure to complete these lines was due mainly to the resistance of the emirs of Mecca and the Bedouins, who feared that the arrival of the trains would reinforce Ottoman authority and lead to the loss of their autonomy and their economic livelihood. As the unique providers of accommodation, food, and transportation on camels in the region until then, the tribes depended on pilgrims for income. They began attacking the construction in 1905 by destroying rails and stoning trains; assaults on construction crews followed, turning into a full-blown revolt in 1908. Construction was protected by military troops, whose numbers increased from 5,000 in 1906 to 15,000 in 1908—in direct proportion to the growing insurgency. One night in July 1908 alone, Bedouins killed 300 soldiers.[48]

Under these conditions, integrating Yemen into the network could not be achieved either. A project in 1910 proposed linking Sana to Hodeida on the Red Sea, paralleling the earlier attempt to connect Mecca to Jidda to ease communication from the sea to inland centers. However, this was another expensive and difficult enterprise, because of the mountainous topography between Hajalla and Sana, which would have necessitated the construction of long tunnels and gigantic viaducts.[49]

Even the parts of the Hijaz Railroad network that functioned were not always considered a "success." Ahmed Şerif, a bitter critic of the project, drew "various portraits" of the railroad from Damascus to Dara in the newspaper *Tanin*, questioning

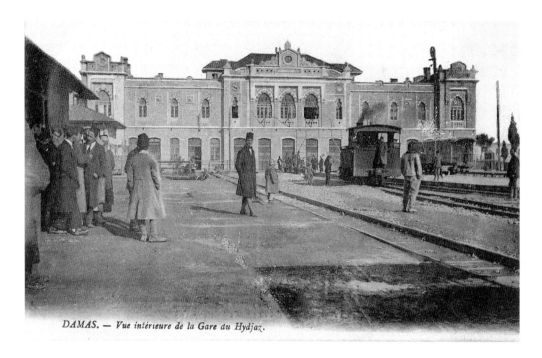

DAMAS. — *Vue intérieure de la Gare du Hydjaz.*

1.7 Damascus, train station, view from the tracks (postcard).

its management and calling for "several steps toward novelty and order." Agonizing
on the state of the line that belonged to "us, to the nation," he sympathized with the
"poor soldiers," who had sacrificed so much and worked so hard to combat the "wild
nature of the desert, as well as the savagery and ignorance of this [part of the] world."
Despite the fact that the Ottomans and Muslims everywhere had "opened their
purses, giving and giving," the conditions he observed were revolting: the soldiers
were left "without water, food, money, and, often, without drugs to fight the danger-
ous and contagious diseases," the trains ran behind schedule, the personnel were
"rough" and "poorly dressed," soldiers were stuffed in open carriages meant to trans-
port merchandise, the stations were "ordinary" and some were only tents. Şerif con-
cluded with a criticism of the constitutional government, then in power for three
years: "neither the representatives in the assembly nor the leading figures in the gov-
ernment thought or wanted to think about this orphan line."[50]

Train Stations: Modern City Gates

A discussion of railways would be incomplete without considering the train stations.
In their role as nineteenth-century gates to cities throughout the world, train stations
offered architectural experiments integrated with the developments in engineering
technology. Their status as new symbols made them prominent urban landmarks

1.8 Aleppo, train station
(Dr. Jean-Alexandre Otrakji, www.mideastimage.com).

and called for an inquiry into appropriate aesthetic expressions—a topic widely studied by historians of nineteenth-century architecture. The neoclassical and the neo-Gothic were the main styles adapted by the architects of the train stations, but a neo-Islamic train station had already been built as the terminus of the Orient Express in Istanbul in 1889. It was only natural that a similar language would be adopted in the two major stations of the Hijaz Railroad: Damascus (fig. 1.7 and pl. 2) and Medina. Designed around the same time (1911), the former by Spanish architect Fernando da Aranda and the latter by German architect Otto Lutz, the stations complemented the message of the "sacred line." They were comparable in size and shared the Beaux-Arts concepts of symmetry and axiality with innumerable other stations. While both were "Islamic," the Damascus Station relied more on an eclectic style reminiscent of the Istanbul Station, whereas the Medina Station's references were recognizably Cairene. Their "Arab" flavor contrasted with that of a third large station, the Aleppo Station on the Baghdad line. Another tripartite symmetrical structure, the roof of the Aleppo Station had wide pitched eaves, which gave it an Anatolian touch (fig. 1.8).

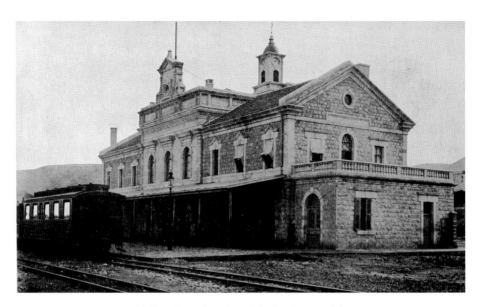

1.9 Haifa, train station, view of the façade toward the sea
(*Salname-yi Beyrut* [1326/1910–11]).

The numerous stations along the rail lines displayed a hierarchy that depended on the importance of the location. For example, Haifa boasted a two-story baroque-flavored station with a clock tower (fig. 1.9) that had replaced an earlier modest, one-story structure. However, the most common form was a stone structure with a pitched tile roof, highly reminiscent of European examples. The Beirut terminal was two stories tall, holding the ticket office, waiting area, and various offices on the lower level and the stationmaster's apartments on the second level. The smaller Zahle-Maallaka and Trablusşam stations repeated the same formula on a more modest scale.[51] The simplest version was a small, one-story building, as observed in a village station on the Haifa line (fig. 1.10). Finally, as Ahmed Şerif pointed out, tents occasionally served as stations. He described their interiors as sheltering a telegraph machine, a table covered with papers and notebooks, a bed, a couple of broken chairs, and a stove for cooking.[52]

Rivers as Highways: The Tigris and Euphrates

As natural "highways" through Mesopotamia, the Tigris and Euphrates rivers had always carried regional boat traffic. In the nineteenth century, the potential of the two rivers to form a part of the imperial (and international) transportation network produced several projects. The British drive to establish routes to India led to an initiative in 1830 to run steamboats on the Tigris by Captain Chesney, who had also

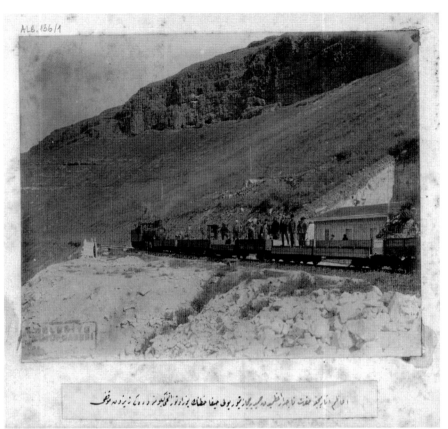

ALB.136/1

الى قرار احال يكله عفت خاجهزه نظريه ديكبه دلمير يوني جيفا حفظانك بازائزه الثوري للوصور نه ريز بنه زرده توقف

ALB.136/2

2 ALB.136/3

1.10 Hijaz Railroad and stations, pages from a photography
album that show different views (AK, album 136).

1.11 Iron bridge near Baghdad (IÜMK, album 90573).

attempted to obtain the first railroad concession in the region. Chesney had two boats, named after the rivers, brought in parts to Iskenderun by sea, carried on camelback to Birecik (on the northern Euphrates), and assembled there. The Ottoman government first gave permission for experimental journeys up and down the Euphrates, then along the Tigris. Within a decade, the British began to run steamboats on both rivers for commercial purposes.[53] As reported by an Ottoman traveler, the boats from Baghdad and Basra went to "India, China, and Japan on the one side, and to Europe via Aden and Egypt on the other, developing trade here."[54] In 1911, the British were still in charge, with the concession in the hands of the Lynch Company. However, upon the appeals of local residents opposed to foreigners' rights on the Tigris and Euphrates, the Lynch Company's operation had been reduced.[55]

An undated survey that mapped the towns and villages along the Tigris and Euphrates testifies to the importance attached to the two rivers by the Ottoman government (pl. 3).[56] Dividing the area into twelve regions and dedicating a smaller-scale map to each region, this comprehensive record provided information on topographic features, as well as indicating every settlement along the waterways. There is no record of the purpose of the document, but a section drawing through the Tigris on

one plate shows the accumulation of silt at the river bottom and suggests that the survey may have been conducted to initiate periodic dredging operations to enable uninterrupted water traffic (pl. 4). The density of the settlements, so clearly conveyed by the maps, seems to validate such an initiative, as well as the high number of small boats that crisscrossed the rivers. Travelers described the chaotic, heavy, and picturesque traffic, which intensified close to major settlements. Near Baghdad, it consisted of a medley of sailboats, rowboats, and circular-shaped boats unique to this region, called *küfes* (see fig. I.2). Made out of palm leaves in "the shape of cooking pots," and with a single oar operated by one person, *küfes* transported people, animals, and merchandise.[57]

Bridges built at points of intense traffic across rivers, together with spans constructed for railroads, inserted powerful images of modernity into landscapes throughout the empire. Baghdad's bridge over the Tigris celebrated the new age and accommodated an advanced form of transportation—the tramway (see chapter 2). In 1911, a project envisioned an iron bridge for Baghdad, as well as steamboats to be operated by the municipality. The latter would enable travelers to reach Felluja from Baghdad in 1 day and, connecting by land to Aleppo from Meskene on the river, would make it possible for mail to arrive in Istanbul within 12 days.[58] Mosul also boasted a bridge on the Tigris: the Altun Bridge.[59] But perhaps the most celebrated of the Mesopotamian bridges was the widely photographed "iron bridge" near Baghdad, constructed in 1899 (fig. 1.11). Resting on stone piers, the iron frame crossing the river imposed the aesthetics of the new technology on the landscape.[60]

Ports: Outlets to the World

Creating an integrated infrastructure system meant developing the port cities, which would act as outlets to the Mediterranean. Connecting land transportation networks to transportation by sea would improve long-distance communication within the empire, granting access to the capital and other centers on the shores of western and southern Anatolia, as far as Salonika. For example, travel between the capital and the Syrian hinterland became much easier when travelers could take a boat to Beirut and then trains from Beirut to Damascus and beyond. At the same time, the development of the ports, together with the land transportation networks, opened the shores of the eastern Mediterranean to Europe, enabling trade and tourism (especially religious tourism). It also facilitated European penetration into the provinces in multiple guises, including the commercial, technical, and missionary.

As the "outlet of Syria, and especially of Damascus," to the Mediterranean, Beirut was the key Ottoman port in the region.[61] Its importance for communication within the empire was equaled, if not overpowered, by its importance for Europe's interest in Syria. The region's centuries-old trade pattern with Southwest Asia had shifted to

Europe in the nineteenth century and, with considerable help from the development of steam navigation in the Mediterranean, turned Beirut into a major financial and commercial center.[62]

State initiatives to reorganize the harbor and build new facilities so that the port could realize its potential went back to the 1850s,[63] but not much was achieved during the following decades.[64] A map from 1876 shows breakwaters that protected the harbor from the north and west winds, defining a coastal area fronting the city and extending considerably toward the west; no major harbor structures are indicated (pl. 5).[65] The facilities had not modernized significantly by the early twentieth century, and Mağmumi noted in 1909 that the waterfront consisted of a great deal of "empty land" and, unlike the port of Izmir, was not yet "bejeweled" (*ziynetlenmemiş*) by fitting structures.[66]

If not developed to the scale of Izmir, the Beirut harbor was built up in increments to handle a busy import and export trade. In 1886, the minister of public works granted the concession to a local engineer, Yusuf Mutran Efendi, despite intensive lobbying efforts by Edmond de Perthuis—in a gesture that showed Abdülhamid's support of local Arabs over foreigners, as argued by Hanssen.[67] The project, dating from 1888, proposed several facilities that would address the needs of an increasingly important port (pl. 6).[68] The design was not particularly imposing or costly. Of the embankments labeled A, B, and C from the west to the east, embankment B, which corresponded to the central axis of the urban fabric (and where the small customs facilities were already located), was given the most articulate treatment while retaining its use as the customs zone. Presenting long façades to the city and the sea, the new warehouse had two sections, divided by the customs offices. Architecturally, this was an unusual composition (pl. 7). The customs offices had "traditional" façades with a subdued, residential image (enhanced by the pitched roof and the shutters on the windows), while the warehouses expressed their functions and interior structures (uninterrupted steel frames) by means of industrial façades and continuous fenestration below the roofline.

Embankment C was symmetrically and axially reorganized, with the Port Administration, Police Headquarters, and Sanitary Office in the center. The embankments were envisioned as large, open spaces, most likely in order to give a "corniche" effect; they were embellished by prominent buildings that replaced the humble structures randomly scattered in the area. The project did not designate new functions along the esplanades and did not focus on their junctures with the city fabric, yet it still expressed the intention to endow Beirut with a spacious and regular waterfront and surpassed merely practical commercial goals.

A plan of the port from 1912 reveals further developments (fig. 1.12). The western pier was widened, and plans were devised to prolong the northern pier. The zone

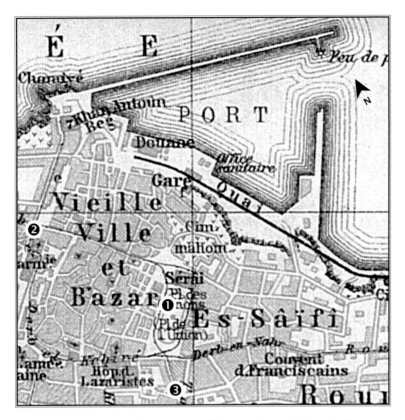

1.12 Beirut, plan of port, 1912 (Baedeker, *Palestine and Syria*, 5th ed.).
1. Burj Square. 2. To Bab İdris. 3. To Damascus.

behind the customs house had been filled in by warehouses and office buildings organized in a grid plan.[69] The extension of the Beirut–Damascus rail line to the waterfront and the construction of a rail terminal there in 1903 played a key role in facilitating the transport of goods.[70] Beirut's port functioned efficiently, as demonstrated by the scale of commercial activity: by the 1910s, about four thousand merchant ships visited Beirut annually. The most important export was raw silk (particularly in demand by French industry), followed by olive oil and fruit. Timber and metal girders and rails for railroad construction, as well as firewood and petroleum, constituted its major imports (fig. 1.13).[71]

Haifa and Jaffa, the two other coastal towns with economic potential, did not fare as well as Beirut—despite recurring attempts to modernize them. Haifa's natural harbor could shelter 15–20 vessels during storms, but the shallow waters did not allow the boats to approach the shore. In 1891, a concession was given to the Syrian Ottoman Railway Company to build the ports of Haifa and Akka within four years. To accommodate its "special importance for exports and imports," an iron pier, 30

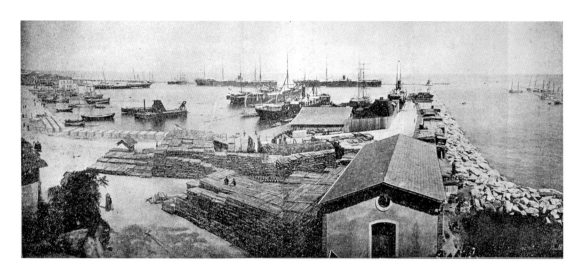

1.13 Beirut, view of port, showing the transportation of rails for the Hijaz Railroad
(*Servet-i Fünun*, nos. 593–94 [1318/1902]).

meters long and 16 meters wide, was stipulated for Haifa. However, the company, which had failed to construct the rail lines, failed to carry out this project as well, and Haifa's waterfront was never organized into a proper port.[72] Another attempt, in 1898, called for the construction of stone piers instead of the existing wooden ones and increased their length from the shore to 85 meters in order to reach the depth necessary for boats to approach. Economic restraints led to a creative solution to minimize construction costs: this involved the recycling of stones from a ruined castle nearby, transported by boats and cranes brought from Beirut.[73] Neither this initiative nor the transfer of the concession to the Hijaz Railroad Company yielded any satisfactory results.[74] As reported in the pages of *Servet-i Fünun* in 1909, "lacking an embankment, Haifa did not even have an orderly pier," but only one "in ruins."[75] Baedeker's guidebook confirmed this observation in 1912: the steamers had to cast anchor at a considerable distance from the shore and passengers had to be transported to land by rowboats.[76] Nevertheless, the Hijaz Railroad Company benefited from the income generated, including that brought by tourists who visited Tiberias. As noted by the increase in the customs office's income, the rail connection had turned this humble "fisherman's wharf" into a locus of economic exchange.[77]

The story of the Jaffa harbor is similar. A report in 1865 emphasized the commercial importance of the harbor because of its proximity to Jerusalem and Nablus and described the existing pier as insufficient to accommodate the traffic of goods and travelers coming from all over the empire, as well as from Europe. It argued for the replacement of the wooden pier by a stone one, which would be "wide and orderly."[78] In the late 1870s, the waterfront was still not organized, but the city's historic walls were demolished, and the resulting open space was dotted with customs and quar-

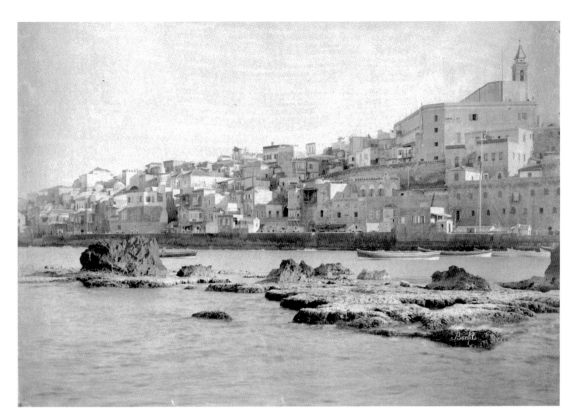

1.14 Jaffa, view from the sea (American University of Beirut, Jafet Library, Special Collections).

antine offices, as well as a lighthouse.[79] A large customs building was completed
only in 1888.[80] In 1897, the newly appointed mayor of Jerusalem, Mehmed Tevfik
Bey, described his difficult arrival in Jaffa, echoing the conditions in Haifa: because
the boat could not approach the shore, the passengers had to be transported to land
in small boats—a passage made rougher by the presence of many rocks in the area
(fig. 1.14).[81]

Several initiatives by the government to improve the port facilities affirmed these
observations and Jaffa's importance as an imperial outpost. A report in 1911 pointed
to the lack of a harbor administration building in Jaffa, badly needed at this point of
"unusual importance for commercial and strategic reasons," as well as the urgency
of operating Ottoman boats along the Syrian coast.[82] In 1913, an order was issued to
rebuild the customs office, to be followed by a larger project to rebuild the port.[83] The
projects were not implemented. However, paralleling the situation in Haifa and
attesting to the persistence of European interest in the region, the lack of modern
port facilities did not halt activity. The city served as the entry point to pilgrims from
Europe visiting the Holy Land and Jerusalem and as a center of considerable import
and export. The growing status of Jerusalem as the nucleus of European politics in
the Middle East enhanced Jaffa's international role.[84]

Ottoman efforts concentrated on the Mediterranean ports because of their strategic importance. Although the ports on the Red Sea did not attract as much attention, they were still considered key points in the infrastructure network of the empire. Jidda and, to a lesser degree, Yanbu gained more and more visibility in the context of the Hijaz Railroad, which was projected to reach these coastal towns from Mecca and Medina respectively. Jidda already served as a major entry point to Arabia for many pilgrims, who would then travel arduously by land to Mecca and Medina. By the end of the nineteenth century, about 60,000 came by sea; out of these, 35,000 were from Java and 15,000 from India.[85] It was hoped that the new railroad, which never materialized, would capitalize on Jidda's location on the pilgrimage route by stimulating improvements to the port facilities.

There were no radical proposals to modernize Jidda's natural port, which was protected by a series of islands that created two natural harbors, the outer one suitable for large boats and the inner one accessed by a narrow channel suitable only for small boats. An undated perspective drawing recorded few interventions to the natural setting except for several light towers (pl. 8). The small town of Jidda occupied a long and narrow strip along the water's edge and was protected by a wall, with two massive forts at the two ends and many gates. An area identified as "the old wharf neighborhood" (*eski İskele Mahallesi*) was reserved for military structures. The most important service provided by the central government was supplying the boats with water; iron pipes incorporated into a pier transported water from a large storage tank on the embankment. A "beautiful fountain" on Wharf Square (İskele Meydanı), erected by order of Abdülhamid in 1886 and adorned with the sultan's *tuğra* (seal) in gold, exploited the opportunity to celebrate the empire.[86]

The Mediterranean had always been the best link between the North African Ottoman provinces and the rest of the empire. With the occupation of Algeria and Tunisia, the coastal city of Trablusgarb gained much importance. Yet the city lacked an efficient harbor. Even though the "natural harbor" on the north side was large, it offered no shelter from the wind to boats and needed to be rebuilt—as officially noted.[87] An 1883 plan shows two short piers that frame the ends of the walled city and two more on each side of the quarantine zone (pl. 9; see also fig. 2.22). Outside the fortifications, at the juncture of the old and new quarters, there was a longer pier. The most substantial pier, farther to the east in the Salıpazarı quarter, was dotted with factories and extended along the waterfront by new neighborhoods; nearby stood a large police station (pl. 10). A later document that argued for the construction of a rail connection between the "port of Trablusgarb" and the city itself may indicate that this area was considered the "port" proper.[88]

In 1889, seven years after Tunisia was appended to France, the Ministry of Construction (Nafıa Nezareti) initiated a project to renovate the port of Trablusgarb upon orders from the Sublime Porte.[89] It is reasonable to suggest that this was in response

to a memorandum from Abdülhamid II on the "prosperity, progress, and reinforcement of the province of Trablusgarb," first unearthed by Deringil, who describes the plan as "nothing other than a 'project of modernity.'"[90] The document called for the construction of the port, a customs building, and "regular embankments," which would enhance the development of commerce in the province, as well as provide a recreational space for the residents of the city "in the evenings"; a boat for the exclusive use of the governor would be docked at the port.

An engineer named M. Weber was commissioned to analyze the conditions and draft a plan to protect Trablusgarb from the violent winds that made anchorage extremely difficult during the winter months. Following instructions, Weber proposed a breakwater that extended east along the natural line of rocks, sheltering the harbor on the north and northwest (pl. 11). The bay thus created behind the seawalls would have an arsenal in the north and, in a gesture to extend the city, the earth dredged up from the bay would be used to create an area that could be sold and developed. Weber projected here a new neighborhood designed on a grid plan, which was very different from the urban fabric of the old city and more in harmony with the new quarters built to the south by the Ottoman governors (see chapter 2). He advocated a stone embankment that would be at least 25 meters wide, a public space that would serve the city as a corniche and comfortably accommodate the embarkation and debarkation of merchandise—in accord with the sultan's memorandum.[91] As a plan of Trablusgarb and its environs from 1909 indicates, the project was not implemented in its entirety and the same piers continued to serve the city (see fig. 2.22). However, the embankments between the arsenal and Bab el-Bahr (el-Bahr Gate (i.e., the waterfront of the walled city) and around the "halfa" pier (named after the esparto grass, used in producing paper) outside the walls were widened and rebuilt by Governor Ahmed Rasim Pasha around 1890.[92]

FRENCH CONQUEST BY INFRASTRUCTURE: "IN THE MIDST OF UNDISCIPLINED PEOPLE"

Land Roads: Connecting the Army Camps

Surveying the state of infrastructure in the Maghrib before the French occupation, Narcisse Faucon concluded that after "fifteen centuries of neglect," that is, since Roman times, land roads in Algeria were in extremely poor condition, with "not a single road in the interior."[93] The lack of navigable waterways compelled the French army to construct a land road network immediately after the conquest. Putting soldiers to work, the army engineers built an extensive system, which, above all, made the movement of troops possible through the country but also played an indispensable role in the development and economic prosperity of the colony. The

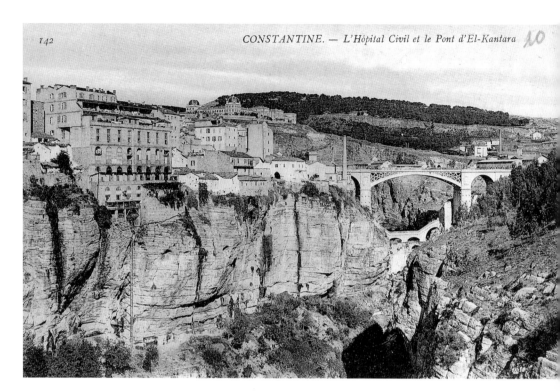

1.15 Constantine, view showing el-Kantara Bridge (postcard, GRI).

roads from the major cities radiated in multiple directions, linking the centers and covering entire regions. Detailed records kept by army engineers and officers reveal issues related to the decision-making processes, considerations taken into account, and negotiations, while providing ample information on technical aspects of highway construction.[94] A brief look at the case of Constantine, situated inland, casts some light on the priorities and the conception of French road construction projects.

A plan dating from 1839–40, two years after the conquest of Constantine, envisioned "great highways of communication" that would originate from the capital and "penetrate" to all parts of the province. Subsequently, military establishments would be built to control the vast territory between two ranges of the Atlas Mountains. After the foundation of Philippeville on the coast, mobile camps of soldiers opened a road to put Constantine in contact with Philippeville. The camp in Arrouch (el-Harrouch) was designated as a permanent establishment, from which another artery branched off to Bône on the eastern coast. Two roads linked Constantine to Sétif. Parallel construction activities produced hospitals, barracks, and arsenals—"all the establishments necessary for a great army."[95] Four decades later, a project that aimed to improve the street network within Constantine described the impressive regional arteries—

the connection to Algeria would bring, he later changed his mind and the Companie Bône–Guelma ended up acquiring the rights to these lines under the beylical regime and went on to be in sole charge of the railroads of Tunisia under the protectorate. The Tunis–Souk el-Arba line was prolonged to the Algerian border in 1877, with the clear intention of connecting the Algerian and Tunisian lines.[112] The entrepreneurial rigor and ambition of the company, as well as its trust in the forthcoming annexation of Tunisia, enabled it to confront the belligerent political attitude toward France in the late 1870s. Two decades later, Faucon summarized the conditions: "The Bey was hostile; and to construct a railroad during a time like this, across a country lacking local resources, in the midst of undisciplined people, [who are] thieves, pillagers, and enemies of Christians, without any assurance of security . . . was, without doubt, a dangerous undertaking."[113]

The Companie Bône–Guelma thus served the interests of France "beyond expectations" and gave a new orientation to French politics, ultimately leading to the occupation of Tunisia.[114] As shown by historian Mohamed Lazhar Gharbi, the strategic and military role of the line between Algeria and Tunisia continued after 1881, allowing for efficient transportation of troops between the two countries to pacify the revolts in the province of Oran and the insurrections in central and southern Tunisia.[115]

After the military conquest, trains would help develop the economic potential of the country. In 1891, a silk merchant from Lyons, named Ulysse Pila, voiced the urgency of capitalist development in a public lecture, endorsing the expansionist policies of Jules Ferry, the former premier of France: "In the midst of the economic evolution that is hitting Europe, in the face of the life struggle that each nation has to address, our field of action has become too narrow. We must break through our walls. I will not pronounce the words of colonial expansion, which shocks, but I will say that the expansion of commerce, of industry, and of French intelligence is upon us."[116]

As argued by a newspaper published in Tunis, the completion of a rail network would "allow the regions, today [in 1891] almost entirely out of [the reach of] commercial movement, to take part in transactions."[117] This was a long project. A "rational extension" of the network depended on the exploitation of the mines and forests of Khoumire in the northwest and the phosphates of Thala in the middle of the country.[118] The Ghafsa region, also rich in phosphates, was linked to the port of Sfax in 1899, and, from 1906 on, trains carried minerals from Haut-Tell to Tunis. Initially intended for transporting minerals, these lines also helped agricultural production.[119] For example, the fertile hinterland of Sousse, already boasting two large olive oil and soap factories, relied on the connection from Kairouan to the port of Sousse that opened for service in 1890.[120] The scale and the pace of rail construction were matters of pride: thanks to railroads, the French "protectorate could be established and asserted in the Tunisian regency," and the region's "economic implementation," as well as its "forward march," were assured.[121]

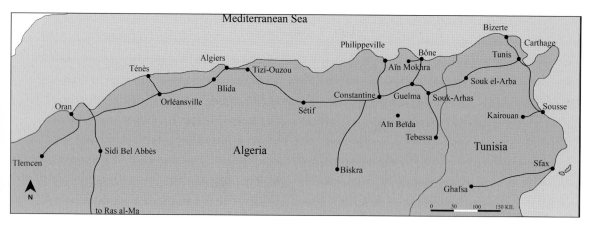

1.16 Map showing the railroads in Algeria and Tunisia, c. 1914 (drawing by Kevin Field).

perity of the region, operated the iron mines in the mountains near Bône and undertook the construction of railroads to link the mining areas to the port of Bône in the 1860s.[107] But the real push came in the mid-1870s, when the Companie de l'Est Algérien acquired the rights to the Algiers–Constantine line and the Companie de Chemins de Fer de Bône–Guelma was charged with building the line between Bône and Guelma. By this time, a military agenda dominated the railroad projects in eastern Algeria, explicitly surfacing in the Bône–Guelma line: the annexation of Tunisia.[108]

In 1879, the governor-general gave urgent priority to the Duvivier–Souk-Arhas stretch of the Bône–Guelma line, which ran parallel to the Tunisian border. The army sent "military workers" (50 military prisoners and 6 *spahis*) to join the company's 3,000 employees, making this the only segment of the Algerian railroad system in which the army was directly involved.[109] In 1881, Grimaud, the chief engineer in Bône, stated that the primary goal of the Bône–Guelma line was "to penetrate Tunisia." He singled out Souk-Arhas as the last European settlement on the road to Tunisia, announced the construction of buildings and facilities necessary for a garrison of 1,600 soldiers, outlined its land road connections (to Bône, to Aïn Beïda, and, under construction, to Tebessa), and emphasized the importance of the rail line that would complete the communication web around Souk-Arhas.[110] A map of the Tunisian border from the same year shows the area ready for attack, with the itineraries of the patrols, the infantry and cavalry stations, and the roads and railroads marked.[111]

At the time of the French occupation, Tunisia had about 200 kilometers of railroads, not surprisingly around Tunis. Prime Minister Khayr al-Din had first granted concessions to the British Tunisian Railroad Company for the Tunis–La Goulette line and to the Société Italienne Rubattino for the Tunis–Souk el-Arba line. Well aware of the military risks that would accompany the project, he had at first opposed the construction of this line by the French. However, considering the economic benefits that

The Railroad Network: Serving the Army and Capitalist Enterprise

The first request by a private company for a concession to build a railroad between Algiers and Blida goes back to 1844, a remarkably early date in the history of railroads. The French administrators considered railroads an essential tool for colonization, but certain problems, including the initial reticence of the banks and private enterprise to invest in Algeria, postponed the operations. However, the main hurdle stemmed from the opposition of the army, which wanted to monopolize the construction—as it did all affairs of the colony at the time. In the 1860s, Napoléon III endorsed the army's claim to the right to build Algeria's rail structure, responding to the advocacy campaign conducted by Général François-Ernest-Henri Chabaud-La Tour, the *commandant superieure de Génie,* and Maréchal Jacques-Louis-César-Alexandre Randon, the governor-general of Algeria. Nevertheless, as military interference in civilian affairs diminished, the projects were relegated to private companies, and negotiations on concessions resulted in the creation of the Companie des Chemins de Fer Algérien. French capitalist enterprise thus began its instrumental and enduring involvement in colonial projects.

A decree in 1857 specified a network that would total 1,357 kilometers and serve commercial development. It would include a line that ran parallel to the coast and connected Algiers to Constantine in the east and Algiers to Oran in the west, with branches to Tlemcen and Sidi Bel Abbès. Two other lines would link the ports to the first line and connect Bône and Philippeville with Constantine, Ténès with Orléansville, and Oran with Tlemcen (fig. 1.16).[103] The first stretch to be built was the Algiers–Oran connection, completed between 1862 and 1870. Théophile Gautier hailed its first segment, the 50-kilometer Algiers–Blida line, as pointing to "a future full of promise that opens for *France Africaine.*"[104] By 1877, the total length of railroads in Algeria—all in the west—had reached 513 kilometers; by the end of the nineteenth century, the northern part of Algeria was crisscrossed with 2,905 kilometers of rail lines.[105]

In northeastern Algeria, the richness of the natural resources made railroad transportation an important consideration. Saint-Simonians played a crucial role in the region's economic development. The Saint-Simonian interest in Algeria went back to the years immediately following the occupation, specifically in Michel Chevalier's attempts to devise new economic strategies for the entire region around the notion of a utopian "Mediterranean system." Writing in 1832, Chevalier argued for the primal role of infrastructure in governance: "The large-scale introduction of railroads on continents and steamboats in seas will be not only an industrial revolution but also a practical one. . . . It will be easy to govern large parts of the continents with borders on the Mediterranean."[106] From 1853 on, industrialist Paulin Talabot and his brothers, credited by their contemporaries for their contribution to the growth and pros-

National Route 3 from Philippeville to Biskra and National Route 5 from Sétif to Algiers—that passed through the city as part of a more systematic national network, implicitly registering France's complete control over the region.[96] An 1888 guidebook showed the radiating vehicular roads that extended from all major urban centers of Algeria and linked them to each other.[97]

As part of the *"grands travaux,"* French engineers endowed the Algerian country-side with many bridges whose striking aesthetic characteristics reflected the newest technology. However, it was the image of Constantine that anchored itself in collective memory because of its bridges, due to its dramatic position atop the cliffs along the deep Rhummel Valley. At the time of the French occupation, el-Kantara Bridge, which dated from Roman times, connected the city to the other side of the canyon; the bridge was substantially rebuilt during the eighteenth century by the entrepreneurial governor of Constantine Salah Bey (1725–75) and integrated with an aqueduct. The bridge and the gate at its end marked the entry point of the French army in 1837, after its famously difficult capture of the city. In 1859, two years after the collapse of one of el-Kantara's piers, an iron bridge with a single arch was built overlooking the old bridge in a project developed by L. de Lannoy, chief engineer of the Department of Constantine. The new bridge above the Ottoman one made a metaphoric statement about the changed power structure; the bridge's connection to a railroad station also told the story of an integrated modern urban infrastructure (fig. 1.15).[98] Next came the demolition of the old gate at the end of el-Kantara Bridge and its replacement by a new one; loaded with political significance, the new gate's architectural character was "severe and imposing," yet "in harmony with [its] picturesque site."[99] In 1912, a suspended bridge spanning the Rhummel at a height of 175 meters and to the north of el-Kantara Bridge made another key contribution to the urban image (see fig. 2.6).[100]

The land roads of Tunisia in 1881 were no better than the ones the French had found in Algeria in the 1830s. Consequently, the Service des Travaux Publics, established in 1883, assumed the task of not simply "improving but rather creating" the entire infrastructure, with some help from the army. By 1888, only the road network around Tunis was effective and well maintained. Construction moved rather slowly in the beginning; for example, during 1891, the total length of roads opened to circulation was only 109 kilometers.[101] Two years later, however, the service flaunted 900 kilometers of "very solid" land roads, constructed with "high quality materials"—which sparked the criticism that the service had spent too much to produce roads that were "too beautiful," even "too luxurious," for a backwater colony. Tunis was at the center, with Sousse and Monastir serving as secondary nodes from which roads radiated. The French had mastered all corners of Tunisia with land roads, down to short stretches in faraway places, such as the road from Houmt-Souk to the port on the island of Djerba.[102]

Bizerte - 30 - La Gare

1.17 Bizerte, train station (postcard).

Train Stations: Centers of Civilization

By the early twentieth century, not only had "rail lines replaced the Roman roads," but Europeans could consider each train station as a "center of civilization, . . . a center of protection, defended by stone walls, . . . and linked directly to the metropole."[122] The early stations had an unmistakable metropolitan aura despite their modesty (fig. 1.17). Almost routinely they were symmetrical, three-part compositions: a two-story central section with two one-story side sections. The ground level contained the ticket offices and waiting rooms; the roof was extended by a wide eave on the side facing the tracks, sometimes also on the street façade. The stations sheltered administrative offices, post and telegraph offices, and, often, the living quarters of the stationmaster. The overall mass, the tile-covered pitched roofs, and the windows framed with decorative stones mimicked the typical European train station. As gates to the settlements scattered throughout the Maghrib, they engraved the colonizer's image everywhere.

The stations in larger urban centers were more monumental and architecturally more adventurous and varied. In port cities, they were placed close to the harbor and, when possible, at the intersection of the old and new towns (as in Tunis and Sfax).[123] Tunis's South Station shared the basic design principles of the small stations, but the formula was expanded and embellished; its North Station boasted an

SOUSSE – Place de la Gare

ph o Perrin Tunis

1.18 Sousse, train station (postcard).

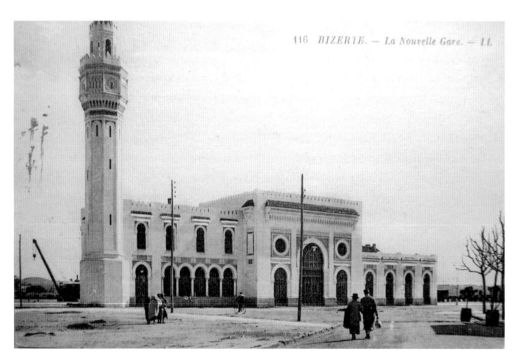

116 BIZERTE. – La Nouvelle Gare. – LL

1.19 Bizerte, train station (postcard).

industrial image, the street façade exposing the large triangular iron frame of the sheds (pl. 12). In Sfax's classical station, the symmetry and axiality of the tripartite composition was emphasized by a monumental entrance, fashioned as a triumphal arch—a favorite feature of nineteenth-century train stations throughout the world. Sousse's eclectic structure followed the same design principles but combined classical and "Islamic" forms; the latter were expressed in the triumphal-arch entry with horseshoe arches and a roofline that echoed the ramparts of the city (fig. 1.18). The architecture of other memorable train stations displayed neo-Moorish features and joined a popular trend in a range of public buildings erected in the Maghrib at the turn of the century (see chapter 4). Bizerte's new station, much more monumental than the earlier one, replaced the French look of the old station with a striking Islamic image, complete with a clock tower in the shape of a minaret and tile decorations in bright colors on the whitewashed walls (fig. 1.19). The tower and the differing heights of the two wings teased the symmetry of the composition, but the Beaux-Arts character of the design still surfaced in the tripartite composition and the triumphal-arch entry. The two-story station in Oran was even more imposing, larger and more elaborate in its details (fig. 1.20). A dome covered the vestibule, eaves inspired from residential architecture lined the entries and the first floor, and the clock tower replicated the minaret of the Mosque el-Djedid in Algiers (see fig. 3.2).

The similar trends in the architectural languages of the train stations in the Ottoman provinces and the Maghrib point to broader associations, linking them to parallel searches in other parts of the world. The "European" type, with its tile-covered pitched roof, appeared frequently in both contexts, as well as elsewhere, and fixed the image of the small-town station—in an affirmation of its universal character. The "neo-Islamic" stations reflect an attempt to adapt the new transportation technology to specific regions. The provocative issue of "regionalism" will be discussed later within the broader context of public buildings that shaped the character of the new urban spaces with their architectural associations (see chapter 4).

Ports: Phosphates, Olives, and Wine for France

The incorporation of the Maghrib into the French Empire depended on crossing the Mediterranean, which in turn prioritized the development of ports. The rail and land roads leading to coastal nodes would thus be connected to sea transportation, allowing a relatively easy passage to southern French ports, where the metropolitan rail system began. In the light of the military and economic benefits to be gained from this trans-Mediterranean network, it is not surprising that some of the earliest infrastructure projects targeted the regularization of waterfront facilities and the construction of specialized warehouses, breakwaters, piers, and embankments.

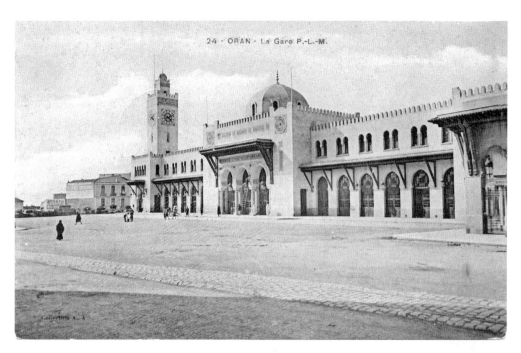

1.20 Oran, train station (postcard).

Projects in Algiers, the foremost port of French North Africa, were ongoing throughout the colonial era, in response to the continual growth of its traffic. As the port bustled with activity, numerous plans were devised, each based on seemingly endless debates; some were partially executed, others totally abandoned.[124] From 1830 to 1848, military engineers focused their efforts on improving the Ottoman port, which covered an area of six hectares. They restored a pier in the north (the Khayreddin Pier, named after the great sixteenth-century corsair) and rebuilt the embankments in the north and the northwest, acknowledging all along the necessity to expand the port. Especially because of France's tenuous relationship with Britain at the time, the government decided to create a great naval base at Algiers, thus designating it as a *port de guerre*. Nevertheless, its commercial potential was not overlooked, and the idea of a *port mixte* that reconciled military defense with the interests of commerce was favored for a few years. Finally, an 1848 law declared its status as *utilité publique* and led to a set of guidelines that were partially implemented; they included extending and repairing the Khayreddin Pier, creating ramps between the city and the quays, and building a new pier in the south.

By 1870, the port of Algiers had gone through major transformations, including the construction of a basin in the south, 600 meters of quays, and ramps that connected the quays to the city proper via the boulevard de l'Impératrice (the boulevard was completed in 1865). The ramps were the work of Charles-Frédéric Chassériau; they were supported by arches that recalled bridges and aqueducts and that gradually

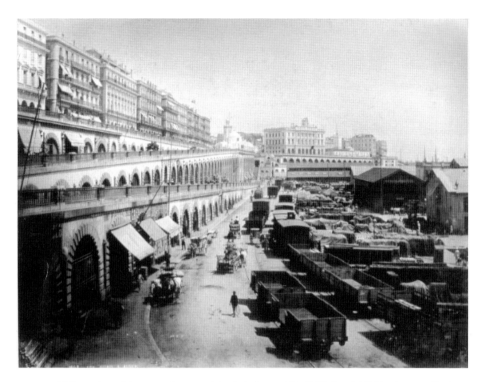

1.21 Algiers, view of the port, photograph by A. LeRoux, 1880 (GRI, Special Collections, 92.R.21).

became taller as the slope of the ramps increased (fig. 1.21). The city's new, elegant perimeter transformed the urban image as viewed from the sea. The project gave Algiers its memorable waterfront: the continuous high arcade at the level of the harbor, animated by the dynamic sculptural quality of the arcades under the ramps and the more delicate galleries of the boulevard de l'Impératrice on the upper level—all in white. Transcending its utilitarian significance, Chassériau's design granted Algiers an aesthetically unique place among port cities throughout the world.[125]

By the late 1870s, maritime traffic was the lifeblood of Algeria, enhanced by the railroads that connected the ports to the hinterland. The links to the metropole had gained further importance due to the increase in various exports of the colony, including a wealth of agricultural products, wines, and coal. After the opening of the Suez Canal, Algiers acquired a new role as a port of call, which further augmented its traffic. In the 1890s, it had become obvious that the port had to be expanded again, and between 1892 and 1912, the inner harbor of Agha, consisting of two basins and three piers, was built. These additions did not compete architecturally with the grandeur of Chassériau's design and projected only an image of commercial activity and hard labor.

Other ports in Algeria and Tunisia were, for the most part, functional; with few exceptions, they remained separated from the city. Their organization and planning

1.22 Oran, plan of port, 1888 (Piesse, *Algérie et Tunisie*).

prioritized creating refuge from the winds for the boats, building wide and uninter-
rupted embankments, and supplying the necessary commercial and administrative
amenities. Their growth and transformation went hand in hand with the develop-
ment of production and commerce in the colonies and were reflected in the image
they broadcast. The ports of North Africa were characterized by spacious docks bus-
tling with workers from different ethnic groups, sophisticated machinery, and
impressive amounts of products neatly lined up in their containers.

In Oran, an early project aimed modestly to create a small basin that would serve
as a "simple shelter" for light-tonnage navy ships. The ever-increasing economic
growth, however, motivated the proposal of a series of expansion projects. A number
of unimplemented solutions from 1833 to 1844 proposed breakwaters against the
north winds and culminated in a proposal to create two adjacent basins. They enclosed
an area of seven hectares and were opened to traffic in 1864, only to be proved inad-
equate. A final project in 1876 more than quadrupled the basins in size and stipu-
lated the construction of a one-kilometer-long pier in the east–west direction to
protect against the north winds and another one in the north–south direction; the
first port, now called the *vieux port,* was included within the new one (fig. 1.22).[126] A
quartier de la marine, where the train station and the customs office were located,
replaced a small fishing village and displayed a commercial character, marked with
customs buildings, warehouses, and workshops.[127]

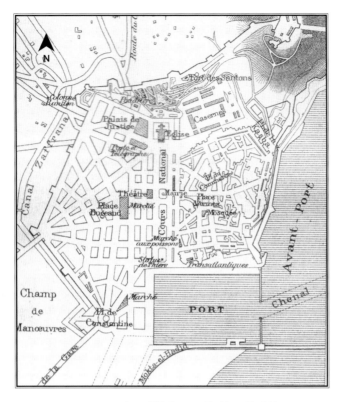

1.23 Bône, plan, 1888 (Piesse, *Algérie et Tunisie*).

A report from 1845 documented that Bône did not have a port and that large boats had to anchor 900 meters away from the shore. Responding to its call for improvements, several plans were proposed; by the 1860s the need for a port had intensified and resulted in the construction of a rectangular basin of about 10 hectares at the southern end of the city (fig. 1.23).[128] Protected from the winds by piers, in the 1880s it was considered the most secure and the most easily accessible port in Algeria.[129] Successive urban design projects emphasized its unique status and, following the model of Algiers, envisioned an aesthetically appealing waterfront. The early designs focused on the enlargement of the quays to facilitate loading and unloading and on the integration of commercial and public spaces; these plans were carried out in a fragmented manner.[130] The next step involved bringing the urban fabric to the waterfront by extending the cours Napoléon (later renamed cours Nationale and cours Bertagna and built on land once occupied by fortifications), which divided the European and indigenous towns (see chapter 2). To give the port area a dignified character that reflected its raison d'être, it was deemed appropriate to open a new square in front of the train station and construct a stock exchange and a chamber and tribunal of commerce.[131]

As typical of projects in Algeria at the time, those for the port of Bône were subject

1.24 Bône, statue of Louis-Adolphe Thiers facing the port (postcard).

1.25 Bône, port, quay for phosphates (postcard).

to many negotiations and transformations. The cours Napoléon was ultimately brought south to meet the waterfront; it terminated in a square with palm trees and a statue of the statesman Louis-Adolphe Thiers (fig. 1.24). With the palm trees framing the statue and serving as the gates to the avenue, the vista testified to the successful integration of the port with the rest of the city. The buildings lining the avenue were in the "style of the conqueror": they were of the same height and character, with their rooflines, fenestration, and horizontal divisions contributing to the Haussmannian uniformity (fig. 1.25). During the following decades, the three embankments around the basin acquired distinct characteristics: the northern embankment became the city's corniche; the southern one, relegated to phosphates in 1896, was designated as an industrial area;[132] and the western quay was defined by a neo-Moorish railroad station. Bône's waterfront may not have matched the scale and glamour of Algiers, but it seamlessly interwove the city with its port and created a series of practical and aesthetically appealing urban spaces.

At the end of the century, René Millet, the resident-general of Tunisia, summarized the progress made in constructing ports in the protectorate against the background of the precolonial picture: in contrast to the one single port on the Tunisian coast, La Goulette, during Ottoman times, now great boats could embark from the quays of Tunis, Sfax, and Bizerte, with Sousse getting ready for the inauguration of its port.[133] Each port in Tunisia played a specific role. Bizerte's location on the Mediterranean turned it into a rest stop for boats going to the "Chinese seas," allowing it to develop as a commercial center and to benefit from "all kinds of taxes."[134] The large population of the city of Tunis made it the most important commercial center in the country. Sfax served, above all, as the outlet for phosphates from the Ghafsa region. Sousse benefited from the railroad coming from Kairouan and bringing phosphates from Djebal Chaketma.[135]

In 1910, the French could boast that due to its "marvelous placement," the port of Tunis enjoyed a "principal role as the intermediary between the regency and France, [that is,] between the protectorate and its protector."[136] The increase in the exportation of minerals, cereals, oils, wines, wool, animal skins, and perfumes from the colony, as well as the projection of growth, had shaped the development of the port of Tunis. It was built between 1887 and 1893 by the Société des Batignolles as a rectangular basin on the Lake of Tunis and was served by a branch of the rail line; its inauguration, with ceremonies that lasted for one week, took place in May 1893 (fig. 1.26).[137] A 10-kilometer-long, 36-meter-wide canal dug into the lake connected the outer harbor in La Goulette with the basin. Addressing the further increase in the traffic (calculated as seven million tons), a 1907 project envisioned a complex of three basins: a "grand basin" enclosing 12 hectares, a second for sailboats, and a third specifically reserved for the delivery of phosphates.[138] The quays formed a vast parallelogram of 1,300 meters by 250 meters.[139]

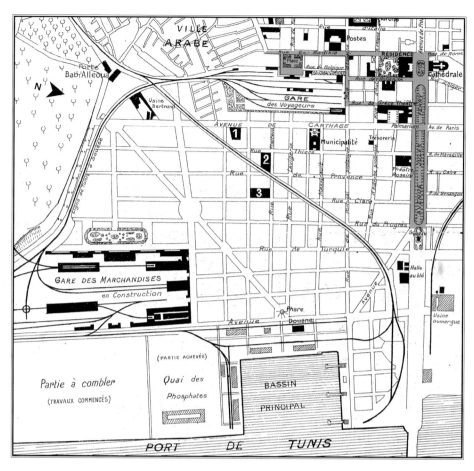

1.26 Tunis, plan showing the port, 1907 (BNF, Département de Cartes et Plans, Ge F carte 3906). The streets occupied during the Bastille Day celebrations in 1909 are highlighted.

The port of Sfax, built between 1895 and 1897 according to a design dating from 1893, capitalized on the phosphates and the rich agriculture of its hinterland, becoming the great port of the south and rivaling Tunis. A 2-kilometer-long and 6.5-meter-deep channel led to its 10-hectare basin of the same depth. A customs house, workshops, warehouses, and offices of the companies holding concessions to various products lined the large embankments;[140] these were functional structures, with no architectural pretensions. Developed to the southeast of the walled city and as an extension of the European town on a rectangular piece of infill land, the port complex included, in addition to the large basin, a channel for small boats to the northwest and the embankment for phosphates on the northeast. The latter, as well as the main quays, were served by rail lines (fig. 1.27 and pl. 13).[141] Sousse, like Sfax, had a functional port, opened in 1899 with a 13-hectare basin and 600-meter-long quays.[142]

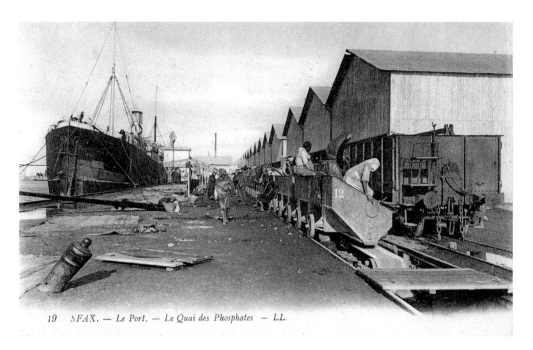

19 SFAX. — Le Port. — Le Quai des Phosphates — LL.

1.27 Sfax, port, quay of phosphates (postcard).

According to a report published in the official bulletin of the Companie du Port de Bizerte, when the company began the restoration of the quays in 1886, the old port had nothing to offer beyond a "very picturesque spectacle of oriental dilapidations for amateur tourists." The following year, the prolongation of the existing pier toward the east was begun; in 1893, still under construction, it was viewed as "the most important work in the great port of Bizerte" (pl. 14). At that time, the company proposed building a second pier in the north–south direction. The two piers, each about 1,000 meters long, would create an outer harbor of 100 hectares (hence significantly larger than those of the other Tunisian ports); in this relatively calm zone, a 60-meter-wide, 7- to 8-meter-deep, and 1,500-meter-long canal would link the sea with the lake, its dimensions accommodating big steam liners. The debris from the digging of the canal would be transported to the north bank to create a landfill for the construction of the "future French city."[143] When completed in 1895, the channel was reported as 64 meters wide and 9 meters deep, and the outer harbor totaled 75 hectares. The embankments, warehouses, and other functional structures completed the installations necessary to meet the needs of great boats.[144] A transporter bridge, high enough to allow ship masts to pass underneath, crossed the canal, defining the image of the port and the city (fig. 1.28). In addition, the port of Bizerte acquired a boat repair facility (fig. 1.29).[145] Despite some diminution from the original plan, the scale and facilities of the port of Bizerte as executed stood out in comparison to others in the Maghrib, with the exception of Algiers.

1.28 Bizerte, transporter bridge (IÜMK, album 90598).

183 — Arsenal de Sidi-Abdallah. BIZERTE-FERRYVILLE. Un Atelier de Machines. ND Phot.

1.29 Bizerte, arsenal, interior view (postcard).

The infrastructure projects carried out from the mid–nineteenth century to the eve of World War I transformed the landscapes of the French Maghrib and the Arab provinces of the Ottoman Empire. Railways, land roads, and (in the case of Mesopotamia) river navigation linked the major centers to each other and to the ports. Land and sea routes were integrated. The previously localized and introverted regions had become parts of a greater whole, as proudly projected in maps showing the landscapes covered by infrastructure networks. This was empire building, boasting modern technology and bringing unprecedented changes that included the expansion of cities, large-scale construction projects, and the introduction of new activities and modes of life. The geographical space it affected in both cases was vast, although the infrastructure networks were more attenuated in the Ottoman territories.

In developing the infrastructure projects, the French and the Ottoman empires focused primarily on military and economic concerns. Nevertheless, the specific conditions of each empire dictated differences in their goals and policies: conquest, occupation, and colonization in the case of the former, reformulation of the mechanisms of governance in the case of the latter. For the French, the military agenda dominated the early period of occupation. The army undertook the construction of roads and bridges to penetrate and control territory and, during the campaign to occupy Tunisia, participated in the construction of the railways toward the Tunisian border. The involvement of the Ottoman army was not comparable, as it directly intervened in only one infrastructure project, the Hijaz Railroad, which was not only built by ever-growing numbers of troops but also protected by them. Nonetheless, trains transported soldiers wherever necessary and were considered part of army matériel—as clearly stipulated in the concession agreements.

The two empires shared the economic goal of facilitating the distribution of resources and hence the development of their colonies and provinces. The relationship between the state and private enterprise was critical. In the Maghrib, the companies that obtained the concessions to build and operate the railways were French; their interests overlapped with those of the empire, intertwining French capitalism and colonialism. The Ottoman scene was much more complicated because of the state's debts to foreign powers, which resulted in their growing control over the empire's economy, and significant conflicts between the state and the myriad foreign companies holding concessions and between the different companies themselves, representing multiple national interests. Historian İlber Ortaylı has explained the parceling of the Ottoman territories into "benefit zones" for foreign powers in terms of the European control over the infrastructure projects in the Arab provinces, arguing that this situation testified to the lack of an Ottoman "colonial order."[146]

Unlike the Ottoman Empire, with its centuries-long presence in the Middle East and North Africa, the French Empire was a newcomer to the Maghrib. Whereas the historically decentralized Ottoman administration was represented by only a small group of officers, the French settlement policies quickly changed the Maghribi social structure, resulting in segregation between the colonizers and the colonized. Not surprisingly, infrastructure projects in North Africa were geared primarily to the settlers and the metropole and only marginally affected the local people, but in the Ottoman Empire, they were meant to benefit the people of the provinces. The Hijaz Railroad and the projects to modernize the port of Jidda went further and catered to the entire Muslim community in an act of ideological unification that surpassed imperial boundaries, conferring a new leadership role on the empire.

The success of the infrastructure projects was not equal in the French and Ottoman empires. In the latter, economic benefits were seen only in certain parts of Palestine and Syria. Haifa, for example, turned into a significant export and import center, with the amount of grain transported from Havran to Haifa doubling from 1903 to 1910.[147] Nevertheless, this did not translate into major economic gains. As vast quantities of grain swamped the Damascus market, prices fell, causing the grain dealers to suffer significant losses. When the railway between Beirut and Damascus opened, the grain could still not be transported to the coast at a profit because the prices in Beirut were still low. As argued by Linda Schilcher, railways brought some benefit, but for the few, and their impact was "much too little, too late, and eventually even harmful" for the majority. If they caused an accumulation of wealth along the coast, the beneficiaries were "a few merchant houses and foreigners."[148]

The state of the Ottoman and North African coasts reveals tremendous differences in economic activity. The shores of Algeria and Tunisia were dotted with busy ports, with the most advanced technology and equipment and extensive commercial structures, whereas the eastern Mediterranean ports still lacked basic facilities and admittedly could not even match the scale and technological sophistication of the port of Izmir on the Aegean shore of Anatolia.

2

TRANSFORMING URBAN FABRICS

THE NINETEENTH CENTURY WAS PIV-
otal for urban history on a global scale. The tremendous changes, prominently in
technology and economic patterns, affected all aspects of life. Cities, which saw
unprecedented growth rates, became sites of technocratic experimentation to address
the problems brought about by the quick and radical developments. New ways of
thinking about the city went hand in hand with practical propositions. They were
applied to urban centers of diverse scales. While geared primarily to functional issues,
the comprehensive modernizing projects that brought together infrastructure
(including roads, transportation networks, sewage and water lines, lighting of public
spaces, and urban landscaping) and architecture also aimed to change the images of
cities. Regardless of certain philosophical differences (e.g., in relation to the preserva-
tion or destruction of historic fabrics), urban planning was understood as an inte-
grated and collective endeavor among administrators and technocrats from different
fields. The transformation of Paris under Napoléon III and Baron Haussmann, the
prefect of the Seine, formed the model par excellence to which all references were
directed (whether from Lyons and Brussels or Cairo and Istanbul).

Transformations to the cities of the Middle East and the Maghrib constituted part
of the frenetic urban planning and construction operations that characterized the
late nineteenth century.[1] The ideas and the models were shared in general terms, but

the specific complexity of each setting led to their reconsideration, resulting in a diversity of experiments in modern urban planning. Looking at the comprehensive picture reveals a daunting multiplicity and complicates notions of modernity, singling out the concern for empire building and its expression through the physicality of cities. The urbanistic and architectural conventions invented to represent power in the French and Ottoman empires displayed similarities in their general principles but also significant differences. Examining them in relation to each other sheds some light on the nature of the two empires, as well as the changing policies in disparate regions of each empire. This chapter is thus organized according to several themes shared by both empires: beginning with interventions to the old fabrics, moving to the construction of *extra-muros* settlements, and finally to new towns.

HAUSSMANNIAN PRACTICES BEFORE HAUSSMANN: "DIRECT AND SPACIOUS"

Corresponding to the goals of the military occupation, the early French interventions in Algerian cities followed a set pattern: the army would take over the Casbah (the headquarters of the Ottoman military forces) and transform it into its own base; it would appropriate the palaces that belonged to Ottoman families, as well as a range of strategically significant buildings, including shops and religious structures; and the army engineers would clear the urban fabric to create the spaces needed for the movement of the troops. A *place d'armes* with easy access to the main gates through the ramparts was the priority.

The first experiments were carried out in Algiers, setting the tone for other cities of the colony. Immediately following the occupation, French urbanism entered Algiers with the carving of a place d'Armes (whose long and charged story will be told in the next chapter) and the widening of the three main streets off this square: rue Bab Azzoun going south, rue Bab el-Oued going north, and rue de la Marine going east to the harbor (pl. 15 and fig. 2.1).[2] To accommodate the eight-meter width necessary to allow the passing of two carriages side by side, buildings on both sides of the roads had to be demolished entirely or in part.[3] The new streets stood out amid the urban fabric not only for their difference in scale but also for the character of the buildings that lined them: with their European façades, fenestrated and decorated in sparse neoclassical style, and arcades on the ground level, they introduced a new type of thoroughfare. The rue de la Marine acquired a unique feature: the *mihrab* arcades from Mosque es-Sayyida (reconstructed in 1794), taken down during construction of the place d'Armes, were incorporated on the street side of the Mosque el-Kebir, creating an "Islamic" rue de Rivoli effect and complementing the arcades of the *place* (fig. 2.2).

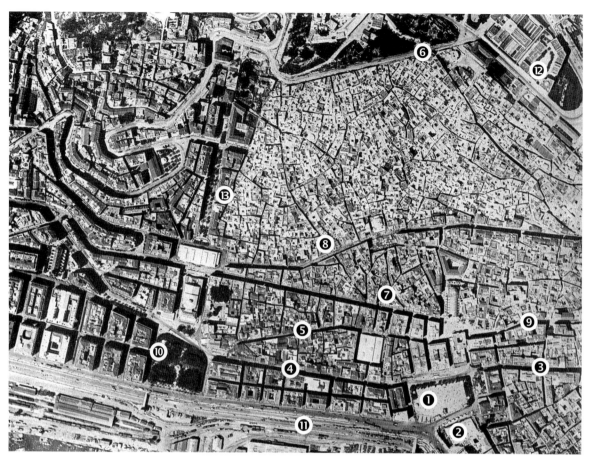

2.1 Algiers, air photo, c. 1930 (*Chantiers*, March 1935).

1. Place du Gouvernement. 2. Mosque el-Djedid. 3. Rue Bab el-Oued. 4. Rue Bab Azzoun.
5. Rue de Chartre. 6. Boulevard de la Victoire. 7. Rue de la Lyre. 8. Rue Randon. 9. Rue Bruce.
10. Place Bresson. 11. Boulevard de l'Impératrice. 12. Boulevard Valée. 13. Boulevard Gambetta.

The cutting and slicing of the old fabric—a Haussmannian operation before Haussmann—continued throughout the first decades of French rule. In 1837, the rue de Chartres was opened to the west of the rue Bab Azzoun, and a small square, place de Chartres, was created on it by tearing down a small mosque and some shops. The boulevard de la Victoire, defining the highest point of the town, also dates from this period.[4] The relentlessly straight rue de la Lyre, opened in 1855 to the west of rue de Chartres and parallel to rue Bab Azzoun, eased the heavy north–south circulation.[5] Its continuous arcade along its entire stretch (unlike the diverse building façades along the rue Bab Azzoun and rue Bab el-Oued) made it a cherished reference to the rue de Rivoli. Rue Randon, its extension rue de Marengo, and rue Bruce were cut around the same time.[6] Other major alterations included two straight boulevards,

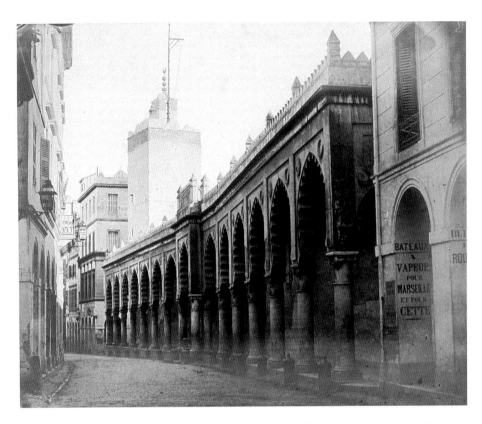

2.2 Algiers, Mosque el-Kebir, rue de la Marine façade, c. 1850 (GRI, Special Collections, 95.R.100).

boulevard Valée on the north and boulevard Gambetta on the south, both built on the grounds of the demolished Ottoman fortifications, hence surrounding the old city on the landward side. On the waterfront, the boulevard de l'Impératrice, discussed in the previous chapter in the context of the port of Algiers, completed the remodeling of the roadways.

These interventions were concentrated in the lower town and began to create a dual structure since the newly opened tissue now contrasted with the tight fabric of the upper town, on the hills facing the Mediterranean. The former had been the commercial and administrative zone under Ottoman rule, but its urban and architectural forms had followed the patterns observed in the more residential upper town. The French initially aimed to regularize the upper town as well, and several projects offered ways to pierce the dense fabric. Nevertheless, the fight against its "tormented" and "accidental" character was declared futile as early as the 1850s. The easier solution was to build a new town that would cater to the needs of the French and separate them from the indigenous population.[7]

The conquest of Annaba (renamed Bône) followed that of Algiers in 1830, but French control was secured only in 1832. Military headquarters were established in

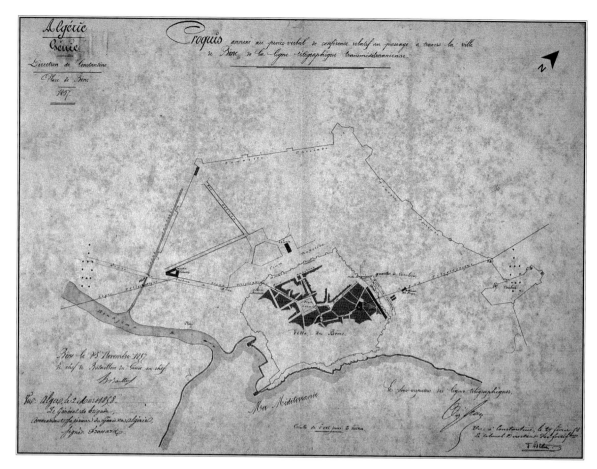

2.3 Bône, city plan, showing the place d'Armes and new streets opened in the old city and the planned growth within the new fortifications, 1857 (Défense, Génie, Bône, 1H 866, art. 8, no. 8a).

the Casbah and to the north of the walled city, where the cavalry barracks were built. The transformation of the old town rivaled that of the lower parts of Algiers and began similarly with the carving of a place d'Armes in front of the Great Mosque. The next step was to connect it to the military establishments in the north by the wide and straight rue Damrémont, named after the general who entered the city on 2 August 1830. It was followed by other arteries leading to the main gates in the west and toward the new town, whose boundaries were established in 1851 by a set of fortifications that included the military complexes.[8] As a plan from 1857 shows, the fabric of Bône was hollowed out (fig. 2.3), with some "narrow and tortuous" streets giving way to European-type arteries.[9]

Constantine, built on the rocky hill to the west of the deep Rhummel Valley, boasted a spectacular setting that rivaled that of Algiers on a hill facing the Mediterranean. Known as the city of revolutions, it was said to have been conquered twenty-four times; the French conquest in 1837 was particularly long and difficult.[10] The

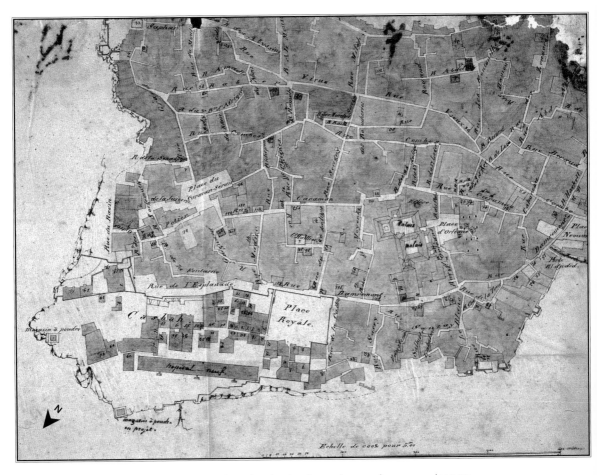

2.4 Constantine, plan showing the newly opened squares and streets in the old city, 1840 (Défense, Génie, Constantine, 1H 807).

French army's appropriation of Constantine followed a pattern similar to that in Algiers, starting with the occupation of the Casbah and the Ottoman governor Ahmed Bey's palace, which was near the Casbah. These initial moves resulted in a "European" upper town and an "indigenous" lower town, reversing the topographical pattern in Algiers.[11] Unlike in Algiers, the "indigenous" quarters in the east were also cut through in order to connect the two gates, the Porte de la Brèche in the southwest and the Porte d'el-Kantara in the northeast. By 1840, a place Royale was created in the Casbah, and the main nodes and arteries were established, if not yet regularized (fig. 2.4; see also fig. 3.6). Most significantly, three open spaces in critical locations were named and designated to become public squares: place Nemours inside the walls at the Porte de la Brèche, place d'Orléans next to the bey's palace, and place du Caravan-Sérail in the north (later, place Négrier); their locations foretold a main road, the future rue de la France, that would eventually connect them and divide the city in

two. Rue Damrémont, the artery adjacent to the Casbah and leading to the Porte de la Brèche, was named after the general who had died while capturing Constantine and was developed as a major street.[12] Next, streets were cut in both directions through the old fabric of the city perpendicular to rue Damrémont, resulting in a network of quick connections. Linking to the place Nemours, the rue Damrémont became the main axis of the European quarter.[13]

Unlike the upper town of Algiers, which was left untouched, the "indigenous" lower town of Constantine was pierced from one end to the other by the rue Nationale in the early 1860s. The rue Nationale connected the place Nemours to the Porte d'el-Kantara in an unobstructed manner, also enabling the link to el-Kantara Bridge over the Rhummel Valley and ultimately to the train station for the Philippeville–Constantine line and the hospital (fig. 2.5). The rationalization was commercial: to provide easy access between the markets around Coudiat-Aty (see below) and the train station. Not only most of the production of the province of Constantine but also a considerable amount of foreign merchandise would pass along this road.[14] Despite some concern "to save the Arab quarter in a town where any exterior expansion is impossible [and] to respect the military buildings,"[15] the demolitions took down part of the thirteenth-century Mosque el-Kebir, including its courtyard and minaret.[16] This massive intervention that erased many streets and the urban fabric bordering them enabled the construction of "European" buildings along the artery, thereby changing the urban image of Constantine: the "indigenous" town became sandwiched between the architecture of the occupier on the higher and the lower parts (fig. 2.6).

The rue Nationale was considered a rare example of *grande voirie* within the city limits,[17] but other proposals aimed to ease circulation and offer more ample public spaces. For example, the construction of the theater on the place Nemours (completed in 1883) led to projects to enlarge the boulevard de l'Ouest so that carriages could approach the building ceremonially from several directions.[18] Another proposal extended the rue de Sassy from the rue Damrémont to the place du Palais, carving a straight artery nine meters wide between the two military compounds.[19]

The early transformations to Tlemcen, occupied in 1842 after battles that lasted for over a decade, once again display the urgency of military concerns in reshaping the city (fig. 2.7). The army first appropriated the Méchouar ("the room of the council"), the rectangular fortified enclave to the south that had served as the city's administrative center since its construction in 1145. The next operation was to replace the "tortuous and narrow" road leading from the western gate toward the city center by a "direct and spacious" one. Another large and straight artery connected the Méchouar to the city center and facilitated the movement of carriages.[20] The Méchouar was remodeled to accommodate the main offices of the army, the military hospital (transformed from a mosque), barracks for the infantry that would soon need extension, as

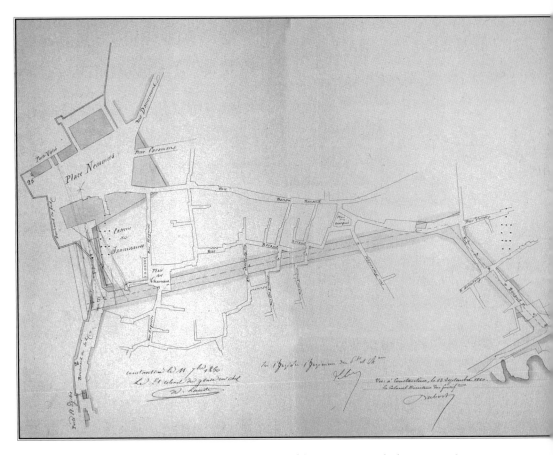

2.5 Constantine, plan showing the regularization of the main street in the lower town, 1850
(Défense, Génie, Constantine, 1H 829, art. 9, no. 18).

well as barns and a mill.[21] However, it was not sufficient, and the Kesaria, "an old fortress" with "very high walls in good condition" and the capacity to hold five thousand men, was taken over for the cavalry.[22] Furthermore, the Great Mosque, across from the Kesaria, was appropriated, on the rationale that it had played a crucial role in "all the civil wars" and was the only public building strong enough "to offer refuge or support to the enemy or an insurrection." Conveniently situated near the new barracks and the double fortifications in the northwest, the army appended the mosque to its compound.[23]

The connection of the army enclaves, each enclosed within its walls, formed a priority. All new roads served this purpose. In 1843, a road was opened that led from the center, skirted the Jewish quarter, and, passing through the *"koulouglu"* quarter, reached the empty area in the west, designated to be the site of the European quarter.[24] The large empty space inside the new city gate in the west was to be used for maneuvers.[25]

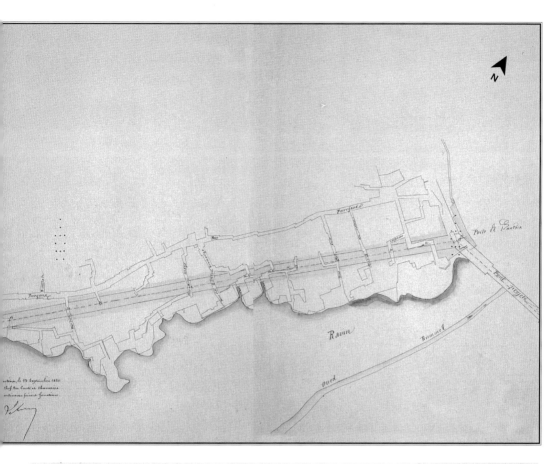

3 CONSTANTINE. — Vue Générale et la Sortie des Gorges. — ND

2.6 Constantine, general view (postcard, GRI).

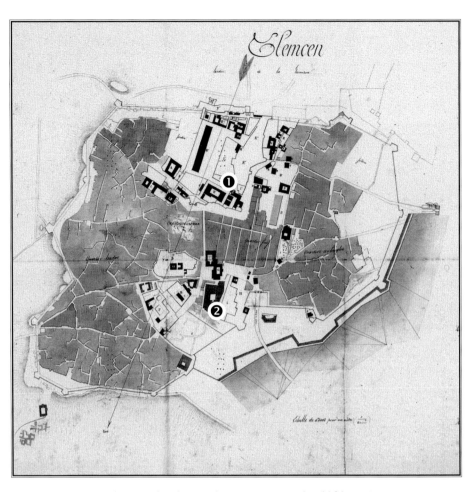

2.7 Tlemcen, plan showing the interventions to the old fabric, 1844
(Défense, Génie, Tlemcen, 1H 758, art. 3, no. 4). 1. Méchouar. 2. Great Mosque.

OTTOMAN MUNICIPAL REFORM:
FOLLOWING "GEOMETRICAL RULES"

The Ottoman interventions to urban fabrics in the Arab provinces were not compa-
rable in scale to those in the Algerian cities; also, they began several decades later and
were not motivated by the needs of the army. They were municipal projects, aimed to
introduce modern urban planning in the spirit of the Tanzimat reforms. Mustafa
Reşid Pasha, one of the authors of the Tanzimat Edict, had formulated the original
principles as early as 1836 in his advocacy of a street network regularization by apply-
ing mathematical/geometrical rules (*kevaid-i hendese*).[26] Between 1848 and 1882, six
major regulations were passed on urban planning; some addressed only Istanbul;
others were geared toward the entire empire.[27] It is not surprising that the Ottoman
capital became the first and foremost setting for the application of the new regula-

tions, hence modern urban-planning principles. Nevertheless, other cities were subjected to similar experiments, some more radically than others.

The municipality of Damascus was established in 1864, seven years after Istanbul, and its municipal board consisted of local notables—unlike in Istanbul, where foreigners residing in the city served on the municipal board. As argued by Stefan Weber, the late-nineteenth-century urban transformations owed a great deal to local power structures, in addition to the initiatives of the Ottoman governors.[28] The tenure of Midhat Pasha (1878–80) marked the beginning of the operations within the walled city of Damascus, when the western section of the "Straight Street," the main east–west thoroughfare since Roman times (pl. 16, no. 2), was enlarged and straightened on the basis of the 1863 Street and Building Regulation (Turuk ve Ebniye Nizamnamesi), which stipulated the conditions for expropriations. Covered by an iron vault, Suq Midhat Pasha recalled the European arcades.[29] Suq el-Hamidiye (construction beginning in 1883 and ending in 1889), named after Abdülhamid II, was pierced through a residential section (fig. 2.8 and pl. 16, no. 1). It connected the Great Mosque of Damascus, in the heart of the old city, in the east to the new center at Marja Square outside the walls (to be discussed below and in chapter 3). Suq el-Hamidiye, 450 meters long and initially covered by a wooden vault (later replaced by a steel one), changed the city's structure.[30] Together with Suq Midhat Pasha (pl. 16, no. 2), which ran parallel to it, Suq el-Hamidiye transformed the medieval fabric and attempted to integrate the historic city with the new quarters in the west.

On the eve of World War I, Governor Cemal Pasha transformed the old core even more. He completed Midhat Pasha's work by linking the Straight Street to two arteries perpendicular to it. One led north to Bab-ı Tuma (pl. 16, no. 3) and the other extended south and defined the western boundary of the Jewish quarter (pl. 16, no. 4); both streets were widened and regularized. In the process, the houses lining these roads were sometimes adjusted, sometimes rebuilt, resulting in an image new to the residential architecture of Damascus. Their fenestration patterns, wooden *musharabbiyas* (latticework on the windows), and basalt façades made strong references to houses in Anatolia, Istanbul, and the Balkans.[31]

The municipality of Aleppo was as old as that of Istanbul, going back to 1857. However, its major transformations took place in the 1890s, under Governor Osman Pasha. The most important intervention was the opening of Hendek Street, which connected the new Cemiliye neighborhood in the west to the Citadel area (figs. 2.9 and 2.10). Built in 1894 over land gained by filling a brook, Hendek Street started at the square in front of the Duyun-u Umumiye Offices (Offices of the Public Debt) and, passing through the Jewish and Christian quarters, ended at the government palace. Its construction attracted a great deal of media and popular attention, in part due to the transportation of materials by a technologically advanced rail line (*dekovil şömendöferi*).[32] This "perfect avenue" thus underlined the imperial presence, testified

2.8 Damascus, Suq el-Hamidiye (Library of Congress, Prints and Photographs Division).

to the modernity subscribed to by the governor and the municipal administration, and took an important step in introducing recent developments into the old city.

In Beirut, the extension of the city began in 1858 with the construction of the Damascus Road, which bordered the south side of Burj Square (Sahat el-Burj, or Municipal Garden; see chapter 3) and followed the fortifications (see pl. 5). Besides connecting Damascus to the Mediterranean, the siting of the road privileged the edges of Beirut's old city and led to their development in the following decades.[33] Another surge of activity took place in the 1890s during the tenure of Governor İsmail Kemal Bey, who based his urban-planning activities on legislation as well as the experiments carried out in other cities of the empire. His most important decision was to open two large arteries through the old city (the first linked the port to the suqs; the second linked Burj Square to Bab İdris) and to pave and widen some others (see fig. 1.12).[34] The operations were carried out at the cost of extensive demolitions, leading to protests by affected residents. The municipal administration responded to the petitions that filled its offices by defending the modernization of the city as a service to the general well-being of the community. İsmail Kemal Bey had articulated

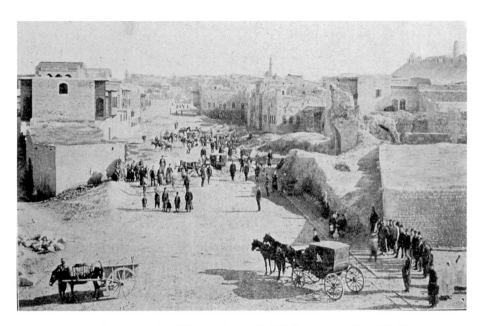

2.9 Aleppo, opening of Hendek Street, 1898 (*Malumat*, no. 153 [1314/1898]).

his agenda clearly when he took office: it was "to accelerate the progress of civilization and to disseminate the lights and knowledge of this époque."[35] Nonetheless, the municipality sought to compensate its citizens. For example, a "beautiful, new-style" neighborhood was developed on a piece of land that belonged to the municipality on the southern shore of the city for those whose houses were seized during the opening of the new avenues.[36]

Baghdad presents a case study where, despite several ambitious attempts, urban improvements remained few and far between. The most intensive phase was during the governorship of Midhat Pasha (1869–73), the founder of the Baghdad municipality. Midhat Pasha's grand idea was to demolish the walls that surrounded the city on three sides and build a boulevard on the land thus gained—following a common practice in Europe (fig. 2.11). The demolition was not completed because of lack of finances, leaving "enormous ruins" that would endure into the 1920s.[37] Despite its failure, this project showed a commitment to easing circulation within the city. With the same goal, a 7-kilometer tramline was built between Baghdad and Kazimiye on the other side of the Tigris. The existing bridge was unsafe and built out of "crumbling wood," according to Mehmed Hurşid Pasha, an Ottoman observer.[38] It was rebuilt under Midhat Pasha; its 220-meter-long span sat on wooden pontoons and opened up for the passage of boats—"just like the bridges in Istanbul," in the words of a journalist from the capital.[39] Double-deck horse-drawn trams traveled from one end of the line to the other in 30–40 minutes and carried "several thousand" passengers every day.[40] The Baghdad bridge was rebuilt again in 1902.[41]

2.10 Aleppo, plan showing the new extensions (BNF, Département de Cartes et Plans, Ge F 2118).
1. Hendek Caddesi. 2. Aziziye quarter. 3. Cemiliye quarter. 4. Hamidiye quarter.
5. Headquarters of the Municipality. 6. Military barracks. 7. Imperial High School. 8. Clock tower.

The "large and regular" part of Baghdad was on the western bank of the Tigris. Due to the placement of the city's prestigious buildings here, the view toward this bank from the river was "beautiful and magnificent," even though the waterfront lacked regular and continuous quays (see fig. 4.27).[42] By the end of the century, there were only two reasonably wide roads in the city: Kışla and Meydan Caddeleri.[43] In 1914, the renowned poet Cenab Şahabettin noted in great surprise that "there was only one avenue in Baghdad and it crossed the city from one end to the other along the river." Locals sarcastically called this sole paved road in the city "the crusted street" (*kabuklu yol*).[44] Another traveler explained the curious phenomenon, unbefitting to an important city such as Baghdad, as stemming from the lack of stones in

2.11 Baghdad, 1908 (*Atlas Vahé Almad Susa* [Baghdad, 1952], courtesy of Caecilia Pieri).
1. Tramline to Kazmiye. 2. Kışla Caddesi. 3. Meydan Caddesi. 4. Government palace.
5. Clock tower. 6. Artillery barracks. 7. Cavalry barracks.

the region.[45] Writing a few years earlier, Hakkı Bey focused on the same problem and argued that, like other historic cities, Baghdad's past formed an impediment to its future prosperity: "to regularize all the streets of Baghdad with the triangle and the compass," the entire city would have to be demolished. His solution was to open several grand boulevards in the most frequented locations, pave them, and incorporate water and sewage lines necessary for the city's hygiene. Furthermore, he called upon the municipality to develop a vacant strip along the riverbank as public space, paralleling incentives in other cities with waterfronts, such as Beirut and Trablusgarb. Governor Nazım Pasha had similar ideas, including opening a 22-meter-wide boulevard parallel to the river (deemed "absolutely necessary" despite the contestations of

property owners along its proposed path) and providing electricity and electric tram-ways.[46] As reported on the eve of the World War I, Nazım Pasha's plans were not realized.

THE DUAL CITIES OF THE FRENCH MAGHRIB: "AIR, SUN, BOULEVARDS LINED WITH TREES, AND ARCADED STREETS"

Colonial urbanism, specifically French colonial urbanism, is widely acknowledged for creating dual cities: a European settlement separate but adjacent to the "indige-nous" town. In Algeria, city building according to European principles had begun as incremental interventions to the existing fabric. However, as the French occupation was secured and understood to be permanent, expansions beyond the existing city limits became inevitable to accommodate the growth in population and the ameni-ties needed.

Algiers played a pioneering role and began developing outside its sixteenth-century Ottoman fortifications at a rapid rate. By the 1850s, French administrators and tech-nocrats saw Algiers not simply as a military outpost but as a city that had to respond to the needs and demands of its civil population. Civic responsibility was oriented toward Europeans and aimed to turn Algiers into a contemporary urban center, one that would project and enhance the glory of the French Empire. On 8 March 1857, the beginning of a "new era" was launched by a decree that stipulated the extension of the city as a necessary measure to accommodate growth and transformation. Two grand projects submitted to Governor General Comte Randon in 1858 increased the size of the city while attempting to endow it with a new urban image: "Alger, projet d'une nouvelle ville" by Vigouroux, a civil land surveyor (*géomètre civil*), and Caillat, a clerk of works (*conducteur des ponts et chaussées*); and "Cité Napoléonville" by architect Chassériau. Neither of the projects was implemented; their importance lies in the clarity of their proposals for a dual urban structure and their vision for Algiers—two themes pursued by the French to the end of their rule and applied in other colonies.

The mid-1850s corresponded, of course, to the heyday of the rebuilding of Paris under Napoléon III and his prefect Baron Haussmann. Immense, comprehensive, controversial, daring, and multifaceted, the project for the capital constituted the framework for the proposals for Algiers. A legible order dominated both schemes, dictated by the regularity of the street network, sometimes cut by diagonal avenues and interrupted by public squares; streets were classified according to width; green-ery was considered an essential element to ventilate the city; infrastructure was inte-grated into the plans; and monumental centers were articulated. Yet the Algiers plans involved vacant land, whereas the regularization of Paris had to be carved into the existing fabric.

The reports that accompanied the two Algiers projects were in total agreement—a point underlined by Chassériau, who stated that, although his was a specific proposal, it was part of a broad vision shared by other planners. He praised the project submitted a few months earlier (on 30 April 1858) to Governor Randon by Vigouroux and Caillat, especially its "excellent [textual] documents." Both reports summarized the problems of building in the old city and critiqued the planning decisions made during the first two decades of the occupation. A few streets accessible to carriages pierced the tight fabric of the lower part of the precolonial city, whereas in the upper part the "real difficulties" stemmed from topography and did not yield to any intervention. Speculators had crowded the old city with European buildings that climbed unusual heights on small and dense lots; they were in bad taste and a menace to the security of their inhabitants, as well as to public hygiene. Algiers, as it stood in the late 1850s, was a "true battlefield, a miniature [town] that denied its residents any land"; it was not a place that could look forward to a happy future.[47]

According to Vigouroux and Caillat, the future of Algiers depended on giving up the futile battle against the "tormented and accidental terrain on which the indigenous people had built their town," because the French had different needs (fig. 2.12). However, not only the site of the old city but the whole region had a complicated topography, including the area covered by Vigouroux and Caillat's project—an issue ignored in their design and in their report.[48] Nevertheless, for Chassériau also, the solution was to create a French city, "proudly camped across from the enemy," "cut by regular and spacious roads," and dominated by the "splendor of a large and intelligent architecture."[49] In both accounts, separation of the French from the Algerians, their visual confrontation, and the articulation of the duality by urban design and architecture emerged as main themes. The scale of the expansion beyond the limits of the old city signaled the further appropriation of land by the French and can be seen as analogous to the occupation of the entire country. The unusual legibility of the city form, due to its geography of hills facing the Mediterranean, mattered to the designers as they visualized and explained their creation as viewed from from the sea.

In both plans, the new image for Algiers was quite similar—in terms of the extent of the territory occupied, the overall physical characteristics, and the monuments that would dominate the city. The plans duplicated the triangular shape of the existing settlement, defined by the French fortifications that had already expanded Algiers considerably, but pushed it farther out by means of rectangular grid settlements. The designs dictated grids: Chassériau's proposed a strict regularity dominated by the right angle, whereas Vigouroux and Caillat enlivened their scheme with diagonal arteries to help create a hierarchical network.

In describing their "large streets, grand boulevards, and spacious plazas," Vigouroux and Caillat emphasized the provision of "all conditions of hygiene necessary to the conservation [of the European society]," which could "never" be met in the actual

2.12 Algiers, plan for a new town by Vigouroux and Caillat, 1858 (ANOM, 1PL 958).
1. Old city. 2. French extensions. 3. Vigouroux and Caillat's proposed extension.

configuration. A uniform width of 20 meters was envisioned for the majority of the roads. The main avenues, leading to the Imperial Palace, were 40 meters wide, with two rows of trees on each side. The street network integrated all necessary infrastructure elements, and new monuments were placed in strategic locations. At the very center of the new design and occupying the highest, the most visible point was the Imperial Palace, which would "dominate the town, the harbor, and the *champs des manoeuvres.*"[50] The main centers of French administration in Algeria, the headquarters of Military Affairs and of Civil Affairs, were symmetrically placed on each side of the Imperial Palace, creating an acropolis that represented the political apparatus of the colony. As the most visible and most monumental enclave in the proposed extension, this cluster competed with the Citadel of the former deys (the Casbah proper) in dominating the city and acted as a reminder that French rule had now replaced Ottoman rule. The architectural differences between the two complexes underlined the modernity of the new order as opposed to the obsolete grandeur of the former.

Vigouroux and Caillat chose not to specify the location of all public buildings, leaving this task to later planning stages. However, they dedicated a site for the Stock Exchange and Tribunal of Commerce on a prominent intersection of diagonal avenues, close to the waterfront and to their proposed train station. The train station itself was adjacent to the quays and to the markets. The extent of the new harbor, protected by monumental breakwaters and linked to the rest of the country by railways, revealed the goal of intensifying commercial activity in the city and linking it economically to the mother country across the Mediterranean. It also pointed to the fact that Algiers was to be a great deal more than a military post. Nevertheless, a spacious sector near the train station was reserved for "military quarters and schools," acknowledging the inevitability of the army's presence in the city.

The other major monument was a cathedral-archdiocese complex. The existing cathedral in the old city, converted from a seventeenth-century mosque immediately following the conquest, was considered "insufficient." Vigouroux and Caillat placed an imposing cathedral, together with a "dignified" palace fit for the highest religious authority in Algiers, on a spacious plaza, creating a "religious node" to complement the administrative one. Other churches were distributed throughout the urban fabric at more or less equal distances from each other. The mosques and synagogues were restricted to the old city in order not to disturb the "customs and traditions" of the "indigenous . . . who would prefer to live there."[51] In the old city, Vigouroux and Caillat pursued the spirit of the first French interventions by enlarging several streets that crossed the dense fabric. They also proposed demolishing a considerable fragment of the residential texture in the upper Casbah to make room for a large new mosque with its own frontal plaza. Even though the old neighborhoods were left to the original residents, the shape of the precolonial city had to be transformed to enable easier access.

Chassériau, the architect who had given Algiers its first French monument, a theater placed at the intersection of the precolonial and colonial cities (see chapters 3 and 4), designed his new extension as a perfect grid on the same terrain as Vigouroux and Caillat's proposal (fig. 2.13). Starting with the statement that "we [the French] need air, sun, boulevards lined with trees, and arcaded streets," he developed his Napoléonville as a spacious, hygienic, green city capable of housing 60,000 people.[52] In contrast to the densities in the old city, Napoléonville's residential structures would not exceed three stories in height, and "vast interior gardens" would define the middle of blocks. The galleries, the novelty of Chassériau's scheme, were conceived as independent, light structures; unlike arcades in masonry, they would not act as obstacles to "air circulation." Large public gardens, trees lining the main streets, and numerous fountains distributed throughout the new town would contribute further to the hygienic welfare of the residents. The street network adhered to a hierarchy that took into account the rows of trees to be planted. For example, the central boulevard that

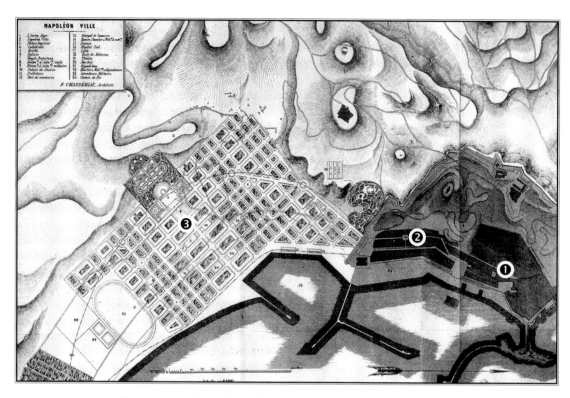

2.13 Algiers, "Cité Napoléonville" by Charles-Frédéric Chassériau, 1858 (Chassériau, *Étude pour l'avant-projet d'une cité Napoléon-Ville*, BNF). 1. Old city. 2. French extensions. 3. Cité Napoléonville.

bisected Napoléonville was to be 46 meters wide, with two rows of trees on each side; other boulevards would be 32 meters wide, with one row of trees on each side.[53]

The monumental center, comparable to that of the earlier project, consisted of an Imperial Palace, now in a vast compound on terraced gardens. Dominating the urban image, the palace would be a "real villa," whose abundant waters would supply the many fountains in the neighborhoods. Like his colleagues, Chassériau distributed the other public buildings in different parts of the city, placed them on squares, and argued that each would "serve as an ornament." The changing role of Algiers was reflected in the provision of a second harbor "designated for commerce." The architect's vision of a garden city for Europeans was completely independent of the "Arab city," on which he did not spend any time. Dismissing it as a place where European architects had made too many errors, he chose to concentrate on his own extension and offered no interventions to the Casbah and the first European quarter outside it. He acknowledged their presence merely by highlighting the arteries that connected them to Napoléonville.

Drafted at the peak of the urban-planning fervor in the metropole, Vigouroux and Caillat's and Chassériau's projects also followed the highly geometric plans devised

by the engineers of the French army for new settlements in Algeria. Whether standing on their own or attached to existing towns, all of these had grid plans. Public squares, bordered by churches, town halls, theaters, markets, courts, prisons, and schools, were placed at the intersections of the main streets. If the settlement was near the sea, the main square, the place d'Armes, would face the waterfront. As a civil-engineering textbook put it at the time, "a symmetry and a regularity indicating the notion of an ensemble" was the starting point; then, "façades were lined up to create regular courts, even when the terrain is irregular." The regularity of the scheme had many practical advantages that varied from assigning prestigious sites to various public buildings to the equal distribution of plots among the settlers—a notion with Saint-Simonian echoes.[54] Nevertheless, the trend for "checkerboard plans" had critics as early as the mid–nineteenth century, whose main objection was based on the predictability and "monotony" of the new settlements, made worse by their high numbers.[55]

The legacy of Vigouroux and Caillat's and Chassériau's projects on the later development of Algiers is mainly in the acceptance of the dual structure, the exclusive investment in the European quarters, and the designation of the historic core as "indigenous"; only fragments from the designs found application in the frenetic development of the city in the following decades of the nineteenth century. The growth of the city continued to occur incrementally, without adherence to grand plans and with results deemed catastrophic by planners, architects, and administrators.[56]

If nowhere approaching the scale of the visionary plans devised for Algiers, other cities in the Maghrib acquired European quarters that differed in design principles from the historic cores. The process was not uniform, and the geographic, military, and political conditions of each city helped shaped the outcome, resulting in a diversity of additions—albeit based on the same principle of creating segregated European settlements.

The "French" town in Bône fitted neatly into the 1851 fortifications with a radial plan that more than doubled the city's size. This bold design, prepared in 1861, was different from the 1851 and 1857 projects. While the earlier projects had proposed a large artery, the cours Napoléon (later called cours National and later still cours Bertagna), as a boundary between the old city and the new one and several arteries to connect the cours Napoléon to the new fortifications, the 1861 design developed the entire territory according to coherent principles (see fig. 1.23). The cours Napoléon was clearly designed to become a monumental strip, resembling the cours Mirabeau in Aix-en-Provence. Starting at the port and ending at the church, which defined its vista, it was lined by prestigious buildings, most importantly a theater and the town hall. It concealed the precolonial city and presented a European image. A well-connected street network characterized the new quarter to the west, composed of blocks of varying sizes but similar character. Some were left as open spaces, such as

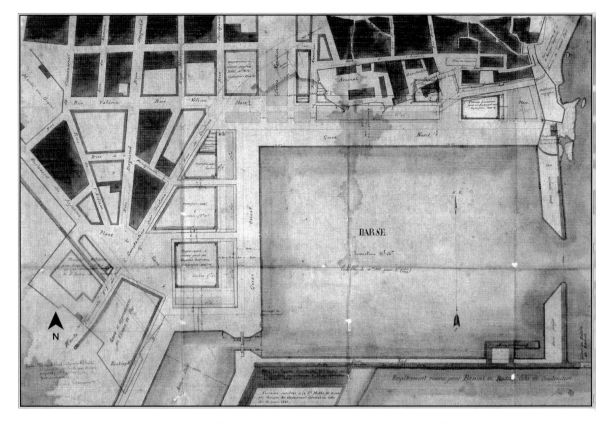

2.14 Bône, plan of new neighborhood around the port, 1869
(Défense, Génie, Bône, 1H 866, art. 8, no. 18).

the place Bugeaud behind the theater and the grain market next to the walls in the southwest. Another plan in 1869 extended the European quarter further to the southeast, connecting to the train station and proposing a square in front of it (fig. 2.14).

The difficult geography of Constantine, coupled with a cautious military establishment reluctant to give up land for civilian use, led to the long story of Coudiat-Aty, a hill with an Ottoman fortress in the south. Negotiations between the army and the municipality began in 1844, when the municipal council decided to create a "French town" here.[57] A report in 1852 specified that the new quarter would house four to five thousand people and also have public buildings. This operation would turn Constantine into a city of three distinct zones: the Casbah, reserved for the military; the existing town, with a mixed population; and the all-European Coudiat-Aty.[58] More than a decade later, the municipality revisited the project, reaffirming that the city should be extended only in this direction.[59] The idea was presented to Napoléon III during his visit in 1865.[60] Numerous projects, reports, and correspondence between the municipality and army officers did not yield results, but a neighborhood grew up around the hill over the following decades. In 1885, the municipality hired a devel-

See fig. 3.6 for the relationship of Coudiat-Aty to the old town.

oper to take the hill down to the level of the surrounding streets, only to be blocked by the army. The War Ministry finally permitted the reorganization of Coudiat-Aty in response to another move from the city in 1899.[61] Nevertheless, the project could not be completed, mainly because of the difficulty of finding space to transport the enormous amount of rubble to be removed from the site.[62] In 1919, boulevard Carnot was constructed to encircle the hill, and an entire quarter developed around it (fig. 2.15).[63]

Searching to extend Tlemcen in the easiest way possible that would still allow for effective defense, army engineers agreed in 1848 that the best direction for expansion was to the north and northwest[64]—a logical proposal given the amount of empty space there, as evident in a plan dating from 1844. In 1853, the chief inspector of engineering presented a project that followed this guideline and pushed back the line of fortifications upon the suggestion of the governor-general (fig. 2.16).[65] However, the new project did a lot more than that, imposing a grid upon the entire fabric. The only areas left untouched belonged to the army and were concentrated in the south.

By the 1880s, Tlemcen, whose fabric had been radically cut through during the early years of the occupation, already had a "totally new town" on the north and north-

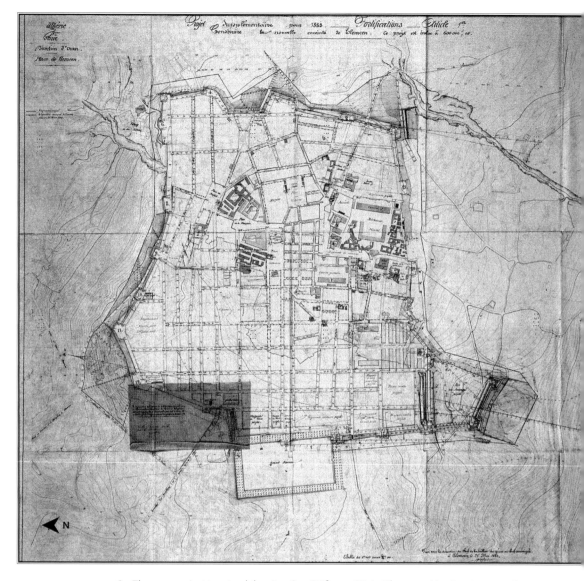

2.16 Tlemcen, project to extend the city, 1853 (Défense, Génie, Tlemcen, 1H 756, art. 2, no. 13).

west (pl. 17). The extension filled in the zone added to the city by the 1842 fortification with a grid plan. Place Cavaignac, named after Governor-General Louis-Eugène Cavaignac, an instrumental figure in the capture of the city, constituted the center of the European town and opened on its south side to the wide boulevard National. Rows of trees helped unite the square and the boulevard, further enhanced by the architecture of the key institutions representing the state. These included the *sous-préfecture,* the palace of justice, the Bank of Algeria, and a church.[66]

Algeria was the trial-and-error case of French colonial urbanism: when the initial

interventions to the historic cities did not produce satisfactory results, the planners shifted their practices to building adjacent new towns. In contrast, the historic Tunisian cities were left untouched, and European quarters were simply appended to them. René Millet, resident-general of Tunisia, explained the difference between the two approaches, focusing on Algiers and Tunis:

> In Algiers, the Casbah was *haussmannized* [italicized in the text] . . . it was hollowed out by large boulevards lined with [new] buildings, which have left nothing substantial from the Arab town. [H]ere [in Tunis] the Arab town has not been submitted to any attack. It is around it, without damaging it anywhere, that our engineers created the boulevards they needed for carriage and tram circulation. It is outside it, between its old fortifications and the port, where there used to be an unhygienic beach, that the European city is built, with its high structures in stone, its large, perhaps too large, streets, its avenues planted with mimosas and ficus trees, its botanical garden and beautiful Belvédère Park. . . . *Tunis la blanche* has preserved its oriental character. . . . The same is true for Sousse and Sfax. . . . We have not touched the picturesque décor of their ancient cores.[67]

French interventions to Tunisian cities hence expressed the protectorate's *"pensée mère"* by juxtaposing the two towns in a sensible manner. The underlying goal, according to Millet, was to create a "French peace," the modern equivalent of the benevolent "Roman peace."[68]

The previous waves of occupation in Tunisia's long history differed from the French occupation. According to one explanation, the French "conquest" did not involve "destruction," and the French army differed from the Roman forces, which had razed Punic Carthage, and from the Arabs, who did away with Roman Carthage. Arab Tunis remained untouched by the French, with its white cubical buildings interspersed with domes and minarets. Modern Tunis, with its "American" grid plan, stood next to her older sister. The example of Algiers, so mutilated that it had lost all its Arab character when its markets were demolished, had served as a good lesson for the French administration in Tunisia. Old Tunis retained "its feudal aspect" and "all the flavor of its Muslim past" but became cleaner and more hygienic, thanks to the "French hand." A tramline surrounded the medina and created a blurred zone between "the old and the new civilizations."[69]

The extension of Tunis had begun soon after the French takeover in 1881. Connecting the old city to the waterfront and passing in front of the Palais de la Résidence (the former Consulat de France), constructed in the 1860s, a one-kilometer-long artery—avenue de France, continued as avenue de la Marine—formed the main axis of the new settlement. Across from the Résidence, which had become the political center after the establishment of the French protectorate, a cathedral was built,

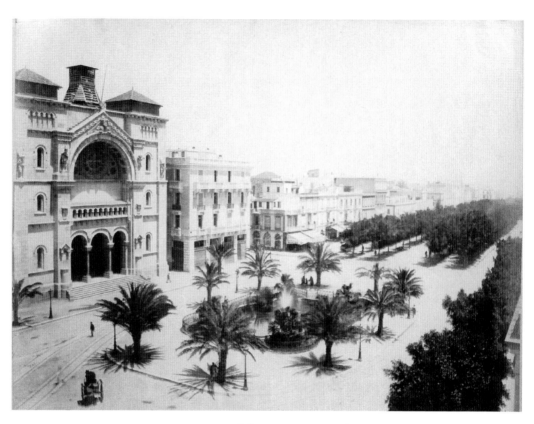

2.17 Tunis, avenue de la Marine, view toward the sea,
with the cathedral on the left (IÜMK, album 90598).

creating a cross-axis on the avenue that represented the new power structure (fig.
2.17; see fig. 1.26). In 1889, the avenue was still not completed, but with four- to five-
story buildings lining it, and a large hotel and the train station in the vicinity, it
anchored the development of the orthogonal street pattern on its two sides, which
would eventually be crowded with "European houses."[70] The slow progress made in
constructing the European quarter was embarrassing, as there was not much to the
"French town of Tunis" almost a decade after the French takeover except for the
delineated streets.[71] A plan from 1899 shows the blocks adjacent to the avenue de la
Marine and the area immediately to the east of the old town as occupied, the projec-
tion of the future growth toward the north and south in grid layouts, and the inten-
tion to fill in the Lake of Tunis to extend the grid (pl. 18). The simple and functional
plan, "without any urbanistic and aesthetic pretensions,"[72] marked the territory in a
distinct manner that contrasted with the tissue of old Tunis. When completed, the
avenue stretched 1,500 meters and boasted a green walkway in the middle.[73]

On a more modest scale, the same pattern was repeated in the southern town of
Sfax. Immediately following the occupation, a European quarter began to develop in

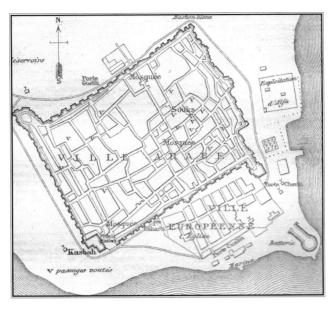

2.18 Sfax, plan, 1888 (Piesse, *Algérie et Tunisie*).

the cramped area between the southern walls of the city and the Mediterranean. It did not boast a grand plan and its rectangular blocks of unequal dimensions reflected practical concerns (fig. 2.18). Bigger changes came with the construction of the port (1895–97), in response to the growing economic importance of Sfax (see chapter 1). The landfill operations dating from these years doubled the size of the city, and the land acquired from the sea was planned as a grid that terminated in the southeast with port buildings (see pl. 13). With a channel for small boats and rail lines on its two other sides, the new town's waterfront remained purely functional. Its spatial relationship to the first European settlement was unique: the shift in the angle between the two resulted in triangular-shaped transitional spaces, which were developed as monumental squares on which the prestigious public buildings (such as the theater and the city hall) would be erected. The original European town became a transitional zone: its loose grid plan linked it conceptually to the new European town, while the scale of the blocks and the street widths related it to the Arab town, from which it was separated by fortifications. A central spine cut through the entire city and connected its three parts. Starting in the port as the rue Émile Loubet, it passed in front of the theater and turned into the rue de la République in the "old" European town, entered the walled city through the Bab Diwan, and continued to the Great Mosque as the rue de la Grande Mosquée. This was the central avenue, the monumental axis of colonial Sfax.

As in Sfax, the new town of Bizerte was built as part of the port and on a landfill. But unlike Sfax, there was no gradual transition between the two settlements since

the new town was immediately adjacent to the Arab one (pl. 14). Eugène Résal, an engineer working for the company commissioned to construct the port, described his vision: "grand avenues planted with trees will connect the old town to the new port; large streets will ensure circulation of sea breezes; drainage in all streets will contribute to the cleanliness; finally all precautions will be taken for hygiene. . . . The sweetness of the climate, the beauty of the country, will turn the New Bizerte into a rival to the winter stations of Côte d'Azur."[74]

The European town filled the area between the walled city and the Bizerte Canal and was designed as a grid cut by two diagonal avenues. At the point of their intersection in the center, a square was created. On and around it, the government had already claimed certain lots for public buildings, such as the Office of Civilian Affairs, town hall, police headquarters, palace of justice, post office, schools, and churches. The company sold the rest for residential, commercial, and industrial purposes.[75] The old Arab town remained isolated.

The development of Bizerte as a main port necessitated the creation of an arsenal. Located south of the Lake of Bizerte, the construction of the arsenal was accompanied by yet another new town, named Ferryville after Jules Ferry, whose statue had just been erected in Tunis (see chapter 3). Ferryville's creation was inevitably linked to the arsenal: first, it provided housing for the workforce employed to construct the arsenal and, once the arsenal was functioning, for those who benefited from the job opportunities generated by the workshops, the administration, and the various activities of this *grand port de guerre*. Nevertheless, the agricultural richness of the region also attracted settlers, turning Ferryville into a European town with dreams of becoming another Toulon. A French settler by the name of Décoret developed a plan for Ferryville that duplicated that for Bizerte: a grid composed of 10-, 12-, and 15-meter-wide streets and cut by two diagonal avenues. Décoret envisioned a "villa type" housing pattern that would allow each family a garden and give Ferryville a "cheerful and engaging" image—as opposed to the grim worker-city type.[76]

THE EDGES OF THE OTTOMAN ARAB CITY: BRINGING THE "FRUITS OF CIVILIZATION"

The Ottoman investment in urban reform as part of the larger modernization project manifested itself in extensions to the crowded historic cores of several major Arab cities in a process initiated in the 1860s.[77] In this section I will discuss two case studies, Damascus and Trablusgarb, in some detail and make references to several others. Damascus is an obvious choice because of its long and unchallenged importance to the empire as the capital of Syria and its history of continual Ottoman investment. Trablusgarb, as the only remaining Ottoman province in North Africa from the 1880s on, opens a different perspective from which to examine Ottoman agendas of urban

reform and modernization. Tracing developments in several other cities displays the overall principles and patterns followed throughout the empire but also highlights areas of uniqueness.

Among the provincial capitals, Damascus had a special place as a center of learning, commerce, and industry and as a way station on the pilgrimage to Mecca. Historically renowned for the wealth of its markets, its situation in the 1830s and 1840s was described as "decline" on all fronts by European observers. Its rejuvenation began with the shifting of its center to the west of the walled city, extending to the Süleymaniye complex (1566) and crossing the Barada River to the north (pl. 16, no. 5).[78]

Governor İbrahim Pasha's (1832–40) drastic decisions in this regard predate the Tanzimat reforms and orient the later developments. The governor, ignoring the fury of the devout, converted two mosques from the Mamluk era outside the walls to modern uses: Yalbugha Mosque (1356) became a biscuit factory in 1832 and Mosque el-Tankiziye (1318) became a military school. He also built a new palace and military barracks immediately to the west of the Citadel, heralding the development of a new district, the Qanawat, along a Roman aqueduct. The area developed considerably in 1864, when Damascus began to be governed by a municipal council, whose responsibilities included urban planning according to modern principles—with Istanbul as the model. Characterized by relatively large, paved, and tree-lined streets, the Qanawat quarter was deemed "the most beautiful and the richest in Damascus" in travelers' accounts.[79] The rebuilding of the banks of the Barada in the 1860s further oriented the future growth of Damascus to the west.

With Marja Square (see chapter 3) as its focal point, the quarter projected a modern image with its straight, wide, and tree-lined avenues and embankments on two sides of the Barada River (regularized in the 1880s) and large buildings—some of which sheltered official functions, others amenities that catered to a new urban lifestyle (see pl. 16 and fig. 2.19). The new arteries accommodated an increased number of carriages, and a few were equipped with tramlines, turning Marja Square into a busy transportation hub. The extension was not the product of a singular design but had grown over a period of six or seven decades. The first of the two main east–west roads was Beirut Road, running adjacent to the Barada and opened in the 1860s. Bordering the Municipal Park and described as "one of the busiest arteries" of Damascus in the 1890s, it was maintained systematically so that its paving stones would always remain new and in a "regular condition" (hal-i muntazama); its sidewalks were built in a "regular manner" (suret-i muntazama).[80] The second east–west artery was Cemal Pasha Avenue, built in 1915 by Governor Cemal Pasha to connect the walled city to the Qanawat Train Station. This was a monumental artery, with a wide, landscaped central strip that the governor was particularly proud of. He wrote in his memoirs: "I believe that the boulevard I built in Damascus was a beautiful thing, unequaled in Eastern cities until then."[81]

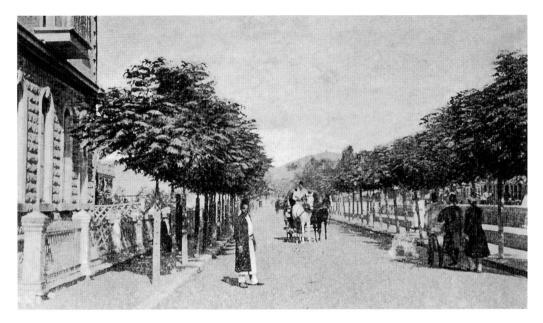

2.19 Damascus, "a new street" (*Servet-i Fünun*, no. 186 [1310/1894]).

Another main street, Dervişiye Street (also known as Havran Road; see pl. 16, no. 9), which ran north to south and skirted the walled city on the west, underwent some regularization in the 1860s; the work was completed in the 1880s. Among the other roads opened during the 1880s was Sancaktar Street, which continued Dervişiye Street and linked to the east and west and turned west, passing diagonally through Marja Square. With the incorporation of tramlines, this network connected the center to the south and the north, that is, to the neighborhoods of Salihiye and Midan respectively.[82]

In 1916–17 Governor Tahsin Bey prolonged Said Street, which had been built in the 1880s and ran along the south side of the Victoria Bridge over the Barada (see pl. 16, no. 10). Passing by the main façade of the train station and opening up in front of it into a large square, this tree-lined avenue brought a final European touch to the quarter, complementing Cemal Pasha Avenue in its landscaping while paying homage to local culture by highlighting the neo-Islamic façade of the terminal. The new street network in this area conformed to a program devised by Governor Cemal Pasha called the "Embellishment of the Cities."[83] Cemal Pasha Avenue was further enlarged in 1917 by a decision to demolish 20-meter strips on both sides for reasons of "public benefit."[84] Spacious, straight, terminating in vistas, and adorned with trees and greenery, the new street network stood in sharp contrast to the crowded, narrow, and irregular fabric of the *intra-muros* city.

Suq Ali Pasha (1879), a hybrid of a modern street and a historic building type, served as a transition between the new quarter and the old city. Situated on the east-

ern side of Marja Square, it opened onto the network of other markets, hence connecting the new and official center with the centuries-old commercial fabric (see pl. 16, no. 11). The creation of this suq was not a government undertaking but was financed by a private endowment from a local Ottoman high official; it heralded a building type that would become popular in Damascus. It consisted of a straight and wide inner street with a regular line of shops on both sides and elaborate interior façades. Reminiscent of the European-style arcades (*pasaj* in Turkish) that had mushroomed in Istanbul, Suq Ali Pasha made a gesture to old Damascus while incorporating the modern influence from the capital and beyond.[85]

Ottomans took great pride in the modernization of Damascus, a city they described as "the largest, historically most important, best-built city in Ottoman Asia," "heaven on earth," "elegantly built," and *"un paradis en ce monde."*[86] *Servet-i Fünun* reported on Beirut Road as "the famous avenue, adorned with two rows of trees and whose elegance is beyond words."[87] Hakkı Bey described the streets of the new quarter as "planted with trees and placed on two sides of a fifteen-meter-wide canal" and likened them to "certain avenues of Paris," echoing a French traveler who maintained that "the promenade along the Barada is probably the zone where European influence is felt the strongest."[88] The roads had also acquired, beginning in 1908, electric lighting and tramlines, which were, in Hakkı Bey's words, the "fruits of civilization." Hakkı Bey praised the "uniformity and conformity" of the new quarter and predicted that, with time, other parts of the city would develop along the same lines, submitting to "contemporary civilization."[89] Taking an oppositional view, Ahmed Şerif argued in his typically contradictory tone that there was "not a trace of taste and order in the planning of the city." He reported on the lack of municipal services and the fact that the "large avenues" were not systematically cleaned and maintained; often, an "exclusive" avenue would be subjected for long periods to the inconvenience of unending repairs and open sewers during the construction of tramlines. Şerif also criticized the scarcity of contemporary structures and stated flatly: "modern works that belong to the public and to novelty with their new shapes are very few and can almost be counted on one's fingers."[90]

In his travelogue, Mehmed Refed mentioned the city's "rather large suburbs." Among them was the residential Salihiye quarter, where upper classes (*"Şam'ın kibar aileleri,"* the elegant families of Damascus) and European consuls enjoyed special amenities (fig. 2.20).[91] Mağmumi praised the good climate of the neighborhood and the impressive view afforded by its hilly site: from here Damascus appeared as a "large island in the middle of a green and wavy sea."[92] Founded in the mid–twelfth century, the suburb had reached its heyday in the late Ayyubid period; it then entered a stagnant period that lasted until the nineteenth century, when it entered a new era of development. The commanders and officers of the Kurdish militia reactivated and extended Salihiye's eastern section; their spacious residences brought a new scale

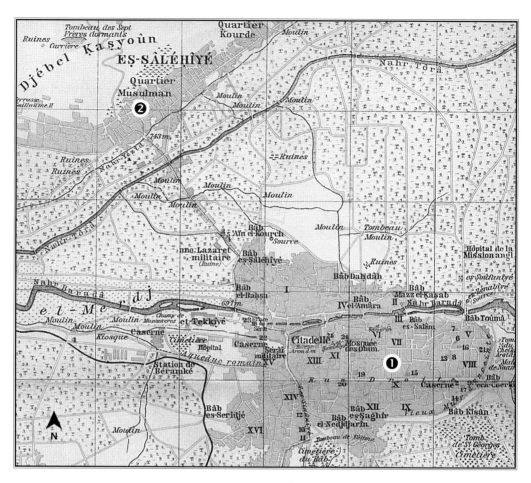

2.20 Damascus, plan, 1912

(Baedeker, *Palestine and Syria*, 5th ed.). 1. Old city. 2. New residential quarters.

and luxury to the suburb. In 1894, Governor Nazım Pasha settled refugees from the Balkans and Crete farther to the west, creating the only state-sponsored residential quarter in the city. It was designed by Paul Aubry, the chief engineer of the municipality, as a rigid grid, with two principal streets that cut each other at right angles. This cross section was given a monumental character by beveled corners—in a possible reference to the redesign of Aksaray, the first neighborhood in Istanbul regularized following a fire in 1856.[93] The three-story houses that lined the streets and that were equipped with "modern comforts" projected an image of uniformity, which was considered *à l'occidentale*. The neighborhood's modernity and good views appealed to wealthy families, who left Salihiye to build their luxurious mansions in Muhajirin (named after the refugees, the *muhajir*). Nazım Pasha's new residence in Salihiye enhanced the attraction of the urban elite to the western edge of the neighborhood and turned it into the city's most prestigious residential quarter.[94]

Trablusgarb's development outside the walled city is commonly attributed to the time of the Italian occupation after 1911.[95] However, from the 1860s on, various governors had struggled to bring urban reform to the city and initiate a controlled growth toward the south. Among them, Ali Rıza Pasha (who served twice as governor, in 1867–70 and in 1872–1874) played a major role. Ali Rıza Pasha's personal history linked him to the developments of the Maghrib and to the avant-garde of Ottoman modernization reforms. The son of Cezayirli Hamdan Efendi, the *kadı* (judge) of Algiers, he was born in that city around 1810 and, following the French occupation, fled to Istanbul with his family—like other Ottoman notables. Ironically, Ali Rıza was among the students sent to France to study military science (*fenn-i askeri*) by Mustafa Reşid Pasha, the grand vizier. Attending the École Militaire and the École d'Application de Metz, he spent a total of eight years in France. Upon his return to Istanbul, he became a close associate of Sultan Abdülaziz (1861–76), no doubt influencing him on his cultural opening to Europe. When he was appointed governor of Trablusgarb, Ali Rıza Pasha relied on French engineers to modernize the city's infrastructure, which began with tapping water from Ayn-Zariye, a nearby source in the southwest. In a unique episode in the history of relations with the French administrations of the Maghrib, he was inspired by the colonial interventions to the Algerian cities and invited engineers from Algeria to work in Trablusgarb.[96]

In a display of his systematic and scientific approach to matters of planning and infrastructure, Ali Rıza Pasha started his tenure by commissioning Mazhar Bey, an experienced military engineer, to draft a map of the province of Trablusgrab.[97] Then came the planned growth of the walled city with the construction of Suq Aziziye (also known as Aziziye Caddesi [Aziziye Avenue]), which prolonged the *intra-muros* Saray Avenue to the south, establishing a strong connection to the old city (figs. 2.21 and 2.22; see also pl. 9). The area was described in 1868 as empty, with the exception of the small mosque and mausoleum of Seyyid Hamude, some shops and cafés, a police station (Salıpazarı Karakolhanesi), an open marketplace (Salıpazarı), a few buildings on the waterfront, and streets leading inland and toward the sea. To expand the crowded markets of the city, to gather some of the dispersed shops in one place, and to put an end to the activities of street sellers, the governor decided to build a large new market here. Suq Aziziye was much more than a commercial building: it was qualified as a "road, ordered and designed from scratch." A report describing the project explained the artery as the nucleus of further growth in this direction: "it is natural that the land will be organized and developed with the construction of many new buildings in the gardens nearby."[98]

Constructed with funds from local notables, Suq Aziziye was a straight, arcaded artery with shops on two sides; its vista toward the city was terminated by a major gate, the Bab el-Hendek—in a firm gesture to establish continuities with the old city. Suq Aziziye did not copy the forms of the old market structures. It displayed an

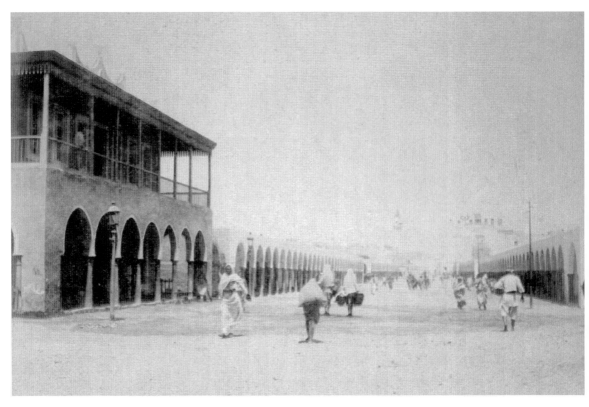

2.21 Trablusgarb, Suq Aziziye (IÜMK, album 90404).

unusual building type that synthesized the design principles of historic markets and the arcaded European-type avenues. Given Ali Rıza Pasha's interest in the French interventions in Algerian cities, it is tempting to propose a conscious relationship to the arcaded new streets of Algiers.[99] Ali Rıza Pasha also restored the Castello Mosque (located near Bab el-Hendek) and created a small park nearby, further promoting the growth of the city in this direction.[100] Referred to as a public garden (*millet bahçesi*) or municipal park (*belediye bahçesi*) and dotted by "elegant kiosks" whose windows boasted orange- and green-stained glass, it did not remain open to the public for long but was incorporated into the military compound.[101]

During the following decades the governors of Trablusgarb continued Ali Rıza Pasha's work by constructing a series of major buildings in the new quarter. Most notably, Ahmed İzzet Pasha (second term, 1879–80) began the construction of the Municipal Hospital, as well as a new market building, Hamidiye Çarşısı—named after the new sultan. Ahmed Rasim Pasha (1881–96) completed construction of the one-hundred-bed Municipal Hospital and the Hamidiye Markets (consisting of sixty-eight shops), expanded the military barracks, and built other government buildings and a flour factory. Hafız Mehmed Pasha (1899–1900), credited for "introducing

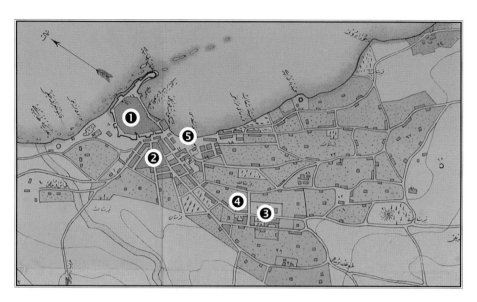

2.22 Trablusgarb, plan, showing the growth outside the
walled city, 1909 (AK, *harita* 1335). 1. Old city. 2. "New" Trablusgarb.
3. Military barracks. 4. Military hospital. 5. Salıpazarı (marketplace).

municipal duties" to Trablusgarb because of his efforts to pave the main avenues of
the city *extra* and *intra muros,* focused at the same time on schools, opening a teach-
ers' college and two elementary schools; he also provided a new building for the girls'
school, turning it into a "respectable" institution, and finished the construction of an
industrial school, begun under Ahmed İzzet Pasha.[102]

The 1887 *salname* of the province pointed to the liveliness of the construction
scene *extra muros,* and hence to the continuation of the development of this area.[103] In
1889, Ali Tevfik's high school geography textbook stated that, "thanks to the build-
ings outside the walls, gradually the city developed and improved."[104] Two Ottoman
plans (1883, pl. 9; and 1909, fig. 2.22) testify to the phenomenon, showing a radial
street system focusing on the city walls; the area is labeled the "new town of Trablus-
garb" (1911 plan) and has commercial and official buildings and a military enclave
with a hospital and barracks farther to the south.[105] Writing just before the Italian
occupation, a European traveler described the growth outside the walls as "a new
quarter, whose wide and rectilinear streets are defined by buildings with grand
arcades." It displayed a *"caché bien moderne."*[106]

Other urban centers witnessed similar extensions, some matching the scale
observed in Damascus and Trablusgarb, others not. Beirut's growth during the sec-
ond half of the nineteenth century was impressive. The first architectural manifesta-
tions of Ottoman centralization reforms appeared in the form of military barracks on

the hills in 1853, also called the Grand Serai; the addition of a military hospital nearby in 1861 amplified the monumental imposition. In addition to engraving Ottoman power onto the physical fabric of Beirut, this compound initiated the development of new quarters—echoing the process observed in Damascus. The heights would thus constitute the site of the "new town."

The Ottoman government made Beirut the capital of the newly created province of Beirut in 1888 in an act that associated the city firmly with Istanbul. This association would impact the urban image further, not only in terms of accommodating official functions, but also in creating ceremonial spaces that contributed to the consolidation of an imperial iconography. Paralleling the procedures applied in the capital, a systematic approach to the regularization of the street network began with legal provisions. Based on Ottoman construction law, the streets were divided into five categories according to their width, their enlargement was rationalized in hygienic terms (access to sunlight and good ventilation), and public zones (port, coastline, public squares and gardens, as well as the areas surrounding places of worship) were differentiated with stipulations that banned construction.[107] The planning principles applied in the new quarters resulted in the creation of an old and a new town, the latter boasting a street network of 50 kilometers. "Stone and elegant" buildings lined its "large and comfortable" avenues, 15–20 meters wide. The *salname* of 1893–94 summarized the work carried out by the municipality in two words: regularity (*muntazamiyet*) and beautification (*tezyinat*).[108] These neighborhoods became populated by wealthy residents.[109]

In Trablusşam (Tripoli of Lebanon), the area called "Tel" to the west of the old city, formerly a sandy piece of land, was developed as the "new Trablus." During the last decade of the nineteenth century, growth began with the construction of official buildings, notably a government palace, a clock tower, and a municipal garden. Other "graceful" buildings, including a post office, consulates, banks, hotels, and the offices of the tramway company, followed (fig. 2.23). The neighborhood, especially along the main street with the tramline that connected to el-Mina (the port), boasted large structures—all considered "matters of pride." At night, gas lamps turned the streets, filled by a fun-loving crowd, into a "sea of light." The contrast between this neighborhood, dotted with many "truly distinguished and select" buildings, and the old city did not escape the administration and was noted critically in a *salname*. The inequality was especially striking in terms of the circulation networks. The streets in new Trablusşam were a stark contrast to the dark and dirty streets and dead ends in the old city.[110]

A more modest, but still distinct, development occurred in Mosul during the first decade of the twentieth century. An administrative center began to take shape outside the city walls on the banks of the Tigris with the construction of a monumental government palace in the "new architectural style" in an elegant garden and facing a

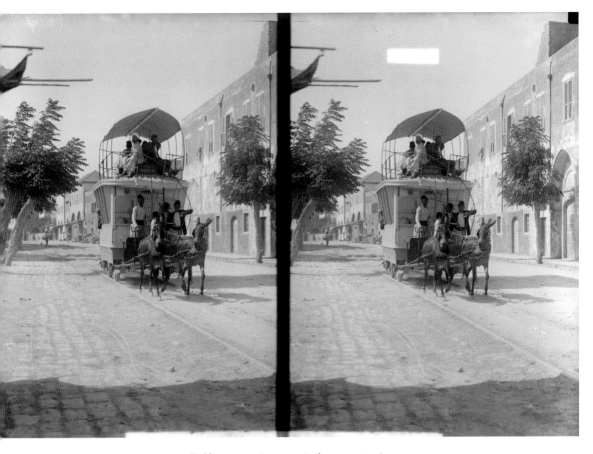

2.23 Trablusşam, main avenue in the new extension
(Library of Congress, Prints and Photographs Division).

modern, tree-lined public square. With the addition of other imperial buildings of imposing scale, including two military barracks, a military hospital, and a tax bureau, a government enclave was formed (see fig. 3.20). Described as the "most convenient and most eminent" location in the city, an empty zone in the vicinity of the complex was chosen for a planned development, a "prosperous neighborhood" that would express "honor and pride."[111] Spreading out on two sides of the avenue that passed in front of the government palace, the quarter soon became filled with residential buildings, inhabited solely by government officials. However, as in the case of Trablusşam, the dual structure was criticized even in the pages of a *salname:* this was not a "happy" separation because the investments had not contributed to the general improvement of the "health of the land" (*sıhhat-i belde*).[112] Such rare glimpses into Ottoman self-evaluation regarding the consequences of developing modern quarters at the expense of creating oppositional settlements point to a difference between Ottoman and French agendas—regardless of formal similarities.

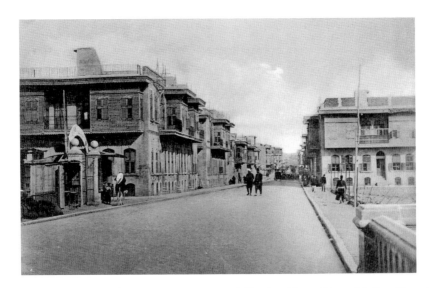

2.24 Aleppo, a street in the new extension (postcard, Fine Arts Library, Harvard College Library).

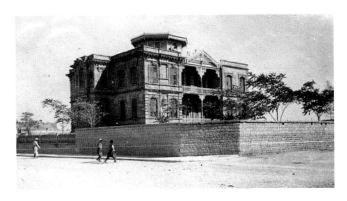

2.25 Aleppo, the residence of the Ottoman governor
(Dr. Jean-Alexandre Otrakji, www.mideastimage.com).

New quarters outside the historic cores were common in many cities. Outside Aleppo, the quarters of Cemiliye to the west and Aziziye to the northwest of the walled city were built on grid plans and dotted with "handsome houses in the European style,"[113] among them the residence of the Ottoman governor in the Cemiliye quarter (figs. 2.24 and 2.25; see fig. 2.10). Their monuments were secular buildings, revealing some of the main reform programs. For example, the imperial high school, the largest structure in the neighborhood, occupied a vast garden in the center of Cemiliye; a municipal park was carved into Aziziye's grid. According to the Ottoman traveler Mağmumi, an architectural feature that distinguished the residential fabric of the newly built neighborhoods was red-tile roofs; they formed a marked contrast to the flat roofs of the buildings *intra muros*.[114] To continue the development of Aleppo

toward the northwest, Governor Raif Pasha (1896–1900) commissioned French engineer Charles Chartier to draft a plan.[115]

Even though reservations concerning this pattern of growth emerged now and then because of the unequal conditions it created, Ottomans regarded it as normal and healthy in old cities and associated its absence with problem cases. According to Hakkı Bey, the glowing failure was Baghdad, where Governor Nazım Pasha's intention to build a modern quarter for government officials with houses in the "new style" could not be realized, leaving the city regrettably without any trace of contemporary planning.[116]

NEW CITIES: "SYMMETRY AND REGULARITY"

Acting on General Bugeaud's initiative to create a "network" of cities throughout Algeria, the French army established many new settlements to ensure their complete control of the colony during the early decades of the occupation. Primarily, these were strategically located inland garrison towns that could shelter six to seven thousand men, but they also served as permanent centers and anchors of colonization in the midst of a nomadic society.[117] The design principles, based on simplicity, practicality, and economy, followed officially imposed guidelines: "symmetry and regularity that express the idea of an ensemble dominate. . . . The façades [are] aligned to create regular streets even when the terrain is irregular."[118] There were no provisions for local residents; the goal was to keep them away from the armed forces and the settlers. Three such settlements in Algeria—Orléansville, Sidi Bel Abbès, and Souk-Arhas—all with critical missions in the occupation of the Maghrib, offer good examples.

Three plans for Orléansville, on the road between Algiers and Oran, help explain the genealogy of the type. The first, designated exclusively for the army in 1843, defined a rectangular fortified compound of nine equal-sized blocks, separated by orthogonal tree-lined streets; one block was to be an open plaza (fig. 2.26). A couple of years later, another plan presented the addition of a civilian quarter, following the guidelines of the 1843 grid and underlining the permanency of the settlement and the future of Algeria as a settler colony. It harbored a repertoire of public buildings deemed essential for any European settlement of considerable size: town hall, law courts, prison, market, church, theater, and hospital. In an unusual proposal, an Arab quarter was appended to the grid of the *quartier civil* on the west, with an array of public buildings that summarized the core of Muslim life as viewed by the French: mosque, bath, caravanserai, and housing for the elderly.[119] The civilian quarter was deliberately kept large so that it could easily accommodate the predicted population growth, which was expected to happen as agricultural and industrial production developed in the region.[120] A third plan, from 1847, revised the settlement pattern by deleting the Arab quarter but keeping the civilian one. The addition again followed

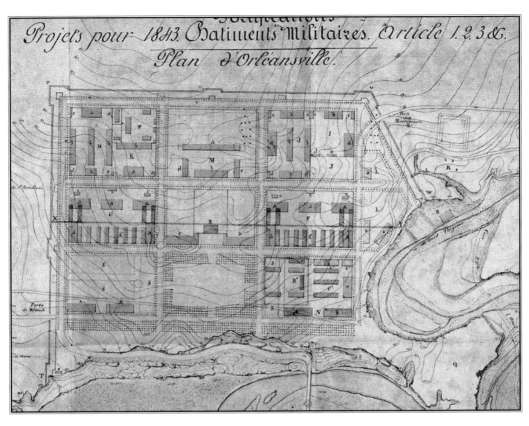

2.26　Orléansville, plan, 1843 (Défense, Génie, Orléansville, 1H 667, art. 2, no. 1, *feuille* 2).

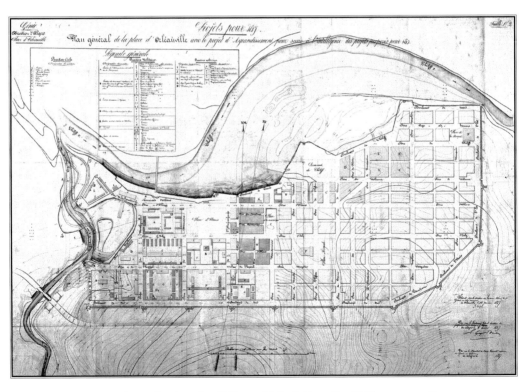

2.27　Orléansville, plan, 1847 (Défense, Génie. Orléansville, 1H 667, art. 2, no. 8).

The civilian quarters are to the right.

the original grid, but its northern boundary was adjusted to the topography of the Chelif River valley, resulting in an irregular edge (fig. 2.27). Echoing the previous plans, this one ignored other topographic conditions and imposed a rectilinear pattern on an area dominated by two hills and a valley in between.

The original plan for Sidi Bel Abbès, in the province of Oran (located between Tlemcen and Mascara), dates from 1847 and mirrors the Orléansville plan of the same year (figs. 2.28 and 2.29). The decision for its location stemmed from the urgency to establish control in the region, which was dominated by Beni-Ammar tribes whose staunch support for Emir Abdel Kader had led to a series of confrontations with the French army. A firm base would enable the soldiers to attack the "insurgents" in more orderly and powerful ways. A 25-meter-wide avenue, planted with trees, stretched from the Tlemcen Gate in the west to the Mascara Gate in the east and divided the grid plan, a rectangle within fortifications. A north–south avenue of the same width separated the military quarter in the west from the civilian quarter. The military quarter sheltered the barracks, hospital, an artillery park, and officers' residences, while the civilian one had the church, the courthouse, the school, the town hall, and the theater. Several blocks were reserved as public squares: a place d'Armes in the west and two squares in the east, both defined by public buildings. On one, the church and the town hall faced each other; on the other, the theater and the palace of justice symmetrically defined the axis. Even though the boundaries of the two sections gained some porosity during the next decades, the formula could still be read clearly. The area around the planned core was divided into agricultural lots to be cultivated by the residents.[121]

As discussed in the previous chapter, Souk-Arhas, on the rail line that ran parallel to the Algeria-Tunisia border, played a key role in the conquest of Tunisia in 1881. A plan from the same year displays several features that deviate from the Orléansville–Sidi Bel Abbès formula, pointing to its higher military importance (fig. 2.30). Souk-Arhas was not divided neatly into two, but large military compounds enclosed the civilian town on three sides. Placed on hills, they dominated the settlement, which was based on a grid plan fitted onto a small plateau. The land road that connected Tebessa and Bône was one of the main arteries of Souk-Arhas and bordered its main plaza. After the occupation of Tunisia, the town would benefit from its convenient placement between Tunis and Constantine as well and would become a commercial hub.

Although they never reached the scale of the new French settlements in the Maghrib, there were scattered Ottoman initiatives that displayed similar settlement patterns. Not systematized into a coherent policy of conquest and domination as in the case of the French Empire and not imposed from the center, they were heralded by governors. For example, the entrepreneurial Ali Rıza Pasha of Trablusgarb, very much aware of the advantages the Suez Canal would bring to the province, presented

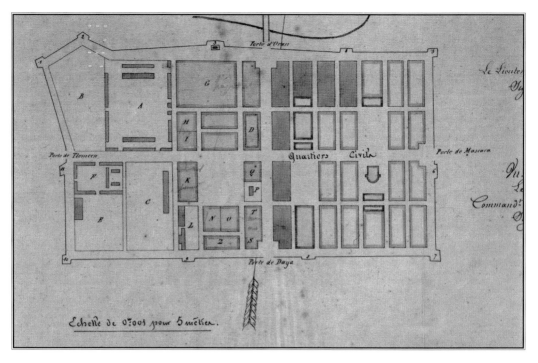

2.28 Sidi Bel Abbès, plan, 1891 (Défense, Génie, Sidi Bel Abbès, 1H 779, art. 3, no. 10).
The military quarter is to the left; the civilian quarter is to the right.

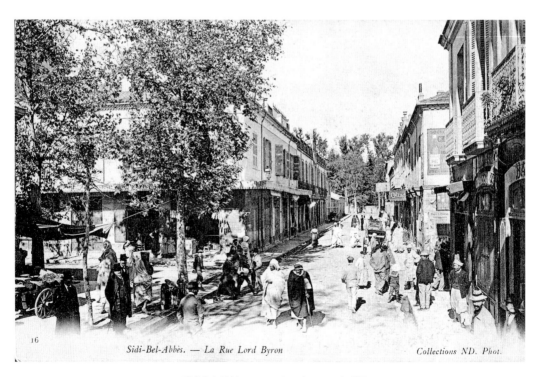

2.29 Sidi Bel Abbès, street view (postcard, GRI).

2.30 Souk-Arhas, plan, 1881 (Défense, Génie, Souk-Arhas, 1H 874).

a project to the sultan in 1869 to capitalize on the strategic position of the Bay of Bomba to the east. His goal was to start a new town in nearby Tobruk, the ancient Roman city of Antigurgos (in ruins). The official buildings would include a quarantine center, military barracks, and warehouses. In an intriguing scheme, he called for the appropriation of the seemingly modern grid plan of the Roman city to develop his new town. To attract residents (young military families), he would waive taxes for ten years, provide free food during one year, and donate animals needed for agriculture, as well as construction materials (mostly recycled from the Roman ruins) to build houses. The land was suitable for growing cereals, and with the rebuilding of the Roman reservoirs, the water problem would be solved. Ali Rıza Pasha's new town would have a military nature similar to the French examples and harbor a diverse population. Issuing land concessions to Catholic missionaries so they could build a hospice and a chapel, he hoped to draw Christian immigrants from Malta, for example. The project was inaugurated but was abandoned soon after.[122]

Conceived during the tenure of Governor İsmail Kemal Bey, the agenda behind the new town of Bir-i Şebi in the Negev Desert (today's Beersheba in Israel), begun in

2.31 Bir-i Şebi (Beersheba), plan, c. 1900 (drawing by Kevin Field, based on Gideon Biger, *Be'er-sheva: Ha-ir ha-atika, 1900–1948* [Tel Aviv: Misrad da-hinukh veha tarbut (Ministry of Education and Culture), 1986], 37). 1. Government palace. 2. Headquarters of the Municipality. 3. Mosque. 4. Post Office. 5. Police Station. 6. Telegraph Office. 7. School. 8. Cemal Pasha Park. 9. Gardens.

1900, was to establish control over the dispersed and unruly Bedouin tribes in the region by providing an official seat that represented the Ottoman state and by beginning to settle the nomadic populations in an orderly pattern. On land bought by the government, two Arab architects, Said and Raghib Nashashibi, were commissioned to design the new settlement. Not surprisingly, the Nashashibis opted for a grid plan, the most convenient, economic, and time-tested scheme for new settlements but one that also evoked an image of modernity (fig. 2.31). The layout was composed of square blocks; a 20-meter-wide main street led to Gaza. The government palace, municipality hall, post office, police station, and telegraph office formed a cluster of official buildings at the northwestern end of the town. According to the memoirs of Naciye Neyyal Hanım, the wife of Jerusalem's governor Tevfik Bey (1897–1901), following the construction of the government palace, locals "flocked" to the building "to register themselves and settle around it." They also requested the construction of a mosque, which completed the cluster. Naciye Neyyal Hanım claimed that it was the local people who demanded that the buildings be named after the sultan.[123]

The official buildings did not adhere to the siting principles of the grid, but by breaking it they emphasized their difference from the residential fabric. Their architectural glamour inspired by European forms and their red-tile roofs also differentiated them from the residential fabric. The government palace, situated at the highest

point, turned its face toward the imperial enclave, offering a blank wall to the town and underlining the separation of the two parts—a situation that recalled the dual structure of the new French towns, with the army compound and the settlers' blocks. A public park, called Cemal Pasha Park after the governor of Syria, was built in 1915; it acted as a transitional zone between the official center and the residential quarter. It was also during this time that the railroad arrived in Bir-i Şebi.[124]

Modest and unsuccessful, the Ottoman new-town projects nevertheless displayed the intention to reinforce imperial control over land by permanent settlements. In Tobruk, the goal was military and economic, whereas in Bir-i Şebi it centered on the establishment of official authority over the local tribes. The settlement plans (the grids) followed tried-and-true colonizing patterns, with the relevance of historic precedents evident in the recycling efforts to build a modern town upon Roman foundations in Tobruk.

Guided by the discussions presented in this chapter and the previous one, and relying on a macroscopic imaginary construction, it may be a useful exercise to draw maps of the Middle East and North Africa at the end of the eighteenth century and at the end of the nineteenth century in order to register the great transformations. The land use pattern of two hundred years ago consisted of wide, open spaces dotted by walled cities with dense built fabrics and by scattered villages, often at considerable distances from their nearest neighbors; the connections between them were few and frail. One century later, the region was crisscrossed by highways, rail and telegraph lines, and bridges, creating a connected network of settlements and incorporating them into a system. The cities had undergone a scale change and had grown beyond their fortifications in all directions, losing their neat compactness due to expansion and the hollowing out of their cores. This "mastery" over land was clearly associated with modernization and empire building, and while the process reveals intricate specificities that explain much about the sociopolitical and economic histories of the region, the broader picture dismantles the boundaries to evoke uniformity.

3

NEW PUBLIC SPACES

European-style public squares were introduced in "Islamic" cities with the French occupation of Algeria. While many cities in the Ottoman Empire had open spaces used for ceremonies and public gatherings, these spaces were informal and lacked the order increasingly imposed on the squares of urban centers in Europe since the Renaissance.[1] Some Ottoman public spaces were inherited from earlier times and situated within urban fabrics (such as the Byzantine fora of Istanbul); others were located at the edges of the cities (such as Marja Square outside the western gates of Damascus). They did not display a geometric order, were not defined by an architecture that unified the open space, and did not boast statues or other memorials. The latter, often statues of prominent civic figures, were understood in France as elements of modern urban design since the beginning of the nineteenth century and occupied the public spaces of French cities as symbols of liberal and secular values.[2] One of the most significant transformations to cities in the Middle East and North Africa was the introduction of regular, monumental squares, surrounded by public buildings and dotted with memorials. Charged with messages about the empire, the new public squares of the French Maghrib and the Ottoman Middle East shared many characteristics. They also differed in telling ways.

The earliest is the place d'Armes in Algiers, opened in the heart of the city in 1830. Practical necessities dictated its construction: the French army needed a large

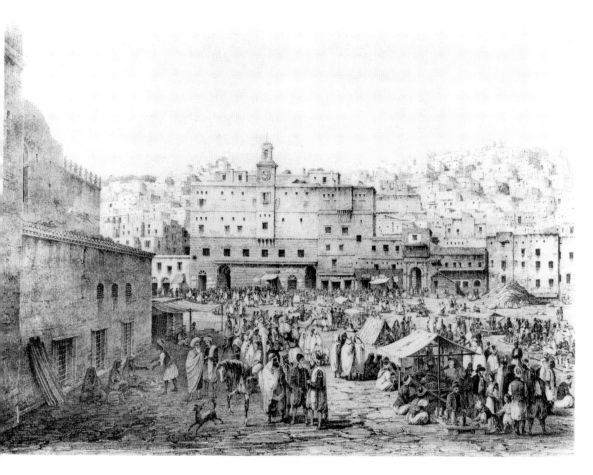

3.1 Algiers, place d'Armes, 1839 (Adolphe Ott, *Esquisses africaines, dessinées pendant un voyage à Alger et lithographiées per Adolphe Ott* [Berne: J. F. Wagner, 1839], pl. 30).

open space for gathering and maneuvers, previously not accommodated by the tight urban fabric of precolonial Algiers. The initial carving out took place in the months following the conquest, and work continued at intervals for the next two years. The place d'Armes, explicitly associated with the French army and the military occupation, was an "immense," if shapeless, void in front of the Palace of the Dey, the headquarters of the Ottoman governor of Algeria (fig. 3.1).[3] The authoritative presence of the place d'Armes was a blatant symbol for both the conqueror and the conquered, but the new plaza was also imbued with the memory of what it was before the occupation. The army engineers had demolished an entire fabric that had harbored some of the city's most vital institutions—most prominently, Mosque es-Sayyida, which stood in front of the Palace of the Dey and was remembered as the most elegant of all religious buildings in Algiers. In addition, an extensive commercial tissue was torn down. It had comprised the food markets and the specialized suqs, such as the

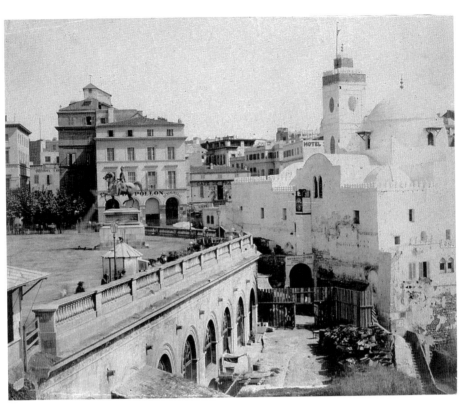

3.2 Algiers, place d'Armes, c. 1857, view of Mosque el-Djedid with the statue of the
duc d'Orléans, photograph by Jean-Baptiste-Antoine Alary (GRI, Special Collections, 92.R.85).

suqs of the jewelers, leather workers, weavers, booksellers, and, in the center, the
Bedesten. Several military barracks that belonged to janissaries and many houses
were also taken down.[4]

Within a couple of years after the occupation, the image of the place d'Armes was
deemed unfitting of the grandeur of the French Empire. Many projects were drafted
to endow it with the appropriate glory. Order and regularity, which contrasted with
the precolonial urban forms of Algiers, were taken as design guidelines to symbolize
the new presence. In 1831, for example, Mr. Luvini, the government architect, pro-
posed a rectangular plaza defined by monumental structures that represented France,
including a theater and a Palais du Gouvernement; the seventeenth-century Mosque
el-Djedid, another major religious monument, would be demolished to make room
for the new configuration.[5] The project encountered opposition from Lieutenant Gen-
eral Lemercier. Acknowledging the initial errors committed by the army engineers,
he advocated showing respect for "the religious sentiments of the Moors."[6] Lemer-
cier's consideration for Algerian society was not immediately taken to heart by the
army engineers, as evidenced by a project for a rectangular plaza in 1833 that also

called for razing Mosque el-Djedid.[7] Nevertheless, his objection to the demolition of Islamic religious monuments found a response in another proposed project for a rectangular plaza in 1834, and Mosque el-Djedid was preserved.[8]

Capitalizing on the damage caused by a fire to the Palace of the Dey in 1844, several projects attempted to readjust the plaza's overall shape in the following years. By midcentury, it had acquired its final hexagonal form, with arcaded buildings in the French style on three sides and the preserved Mosque el-Djedid determining the irregularity of the east side (fig. 3.2; see also fig. 2.1 and pl. 15). The edges of the plaza that bordered the steep hill descending to the harbor level were neatly defined by a balustrade. Most significantly, an imposing, five-meter high equestrian statue of the duc d'Orléans, Louis-Ferdinand Philippe (the son of Emperor Louis-Philippe and prince to the throne who had fought and was wounded in Algeria in 1836), was erected on the site in 1845—in a gesture that complemented the nineteenth-century French "statumania" at home.[9]

The placement of the statue of the duc d'Orléans (by Italian sculptor Carlo Marochetti) did not follow the rules set for similar gestures of celebration in the metropole but was manipulated to respond to the colonial mission. It was strategically situated, not in the center of the plaza as one might expect from the geometry-conscious army engineers, but to the side—directly in front of Mosque el-Djedid. Elevated on a high base and contrasting with the serene mass of the white mosque in its blackness and dynamic shape, and with its back to the mosque, it conveyed a straightforward message about the power structure in Algeria. The gaze of the duc d'Orléans, turned away from the plaza to face the Casbah, symbolized French control over the Algerian people. A public art form that was totally foreign to local norms, the statue dominated the major perspectives toward the plaza, thereby reiterating its message.[10]

The passage from a military to a civilian regime in the 1870s, with the implication that France was here to stay, led to the renaming of the plaza as place du Gouvernement. It was frequently referred to as the "forum of the colony." René Lespès, the author of a comprehensive monograph on Algiers, described it as the site where "the most passionate discussions on colonization and the future of our conquest took place" and where great historic events were acknowledged by public ceremonies that ranged from commemorative gatherings to funerary processions, proclamations of changes in the political regime, and civic and patriotic banquets.[11] The place du Gouvernement was also seen as the heart of Algiers. Théophile Gautier, for example, wrote that it was "the meeting point of the entire city," the place to make appointments, and through which "all of Algiers passed inevitably three or four times a day."[12] A monograph from 1861 described the public space as the site of meetings between businessmen and of evening promenades to take the air. It also acted as the stage to play "military music" in order "to ensure that the Arabs heard frequently

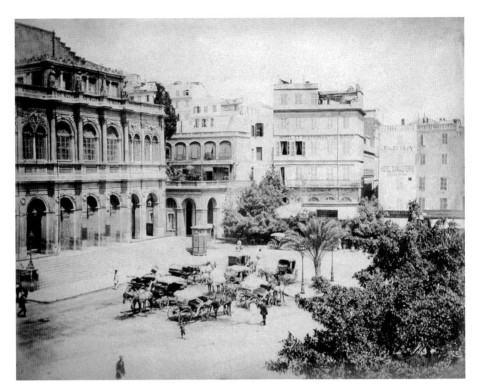

3.3 Algiers, place Bresson with the Grand Theater on the left,
photograph, 1884 (GRI, Special Collections, 95.R.95).

several of the bellicose tunes that announce their historic defeat, and remind the French gently . . . of their homeland."[13]

Although not acquiring the same intensity of associations as the place du Gouvernement, two other mid-nineteenth-century squares became anchors of colonial Algiers. The place Bresson was located at the juncture of the precolonial and the European cities, near Bab Azzoun, a major gate in the Ottoman fortifications that was demolished in 1846 to accommodate the growth of the city toward the south (see fig. 2.1 and pl. 15).[14] The crowning feature of the place Bresson was the Renaissance-style Grand Theater, designed by Chassériau and completed in 1853 (fig. 3.3). A physical expression of French culture, the theater made a statement about the monumental presence of the occupier, its façade decorated with statues and topped by an eagle with open wings. The architectural vocabulary seemed to answer an earlier call in a newspaper editorial that argued that the French theater in Algiers should serve "as a means of civilizing propaganda."[15] Its inauguration was celebrated by a *pièce lyrique*, titled "Alger en 1830 et en 1853."[16] A freestanding structure, it faced the Mediterranean and dominated the square, making up for the lack of a statue. The theater determined a main axis terminating in the bastion that descended to the harbor level by

sculptural stairs. On the waterfront side the open space met the arcades of the boule-
vard de l'Impératrice, completed in 1865 and named in honor of Empress Eugénie,
who had accompanied Napoléon III to Algiers in that year—all the work of Chas-
sériau (see chapters 1–2).[17]

If not to the dramatic scale of the place d'Armes, the regularization of the place
Bresson necessitated the demolition of several buildings that had mushroomed out-
side Bab Azzoun after the 1830s (pl. 19). In contrast, the place d'Isly, more commonly
known as the place Bugeaud, was part of a plan to control the expansion of the city in
an orderly manner—as witnessed by its perfectly square shape bisected by two roads
and by the placement of a statue at its center (see pl. 15). Named after Maréchal Buge-
aud (made duc d'Isly in 1843), the square opened up in the middle of the north–south
running rue d'Isly. The perspective from place Bugeaud toward the north was termi-
nated by a view of the Casbah on the hill beyond. European-style buildings framed
the vista to the old city, etching another contrast onto the already-charged image of
Algiers. The square was eventually lined by elegant residential structures with com-
mercial functions on the ground level, and in 1852 a statue of Maréchal Bugeaud was
erected at its center (fig. 3.4). This key figure in the conquest of Algeria had fought
against the Algerian leader Abdel Kader in the 1830s and was named governor-gen-
eral of Algeria in 1840. Like that of the duc d'Orléans, Bugeaud's gaze was fixed on
the Casbah in an act of permanent supervision. In the words of artist and writer
Eugène Fromentin, "the statue of the Maréchal [was] placed there as a definitive sym-
bol of victory."[18]

Elsewhere in Algeria, the squares carved into the old fabrics carried vestiges of the
past, albeit transformed to reflect colonial conditions. Recalling its counterpart in
Algiers, the place d'Armes in Bône was also hollowed out in the historic fabric, in
front of the main mosque, the Mosque el-Bey (see fig. 2.3). Arcaded three-story buildings
surrounded the quadrilateral space. A radical intervention to the mosque endowed it
with a frontal "Moorish" arcade that complemented the other sides of the square (fig.
3.5)—in a gesture that replicated the new façade of Mosque el-Kebir on rue de la
Marine in Algiers. Furthermore, it was given a clock tower. Square in plan and topped
with a dome, it sat in the center of the front façade, overshadowing the original, Otto-
man-style pencil minaret. A fountain surrounded by bamboo and fig trees punctuated
the center of the square; trees, planted in a grid pattern, filled the rest.[19] Regularity
dominated the image of the plaza, helped by the new façade of the mosque, which
served as a reminder of the submission of the colonized culture.

The place du Palais in Constantine, opened by demolishing the Suq el-Gazi (which
specialized in wool), took its name from the Palace of Ahmed Bey, built by the last
Ottoman bey between 1826 and 1835, right around the French occupation.[20] Ahmed
Bey resided in his palace only for a few months, first as a sovereign, then as a pris-
oner. The appropriated building was turned into the headquarters of the army,

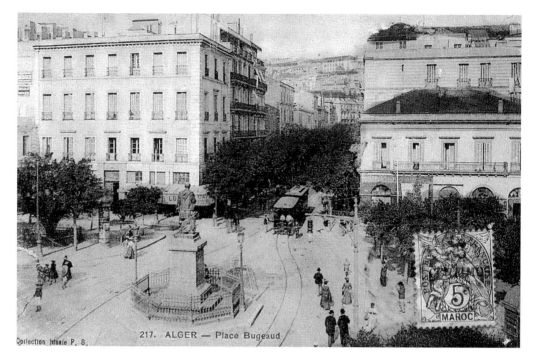

3.4　Algiers, place Bugeaud (postcard).

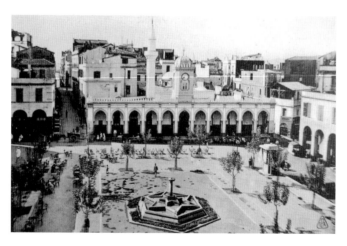

3.5　Bône, place d'Armes, view toward the mosque
(postcard, Défense, Département de Terre, Fonds Michelet).

including the Directorate of Engineering and the Arab Bureau, which was responsible for affairs concerning the local population. Over a span of several decades, the palace was submitted to incremental transformations to accommodate its various functions, some addressing the exterior space. While the army retained the building as "military property," it acknowledged the necessity to keep the square in front of it

open, as a "place de disposition publique."[21] The mayor of Constantine welcomed the military plans and maintained that isolating the building from its surrounding fabric and turning it into a freestanding structure in the square would emphasize its primary importance as a "historic monument," relegating its military status to the background; this operation would facilitate the movement of the army, showing how the "double interest of the state and the commune were engaged."[22] In the 1880s, projects to regularize the street network took priority, and the palace, acknowledged as a "unique monument from the Arab domination [bearing a] sacred character," acquired new façades to harmonize with the urban interventions around it (fig. 3.6; see also fig. 4.12).[23] The cathedral, left standing alone to retain its visual grandeur, bore the memory of the precolonial era as well: it occupied Mosque el-Rezel (1703), in a repetition of the transformation of Ketchaoua Mosque in Algiers into the main cathedral in 1830. Enlarged and endowed with an octagonal dome, the exterior of Constantine's cathedral lost its original character. However, the decoration of the interior, complete with an ornate *minbar* turned into a Christian pulpit, served as a reminder of its history. The Banque de l'Algérie sat across from the palace, completing the military, administrative, technical, and religious French presence with the monetary. Cafés surrounded the square, which was periodically used as a stage for musical performances by army bands.[24]

Among Constantine's other public squares, the place de la Brèche (place Nemours), at the southwestern gate of the city's fortifications, also was subjected to an incremental development. As the only gate providing easy access to Constantine, this was the location of the barracks of the janissaries, appropriated after the French conquest, demolished, and transformed into a parade ground. The commanders of the army acknowledged the necessity of "civil constructions" on the square but maintained that they should not obstruct the gathering and movement of the infantry, cavalry, or artillery forces and not block the roads leading off from the area. Most importantly, the vehicular artery on the axis of the public space had to be conserved: in addition to its use by the troops, this was the route for the ceremonial arrival of the *général commandant* of the army and the navy, the ministers, the prince, and even the emperor on their visits to the province; it led to the central gate of the palace.[25]

The square was regularized in conjunction with major public buildings that gradually defined the place Nemours.[26] A decision in 1880 led to the demolition of the Porte Valée and opened the area to further expansion (fig. 3.7).[27] On the site of the demolished barracks of the janissaries, an elaborate neoclassical theater opened in 1883. Adjacent was the covered vegetable market, again from the same period—to be soon replaced by the Crédit Foncier. A music kiosk was placed on the square in 1903, and in 1905, the army agreed to give up the plot on the southwest side of the place Nemours so a central post office could be built.[28] The palace of justice, erected during World War I next to the post office, completed the monumental definition of the

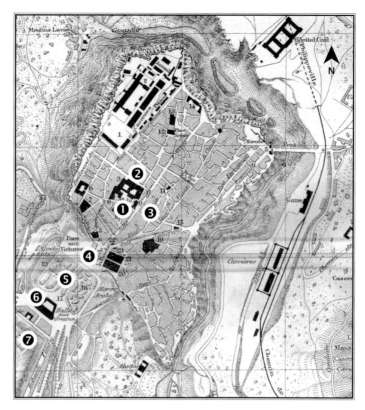

3.6 Constantine, plan, 1888 (Piesse, *Algérie et Tunisie*). 1. Place du Palais. 2. Palace of Ahmed Bey.
3. Cathedral. 4. Place de la Brèche (place Nemours). 5. Place Valée. 6. Grain Market. 7. Coudiat-Aty.

square in a neoclassical language.[29] To the southwest, outside the old fortifications
and occupying the site of a former Arab cemetery, was a wide, open space, named
place Valée (fig. 3.8). At its edge the Grain Market, built in 1863, faced the city. Land-
scaped and shady, this parklike area was divided in two: the northeastern part served
as an open-air museum that displayed antiquities found in the region; the southwest-
ern part boasted a statue of Maréchal Charles-Sylvain Valée, who was instrumental
in the occupation of Constantine as the commander of the artillery forces.[30]

Paralleling the place de Gouvernement in Algiers and the place du Palais in Con-
stantine, Tlemcen's double-squares, place d'Alger and place de la Mairie, cut through
by rue de la France, represented the cultural duality of colonial order (see pl. 17). The
Great Mosque of Tlemcen, one of the most important monuments of medieval archi-
tecture in Algeria, was left as a mosque, following the example of Mosque el-Djedid
in Algiers. However, it was juxtaposed with the colonial administration in the form
of the city hall built on the other side of the square.[31] In contrast to these case studies,
in the newly planned towns and extensions to old cities, the design of public spaces
often followed European formulas. Among many examples, the small settlement of

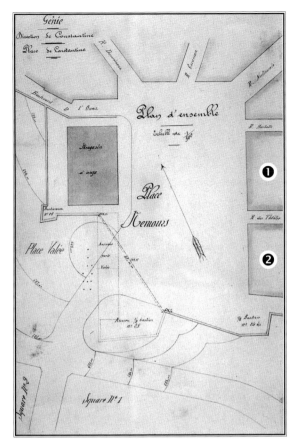

3.7 Constantine, plan of the place Nemours, 1890
(Défense, Génie, Constantine, 1H 807, art. 3, fig. 4). 1. Covered market. 2. Theater.

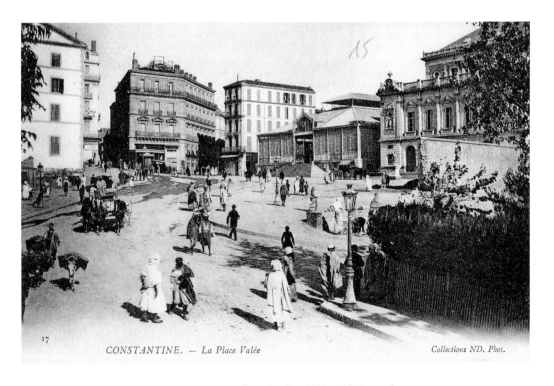

CONSTANTINE. — La Place Valée

Collections ND. Phot.

3.8 Constantine, view from the place Valée, with the market
and the theater on the right (postcard, GRI).

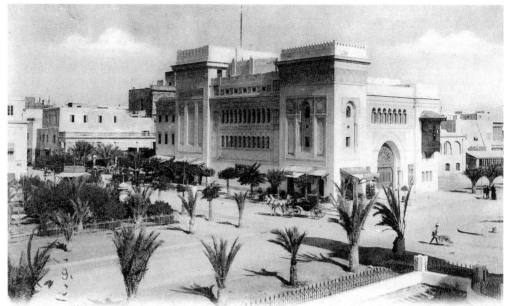

101 SFAX. — Le Théâtre Municipal. — LL.

3.9 Sfax, theater (postcard).

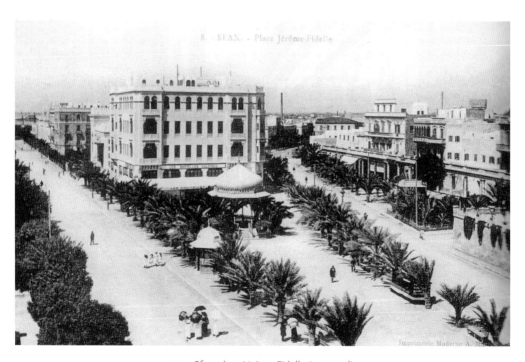

8. - SFAX. - Place Jérôme-Fidelle

3.10 Sfax, place Jérôme Fidelle (postcard).

Sidi Bel Abbès had its two squares fitted neatly into the grid plan: one square is defined by the church and the city hall, facing each other axially, with the police headquarters tucked behind the city hall; the other is dominated by the theater and the palace of justice, again facing each other across the open space, with the covered market behind the theater and the prison behind the palace of justice (see fig. 2.28).

The pattern of French interventions to the cities of Tunisia that did not cut through the old fabrics (see chapter 2) resulted in the insertion of public squares into the grid-planned extensions, again following European formulas. In Sfax, for example, the main square was located at the intersection of the first European settlement with the later extension on landfill. Two architecturally flamboyant buildings in neo-Moorish style, the theater and the town hall, defined its two sides (fig. 3.9; see fig. 4.16). The orientation of the town hall, with its principal façade turned toward the Muslim and the early French cities, established a visual and spatial connection to them. The rue de la République directly led to Bab Diwan, the main gate in the fortifications surrounding the precolonial settlement. The monumental white-washed masses, colorful details, and elaborate, dream world details of the theater and the town hall, complemented by the similar character of the post office, the Office of Civilian Affairs, and Office of Public Works lining the avenue Jules Gau, endowed the landscaped square with "oriental" flavors. Sfax's other major public space, the triangular place Jérôme Fidelle, was nearby, behind the theater and at the intersection of the avenue Jules Gau and boulevard de France (fig. 3.10). A department store in neo-Moorish style, Les Nouvelles Galeries, closed the short side of the triangle, while rows of palm trees bordered the two other sides. In front of Les Nouvelles Galeries, a domed music stage continued the architectural theme.

Another common practice was to place public spaces in front of the gates in precolonial fortifications, as occurred, for example, in old Tunis. Their architectural qualities helped give the squares, which also acted as border spaces between the colonial and indigenous settlements, a monumental definition. The arched entry of Bab el-Bahr (the sea gate) stood as the vista of the avenue de France (continued as avenue de la Marine), the backbone of the European quarter (fig. 3.11). Its name was changed to Porte de France, and it anchored the colony to the waterfront and, further, to the metropole. Public squares opened during French rule in Algeria and Tunisia offered a rich variety of experiments in siting, compositional principles, and imagery. In some manner, they all expressed the presence of the colonial power: by their design principles, the way they connected to the street systems, their names, the character of the buildings around them, and the memorial structures erected on them.

Public squares in the Arab provinces of the Ottoman Empire were usually not created by tearing down old urban fabrics. In fact, the practice of destroying the old fabric may have been pursued only in Istanbul, and even then sparingly. After the destruction of a significant area of the historic core between Hagia Sophia and Beya-

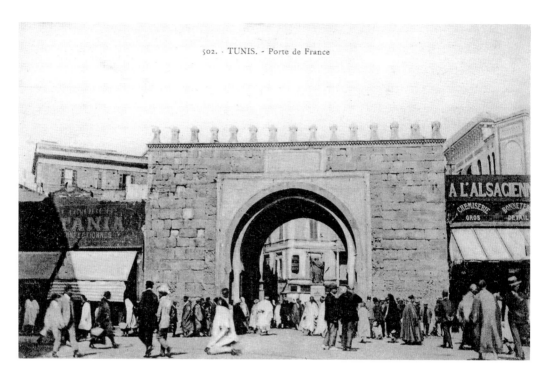

502. · TUNIS. · Porte de France

3.11 Tunis, Porte de France (postcard).

zid Square caused by the great fire of 1865, two public squares were created in the capital: in front of Hagia Sophia and around Constantine's Column on Divanyolu. The first was rectangular and planted with rows of trees; the impressive presence of the church dominated its north side, whereas its south side was lined with modest houses behind which the silhouette of the Blue Mosque rose. The second was small and triangular, a celebration of the column more than a public place.[32]

The squares that expressed the modernity of the empire appeared at the edges of Arab cities and evolved over time, rather than as products of singular projects. In terms of their siting and the contrasting images they projected onto neighboring historic cities, they recall, for example, the transitional role between the Casbah and the French city in Algiers played by the place Bresson. Their symbolism also paralleled the French public spaces in the Maghrib, but the differences were significant, in great part stemming from the long-term Ottoman presence in the region, its established practices of investment and intervention, and the broad sociocultural and religious unity between the capital and the Arab provinces. Three case studies of varying scales and character display the range and repertoire of the urban type within the Ottoman framework, as well as reference to the French colonial urbanism.

The public square in Jaffa evolved on the site of a vegetable and fruit market at the eastern edge of the walled city. Following the demolition of the land walls in the 1870s, the market grounds outside the old gate were expanded. An open area sur-

rounded by orchards and conveniently close to the waterfront was first endowed with an official monumentality during the last decade of the century by the construction of the government palace in 1897. Four Ionic columns three stories high defined its memorable façade on the east side of the square; the elaborate entablature and the single entrance reached by a set of marble steps enhanced its importance (see fig. 4.24). The construction of military barracks across from it the same year complemented the Ottoman administrative presence with the military one. The transformation of the market into an imperial public space was finalized in 1900 with the addition of a municipal garden adjacent to the government palace and a clock tower that changed the skyline of the town.[33]

An 1876 map of Beirut shows a rectangular, open area planted with rows of trees immediately to the east of the built fabric (see pl. 5). At that time, there were only two buildings facing it: the barracks of the imperial light infantry and the headquarters of a German company responsible for the construction of the road between Beirut and Damascus. A cemetery occupied the terrain between the northern edge of the orchard and the waterfront. The demarcation of this area as the main public space of Beirut began in 1879, when the Municipal Council obtained the governor's permission to improve and beautify it. Bishar Efendi, the chief engineer of the province, developed a scheme that proposed a rectangular public garden, surrounded by regular building lots larger than the city's older lots and side streets that were wider than the old ones (fig. 3.12).[34] Bishar Efendi also envisioned a *hükümet konağı* (government palace, also known as the *petit sérail*) on the northern side of the garden. Constructed between 1882 and 1884, the palace qualified, according to Mağmumi, as "number one" among the important buildings, and the square was the "most honorable location" in the city.[35] The government palace's façade fixed the main axis of the public space, referred to as Sahat el-Burj or Sahat el-Hamidiye, and dominated it. The structures on the longer sides were built over time, and although they did not rival the commanding presence of the palace, they offered a variety of functions associated with a new urban lifestyle. In 1909, a casino, a hotel run by the British (İngiltere Oteli) and its "excellent restaurant," and a pharmacy lined the west side; the east side boasted a theater (Suriye Tiyatrosu), and the south side another casino (the Astre) and the Banque Ottomane.[36] The barracks still maintained their original function, whereas the Hijaz Railroad Company, "the epitome of Hamidian development of the Arab provinces," now occupied the offices of the road company.[37] The imperial presence was hence comprehensive (governmental, military, and infrastructural) but interspersed with other buildings that represented a modern way of life.

The oval-shaped Sahat el-Burj did not neatly fit into the typology of a public square but was something in between a square and a park and indeed sometimes was referred to as the "municipal garden." The buildings (especially the government palace) defining it may have given it the air of a square, even though its design was closer

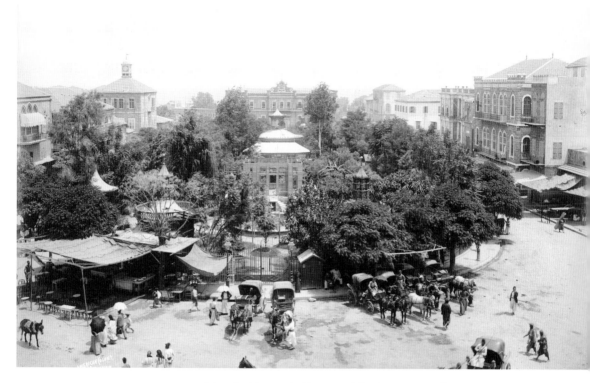

3.12 Beirut, Burj Square, looking toward the Government Palace
(Library of Congress, Prints and Photographs Division).

to that of a park with a symmetrical plan and careful landscaping. A kiosk marked its center and two pools were placed on the north and south ends of the longitudinal axis; four smaller kiosks, "very elegant and like cage kiosks," framed the central one. A path followed the boundary line, and lush vegetation with eucalyptuses and a variety of trees and flowers adorned the garden. The gates of the iron fence were opened at nine o'clock in the morning; on Fridays and Sundays, the military band performed for the public.[38] A smaller garden to the west of the government palace, on a site initially intended for a town hall, served as a forecourt to its side façade and as a transitional space toward the suqs.

Marja Square (also referred to as Arabacılar Meydanı, Square of Carriage Drivers) in Damascus, outside the western gates of the walled city, also stood as a metaphor for modern order, embodied by the state (fig. 3.13). Again developed over a considerable length of time, it became the site of government buildings, which inscribed the presence of Ottoman imperial control on the urban landscape. Several types of structures gave this area its image as the seat of "imperial" power, attesting to changes in the administrative, educational, and cultural spheres. Among the most prominent administrative buildings were the palace of justice (1878–80) and the police headquarters (1878–80), which represented centralized supervision; the Post and Tele-

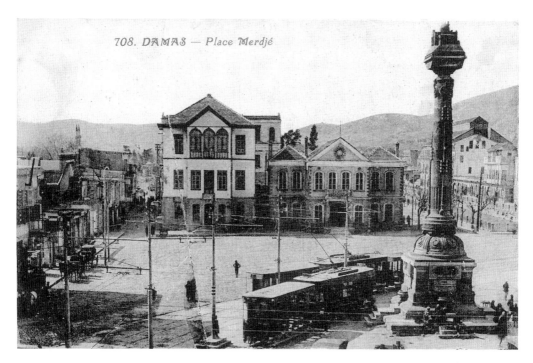

708. DAMAS — Place Merdjé

3.13 Damascus, Marja Square (postcard). The Telegraph Tower is in the foreground.
Behind it to the right is the Municipal Building, and farther to the right is the Victoria Hotel.

graph Building (1883), which represented the unification of the empire through communication technology; the Municipal Building (1892); and the New Palace (1899–1900), which represented Ottoman authority. Numerous educational institutions were spread out in the vicinity and included a vocational school, a teachers' college, several military schools, and a medical school. There were cafés and theaters, commercial establishments (including the Ottoman Bank [1892] and the Suq Ali Pasha, which linked Marja Square to the older suqs), and hotels (Hotel Victoria was the best known) that catered to Europeans and the upper echelons of Ottoman society. The largest structure here was the Abid Commercial Center, designed by Spanish architect Fernando da Aranda (who was also responsible for the Damascus train station; see chapter 1) in a neoclassical style and built between 1906 and 1910. Organized around a courtyard, it accommodated diverse functions that included shops and offices, as well as a hotel on the upper stories; its lower level was originally intended for the Ottoman Bank.[39]

The incremental development of the square and the lack of a master plan produced single standing structures, sometimes with architectural references to each other (as in the case of the adjacent Office of Taxation and palace of justice; see fig. 4.30), sometimes not (as in the case of the city hall and the police headquarters). Like the public spaces in Beirut and Jaffa, and unlike the ones in Algeria, Marja Square

lacked a uniformity of design, but it functioned nevertheless as the imperial center. It also contributed to the growth of the city in the northwest direction and became a major hub. When trams came to Damascus in 1907, they passed through Marja Square, connecting to the neighborhoods outside the walled city.

MEMORIALS IN PUBLIC SQUARES: "AN ALLEGORICAL ENSEMBLE" / "BEAUTIFUL AND PERFECT IN A NEW STYLE"

Colonial urbanism had brought statues to the new public spaces of the Maghrib, as observed earlier in the case of the place du Gouvernement and place Bugeaud in Algiers. French military men and statesmen, most often those who had played a role in the colonies, were memorialized throughout Algeria and Tunisia. The memorials conveyed stories about various episodes of the occupation, most notably the conquest but also the historic legacies, the civilizing mission, and the exploitation of resources. The association of French domination with the Roman Empire was reflected in the utilization of revalorized antique statues to complement the French figures, especially in regions rich with antique remains—as seen, for example, in the statue of Caracalla in Philippeville (fig. 3.14). This early practice, documented by Moulin's photographs, helped establish the tradition of endowing public spaces with figural statues, linking the modern practice to Roman antiquity.

The memorials in Constantine narrated the legendarily difficult conquest of the city. The monument to General Charles Damrémont, who was killed during the conquest, was in the European quarter facing the church of Sacré-Coeur. It celebrated the general in the act of attack, his sword raised—with the headquarters of the police behind him.[40] The statue of General Christophe-Léon de Lamorcière, seriously wounded during the same campaign but surviving to fight in other battles in the colony, also flaunted a sword, standing on rocks in the place de la Brèche. In Bône, the statues of Jérôme Bertagna (1907) and Louis-Adolphe Thiers (1879), on the north and south ends respectively of the cours National (earlier called cours Napoléon; later, cours Bertagna), told tales of more peaceful times. In civilian attire and with relaxed postures, these statues were situated among palm trees. The most significant work of Bertagna during his tenure as the mayor of Bône (1888 and 1903), the modernization of the port, was acknowledged in the narrative of the statue complex: the fisherman (complete with his boat) looked up at him with gratitude (fig. 3.15). Thiers, who had played a key role in the suppression of the Paris Commune and served for two years (1871–73) as the first president of the Third Republic, did not have any specific ties to Bône and Algeria; the statue was erected as an homage following his death in 1877 (see fig. 1.24). In Tunis, the statue of Cardinal Léon Lavigerie (1892), who was the archbishop of Algiers and Carthage, was placed right outside the Porte de France

3.14 Philippeville, statue of Caracalla
(Défense, Département de Terre,
Fonds Moulin, *série* D, no. 128).

3.15 Bône, statue of Jérôme Bertagna (postcard).

(fig. 3.16). The figure of the cardinal holding a huge cross and facing the European city, against the background of the precolonial gate, hailed the dominance of Christianity in this old center of Muslim civilization.

The statue of Jules Ferry in Tunis celebrated one of the most instrumental figures of colonial expansion and educational reform in the late nineteenth century (fig. 3.17). Millet saluted it as "the first statue erected [in Tunisia] since the fall of the Roman Empire, that is, since fourteen centuries." Like Roman councils, Ferry was a founder, whose mark on Africa would live.[41] Standing on a high pedestal at the end of the avenue de la Marine, the statue, with its chin up and long coat in the wind, looked confidently toward the city—in the words of Millet during the inaugural ceremony, toward "the Arab town he had subjugated to France [and] to the French town between the port and the ramparts that grew from year to year, almost from month to month, where houses shoot up almost as fast as the eucalyptus trees our settlers plant in the countryside."[42] The figures on the lower level told the successful story of the colonizing mission: a young Arab woman offered to the "regenerator of Tunisia" a bunch of wheat; a settler, his tools in his hand, took a break from his agricultural work; a French schoolboy, with his finger on the page of a book, taught an Arab boy how to read; and on a bronze medallion, the profile of Bathélemy Saint-Hilaire reminded of the "Roman ideal." In short, the statue complex was "a living translation" of the French ideas that were applied in Tunisia.[43]

In addition to soldiers and statesmen, other personalities who had played significant roles in the colonies were celebrated by statues. Philippe Thomas, a veterinarian with a serious interest in antiquities (he was a member of the Institut du Carthage), was known best as the "inventor of phosphates in North Africa," as a result of his "geological mission" in Tunisia during 1885–86. Upon his death in 1913, Tunis and Sfax each acquired a statue Thomas.[44] The one in Tunis, an "allegorical ensemble" in white marble, stood in the square fronting the train station. In its lower part, a female figure represented science; next to her, fossils evoked Thomas's studies (fig. 3.18). Thomas's profile, cast in bas-relief, defined the background and was complemented by a French flag that alluded to Thomas's life as a soldier. The memorial was crowned by another female figure, referring to the regeneration of agriculture under French rule and made possible by using phosphates. An inscription on a bronze plaque summarized the commercial and industrial developments (such as railroads, ports, and factories) stimulated by the exploitation of phosphates and considered dead since the "disappearance of Roman civilization" from the land.[45]

Memorials began to appear in the cities of the Ottoman Empire during the post-Tanzimat period, making imperial statements in key locations—as in the French Maghrib. However, these were nonfigurative works in conformity with Islamic tradition. They originated in a series of unexecuted monuments to "justice" intended to celebrate the reforms. For example, a year after the declaration of the Tanzimat Edict,

3.16 Tunis, statue of Cardinal Léon Lavigerie (postcard, ADN).

3.17 Tunis, statue of Jules Ferry (postcard).

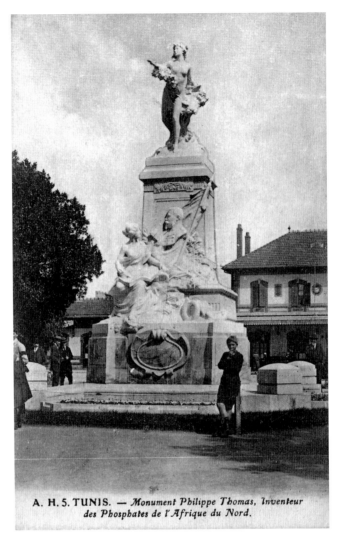

A. H. 5. TUNIS. — *Monument Philippe Thomas, Inventeur des Phosphates de l'Afrique du Nord.*

3.18 Tunis, statue of Philippe Thomas (postcard).

an imperial order stipulated the erection of a monument celebrating Tanzimat in the gardens of the Topkapı Palace, but the site was shifted to the centrally located Beyazid Square (the Forum Tauri of Constantinople) to enable better visibility. Bilekçi Efendi's unexecuted design offered an elaborate "Ottoman baroque" structure composed of three parts, an amalgam of abstract decorative elements and inscriptions, including the complete text of the reform charter.[46] Corresponding to significant events that affected the entire empire (such as the jubilee of Abdülhamid and the opening of the telegraph or railway), memorials mushroomed throughout the empire especially during the last decade of the nineteenth century, endowing Ottoman public spaces with symbolic associations. The newspapers and periodicals reported the

inaugural ceremonies and published photographs and drawings, situating the monuments in a network of imperial statements, as well as establishing metaphorical ties between the various cities. Expressing their messages with symbols and texts, the Ottoman memorials developed an idiosyncratic repertoire of *architectures parlantes,* often with references to local architecture and without ever incorporating representations of living creatures. The first Ottoman design to use an "animated being" (a lion) dates from 1914, in a war memorial (not built) envisioned again for Beyazid Square in Istanbul.[47]

The twenty-fifth year of Abdülhamid's accession to the throne formed a fitting occasion to celebrate the sultan and the empire. In Jerusalem, its expression was a fountain built against the sixteenth-century fortifications, just outside the Bab-ı Halil (Jaffa Gate; fig. 3.19, pl. 20). A historic building type associated with a benevolent act, this monument recycled the traditional form of a small circular chamber topped with a dome. Its *"objet*-type" structure stood awkwardly in front of the historic wall; a text on a plaque inserted into the dome explained its raison d'être and displayed the sultan's *tuğra.* The dome was terminated with a decorated spire bearing the crescent and the star. The *tuğra* and the crescent and the star would be the much-repeated elements of Hamidian memorials.

Unlike in Jerusalem, where the memorial was placed in a historic context, in Mosul the same occasion was celebrated again by a fountain but now freestanding in a modern enclave: in the spacious, tree-lined square created in front of the Office of Imperial Lands (fig. 3.20). This was a different kind of fountain, light and playful with open arches and delicate details in an eclectic "Islamic" style. The celebratory text was inscribed continuously below the dome.

Although described as a "beautiful and perfect fountain in a new style," Beirut's memorial to Abdülhamid's jubilee was a lot more than a fountain (fig. 3.21).[48] In the tradition of obelisks, an eight-meter-tall marble column towered over the water source. In the midst of the irregular Sur Square and with the monumental mass of the Imperial Barracks on the hill behind, it was elevated on a circular platform. Its base incorporated a fountain on squat classical columns, and curvilinear forms made the transition from the lower level to the tower. The sultan's *tuğra* sat above the fountain. The monument was terminated by a complicated construct of three small Ionic columns carrying a small, turnip-shaped cupola on which the crescent was placed. The monument was the work of architect Yusif Aftemos in collaboration with sculptor Yusif el-Anid, both locals, and its references to classical antiquity acknowledged the region's historic sites. The commemorative plates with gold writing were done by another local artist, Sheik Muhammad Umr el-Barbir.[49]

Two infrastructure projects, the Hijaz Railroad and telegraphs lines, provided the other occasion for the construction of memorials. Haifa's monument to modern communications (1902) was placed in a very different context than Beirut's jubilee

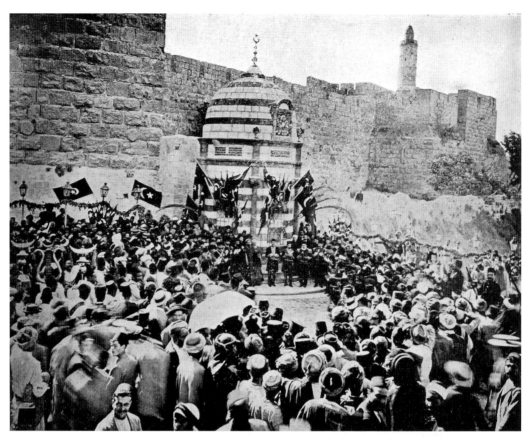

3.19　Jerusalem, memorial fountain for Abdülhamid II's twenty-fifth jubilee, inauguration ceremony (*Servet-i Fünun*, no. 498 [1316/1900]).

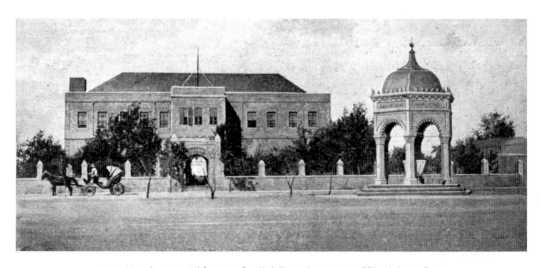

3.20　Mosul, memorial fountain for Abdülhamid II's twenty-fifth jubilee in front of the Office of Imperial Lands (*Servet-i Fünun*, no. 501 [1316/1900]).

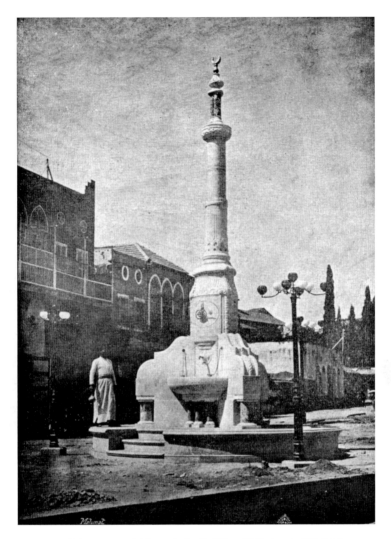

3.21 Beirut, memorial fountain for Abdülhamid II's twenty-fifth jubilee
(*Malumat*, no. 254 [1318/1902]).

memorial, but it manipulated some of the latter's architectural elements into a new synthesis (fig. 3.22). A tower composed of several levels, it sat all alone in the otherwise-empty Station Square to the side of the new station but alluded to greater ambitions for the development of the public space. Above the massive, square stone base, the message was visually conveyed on the pedestal in bas-reliefs that showed a locomotive and a train car, as well as telegraph lines. The level above that was dedicated to inscriptions that described the mission. Then, four Ionic columns supported an entablature (with more text and the *tuğra*), finally reaching to a cluster of four small domes that carried a fifth one, terminating in a crescent.[50] The Haifa monument hence spoke of many themes: the trains and telegraph lines in the service of pilgrim-

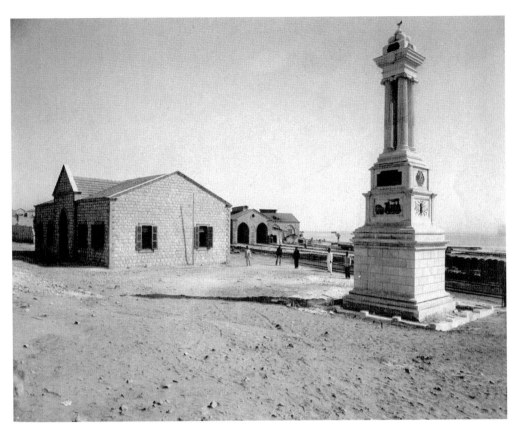

3.22 Haifa, memorial to celebrate the Hijaz Railroad and telegraph lines (IÜMK, album 90606).

age, the modernity of the new infrastructure, the architectural heritage that incorpo-
rated Greco-Roman antiquity and the Islamic past, as well as the power of the sultan
and the grandeur of the empire.

The photograph of a tower under construction in Yemen (fig. 3.23) suggests that
there were others in the region. Dedicated to the telegraph line reaching Sana, the
completed parts of the *sütun* (column) follow the precedent set by the former towers
with their multiple layers and repertoire of elements derived from the area's heritage.

The best known and the most intricate of this type of memorial is the Telegraph
Tower (1902) in Damascus's Marja Square (fig. 3.24; see also fig. 3.13). The Telegraph
Tower, which commemorated the completion of the telegraph line that linked Istan-
bul through Damascus to Mecca, facilitated communication with the holy city and
the pilgrims, and announced the spread of modernization to the far corners of the
Ottoman Empire, was designed by the sultan's chief architect, the Italian Raimondo
D'Aronco. The base, a fountain, bore the emblem of the Ottomans, with the crescent
and the star now brought to a lower level. The body of the tower was adorned with
bas-reliefs of telegraph towers and lines, stylized according to the conventions of art

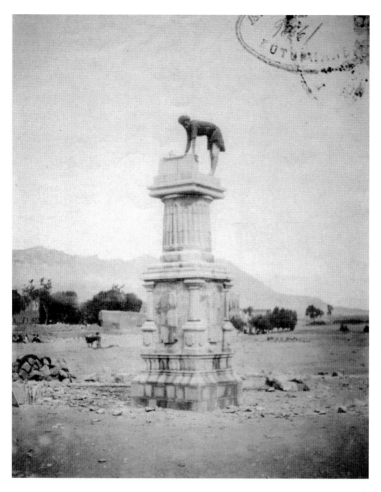

3.23 Yemen, memorial to celebrate the telegraph line reaching Sana (IÜMK, album 90661).

nouveau. The monument was topped with a huge capital upon which a replica of the Hamidiye Mosque (1886) was placed. This mosque, outside the Yıldız Palace in Istanbul and the site of the elaborate Friday prayer ceremony preceded by a royal procession, had an unmistakable association with the sultan and acknowledged Hamidian imperial prowess.[51] Furthermore, the concrete image of the mosque on the Telegraph Tower represented the Islamicist policies of Abdülhamid that capitalized on religion to win the loyalty of Arabs in an attempt to rejuvenate the empire, while the telegraph lines announced the adoption of modern technology.[52]

There was a curious communication between D'Aronco's Telegraph Tower and an earlier, unexecuted design in Algiers for Napoléon III by prominent French architect Eugène-Emmanuel Viollet-le-Duc (fig. 3.25).[53] Given the impact of Viollet-le-Duc on Ottoman architectural discourse in the late nineteenth century and the wide publicity this project enjoyed (e.g., it was published and discussed in *L'illustration*), it is

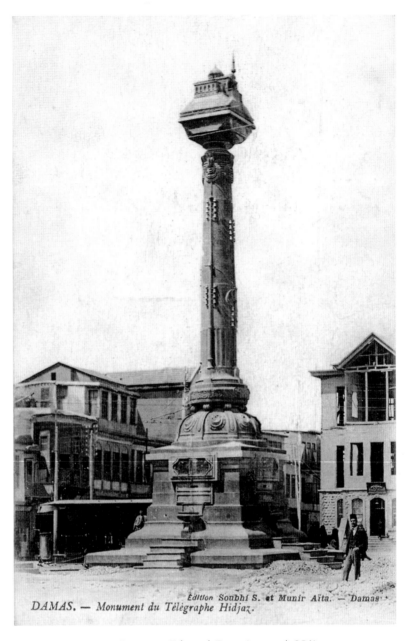

DAMAS. — *Monument du Télégraphe Hidjaz.*

Édition Soubhi S. et Munir Aïta. — Damas

3.24 Damascus, Telegraph Tower (postcard, OBA).

likely that D'Aronco knew about it. Despite the absence of textual evidence to connect the two projects, they both rely on a similar iconographic vocabulary to support imperial policies, albeit different ones.

By the time of his second visit to Algeria in 1865, Napoléon III had developed his vision of an Arab kingdom, which called for a significant change from the earlier French policies of military imposition and control. Initially revealed in the emperor's

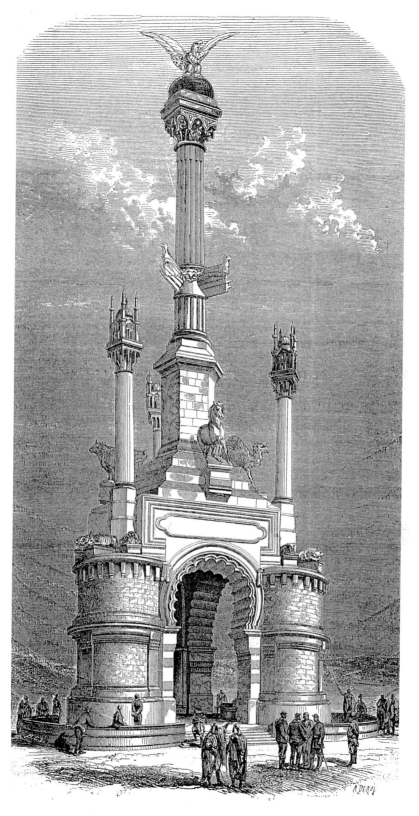

3.25 Algiers, project for a memorial to Napoléon III by Viollet-le-Duc
(*L'illustration* 46, no. 1177 [1865]).

first visit to Algeria in 1860, this shift was influenced by the writings and direct advice of Thomas Ismail Urbain, a Saint-Simonian who served as a government officer in Algeria and who advocated a biracially harmonious society for the colony.[54] Taking a stance against the practice of thirty-five years of French domination, Napoléon III stated his refusal to treat Arabs as "Indians of North America." Addressing the French settlers, he said, "Treat the Arabs, among whom you must live, as compatriots," because, he declared with a straight face a few days after his return to France, "Algeria is not a colony . . . but an Arab kingdom . . . and I am as much the emperor of the Arabs as of the French."[55]

The relationship would be founded on notions of reconciliation, protection, and association, but it was also obvious to the emperor that a hierarchy should be maintained: "We must be the masters," he continued, "because we are more civilized; we must be generous, because we are stronger." He made his message clear to Algerians when he addressed them: "I want to increase your well-being, to make you participate more and more in the administration of your country as well as the blessings of civilization; but these depend on conditions: from your side, you will respect those who represent my authority. Say to your strayed brothers that to attempt new insurrections will be fatal for them. . . . Two million Arabs cannot resist forty million Frenchmen. . . . As your ruler, I am your protector."[56]

Napoléon III's Arab kingdom policy hence adhered to the essence of the *mission civilisatrice* but reframed it according to the Saint-Simonian idea of a racial *rapprochement,* if an unequal one. Viollet-le-Duc's design translated it into architecture. The memorial was to occupy a prominent site in the place Bresson on the axis of Chassériau's Grand Theater.[57] In addition to the Monument to the Emperor, Viollet-le-Duc placed the administrative headquarters of Algeria (labeled "Palace of the Governor-General" on the site plan, but "Imperial Palace" on another drawing) on the square, cleared the square of impeding structures in order to endow it with a perfectly rectangular shape, renamed it "place Napoléon," and proposed a palace of justice for the site behind the theater.[58] The entire complex, symmetrical and oriented toward the Mediterranean, would meet the arcades of the newly opened boulevard de l'Impératrice on the waterfront side.

The project was devised in three stages, and the more subdued earlier scheme was progressively developed into a complicated amalgam of symbols in a daring composition. The first design proposed a freestanding monument, with a high cylindrical base on which sat statues of three animals deemed to represent Algeria: the horse, the camel, and the ox. Interspersed between them, three pylons symbolized the three provinces of the colony: Algiers, Oran, and Constantine. In the center, the architect placed a much higher column, topped with an eagle on a sphere from which the soaring figure of Marianne rose.[59]

The second design revealed a more complicated monument that introduced

"Islamic" elements, acknowledging the Arab kingdom notion of the emperor. An article in *L'illustration* put it clearly: "This monument . . . is designed to remind one of the acts of the government of the emperor, who gave the Arabs the advantages and rights they did not possess before the conquest."[60] Not exactly a triumphal arch, but nevertheless composed of three arches that defined an interior space open on three sides on the lower level, the monument rose up to 44 meters.[61] With its soaring height and prominent positioning on the waterfront, it would dominate the image of Algiers. Its various pieces were cluttered with legible symbols that revealed a great deal about the current political climate. The base brought together cylindrical towers in a generic French medieval military mode with North African Islamic lobed arches, conveying an ambiguous message. On the one hand, this coexistence could be read as a dialogue between the two cultures and the two peoples and as an architectural expression of Napoléon III's call to treat Arabs as "compatriots." On the other hand, the juxtaposition between the heavy and imposing French military forms and the delicate and ephemeral lobed arches seemed a reminder of a relationship based on force and hierarchy, underlined by the emperor. In this design, the "conquered wild animals" were depicted lying down, presumably to recall the subjugation of the country, whereas the "domestic" animals, carried over from the first scheme and contrasting in their dynamic forms with the pacified ones, pointed to production in the Algerian countryside—activated by the European settlers.[62] The pillars that represented the three provinces of the colony were kept from the initial design but elongated. The central column, also made taller, was ornamented with three projecting prows.

The third and final design brought further elaborations. The pillars were now terminated by three identical "mosques" to celebrate the three capital cities. Ironically, the architectural model chosen to represent Algerian towns—the miniature buildings with central domes and four pencil minarets—was derived from Ottoman monuments (notably, the sixteenth-century Selimiye Mosque in Edirne, designed by Sinan) and had no precedents in Algiers, Constantine, and Oran. Marianne was deleted, but the eagle with open wings continued to perch on a sphere that in turn was placed on an enormous capital, crowning the whole structure and signifying the French Empire, as well as replicating the eagle sculpture on the theater across the square. The column, taken in its entirety, commemorated "the expedition following which Algeria had become French."[63]

The parallels between the two memorials extend to the other Ottoman designs discussed earlier and were not restricted to the unusual sculptural element of the mosque but include the use of multiple columns, their symbolic termination, and the architectural language in general. The French project's reliance on figurative elements is countered by a more abstract symbolism in the Ottoman examples: the eagle and the crescent represent the respective empires. The eclecticism of the architectural language was shared by both contexts, with some of the very same features

(consider the lobed arches of the monument to Napoléon III and the monument to Abdülhamid in Mosul). The French-Ottoman encounter in this case was complicated further by Viollet-le-Duc's search within classical Ottoman architecture for a symbol for Algeria. Coincidental or consciously borrowed, public memorials showed similar approaches to the use of iconography, attesting to a "shared" and universal imperial culture at the end of the nineteenth century. Yet they were also shaped by their specific historic contexts.

CLOCK TOWERS, SIGNS OF MODERNITY:
"IN A BEAUTIFUL ARAB STYLE"

In 1852, Mosque el-Djedid in Algiers acquired an unusual feature when the French authorities placed a clock on its minaret.[64] The minaret was thus transformed into a clock tower in a blatant act of secularization that showed the official, "French" time and blurred the symbolism of the tower. Coupled with the statue of the duc d'Orléans, the clock functioned to appropriate the most prominent symbol of precolonial culture in the city and subdue it to the colonizing power. Similarly, the new minaret added to Mosque el-Bey in Bône was given a clock on the side that faced the place d'Armes. While the new minaret kept the French time, the old one maintained its function as the place for the muezzin to call Muslims to prayer.

These remained rare interventions. However, the notion of a clock tower to express the modernity of the post-Tanzimat period became widespread in Ottoman cities in the late nineteenth and early twentieth centuries. While their locations varied from city to city, they were usually situated at the centers, on public squares, or other dominating points (usually hills). They were always freestanding structures. Two prominent examples in Istanbul, the clock towers of Tophane and Dolmabahçe, stand next to the Tophane and Dolmabahçe mosques respectively but maintain their distance and individuality. As if responding to the interventions in Algiers and Bône, they are both dominated (indeed dwarfed) by the monumentality of the mosques. Nevertheless, their proximity to the signifiers of "other" time points to the coexistence of modernity and Islamic values.

In the Arab cities of the Ottoman Empire, clock towers go back to the late 1860s, to the tenure of Ali Rıza Pasha, the entrepreneurial governor of Trablusgrab. The "big clock" of Trablusgarb that imposed the new order of Ottoman administration was situated in the center of the old city, amid the suqs. Short and squat, it did not rival the minarets of the inner-city mosques. With its whitewashed and irregularly fenestrated façades, it conveyed a vernacular feeling that allowed it to sit comfortably in its context (fig. 3.26). It was composed of three parts, separated from each other by metal balustrades and diminishing in size from bottom to top. The upper section was the

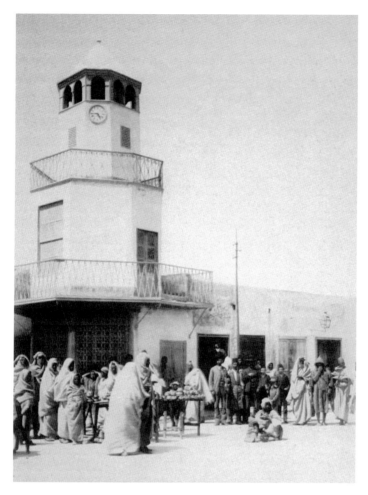

3.26 Trablusgarb, clock tower (IÜMK, album 90404).

most elaborate, with an open loggia topped by a conical roof. The clock itself, dispro-
portional in its small size to the bulky mass of the tower, could be seen only from a
certain distance. During Abdülhamid's reign, a grander clock tower was built in
Trablusgarb. It had a square plan, three horizontal levels, and Corinthian columns at
corners; it was terminated by a dome.[65]

Beirut's clock tower was a grand affair, architecturally ambitious and situated on
a hill between the military hospital and the Grand Sérail (Kışla-yı Hümayun, the
imperial barracks), hence dominating the skyline. Built in 1898 upon the initiative
of Governor Reşid Bey and to Yusif Aftemos's design (the architect responsible for the
memorial to celebrate Abdülhamid's jubilee), the 25-meter-tall square tower was con-
structed in a range of local materials and using an eclectic repertoire of architectural
references (fig. 3.27; see also fig. 4.1). For example, the third floor had neo-Islamic
balconies, reached by doors with intricate *muqarnas* ornaments, while the crenel-

3.27 Beirut, clock tower during construction
(*Servet-i Fünun*, no. 395 [1314/1898]).

lated roofline recalled European medieval towers and made a visual connection to the government palace in the Sahat el-Burj in the "style of old castles." Admired for the "graciousness of its architectural style" even during its construction,[66] the tower also incorporated the new technology, evident in its iron staircase. Its third floor sheltered a bell, above which four large clocks were placed on four façades, two show-ing *alaturka* time in Arabic, and two *alafranga* time in Latin numerals—in response to the governor's concern that, "despite a number of foreign institutions that ha[d] established clock towers with bells," there was "no public clock [that] showed . . . the religious times of the Muslims."[67] This was a hybrid structure with multiple symbol-isms: Islam, modernity, and the cosmopolitan character of Beirut but, above all, the Hamidian Empire. As argued by Hanssen, the choice for its site enhanced the etch-ing of the Ottoman presence on the late-nineteenth-century urban image.

The Beirut clock tower was not built to mark a special event but was loosely con-nected to Abdülhamid because construction had begun on his birthday. Four years

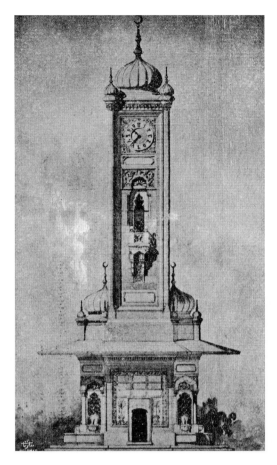

3.28 Design for a clock tower to celebrate the beginning of construction
of the Hijaz Railroad (*Malumat*, no. 13 [1318/1902]).

later, the journal *Malumat* published on its cover a drawing of a clock tower that was
associated with a memorial function, that of the inauguration of construction of the
Hijaz Railroad (fig. 3.28).[68] The journal did not give the name of the architect or the
location of the tower. Because of the scale, architectural character, and level of detail,
it may be reasonable to assume that the monument was intended for Istanbul, sym-
bolically linking the capital to Hijaz and reminding its residents of the importance of
the Arab provinces. This grandiose two-part composition combined a *sebil* (fountain
kiosk) below with a square clock tower above.[69] The fountain kiosk mimicked the
familiar elements historically associated with it: it was a symmetrical, square-plan
structure with large eaves and intricate façades. The transition from the roof of the
sebil to the tower was made by means of half-domes, each with a spire and a crescent
on top. The highly ornamented façades of the tower complemented the *sebil* with
their "Islamic" references; they might have been jumbled in their composition (in the
typical late-nineteenth-century manner), but they clearly gave a nod to Ottoman

monuments. A dome placed on the top of the tower, and surrounded by four smaller domes, mimicked the half-domes of the lower level, terminating with a spire and a crescent like them. The drawing shows one clock face with Arabic numbers; it is most likely that there were four clocks, following the example of the Beirut tower.

Abdülhamid's jubilee served as the occasion for a clock tower boom throughout the empire, each tower distinguished by its idiosyncratic features. A comparison of the towers erected in Aleppo and Jaffa helps to shed light on the range of visual differences. Aleppo's tower, on a triangular square in the northwest of the city, was divided into three parts, getting lighter and architecturally more elaborate from bottom to top (fig. 3.29). The second level, separated from the first by a balcony, had four large clocks on four sides. An onion dome made up the third part and was topped by another, smaller dome with a spire and a crescent, which gave the tower its "Islamic" appearance. In comparison, Jaffa's tower, across from the governor's palace on the new square, borrowed its references from medieval European examples. Built in stone, it had four levels, the fourth level terminating in pitched gables under which the clocks were placed (fig. 3.30). It evoked an "Islamic" flavor only at the very top, by means of a small, elongated onion dome, complete with a spire and a crescent.

As a building type, clock towers represented the imperial presence and pointed to its modernity, with the new "Ottoman time" attempting to bring an order and discipline to cities in a manner that secularized time by dissociating it from the religious realm, that is, the call to prayer. The clocks towers also helped regulate the call to prayer and impose a scientific precision to it by synchronizing it. The desire to associate this symbol of modernity with "religious time" surfaced clearly in the clock tower of Jerusalem, completed in 1902 (pl. 20). The rationale for building this tower was that, "although there are clock towers showing European time in almost every corner of the city of Jerusalem, there is none that shows the time of prayer." The tower, constructed with funds collected from the citizens by the municipality, was situated near Bab-ı Halil on one of the forts of the walls. It boasted a "beautiful Arab style" and "ornamented" architecture.[70]

The intensity of clock tower construction during the reign of Abdülhamid II turned this building type into one of the notable symbols of the period. The skylines of cities large and small, ranging from Baghdad to Raqqa and Trablusşam, were changed by these vertical structures. Near other government buildings, they shaped public spaces and became key points of directional reference within the urban fabrics. While expressing a new idea about the empire, the architectural uniqueness of each tower also honored the diversity of its various regions—a theme that dominated the architecture of the period (see chapter 4).

The clock tower enjoyed a similar popularity in the Maghrib around the same time, but took on another configuration. Perhaps in the footsteps of the intervention to Mosque el-Djedid (Algiers) and Mosque el-Bey (Bône), it became incorporated into

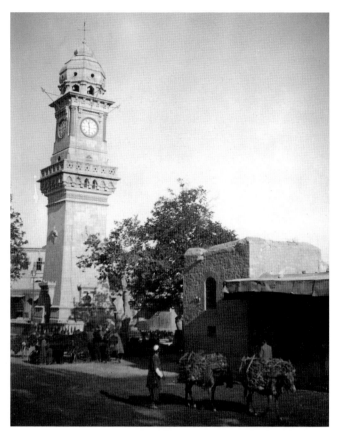

3.29 Aleppo, clock tower (Dr. Jean-Alexandre Otrakji, www.mideastimage.com).

public buildings, especially those in neo-Moorish styles. Among many examples in Algeria and Tunisia, the Galeries de France in Algiers (by Henri-Louis-Paul Petit), the Harbor Administration building in Sidi Abdellah, the train stations in Bizerte and Oran, and the city hall in Sfax stand out (see figs. 1.19, 1.20, and 4.16).[71]

An intriguing episode in the Ottoman tower tradition occurred in Algiers to celebrate the centennial of the French occupation; this involved reverting back to the abstract designs that had characterized the public monuments in the Arab provinces of the Ottoman Empire. In the frenzy of memorials to the event (literal and highly legible representations), the one dedicated to General Boutin displayed a link to the Ottoman towers in its abstraction and references (fig. 3.31). General Boutin had played an important role in the conquest of Algiers because he had documented the city and its surroundings in 1808 (pretending to be a fisherman so as not to raise the suspicion of the *"indigènes"*); he had provided the plan of the fortifications and outlined a strategy of attack, starting from Sidi-Ferruch. This was an invaluable document for the expedition of 1830 and was followed closely, thereby making Boutin the "real

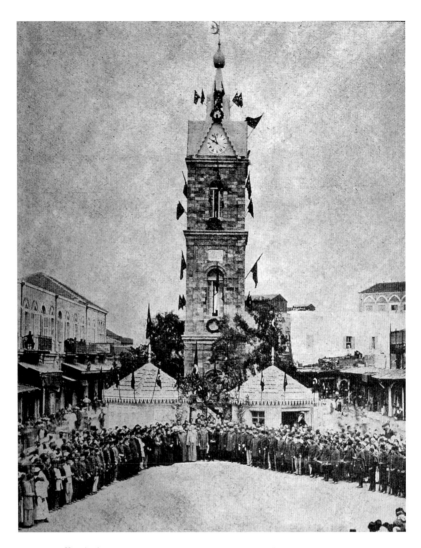

3.30 Jaffa, clock tower, inauguration ceremony (*Servet-i Fünun*, no. 601 [1319/1903]).

guide" of the conquest of Algiers. The monument that aimed to inscribe Boutin's name into the colonial history of Algiers was designed by architect Mme Scelles-Millie, who worked closely with a committee. It was placed just outside Algiers near the village of Dely-Ibrahim, the first village that was colonized, on a plateau that dominated the surrounding landscape. Conceived not as a figurative statue, it aimed to engrave Boutin into the colonial history of Algeria in an "impersonal" mood. The solid, mono-lithic tower in concrete boasted "Islamic" details and was topped by a dome in the "Syrian" style that could be observed from long distances.[72] This unusual design from 1930 served at the same time as a statement about a much greater French empire that now included the Ottoman provinces in the Middle East. The formal ele-ments of the Hamidian memorials could thus be freely incorporated into the archi-

3.31 Dely-Ibrahim, memorial to General Boutin, 1930 (Mercier, *Le centennaire de l'Algérie*).

tecture of the French colonies, including the spire on the dome that terminated in the crescent—the ultimate symbol of the no-longer-existing Ottoman Empire.

PUBLIC PARKS: "A CERTAIN FANTASY" /
"FOR THE USE OF THE GENERAL PUBLIC"

Like public squares, public parks entered "Islamic" cities with the French conquest of Algeria. These controlled spaces served as alternatives to the informal gardens at the outskirts of urban centers that were frequented by local populations as recreation spaces. Intended for Europeans, public parks introduced a communal form of repose and recreation, inserted nature into the city in a regimented manner, and contributed to the improvement of hygiene. The Jardin Marengo in Algiers, reached through Bab el-Oued, was designed by Casale-Joseph Marengo, then in charge of the regularization of the area, as a series of terraces in 1839 (fig. 3.32).[73] Occupying the foot of the hill that descended from the Sidi Abd el-Rahman complex, the site afforded good views of the Bay of Algiers. Palm trees, yuccas, bellomras, and bamboos created

3.32 Algiers, Jardin Marengo, with the old city behind the Ottoman fortifications,
photograph by Alary, c. 1857 (GRI, Special Collections, 92.R.85).

shady spaces, and acanthuses and morning glories adorned the paths. Kiosks, deco-
rated with tiles, were scattered throughout, while a marble column in the center com-
memorated the union of the two French armies: that of the First Empire (Marengo
had served in the army of Napoléon I) and the one that conquered Algiers.[74] As seen
in several early photographs, the park's physical character contrasted with that of the
nearby old town, which was densely packed within the fortifications, and etched
another dichotomy onto the urban image. The photographs testified at the same time
to the use of the park by Europeans, at least during the early decades of French rule.

Jardin d'Acclimation (later Jardin d'Essai) in Hamma, to the southwest of Algiers,
began to be developed into a botanical garden in the 1840s under the auspices of the
governor. Called at the time the "central nursery of the government" and well pro-
tected from cold winter winds and hot south winds, it could accommodate a rich
variety of vegetation. In 1861, it also became the site of a zoological garden—the first
of its kind in Africa.[75] In 1867, it was taken over by the Société Générale Algérienne,
which would maintain it as a nursery for indigenous and native plants, as well as a
"public promenade."[76] The park consisted of two distinct zones: the lower, flat part
was separated from the upper, hilly part by a boulevard. The 68-hectare grounds of

3.33 Tunis, casino in Belvédère Park (postcard, Fine Arts Library, Harvard College Library).

the lower park were organized in a grid pattern of *allées*. Three in a northwest–south-east orientation served as the main thoroughfares of a "marvelous beauty"; the first, leading to the main entrance, was lined by plane trees; the second, with palm trees, was bordered by the railroad and the sea; and the third boasted magnolias and fig trees. Narrower alleys, again with specialized vegetation in groups (such as bamboos and palm trees) crossed them.[77] The Café des Platanes, originally an Ottoman *sebil*, gave the park a picturesque piece of Moorish architecture. Famously painted in the late 1880s by Auguste Renoir and photographed over and over, this was a popular excursion place by foreign visitors as well as local residents, both European and autochthonous.[78] The upper garden was reserved for forestry.[79]

In 1891, as part of the sanitization projects for Tunis, the Municipal Council decided to create a large park, the Belvédère (see pl. 18).[80] To the north of the old city and in the midst of the expanding European city, it was reached by a short ride on an electric tram from the town center. It occupied a hilly site that had a view of the Lake of Tunis and the two-horned mountain of Bou-Kornein. The winding paths had abundant pleasant "flowering shrubs," but there was a "rather sad absence of trees," in the words of a British traveler.[81] The Belvédère's main structure was a large casino (fig. 3.33), designed by Henri-Jules Saladin in an Orientalizing style that demon-strated, according to a newspaper report, "a certain fantasy and an originality" that evoked "memories of the 1889 exposition" in Paris—in reference to the pavilion

that represented Tunisia on that occasion.[82] Its large terrace on a main alley served as a popular café for Europeans, especially during late afternoons when music was played.

As discussed earlier in the case of Beirut and Jaffa, municipal parks had also entered the repertoire of Ottoman cities. In addition to an urban park, it was not uncommon to dedicate land outside the city for another type of recreational open space for the public. For example, following the construction of a new police head-quarters in the area, Abdülhamid II had donated a piece of "beautiful" land in the south of Beirut, famous for its good air and beautiful gardens, including nut trees, "for the use of the general public." After the completion of a paved road to Rais Bei-rut in the west, another "beautiful public garden" on an "appropriate and important point" was envisioned for the city.[83] In Trablusşam in 1895, the municipality created a public park on a hill covered with orange and lemon trees to the northwest of the city.[84]

The municipality of Damascus also undertook public park projects but did not have the degree of success enjoyed by Beirut. Governor Midhat Pasha initiated the concept in 1878 by enclosing an open area with an iron railing to the west of Marja Square, bordering the Barada River; it was complemented with a Municipal Café, whose façades were lined by arcades. However, ten years later, Governor Nazım Pasha chose the site for the construction of the New Serail; in the early 1890s, the construction of the "marble columned" Municipal Palace further reduced its size. The garden remained "public" in name, but, by 1909 in an "abandoned" state, it was closed to the public.[85] In 1895 another park was created on the Beirut Road, farther to the west. The new park faced the Barada River to the south and, across it, the Süleymaniye complex; it boasted a beautiful "government café," surrounded by arcades and remi-niscent of residential architecture (fig. 3.34). A bridge, dating from the same period, connected the two banks.[86]

The parks of Damascus testify to the value placed upon them as indispensable components of a modern city center. However, they had not exerted much appeal on the residents. An Ottoman visitor noted: "despite the increase in modern customs, the inhabitants have not yet been able to get used to the communal life of the cities of Europe and restrain their tastes and pleasure to their privacy."[87] Furthermore, like other public spaces, the parks were poorly maintained. In the early years of the twen-tieth century, numerous accounts complained of the municipal neglect that resulted in poor conditions and extreme filth. Some explained this in terms of the modest size of the municipal budget.[88] For others, the dysfunctionality stemmed from the incom-petence of the city administration to engage in the life of the city and its citizens. Ahmed Şerif, for example, complained that the "municipal officers in fancy outfits" broadcast their disinterest in the state of urban affairs in complete serenity and indif-ference, watching the city from a distance as they would "a natural view."[89]

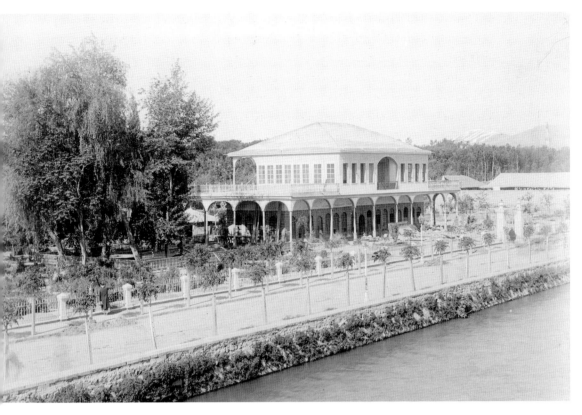

3.34 Damascus, "government café" in the public garden
(Library of Congress, Prints and Photographs Division).

An order from the Ottoman Ministry of the Interior in 1918 to all municipalities testifies to the eventual misgivings of the central administration about the resources invested in such public spaces. Arguing that funds were spent on "things like gardens, parks, and clock towers" at the expense of "public health" (*sıhhat-ı umumiye*), the ministry urgently asked all municipalities to attend to their primary duty.[90] With its implication that urban open spaces were superfluous, the Ottoman administrators clearly did not consider them the "lungs of the city"—a familiar analogy in nineteenth-century European city planning. This dramatic turn from the principles of modern town planning may perhaps be explained by the extremely lean municipal budgets at the end of World War I and the need to establish priorities. However, in contrast to the French planning policies in the Maghrib, it also reflects an attitude that considered such operations as simply "beautification."

The public parks in the Ottoman provinces were, in principle, open to all citizens and, unlike their Maghribi counterparts, were not oriented to a special group. Nevertheless, they often ended up serving the Ottoman bureaucracy—as seen, for example,

in the case of Damascus, where the insertion of a "government café" claimed at least a prominent part of the park for an exclusive group. The proximity of parks to government buildings (as in Damascus, Beirut, Trablusşam, and Jaffa) enabled such appropriations, and Ottoman administrators, with their "modern" lifestyles, welcomed the facilities. The most extreme takeover happened in Trablusgarb, where the public park was closed to the public altogether and integrated into the military headquarters (see chapter 2).

4

A NEW MONUMENTALITY
AND AN OFFICIAL ARCHITECTURE

ENCLAVES OF MODERNITY:
"A MOUNTAIN OF STONE"/"PERFECT AND REGULAR"

Transformations to cities included new public buildings that introduced unprecedented functional repertoires, as well as different notions of monumentality, architectural expression, and siting principles. In both the Ottoman provinces and the Maghrib, these public buildings were military and civic structures that gave the cities a secular identity, in contrast to the religious buildings that had helped define the urban image in earlier centuries. They were conceived as individual, freestanding buildings with elaborate façades on public spaces and stood apart from the previous monuments, which commonly merged into their surrounding fabrics, often with only an ornate gateway that announced what was behind. Placed in clusters in the regularized areas or the extensions of old cities, the new monuments presented a collective image: spread along a wide avenue (such as avenue de France in Tunis), around a public square (such as Marja Square in Damascus), or simply near each other (as in Sfax). Their cumulative effect resulted in specialized zones that represented the imperial rule over the secular and civic sphere, at the same time enhancing the message of modernity, interlinked to the larger image of the empire. There was one significant difference between the new monuments of the two empires: the insertion of cathedrals in the official centers of cities in the French colonies. Whether strategically located on a public square as in Constantine, at the vista of a main avenue as in Bône,

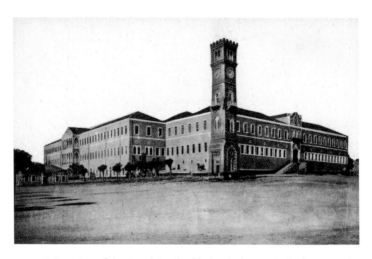

4.1 Beirut, view of the Grand Serail, with the clock tower in the foreground
(*Salname-yi Beyrut* [1326/1910–11]).

or along a main avenue as in Tunis, the cathedrals, architecturally elaborate and
grand in all respects, attested to the religious difference of the new rulers.

In Beirut an imperial complex was created incrementally by the construction of
the imperial barracks (Kışla-yı Hümayun), also known as the Grand Sérail, in 1851
and the military hospital in 1861 on the hill above the old town. The insertion of a
clock tower between the barracks and the hospital in 1898 completed the monumen-
tal compound of the central government visible from everywhere (fig. 4.1). Baghdad's
skyline, viewed from the western bank of the Tigris, acquired an imperial seal with
its longitudinal government palace on the embankment and the nearby clock tower.
The strategic choice of sites for these clusters transformed and dominated the overall
looks of both cities. In the French Maghrib, the opening of cours Napoléon in Bône
shifted all important buildings to this spacious avenue, with the town hall and the
theater across from each other, the cathedral closing its vista, and the palace of justice
nearby. In Sfax, the juncture between the first and second French extensions to the
city became the site of the buildings that represented the imperial presence: the town
hall, theater, post office, and other government buildings lining the avenue Jules
Gau. As in Beirut and Baghdad, the sites were carefully chosen, responding to the
specific conditions of each city and establishing a hierarchical relationship with the
existing fabrics.

The late-nineteenth-century interventions marked a break from past expressions
of power through architecture. Ottoman construction activity in North Africa and
the Middle East had been consistent and significant since the sixteenth century.[1] This
practice was characterized by conformity to local architectural norms, with notable
exceptions. In some cases, such as the sixteenth-century Süleymaniye in Damascus

and the Sidi Mehrez Mosque in Tunis, the monuments made blatant architectural references to the Ottoman capital and stood apart in the fabrics of the major cities. Yet even then, they did not cause dramatic ruptures with the urban fabrics. As religious monuments, they belonged to the existing norms and types.

The formulaic presentation of "important buildings" in the Ottoman *salnames* underlines the cumulative impact of the new structures on the urban image. These publications brought the nineteenth-century additions to the level of prominence given to historical anchors of urban fabrics (such as the Great Mosques of Damascus and Aleppo) by including them in the same lists to convey general descriptions of particular cities. Nevertheless, the clustering of the recent public structures helped differentiate them in their representative associations: imperial and modern. A survey of randomly selected *salnames* reveals the systematic nature of the siting of the new buildings. In 1883 Sana had four concentrations. Within the walled city, the government palace, civil and sharia courts, headquarters of the provincial administration and the police, telegraph office, publishing house, and high school occupied the southeastern area. Military barracks, ammunition depots, and food storage warehouses were in the east. The military hospital, a police station nearby, and the residence of the governor were in the west. Outside the fortifications, a large military complex included the offices of the commander in chief, barracks, stables, and several gardens.[2] In 1901, Beirut had "a government palace and a town hall and imperial barracks and a military hospital and a college of political science," all "perfect and regular" (*mükemmel ve muntazam*).[3] A few years later, "a military high school and a branch of the Ottoman Bank and administrative offices of the port" were added to the list.[4] The state of "development" (*mamuriyet*) reached by the city was evident in the "regularity and perfection" (*intizam ve mükemmeliyet*) of its government buildings, which added to its "honor and excellence" (*şeref ve meziyet*).[5] At the turn of the century, Baghdad boasted among its "sublime, large, and regular buildings" a government palace, infantry, cavalry, and artillery barracks, an industrial school, the publishing house of the province, high schools, military schools, colleges, municipal buildings, courts, and a military hospital, as well as a hospital for the poor under construction.[6] Mosul's "commanding institutions" (*müessesat-ı emiriye*) in 1907 consisted of "a large government palace," "majestic infantry barracks," cavalry barracks, a military hospital, and an ammunition depot, along the Tigris and outside the walled city.[7]

Salnames described the new buildings in a reductive vocabulary, which conveyed the message quickly and clearly, while enforcing it by repetition. An architecture that projected the modernity of the empire had to be regular, impressive in size and quality of materials, and ornamented in a gracious manner. In Damascus, the municipal building was "superior and majestic" (*fevkani ve tahtani*), "adorned and perfect" (*müzeyyen ve mükemmel*); the telegraph and post office was "in stone and regular"

(*kargir ve muntazam*).[8] Trablusgarb's government palace was "perfect" (*mükemmel*) and its municipal hospital "large and regular" (*cesim ve muntazam*).[9] Beirut's government palace was "regular and glamorous" (*muntazam ve mükellef*) and increased the "honor and decoration" (*şeref ve ziynet*) of the country.[10] It was also "elegant" (*dilnişin*); the military hospital was "perfect" (*mükemmel*), and all the buildings of the military compound were remarkable in terms of their "interior and exterior order and ornamentation" (*tanzimat ve tezyinat-ı dahiliye ve hariciye*).[11] In Trablusşam, the government palace was again "regular."[12] Geography and history textbooks for high schools adopted the official presentation format and the vocabulary of the *salname*s and repeatedly highlighted the new building types in addition to the historic monuments. For example, describing Baghdad, a geography textbook appended military barracks, government offices, and police stations as "famous, . . . beautiful and large" (*meşhur, . . . güzel ve cesim*) buildings to its list of important mosques, madrasas, and churches.[13] In his travel account, Mağmumi contributed to the dissemination of the official vision by describing Beirut's Grand Sérail and hospital as "large and ornate" (*cesim ve müzeyyen*) and all its new structures as "in stone and elegant" (*kargir ve zarif*).[14]

The nineteenth-century French architectural culture was very different from the Ottoman one. Architectural education, theory, and practice had developed a sophisticated discourse, especially since the sixteenth century, reaching a new level of dissemination from the 1850s on. In addition to numerous specialized publications and periodicals, the popular journals and newspapers brought architectural debates to the public realm, and the Haussmannian construction activity helped integrate discussions on architecture into everyday life—a condition opposed to the Ottoman scene, where the architectural discourse was just beginning to shift to European norms. The vocabulary that described the new buildings in the Maghrib was hence richer and more nuanced, even critical. It was common for government officers to offer correctives to engineers and architects. For example, in 1844 a letter from the Ministry of War found fault with the unquestioning application of the "construction methods of northern Europe" and the failure to take into consideration climatic differences. The same year, the minister of war wrote to Maréchal Bugeaud reporting that the project for a government palace in Algiers "was lacking in style and ornament."[15] Nevertheless, a simpler terminology ran parallel to the more sophisticated discourse, its repetition resulting in formulas that shifted between the technical, the ideological, and the celebratory. Design principles exalted "symmetry and regularity."[16] The post office in Tunis was a "mountain of stone," an example of the "style of the conqueror".[17] The monuments of the proposed 1858 extension to Algiers were "large and intelligent," "dignified," and "splendid." Furthermore, they met "all conditions of hygiene."[18]

Without attempting a comprehensive analysis of the new monuments that filled the cities of the Ottoman Middle East and French North Africa (great in variety and in numbers), in this section I will introduce a selection that represents the range, forms a kaleidoscopic picture, and defines a broad framework in order to ask more specific questions. The goal is not to single out any building and examine it in detail but to raise issues that pertain to the collective enterprise. What follows is an unbalanced survey, categorized according to functional types. A few critical case studies are explored in some detail because they effectively highlight characteristics that are relevant to others, treated in brief references. The deliberate focus on the exterior appearances of the buildings helps trace their impact on the transformations of urban images. While the interior organizations cast great light on the changing notions of modernity and will be dealt with in selective examples, my emphasis here will be on the siting, massing, and architectural vocabularies of buildings.

Military Structures

The earlier discussions on infrastructure, urban fabrics, and public spaces revealed the primary importance of the army in both the French and the Ottoman cases. It should come as no surprise that some of the most impressive structures inserted into the cities of the Middle East and North Africa catered to military needs, while conveying a powerful message about power structure and control. In quantitative terms, the construction activity was enormous, accommodating the great numbers of troops and the attendant equipment. The French army in Algeria consisted of 60,000 men in 1840, 90,000 in 1844, and 107,000 in 1847.[19] Although the numbers did not reach those of the French army in North Africa, the Ottoman state increased its military presence in the Arab provinces from Tanzimat on. Following the reorganization of the Ottoman forces, major army corps were allotted to Syria and Baghdad. Yemen and Libya acquired separate units, and often the number of troops was raised.[20] At the turn of the century, 12 new battalions were sent to Yemen to fight against the insurrection of Arab tribes.[21] In Trablusgarb, the increase was from 900 to 12,000 in the 1880s, around the time of the French occupation of Tunisia.[22]

The architecture of military barracks in the French and the Ottoman contexts displays remarkable similarities, particularly in their plans, which follow the same design guidelines regardless of differences in scale or location. This should not be surprising, as the reforms in the Ottoman army followed European models, privileging the French ones. A volume on the "science of architecture" establishes a direct connection. Titled *Fenn-i Mimari* (The Science of Architecture), the book was translated from the French original in the mid-1870s by Mehmed Rıfat, an instructor in

land surveying and construction in the Imperial War Academy.[23] *Fenn-i Mimari* stands as a solid witness to the widespread use of European guidelines and precedents. However, while its importance for the dissemination of technical expertise is indisputable, it should not be considered the sole reference for Ottoman military constructions. The liberties taken in the translation also attest to its use as a flexible reference: when deemed necessary, Mehmed Rıfat inserted his own expertise into the text in response to the requirements of an Ottoman army—such as the provision for the construction of "a perfect sacred mosque" next to the library.[24]

In addition to conveying technical information on construction and principles of design and aesthetics, including the canonical orders and "decoration of exteriors," *Fenn-i Mimari* dedicated detailed sections to the design and construction of barracks for the infantry, cavalry, and artillery. The rationale for functional divisions (such as separating the dormitories according to rank in order to avoid inappropriate relations), the right amount of space given to each soldier, formulas for calculating all spaces, and the location and design of libraries, reading rooms, kitchens, laundry rooms, and bathrooms were specified. Site conditions were to determine the overall design strategies: hence, if the barracks was in a walled, large area, it would be good to surround the building with arcades on the ground level; otherwise, arcades should line only the interior courtyard.[25]

The drawings of the barracks in Souk-Arhas in Algeria (fig. 4.2; see also fig. 2.30) and several drawings of barracks found in the Ottoman archives belong to the same nineteenth-century military formats. Like the military headquarters of the French army in Souk-Arhas, the "Şevkiye" (pl. 21) and "Hamidiye" (pl. 22) barracks, both in Syria and both dating from Abdülhamid II's reign, and the barracks in Felluja (undated plan) are all rectangular, symmetrical buildings with similar distributions of the dormitories and service spaces, ceremonial entrances, and either continuous inner arcades (Felluja) or partial ones (Şevkiye).[26] Four projects prepared for different regions of the province of Trablusgarb (1897) reveal another typology, one that places the artillery storage in the center of the structure.[27] The exterior views share a homogeneous rigidity, with the entrances as the only elements breaking the rows of fenestration and giving some individuality to the buildings. The entrance was often arched, but framed in different ways, sometimes by columns, sometimes by decorative stones. The central pavilion could be projected and treated in a more elaborate manner, as in the case of the barracks in Bengazi (pl. 33). A modest example from the province of Trablusgarb displayed a two-story entrance, the second level with a balcony, no doubt intended for ceremonial functions (pl. 23). In terms of architectural principles, there were no significant differences between the Ottoman and French examples, but only some articulations, such as the masonry details and the widespread French use of shutters on windows. However, some unusual experiments took place; for example, the façades of the three-story Caserne Lambert in Bizerte

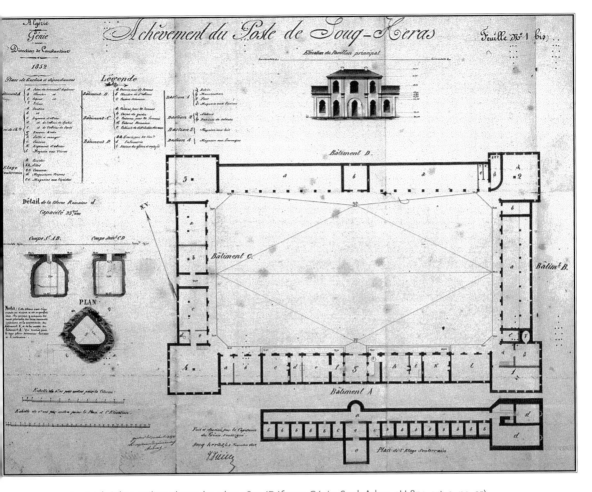

4.2 Souk-Arhas, military barracks, plan, 1852 (Défense, Génie, Souk-Arhas, 1H 874, art. 3, no. 25).

were surrounded by colonnades and arcaded balconies on all stories that gave the building a light and open appearance (fig. 4.3).

In the cities of both empires, the impact of the military barracks, coupled with their imposing, somber architectural features and immense size, was profound: they sat as unprecedented masses of stone, often at the edges of cities. The scale of one example, the barracks in southern Sana that would shelter two regiments, was effectively conveyed in *Servet-i Fünun* by graphics: a photograph of the main façade was published sideways because it would not fit the page otherwise.[28] The imperial barracks of Beirut, situated in a "dominant, central location" and built in a "beautiful style" suitable to the sultan's grandeur, overshadowed all other structures on the 1876 plan of the city (see pl. 5); the military structures in Constantine on the hilltop, likewise visible from everywhere and much larger than all other buildings, dominated the urban image.[29]

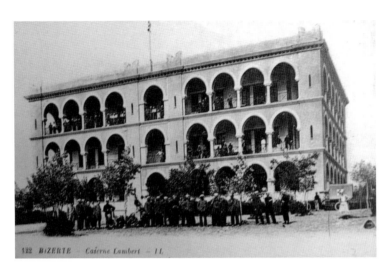

4.3 Bizerte, military barracks (postcard, Défense, Département de Terre, Fonds Michat).

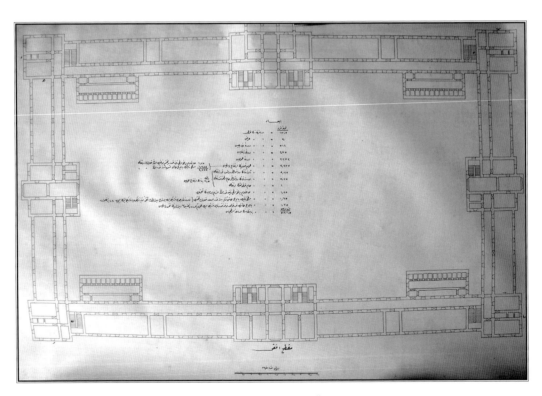

4.4 Mecca, guesthouse, plan (IÜMK 93376).

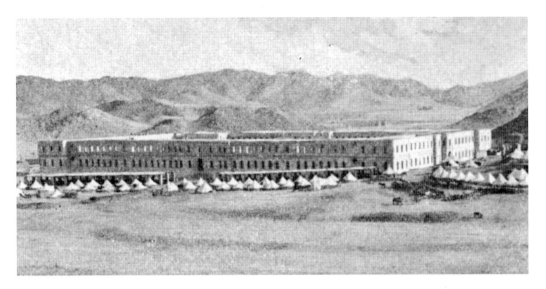

4.5 Mecca, guesthouse, view under construction (*Servet-i Fünun*, no. 341 [1313/1897]).

The formula used for barracks could be adapted to certain other functions. It came in particularly useful for the design of guesthouses (*misafirhanes*), or modern cara-vanserais, such as the vast facility outside Mecca to accommodate pilgrims (figs. 4.4 and 4.5). Its main spaces consisted of large dormitories, behind which bathrooms were placed. The courtyard and the long corridors provided communal spaces, the former open to the sky and the latter inside the building. The two-story building in stone and in a simple neoclassical style imprinted the image of Ottoman authority onto the ragged landscape, indicating the newly imposed control over the region and challenging the local emirs.[30]

Karakolhanes, or police stations, complemented the barracks in establishing con-trol and representing imperial authority. Scattered throughout the empire, they were signature buildings of the Abdülhamid period that expressed the state's tight grip over society. Nevertheless, their exteriors, in contrast to their function and symbol-ism, were playful experiments in a range of revivalist and hybrid vocabularies, recall-ing another typical Hamidian building type, the clock tower. A generic Ottoman project for a small *karakolhane* shows a symmetrical one-story structure with a colon-naded entrance and with the offices in the front, the dormitories in the middle, and the service functions in the back; it could be doubled in size by repeating the plan along the main axis (pl. 24). The façade was neoclassical, with marble columns car-rying a pediment and giving an official aura to the otherwise-modest building. On a comparable scale, the *karakolhane* in the new neighborhood of Selimiye in Aleppo, designed by the students at the School of Fine Arts in Istanbul and built in local stone, was inspired by crusader castles (fig. 4.6). Its pointed windows, heavy stones

4.6 Aleppo, police station in Selimiye neighborhood (*Servet-i Fünun*, no. 211 [1311/1895]).

4.7 Sana, police station (*Servet-i Fünun*, no. 463 [1315/1899]).

that articulated the corners, and the crenellated roofline complete with cylindrical minitowers recycled historic local elements in daring combinations. *Servet-i Fünun* described it as "truly elegant" and enjoying "an architectural style of its own."[31] A larger police station in Sana was clad in a neoclassical façade: fancy stonework defined its corners and windows, columns and pediments marked the entrances, and a crenellated roofline complemented its monumentality (fig. 4.7).

The gendarmeries in the French Maghrib were also varied and experimental. In Sfax, the architectural language combined the neoclassical (the symmetrical treatment of façades, the stone basement) with the "Islamic" (the stonework around the arched entries and the windows of the third story) and added a medieval roofline to

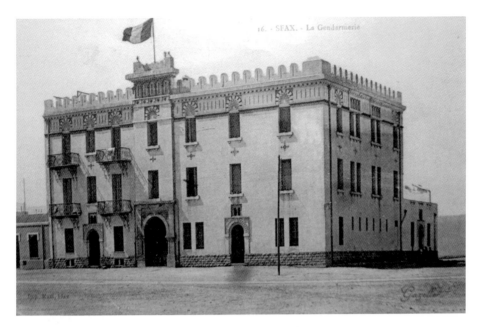

4.8 Sfax, gendarmerie (postcard, ADN).

4.9 Philippeville, barracks (postcard).

lend it a military touch (fig. 4.8). In Philippeville, the barracks were purely neoclassi-
cal, with the stone detailing at the corners and around the windows similar to that of
the *karakolhane* in Sana (fig. 4.9).

A quick look at the transformations made to precolonial buildings in Algeria that were appropriated for colonial use gives us insight into the architectural strategies used in the design of buildings that would represent the French Empire. A number of these appropriated structures were palaces and large mansions that belonged to Ottoman dignitaries who had fled the country after the French invasion. The Palace of Ahmed Bey in Constantine, built a few years prior to the occupation, provides a good case study because of the drastic changes it underwent and because of its deemed architectural importance. Charles Féraud, the chief interpreter of the army, found the palace of "the highest interest" among all the monuments of Algeria as a piece of *"architecture barbaresque."* If not particularly imposing or refined in its details, he saw it as superior to other sumptuous residences of the Ottoman period, thanks to its "elegant and grandiose proportions" and the "seductive reunion" of an "ostentatious taste and Algerian luxury." It was the "most complete type of architecture . . . suitable to the customs and the climate of the country."[32]

Turned into the French military headquarters, the palace also served as the seat of the imperial administration in the province, in conformity with the role of the army as the overseer of civilian affairs during the early stages of the occupation. The transformations began immediately after 1837 and continued during the following decades to accommodate shifting needs.[33] While it would take a monograph to conduct an archaeological examination of the interventions to this building, a quick focus on the northwest side reveals their complexity. The offices concentrated in this section (including the recruitment bureau, the military library, the management services of various departments, and even the kitchen of the division's general) had to be independent from each other and had to have individual entries (some from the courtyard, some directly from the street).[34] To meet these needs, manipulating interior spaces would not suffice, but parts of the building had to be demolished to allow for two straight streets, rue du Centre and rue Sassy (figs. 4.10 and 4.11). The façades on the new arteries expressed the official look in its bare essentials: three stories, separated by horizontal bands of stone, neatly stacked windows with stone trims, a more decorative treatment of first-level fenestration and entrances, and tile-covered pitched roofs (fig. 4.12). Completely at odds with the irregular massing and blank façades of the original palace, the interventions created an image that represented the French presence.

The architects of the town halls in Algeria adopted the "style of the conqueror" in some of the most elaborately decorative buildings of the period. In Oran and Bône, they opted for an extravaganza imported from the metropole of Napoléon III on a monumental scale (fig. 4.13 and pl. 25). In the smaller town of Koléa, the "empire style" was adapted to a villa style by breaking up the mass and with a generous use of

4.10 Constantine, Palace of Ahmed Bey, site plan showing the projected demolitions
(Défense, Génie, Constantine, 1H 809, art. 3, no. 256).

balconies; the clock, centrally placed in a broken pediment on the roof level, estab-
lished its clear link to the typology (fig. 4.14). On a comparable scale, Sidi Bel Abbès's
town hall made up for its modesty with the exaggerated height of the roof structure
of both the central part and the side pavilions (fig. 4.15). Constantine's remarkably

4.11 Constantine, Palace of Ahmed Bey, partial plan showing the projected

transformations (Défense, Génie, Constantine, 1H 809, art. 3, no. 256).

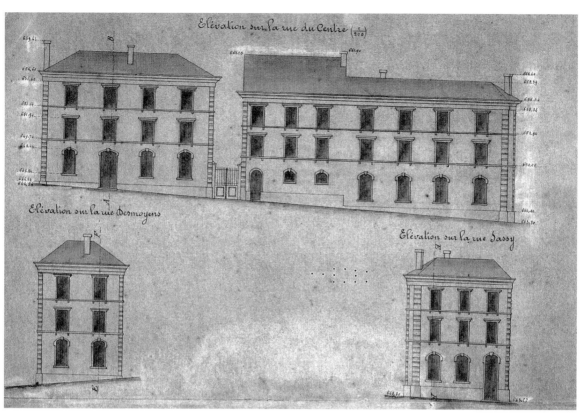

Élévation sur la rue du Centre (1/200)

Élévation sur la rue Desmoyens

Élévation sur la rue Sassy

4.12 Constantine, Palace of Ahmed Bey, drawings showing the new façades
(Défense, Génie, Constantine, 1H 809, art. 3, no. 256).

1. - ORAN. - L'Hôtel de Ville

4.13 Oran, town hall (postcard, GRI).

4.14 Koléa, town hall (postcard).

4.15 Sidi Bel Abbès, town hall (postcard, GRI).

late town hall, built between 1895 and 1903, almost half a century later than the establishment of the "commune," followed the same tradition in a compact, three-story building with a tall tower above the clock.[35]

Yet, much had changed in architectural practice around the turn of the century. In the aftermath of Napoléon III's notion of *royaume arabe*, the gradual replacement

of policies of "assimilation" of autochthonous populations with those of "association" had produced a more accepting attitude toward local aesthetics. Rehearsed in temporary structures erected for celebrations, in pavilions that represented Islamic lands at universal expositions, and in an unrealized monument to Napoléon III (discussed in chapter 3), elements from "Islamic" art and architecture were applied to Beaux-Arts buildings, culminating in a widespread "style néo-Mauresque."[36] The "Préfecture" of Algiers (1908–13), designed by Jules Voinot and situated on the avenue de l'Impératrice, was one of the most monumental government structures in a neo-Moorish vocabulary (pl. 26). With its white façades, horseshoe arcades, domes, and blue-tile decorations, the Préfecture stood in stark contrast to the surrounding architecture on this "European" strip and inserted a prominent element into the celebrated image of the city from the sea. It could be read as yet another level of colonization and appropriation or as a gesture of acknowledgment to local cultural norms.

If not comparable to the grandeur of the one in Algiers, neo-Moorish town halls proved to be popular in Maghribi cities large and small. In playful arrangements, they offered a wide range of experiments. Raphaël Guy designed Sfax's town hall on a typical Beaux-Arts plan but unsettled its symmetry with a minaret-like clock tower on the side and filling its customary place at the center with an "Islamic" dome (fig. 4.16). The treatment of exterior and interior details repeated the local references. The more modest examples, for example, in Ferryville (fig. 4.17) and Monastir in Tunisia and in Birtouta in Algeria (fig. 4.18), testify to free-spirited variations on the theme.

The same approach shaped other government offices in the Maghrib: neo-Moorish experiments followed the neoclassical ones, with some fluctuations in the sequence. The palaces of justice in Bône and Philippeville adhered closer to neoclassicism, both boasting a Roman aura thanks to their grand triangular pediments; the later one in Sousse was neo-Moorish (figs. 4.19 and 4.20). The post offices in Bône, Constantine, Tunis (1892, designed by Guy, the architect of the neo-Moorish town hall in Sfax), and Bizerte were in the "style of the conqueror," but not the one in Ferryville (figs. 4.21 and 4.22). One of the most memorable post offices in the history of the building type was the neo-Moorish example in Algiers. Designed by Voinot, the architect of the Préfecture, the Grande Poste redefined the prominent corner it occupied with its monumental white mass, arcaded entrance on its beveled main façade, domes at the corners, and selective use of "Islamic" fragments (pl. 27).

The Ottoman state engaged in a comparable venture and used government buildings to express political agendas. It imposed its redefined presence shaped by the post-Tanzimat transformations with the help of a rich taxonomy of government office buildings scattered throughout the empire. Aside from their symbolism and their contribution to the remaking of the urban images, these buildings sheltered a new form of administration, a new bureaucracy based on ordering, systematic documentation, classification, and filing—according to the modernization and centralization

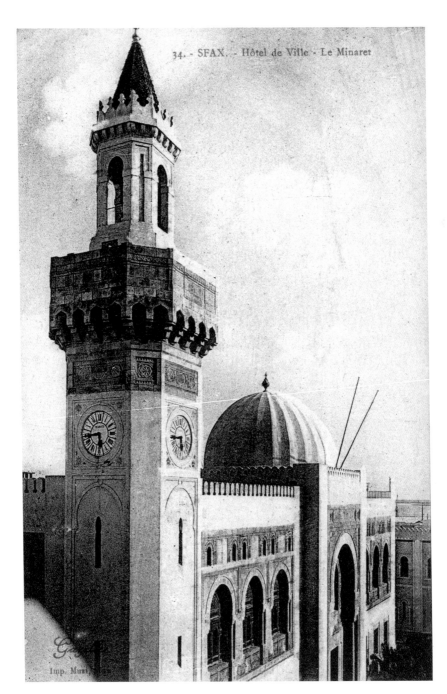

34. - SFAX. - Hôtel de Ville - Le Minaret

4.16 Sfax, town hall (postcard, Fine Arts Library, Harvard College Library).

4.17 Ferryville, town hall (postcard).

4.18 Birtouta, town hall (postcard).

4.19 Philippeville, Palace of Justice
(postcard, Fine Arts Library, Harvard College Library).

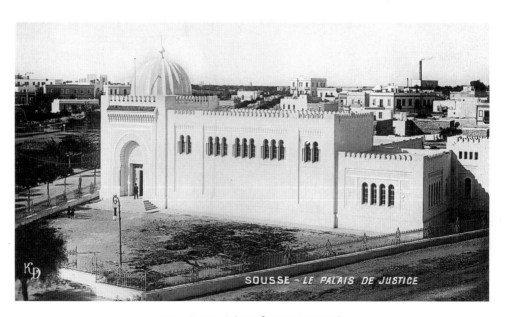

4.20 Sousse, Palace of Justice (postcard).

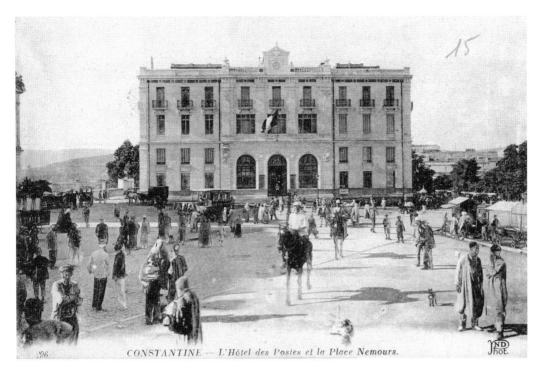

4.21 Constantine, post office (postcard, GRI).

4.22 Tunis, post office (IÜMK, album 90598).

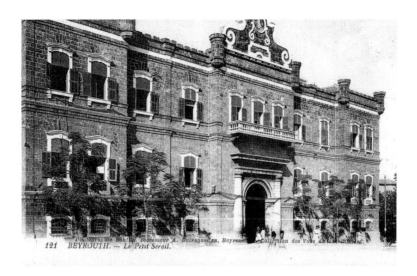

4.23 Beirut, Government Palace (postcard, Fine Arts Library, Harvard College Library).

agendas. Even if the execution of the reforms remained fragmented, the idea of a central authority was a new concept in Ottoman governance, and architecture conveyed the message effectively. As in the case of the French Empire, the repetition of similar buildings in disparate places reinforced the idea of connectedness.

Government palaces (*hükümet konağı*) were the foremost signs of the Ottoman state. The architectural ambition and range of experimentation in these prominently located buildings were great, regardless of the size and importance of their cities. At times, their huge construction budgets invited criticism based on the argument that fancy structures could not even begin to resolve the serious problems the empire faced everywhere. For example, the Paris-based Young Turk journal *Méchveret* considered the extravagant construction of a government palace in Sana another Hamidian "whimsical idea" to address the harsh political realities of the region and the recurring insurgencies.[37]

Beirut's government palace (1302/1884), sometimes called the Petit Palais or the Petit Sérail (the Imperial Barracks being the Grand Palais), was a matter of great pride to Ottomans (fig. 4.23). Designed by the chief engineer of the province, Bishar Efendi, it stood out among the city's "sublime buildings." It was in the style of "old castles"[38] and "extraordinary attention had been paid to its exterior and interior planning and decoration."[39] Composed of three stories around a courtyard, the latter used as an open-air museum for antiquities found in the region, the palace had eighty-two rooms.[40] The regular, symmetrical, and axial overall design expressed a bold stylistic synthesis of medieval, Renaissance, and baroque elements. Its most idiosyncratic feature was the roofline, which made references to crusader castles with its small circular towers (as seen above, the police station in Aleppo would recycle the same

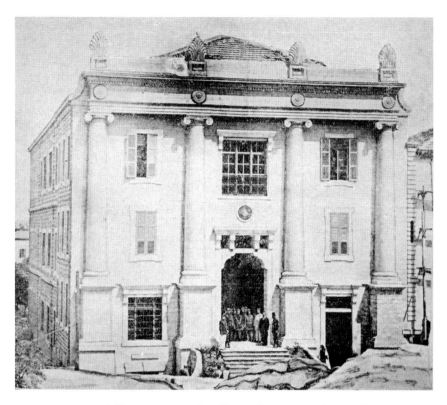

4.24 Jaffa, government palace (*Servet-i Fünun*, no. 335 [1313/1897]).

element a few years later), and a sculptural baroque pediment placed on the project-
ing middle section of the main façade.

Among the neoclassical government palaces, Jaffa's (1893) distinguished itself
with its main façade, defined by four three-story-high Ionic columns (fig. 4.24) and a
sculptural roofline. *Servet-i Fünun* praised it as a "solid" and "elegant" building that
was worthy of the government: its columns, window details, doors, stairs—in short,
everything about it—reflected an excellent "architectural taste" and displayed great
harmony and sensitivity to scale.[41] A stripped-down neoclassicism was more com-
mon, as represented by two examples: in Horan (1899; fig. 4.25) and in Trablusşam
(1894; fig. 4.26). The two *konak*s shared a similar scale and spatial organization: a
rectangular mass mostly likely organized around a courtyard, and a main façade
divided vertically by a projecting central and two end sections. A portico accentuated
the entrance at the center, orthogonal in the case of Horan and with pointed arches
in Trablusşam. While both roofs were covered with tiles, a pediment broken in the
middle by a plaque with imperial insignia endowed the Horan palace with further
monumentality. The decorative stone treatment of the windows and the corners con-
tributed to the effect. Baghdad's government palace revealed a simpler arrangement
and architectural vocabulary: it was a longitudinal structure with a flat roof, two pro-

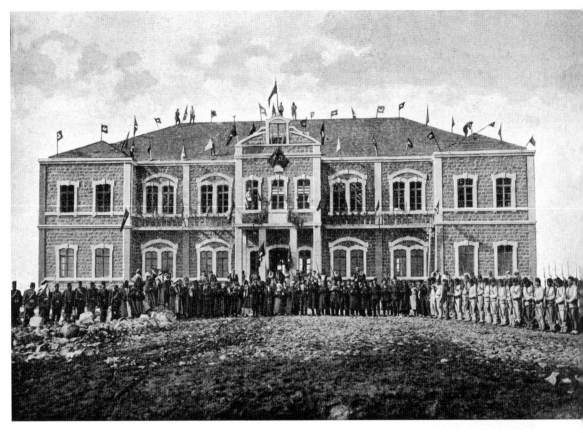

4.25 Horan, Government Palace, inauguration ceremonies (*Servet-i Fünun*, no. 514 [1318/1902]).

jecting sections at the two ends, and neatly stacked arched windows (fig. 4.27). Even
though built in stone and in a new monumentality, the building's horizontal mass
responded to its site on the banks of the Tigris by evoking the river's flow and acknowl-
edged the local architecture in its height and its relative simplicity.

The smaller government palaces give further insight into the variety of architec-
tural experiments. The "government palace with light defense" in a Red Sea town in
Hijaz Province (1885) addressed the vulnerable political situation in the region and
made an imperial statement by its local architectural references (fig. 4.28). A fortified
building, it was firmly sealed from the outside except for the entrance portal, above
which a flagpole was placed. Yet, this defensive and introverted architecture related
to the vernacular of the area and to the climatic conditions, most likely in an attempt
to belong. The "palace" in the small town of Zaviye in Trablusgarb Province (1895)
did not need the same kind of protection as the Red Sea post but simply used the
regional architectural vocabulary, which extended from the choice of construction
materials to the irregular mass of the building (fig. 5.14).

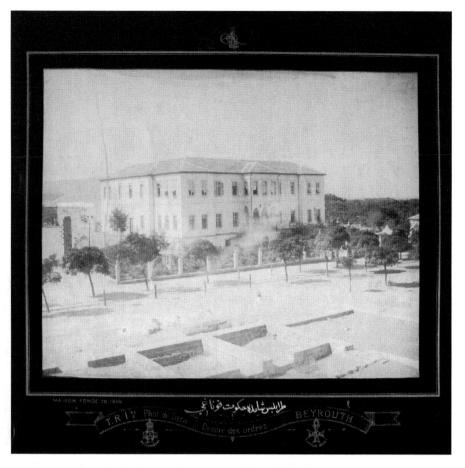

4.26 Trablusşam, Government Palace (IÜMK, album 779/44).

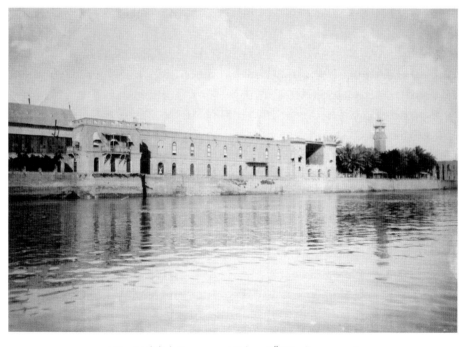

4.27 Baghdad, Government Palace (IÜMK, album 90573).

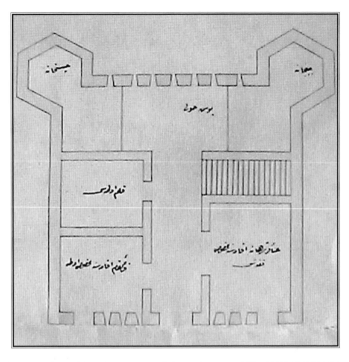

4.28 Emer, on the Red Sea, Government Palace, plan, 1302/1885 (BOA, Y.PRK.UM 7/84).

Other government buildings sheltered and celebrated the new institutions of the empire and paralleled the architectural idioms of the government palaces. The most memorable features of the Municipal Building on Marja Square in Damascus (1892) were concentrated on its projecting central part: the entrance reached by a set of steps and framed by two columns, a balcony with a sculptural balustrade, inscriptions, and finally the star and the crescent in the pediment (fig. 4.29). The municipality in Trablus-şam (1313/1895) used its street corner site that faced the city's public park creatively: the beveled main façade was dominated by two-story-high Corinthian columns that carried an arch framing the entrance, reached by a set of marble steps (pl. 28). Again on Marja Square in Damascus and at a right angle to the Municipal Building, judicial and government offices, situated next to each other and defining a row of official buildings that terminated in the Hotel Victoria, were humbler structures, and their references, specifically the eaves of their tiled roofs, evoked residential architecture (fig. 4.30). Mosul's Office of Imperial Lands was of a similar scale and massing but had a more monumental, neoclassical effect due to the hiding of its pitched roof behind a high stone cornice, the pilasters that articulated its façades, and the promi-nent arched entrance. Its main façade faced the government palace across a square with a ceremonial fountain; its back façade mirrored the front and overlooked the Tigris (see fig. 3.20). A "government office" in Yemen (1898) displayed the same dimensions and overall arrangement and, most likely, the same plan (fig. 4.31). Yet,

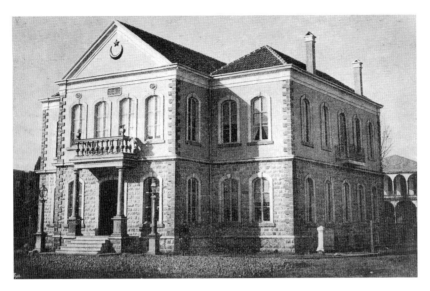

4.29　Damascus, Municipal Building (*Servet-i Fünun*, no. 158 [1310/1894])

4.30　Damascus, government offices lining Marja Square (*Malumat*, no. 157 [1314/1898]).

despite the neoclassical references, the Yemen structure was given a local flavor by the detailing of its roofline and the use of local construction materials. This was a characteristic of Ottoman government buildings in the province, as noted by a European observer who found them "rather imposing" but argued that, because of the consistent use of the "same black stone, . . . quarried in the neighborhood," they shared a "gloomy appearance."[42]

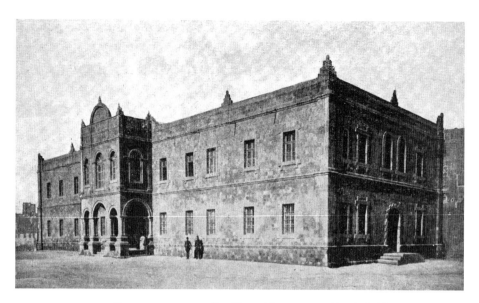

4.31 Yemen, government office (*Servet-i Fünun*, no. 496 [1316/1898]).

Hospitals

Hospitals, at first only for the military, were among the earliest French structures in Algeria. The common practice was to transform an existing building. Curiously, as observed in Blida, Oran, and Tlemcen, this would often be a mosque. In Blida, the small hospital could accommodate only 70 beds, but all the surrounding buildings, with the exception of a saint's tomb (*"tombeau de M'barek"*), were claimed for use by the hospital. The tomb was protected from the gaze of Europeans by a wall so that the "indigenous" could continue their visits in privacy.[43] In Oran, the "hôpital permanent de la Mosquée" could shelter 490 beds in 1841; the need for more led to the installment of a "temporary" hospital in a building in the Casbah.[44] Tlemcen's Méchouar Mosque, restored in 1863, was not converted into wards but served as the chapel of the military hospital; despite several demands, the army refused to return it to Muslim use because of its location in the military compound (fig. 4.32).[45] These temporary solutions failed to meet the functional requirements of modern hospitals, mandating the construction of new facilities.

As illustrated by an 1880 modification project for Constantine, already in place in 1840, the new military hospitals were vast structures that reflected their rational organization (see fig. 2.4). However, their doors were closed to civilians. An editorial in the settler newspaper *Tunis: Journal d'Afrique française* brought the issue to public debate. It described the military hospital in the Belvédère quarter in Tunis as designed according to the "desiderata of modern science" in separate pavilions and praised its airy, "almost cheerful" appearance before stating that it admitted "neither the settlers nor the French workers." Arguing for the construction of a large civilian hospital to

serve the settler communities, the newspaper *Tunis* made the case: "In this country, where large numbers of French, including the well-off, do not have families, where many others lack resources, and where distances and absence of rapid communication routes make home care impossible, a Civilian Hospital is indispensable."[46]

The building that served as a civilian hospital in Tunis (Hôpital St. Louis) in the early 1890s was a somber old Arab house, according to the newspaper. It lacked air and light; the long and vaulted rooms that opened onto a narrow patio suffered from humidity. In short, a modern hospital was needed at least as much as the other buildings then under construction, namely, a municipal casino, a theater, and a palace of justice.[47] Most likely, the journalist had in mind as a model the Civilian Hospital in Constantine, built on the hill on the eastern bank of the Rhummel amid larch and pine trees. A vast building organized around three courts, it turned a monumental façade to the city, emphasized by Renaissance-style domes on four corners (fig. 4.33).

The Ottoman army hospitals likewise predated those intended for civilians and formed part of military enclaves. The "large and ornate" military hospital in Beirut (1278/1861) faced the Grand Sérail (imperial barracks) across a landscaped garden and was a matter of great pride, not only because of its architecture but also because it was a modern institution that accommodated contemporary science and conformed to all rules of hygiene. Mağmumi dedicated a long description to it:

> at the entry, one is met by a regular interior garden that is a greenhouse. When you reach the stairs, their purity and cleanliness invite you to take your shoes off. The walls seem as though their fresh paint had just dried; they are entirely white, without even the tiniest speckle. At the entrance of every ward, there is a table with a water jug and a glass and two long seats. The patients eat here in the morning and in the evening. Those who are too sick to get up are served in their beds. The beds are the same color and shape and in the newest style. Nowhere can you detect the odors that normally characterize hospitals. The surgery room, the laundry, and the pharmacy are perfect. In reality, I stood in admiration of this hospital, which surpasses even the examples in the capital.[48]

The same agenda for modernity and the growing concern for public health extended to civilian hospitals, large and small. The new outlook that valorized a modern and scientific approach to health brought hospitals into the secular realm, outside the auspices of religious complexes, which had been a historic association. *Servet-i Fünun* presented the Municipal Hospital in Damascus (1315/1897) with photographs showing not only the inauguration ceremonies (fig. 4.34) but also how it operated according to contemporary standards, namely during a surgery. Sitting on the hill facing the newly opened avenue behind the Süleymaniye complex that led to

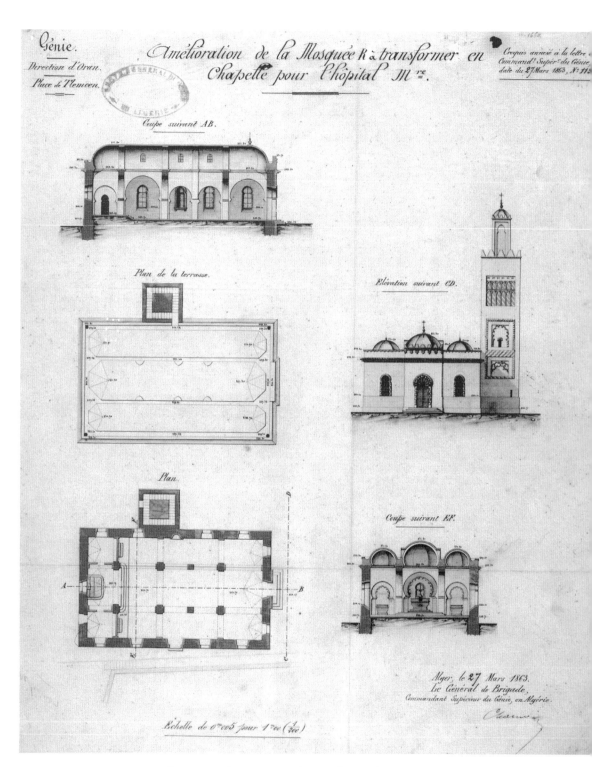

4.32 Tlemcen, Méchouar Mosque, drawings for transformation into a chapel, 1863
(Défense, Génie, Tlemcen, 1H 758, art. 3, no. 60).

233 CONSTANTINE. — L'HÔPITAL CIVIL. — LL

4.33 Constantine, Civil Hospital (postcard, GRI).

the train station, the building was clearly one of the new monuments of the city—highly visible and architecturally experimental in a neoclassical style that made a reference to the Great Mosque of Damascus in the clerestoried arrangement of its roof structure. In 1902, a medical school was built behind it, turning it into a teaching hospital.[49]

The last years of the nineteenth century saw a surge in hospital construction, including the *gureba* hospitals (hospitals for the poor). The buildings in el-Deir, on the Euphrates (1895), and Sana (1897) related to local vernacular forms in an attempt to blend into their contexts (figs. 4.35 and 4.36). The Sana hospital was especially notable in its architectural characteristics. A symmetrical and axial structure, marked by a classical central entrance, it had the compositional elements of other modern structures of the time. However, its façade treatment displayed a careful study of the city's architecture—monumental and residential. The category of buildings that addressed public health extended to hospices for the poor. A project for Trablusgarb (1911) preserved the regimented plans of military and public architecture. In a rectangular, walled enclave, the wards were placed in parallel rows, the service rooms pulled against the back wall, and a small prayer hall (*mescid*) placed at the center.[50]

Buildings for Education and Culture

Education lay at the heart of French colonial practices and Ottoman reforms. The link between public education and the state affirmed the authority of the latter over

4.34 Damascus, Municipal Hospital, inauguration ceremonies (*Servet-i Fünun*, no. 450 [1315/1899]).

the people and contributed to the glorification of imperial images. Modernizing education paralleled the greater imperial projects, with the belief that it would address and resolve a host of issues, including economic progress, political and social control, and cultural identification.[51]

In the French Empire, schools primarily served settlers and followed metropolitan models. They were the foremost mechanism to unite the immigrants, who came from different parts of southern Europe, by providing them with a shared language and culture; they also took on the education of the autochthonous youth by means of special schools adapted to local norms. The earliest primary schools in Algeria went back to 1832, but a new policy to develop public education was adopted in 1845. The goal was to open "European-style" schools that would accommodate 160,000 students (including 40,000 Muslims) and exclusively "indigenous" ones to educate 92,000 Muslims. The first high school, later named Lycée Bugeaud, dated from 1835; by 1859, Algeria boasted twenty-five high schools and twenty-four middle schools, attended by 3,110 students (225 were Muslims). The first institution for higher education, a military school of medicine, was established in 1832. Schools of law, science, and letters opened in 1879 and were consolidated into the University of Algiers in 1909.[52]

It is noteworthy that in Tunisia, which generally followed the Algerian model, the first "modern" schools predated the colonial era. In the spirit of Tanzimat reforms, in 1837 Ahmed Bey founded a school to train military and administrative cadres, paralleling a series of modernization initiatives he undertook in the army and the admin-

4.35 El-Deir, hospital, inauguration ceremonies (*Servet-i Fünun*, no. 353 [1313/1898]).

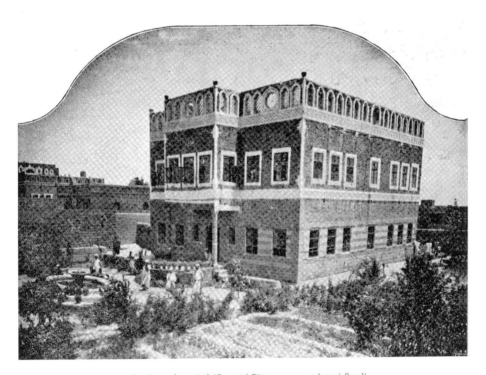

4.36 Sana, hospital (*Servet-i Fünun*, no. 445 [1315/1899]).

istration; it became the *makhab al-muhandisin*, or school of engineering in 1840. The reformist prime minister Khayr al-Din established the Collège Sadiqi in 1875; in five years, up to the date of the French occupation, the school had graduated 120 students. Based on "the model of European *lycées*" and inspired by the Imperial Galatasaray

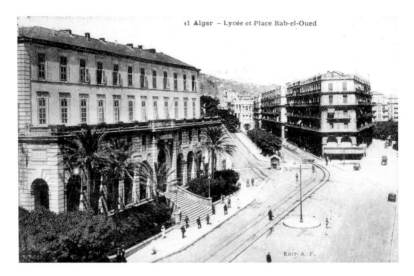

4.37 Algiers, Lycée Bugeaud (postcard, Fine Arts Library, Harvard College Library).

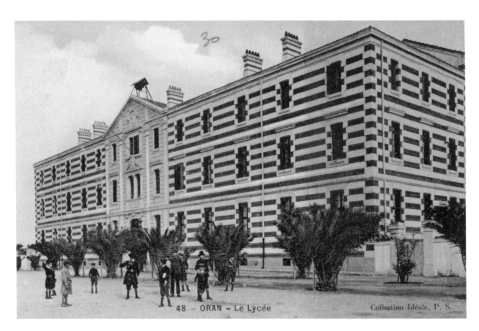

4.38 Oran, high school (postcard, GRI).

High School in Istanbul, the instruction at Collège Sadiqi was in Arabic and Turkish, but the students had to learn either French or Italian—not as a "foreign" language but as a "vehicular language" of modern education. The student uniforms reflected the particular nature of the school, as well as its ties to Istanbul: "hybrid clothing borrowed from young Turkey" that was "neither oriental nor occidental."[53]

4.39 Sousse, middle school for boys (postcard, ADN).

Schools built by the French in Algeria and Tunisia echoed the patterns observed in other building types. An outstanding feature of the high schools was their grand scale. For example, Lycée Bugeaud, in Algiers, occupied a vast terrain next to the old town, and its immense wings etched another striking contrast between the French structures and the precolonial ones (pl. 15). The early preference was for metropolitan designs (figs. 4.37 and 4.38). But, a neo-Moorish architecture became popular toward the end of the century in smaller buildings, mostly in Tunisia (fig. 4.39). Not surprisingly, it was seen as more appropriate for schools attended by "indigenous" students.

The impact of Tanzimat on education in the Ottoman Empire was primarily on the development of a relatively secular public school system, classified by an 1869 law into primary (*ibtidai*), middle (*rüşdiye*), and high (*idadi*) schools and university (*dar ül-fünun*). However, it was during the reign of Abdülhamid II that educational reform was made a priority and undertaken as an urgent imperial project. A prominent statesman described the systematic and overarching approach: "an education council is to be established in every city and town in the provinces. In this way all primary schools are reformed. By hastening to establish public schools, . . . first *idadi*, agriculture and trade schools and subsequently a teacher's college is to be founded in each of the major cities which serve as provincial capitals."[54] The quantitative results registered the growing scale of the initiative: the number of middle schools in the empire increased from 277 in 1879 to 435 in 1888; the number of high schools increased from 6 in 1876 to 55 in 1893 and 98 in 1908.[55]

The architecture of the school buildings was a matter of careful consideration—as expressed in a document summarizing the situation in the provinces of Syria and Beirut in 1892. Comparing the construction of "regular and perfect high schools . . . and even medical schools" by the French, English, and other foreigners with the Ottoman military high school in Damascus, which had not been repaired in twenty-five years and hence was in a ruinous state, the report underlined the importance of impressive buildings dedicated to education. It called for the construction of the military *idadi* from scratch so that its "perfection and order" would improve future benefits and its "beautiful effect" would impress the Arabs.[56] The belief in the power of architecture to make an imperial statement paralleled the French project of imposing a hierarchical visual order in the colonies through monumental structures.

The Ottoman government had given due attention to the architecture of *idadi* schools some years earlier. Upon the orders of Grand Vizier Mehmed Küçük Said Pasha, Esad Saffet Pasha, the Ottoman ambassador to Paris, had compiled plans and sent them to the capital; in 1885–86, 80 sets of plans were distributed to the provinces. Said Pasha's justification for the adoption of French designs reveals much about the Ottoman elite's consciousness of the power of architectural expression, recognition of the need to revive local historic styles, and the relationship between architecture and modern "civilization":

> Beyond the architectural styles popular in Europe, there is also an architectural
> style in our country. But decline in every field has affected architecture as well. . . .
> According to their arbitrary and individual tendencies, some ignorant architects cre-
> ated buildings that bear no connection to Ottoman architectural style and [are based
> on] their own random rules. In effect, their buildings do not belong to any style. We
> would like to develop our own national architecture, but it is hard to find experts for
> this task and we need to improve our construction techniques. The design methods
> [of Ottoman architecture] do not correspond to the new methods produced through
> the experiments of civilization and in order to fulfill present needs. . . . Therefore,
> we have been obliged to order façade drawings and plans from Europe. . . . The shapes
> and plans of our *idadi*s are in accord with Parisian schools.[57]

The Ottoman schools did not mimic the French ones. The remarkable multiplicity in the architecture of Ottoman educational institutions of all levels from this era points to the likelihood that the architects used the French designs only as suggestions and refined them in response to a growing awareness of regional differences. This awareness was meticulously articulated in *Les costumes populaires de la Turquie en 1873* (see epilogue), an important book that displayed the diversity of costumes in the empire. A main argument in *Les costumes populaires* concerned how clothing was adapted to local climatic conditions, availability of materials, customs, and daily life

patterns. It was only a small step to consider a similar set of criteria in architectural projects.

Like their Maghribi counterparts, the foremost characteristic of the new school buildings was their imposing scale. Often, they would be located outside the old cores, as in the case of the military middle school and the Commercial and Agricultural School in Beirut, the high school in Nablus, and the imperial high school (*sultani*) in Aleppo. The Commercial and Agricultural School in Beirut occupied a vast terrain necessary for its purposes, while the Aleppo *sultani* sat in the middle of a large garden that emphasized its prestige in the grid-planned Cemiliye quarter (figs. 4.40–4.42).[58] Some were built inside the cities: the high school in Jerusalem used the site of an old madrasa, which had been in ruins and was close to the Dome of the Rock in the Muslim quarter,[59] and the military middle school in Aleppo, lodged in a one-story but large building in a garden, faced the Citadel.[60] Their plans adhered to the principles of regularity, symmetry, and axiality but were far from cookie-cutter arrangements. Even though organized around rectangular courtyards, the military middle school in Beirut and the military high school in Damascus were very different buildings: the former had an intimate courtyard with a pool in the center, and the latter had a grander, colonnaded courtyard that worked well with its larger scale (figs. 4.43–4.45). Other plans diverged from the courtyard type. The classrooms in Baghdad's military high school were organized along corridors, with a garden in the back. The plan of the Sana military high school shows yet another variation: although there was a courtyard with a fountain, the layout was deliberately not symmetrical, and furthermore, unlike the typical two-story school buildings, it had four stories (figs. 4.46 and 4.48).

The differences in the plans reveal the attention paid to site conditions, as well as to local architectural conventions. Architectonic qualities and façade compositions enhanced regionalist experiments. While they adopted a basic neoclassicism that had come to symbolize the new Ottoman public architecture, many examples reflected local architecture in the use of materials and incorporation of details. For example, the high schools in Nablus and Baghdad, and the military middle school in Beirut were each built with local construction materials, with clear references to their architectural contexts—as observed in the forms of the arches, fenestration, and roofs. Sana's military high school broke the rules of regularity and symmetry with a nod to the picturesque arrangements of the Yemeni vernacular, down to the window ornaments (as observed in the *gureba* hospital in Sana as well). The careful choreography of these experiments could be linked to the Ottoman interest in Yemeni architecture— as witnessed by the *salname* of 1298/1880 that not only dedicated some discussion to it but also provided a drawing of a "typical" structure (fig. 4.49).[61]

The French Empire represented itself extravagantly in the cultural realm with theaters, placed close to other government structures in the centers of cities. In Algiers,

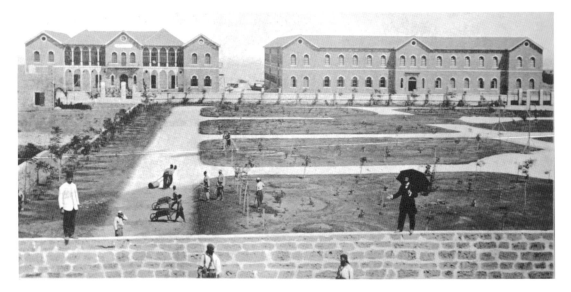

4.40 Beirut, Commercial and Agricultural School (*Salname-yi Beyrut* [1326/1910–11]).

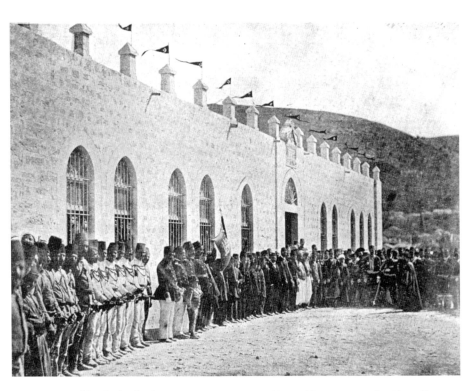

4.41 Nablus, high school, inauguration ceremonies (*Servet-i Fünun*, no. 507 [1316/1900]).

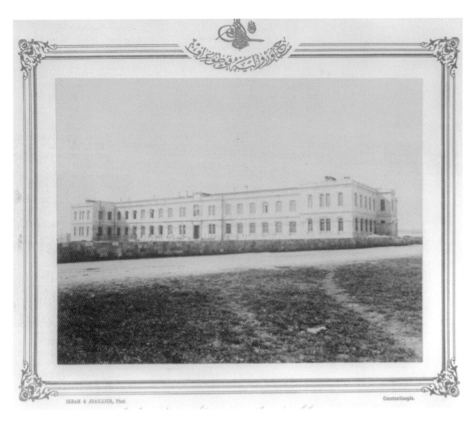

4.42 Aleppo, imperial high school (Library of Congress, Prints and Photographs Division).

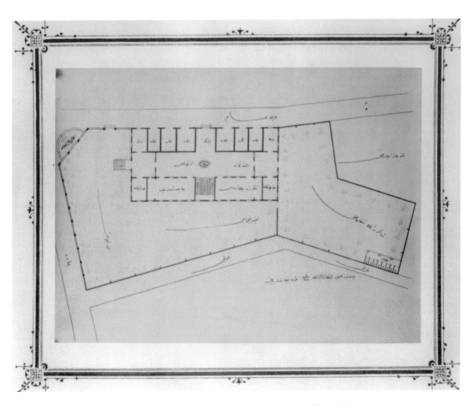

4.43 Beirut, military middle school, ground-floor plan
(Library of Congress, Prints and Photographs Division).

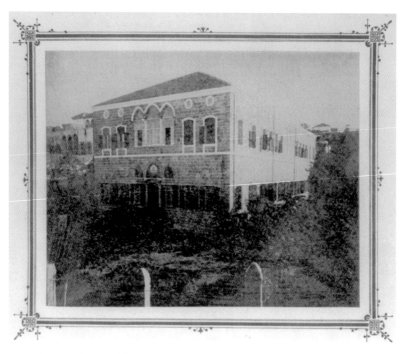

4.44 Beirut, military middle school (Library of Congress, Prints and Photographs Division).

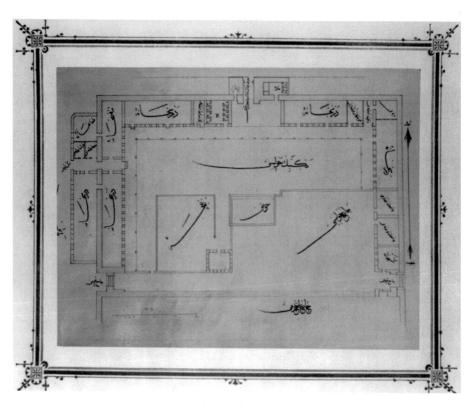

4.45 Damascus, military high school, ground-floor plan
(Library of Congress, Prints and Photographs Division).

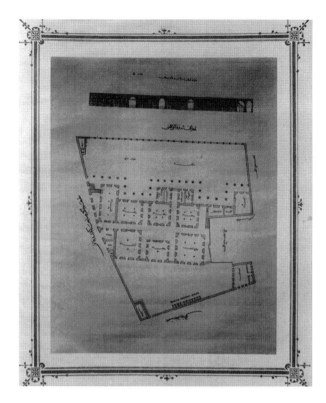

4.46 Baghdad, military high school, ground-floor plan and façade drawing
(Library of Congress, Prints and Photographs Division).

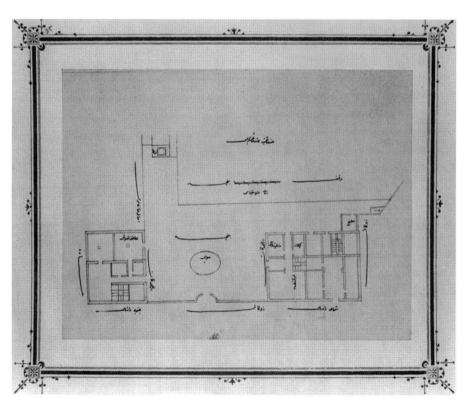

4.47 Sana, military high school, ground-floor plan
(Library of Congress, Prints and Photographs Division)

4.48 Sana, military high school (Library of Congress, Prints and Photographs Division).

the theater predated other colonial monuments, underlining the cultural presence of the occupier (see chapter 3). Theaters in other cities copied the architectural grandeur and the prominent setting of the one in Algiers. Constantine's theater (1883), with 800 seats, opened onto place Nemours with arched gates; its ornately decorated façade and interior flaunted the best marble of the region (fig. 4.50).[62] Bône's theater, on the same scale and from the same years, faced the cours National (earlier called cours Napoléon) with a similar row of gates but separated by Doric columns; arched windows, with Ionic columns between them, were stacked above the doors on the second level (fig. 4.51). Oran's theater on the place d'Armes diverted from the model with two ornate towers on the roof level, conceived of as domed pavilions. In contrast to the theaters of Algeria, which were powerful proponents of the "conqueror's style," the Tunisian examples kept their grand scale but exhibited a more playful and whim-

4.49 Sana, drawing of a "typical" building (Veli, *Yemen Salnamesi*, 1298/1880).

sical architecture. Sfax's Municipal Theater (c. 1900), with its references to the ramparts of the old city and façades covered with "Moorish" elements, is the ultimate example of this style (see fig. 3.9).

European-style drama entered Ottoman literature during the second half of the nineteenth century, with a surge of plays in Turkish. A theater was included in Dolmabahçe Palace, municipal theaters were built in Istanbul and Bursa, and the Pera

CONSTANTINE. — *Le Théâtre*

Collections ND. Phot.

4.50 Constantine, theater (postcard, GRI).

4.51 Bône, theater (postcard, GRI).

quarter of the capital was dotted with private theaters where foreign groups performed. This scene extended to the major cities of the provinces. For example, in the early years of the twentieth century, there was a theater on the east side of the Sahat el-Burj in Beirut.[63] The building type was far from representing Ottoman culture in the peripheries, however.

A CHANGING DISCOURSE FOR A NEW ARCHITECTURE: "DECORATION IS EVERYTHING" / "IN HARMONY WITH SPECIFIC TASTES AND AESTHETICS"

The broad-brush view of the architectural scene presented above points to a search for an architectural expression to represent the empire. It also brings to light the encounters with the specific character and historic heritage of the colonized territories. Architectural theory in nineteenth-century France was a well-developed field, with its own traditions, legacy, and myriad publications. The colonial *chantiers* may not have transformed it, but they certainly brought a new flexibility to it, testing and expanding its boundaries. The Ottoman case was far more complicated. The exposure to and adoption of European norms and models that accompanied the post-Tanzimat reforms inevitably came with a reevaluation of the rich Ottoman architectural past and attempts to find a synthesis between the two.[64] In the search that gained momentum from the late 1860s on, the obvious references were to the "classical" period of Ottoman architecture, that is, the great monuments of the fifteenth and sixteenth centuries, concentrated mainly in Istanbul but also in Bursa and Edirne. The surge of building activity in the Arab provinces introduced a further confrontation, one that raised questions about how to incorporate other layers of the past into contemporary Ottoman work while taking into consideration the significant regional differences. This also meant a new look at what constituted Ottoman architecture and its debts to the early Islamic and pre-Islamic traditions.

Claiming to be picking up where the Romans had left off, the French placed great value on the Roman archaeology of North Africa. They surveyed the sites, carried out archaeological research, and published their findings from the 1840s on, as exemplified in the work of Amable Ravoisié. Ravoisié's three-volume *Beaux-arts, architecture et sculpture: Exploration scientifique de l'Algérie pendant les années 1840, 1841, 1842* (published in 1846–59) documented the rich Roman remains of the colony in macro- and microscale as part of the greater project of linking the colony to the metropole historically and culturally and thereby underlining the right of conquest.[65] In contrast, the French did not value the Islamic heritage in the early decades of the occupation. The transformations to many monuments to fit new uses and their indiscriminate demolition to make room for orthogonal streets and squares exemplify this attitude. The turning point came with Napoléon III's *royaume arabe* policies advocating

a special fraternity between the French and the autochthonous peoples. Viollet-le-Duc's project for a monument to the emperor (see chapter 3) that acknowledged the Arab heritage was not the unique manifestation of the changing climate. Paralleling it, a discourse that criticized wholesale demolitions and called for the preservation of the "indigenous" towns developed from the 1860s on.[66] Meanwhile, and in part responding to the interest generated by the pavilions of the 1867 Exposition Universelle in Paris, a debate on Islamic art and architecture had entered the French discourse, bringing with it the visual representations of major buildings, mostly from the Ottoman Empire, Egypt, Spain, and Persia. The need to integrate the French possessions *outre-mer* in the subsequent fairs expanded this inquiry. For example, the Algerian Palace in the 1878 Exposition Universelle combined fragments from several monuments in Tlemcen; a replica of Mosque el-Kebir's central gate found its way to the same event as a freestanding structure. The same approach was followed in the Tunisian Palace for the 1889 exhibition with a collage of clearly identifiable elements from Tunis and Kairawan, and again in 1900, when both colonies were represented in similarly assembled structures.[67] In effect, these temporary pavilions provided rehearsal grounds for architects who would play key roles in the study of Islamic architecture and its integration into neo-Moorish buildings in Algeria and Tunisia. To name two, Saladin was the architect of the 1889 Tunisian Palace, while Albert Ballu, responsible for the Algerian Palaces in 1889 and 1900, would serve as the chief architect of the Monuments Historique de l'Algérie from 1889 to 1927.

Edmond Duthoit's *"mission architecturale"* (conducted in 1872) documented Tlemcen's urban forms, streets, monuments, and architectural details as a first step to incorporating Algeria's Islamic past into the official heritage of the colony, complementing Ravoisié's work on Roman antiquities.[68] Duthoit would go on to serve as the first director of the Service des Monuments Historiques (1880–89), the institution responsible for classifying, recording, and restoring historic monuments, including mosques and palaces. Albert Ballu's meticulous drawings that showed the buildings in plans, sections, elevations, and perspectives, along with many of their details, feature among the documents produced under the auspices of the service in the 1880s (figs. 4.52 and 4.53). Shown in the salons of Paris, the drawings called attention to the aesthetic value of Algeria's prominent precolonial monuments, such as Mosques el-Djedid and Abd el-Rahman. In a few years, the list of buildings under the direction of the service extended to smaller mosques, *marabouts* (mausolea), tombs, and fountains, as well as to larger houses from the Ottoman period.[69] Meanwhile, the increasing number of Islamic artifacts in the museums in Algeria, established by the French initially for antiquities, contributed to the valorization of the country's Islamic heritage.[70]

A significant step toward incorporating something from this architecture into the otherwise-French buildings of the Maghrib was initiated in Algeria during the

4.52 Algiers, Mosque el-Djedid, façade drawing by Albert Ballu (MHS, Fonds 81/99-01, Algérie).

4.53 Algiers, Mosque Abd el-Rahman, façade drawing by Albert Ballu
(MHS, Fonds 81/99-01, Algérie).

tenure of Governor Charles-Célestin Jonnard. He stipulated in 1906 that all public buildings would be given an "Oriental style . . . in harmony with the monuments left in the colony by Arab civilization and with the light and gracious works that inspired in Algeria memories of Byzantine art,"[71] interestingly citing a Christian heritage in order to give Islamic art and architecture a veneer of respectability. In Tunisia, the desire to create an architecture that would be specific to the place had emerged immediately after the conquest. The decision not to cut through the precolonial town was accompanied by a romantic embrace of its architectural forms. One admirer "dreamt of the heart of the city with its great palaces, palaces in marble, ornate small columns, polychrome balconies, and an architecture that is impossible at home but realizable in the country of magicians and genies."[72] Saladin, the architect of many neo-Moorish buildings in Sfax, attributed the success of Arab architecture to the treatment of surfaces with beautiful tiles as "cladding." "On a reductive building," he commented, "ornamentation is nothing but a veneer, or even simply painting. . . . Arabs are the past masters in this art of veneering and their tiles are beautiful."[73]

The neo-Moorish buildings included in the kaleidoscopic view offered above utilized pieces of the precolonial architectural heritage exactly as "veneer," without any inquiry into its spatial and architectonic characteristics. The theoretical debates, the scholarly documentation, and the easy accessibility of the monuments in the colonies did not change much about the French discourse on "Islamic" architecture from the 1860s to the first decade of the twentieth century. Charles Edmond's statement in 1867 that "In an Arab building, decoration is everything, and the beauty of the ensemble depends on the harmonic and difficult fusion of details,"[74] maintained its authority, to be endorsed by Viollet-le-Duc, who argued that "from time immemorial . . . Arab conquerors lived in tents. . . . They had no luxury other than fabrics and weapons. For them, as for the Jews of the primitive period, the monument was nothing but the tent, the hut, covered with a precious fabric."[75] Calling for a halt to the proposed changes to the Résidence des Evêques, an already much-transformed Ottoman palace in Algiers, Charles Chevalier, the architect in charge of the conservation of historic monuments, described the positive qualities of its courtyard solely as "decorated with plaster and marble sculptural elements, tiles, and bronzes, representing the best that Moorish art produced." The Service des Monuments Historiques continued to praise the decorative elements in buildings to be classified for preservation: for example, Mosque Abd el-Rahman offered "some curious details" in its minaret and surrounding stairs, and its *zawiya* distinguished itself with a large number of "beautiful Persian tiles."[76] The French practice in Algeria and Tunisia, then, remained faithful to this enduring reading of "Islamic" architecture by creating a surge of buildings with an Islamic veneer and details; they maintained their "European" character in all other aspects.

Ottomans had, of course, built monuments in Arab provinces under their names

since the sixteenth century. The post-Tanzimat construction scene represents both continuity and novelty. Studying fifteenth- and sixteenth-century Ottoman drawings, Gülru Necipoğlu-Kafadar has shown that architectural ideas were disseminated effectively throughout the empire by grid-based ground plans, accompanied by imprecise elevation sketches. This was in accord with the Ottoman attitude that accepted variations in façades and interior treatments in response to local traditions while expecting that the ground plans would remain faithful to the plans sent from the capital.[77] The nineteenth-century practice seems to have been based on this earlier tradition, leading to the production of government palaces and schools, for example, with similar plans but different elevation treatments, the latter stemming from the use of local materials, forms, and decorative elements. The big change was in the shifting of construction activity to secular building types. Nevertheless, mosques and other religious structures, expressing regional characteristics, continued to be funded by the government, with a considerable surge during the Hamidian period.[78]

Other developments began to lead the way to rethinking regional differences so that they would coalesce into a larger entity under the banner of the empire and give the Ottomans a modern national definition based on multiplicity. The appropriation of pre-Islamic heritage, in the footsteps of the European interest in antiquities, played an important role. Laws were passed to prevent the smuggling of antiquities (the first law dates from 1874; it was revised in 1884), Ottoman inspectors controlled the activities of foreign archaeologists, Ottomans conducted their own excavations (most notably Osman Hamdi's work), and the artifacts transported to Istanbul were displayed in museums, leading to the establishment of the Imperial Museum, "similar to those in other civilized countries."[79] As argued by Makdisi, claiming antiquities as part of the Ottoman heritage turned around the European metaphor that equated the ruinous state of ancient remains with the decline of the Ottoman Empire, in an attempt to endow the empire with a layered and complex history.[80] This also meant linking the empire to the European cultural heritage, emphasizing its current modernity. The neoclassical architecture of the museum in Istanbul stated the connection explicitly.[81]

Knowledge about archaeological excavations and sites was collected and disseminated in the empire in other ways as well. For example, Abdülhamid's photography albums were filled with images of antique sites, and publications informed the public in various formats. *Servet-i Fünun* included reports and photographs in the 1890s.[82] *Salname*s consistently reported on the *asar-ı atika* (old works) of the region; they sometimes gave detailed descriptions but often provided only annotated lists. Mehmed Refik and Mehmed Behçet's *Beyrut Vilayeti* was a comprehensive presentation. After a brief introduction underlining the vast construction activities of all the past states established in Syria and attributing their current ruinous state not only to the many wars but also to the "ignorance of Syrian people," the authors gave sum-

maries under five categories: "prehistoric," Assyrian, Phoenician, Greek and Roman, and Arabic, highlighting the key monuments from each period, such as the palaces and temples built by David and Solomon from the prehistoric period, the Greek kings' tombs in Saidon, and the Roman towns of Tedmur, Baalbek, and Gerash, with their landmark "rows of columns that crossed the entire settlement from one gate to the other."[83] The embracing of this historic diversity explains much about the regional references in the new imperial architecture.

Refik and Behçet's discussion of an "Arab" period points to its perception by Ottomans as distinct from their own culture. They argued that the initial reliance on "Yunani" (Byzantine) architects explained the similarities with "Western and Christian" styles, but later Arab architecture developed its own forms, characterized by domes, courts open to the sky, and stalactite decorations.[84] *Salname*s revealed the hierarchy of "Arab" monuments, not surprisingly, ranking the old central mosques, for example, the Great Mosque of Damascus, above others. Furthermore, the museum conducted archaeological work on a late-eighth- to early-ninth-century Islamic site, extending the mission of the discipline beyond antiquity and acknowledging the cultural and artistic importance of the early Islamic era. Raqqa, the sometime residence of Harun al-Rashid on the Euphrates River to the west of Aleppo, was excavated in 1905 upon the orders of Osman Hamdi, then director of the museum, and under the supervision of Theodor Makridi, an Ottoman-Greek numismatist (fig. 4.54). The artifacts from the site—china and pottery—were transported to Istanbul and given an entire display hall in Çinili Köşk (the Tiled Kiosk), an annex to the museum across from the new building.[85] The museum had opened an Islamic Arts Section in 1889, and despite its relatively slow growth in comparison with the Greco-Roman-Byzantine collection, the scholarly interest in Islamic culture echoed Abdülhamid's pan-Islamist policies. It also celebrated the "Arab civilization" for its great contribution to the "advancement of knowledge of science and literature and arts across the world" and acknowledged it as another layer of the empire's complex heritage.[86]

An awareness of the historic specificities of the "Arab" period surfaces in the debates around the restoration of the Great Mosque of Damascus. While it was routine to repair all major monuments, the rebuilding of the Great Mosque, burned in a major fire in 1893, was a task of a different magnitude that stimulated discussions about stylistic issues and attracted public attention to early Islamic architecture (fig. 4.55).[87] Caused by the sparks from the braziers and *narghile*s of the workers making some minor repairs in the building and spread quickly by brisk winds, the fire had moved from the mosque to the fabric around it, destroying 175 shops and 26 houses within 45 minutes. The mosque was entirely ruined, its columns broken into small pieces and its walls so weakened that they were in danger of collapsing at the first rain.[88] The initial restoration project, undertaken by Evkaf-ı Hümayun (Office of Imperial Endowments), reconceived the "interior and exterior design [of the mosque]

Rakka
Vieille porte de Bagdad

مرقة
باب بغداد

4.54 Raqqa, Baghdad Gate (Dr. Jean-Alexandre Otrakji, www.mideastimage.com).

entirely according to the new-style architecture."[89] Assuming a controlling role over the totality of the empire's cultural and artistic heritage, the Directorate of the Imperial Museum challenged this position and proposed a scholarly approach to the restoration of historic monuments. This shift was no doubt influenced by European discourses on restoration and preservation of the time, especially by Viollet-le-Duc's advocacy of remaining faithful to original structures,[90] but it also meant an informed reading of early Islamic architecture.

Osman Hamdi, the director of the museum, explained that the Office of Imperial Endowments aimed to clear out all historic elements of the mosque, including the marble decorations and columns that lined the large courtyard, and replace them with new pieces fabricated according to patterns taken from the surviving parts of the building. Yet, he argued, the extraordinary historic importance of the mosque mandated the kind of restoration that would return it to its original architectural and artistic state. To this end, it was essential to repair the damaged columns and all other fragments. Even from the economic point of view, restoration was more advantageous than new construction.[91] The museum's authority was acknowledged in the immediate assent to rebuild the Great Mosque according to its original form, using the restored original pieces.[92] The director then voiced the need for "perfect plans and drawings of the building according to scientific methods"[93] and demanded that an architect be appointed to the job.[94] Eight years later, *Servet-i Fünun* published a series of photographs that provided a comprehensive documentation of the almost-completed restoration. The photographs depicted general views of the interior and the courtyard, the *mihrab, minbar,* doors, columns, and mosaics—meticulously restored to their original forms. One photograph emphasized the complicated process: the transportation of columns, repaired elsewhere, through the city streets by means of a carriage designed specially for the task (figs. 4.56–4.58).[95] Collectively, the photographs

4.55 Damascus, Great Mosque of Damascus, after the fire
(Fine Arts Library, Harvard College Library).

conveyed the magnificence of one of the earliest mosques, whose pre-Ottoman histo-ricity was obvious from its name: Emeviye Camisi, the Umayyad Mosque. The invest-ment in the restoration and the attention paid to details, strikingly different from those of Istanbul mosques, emphasized the cultural and aesthetic value of the monu-ment. Its furbishing, which included 400 square meters of new rugs specially woven in factories in Hereke (to the east of Istanbul), reiterated the impressive scale of the operation.[96] This was an imperial endeavor that incorporated the "Arab" past into present-day Ottoman identity, capitalizing upon the visibility of a major monument.

Attempts to represent the empire comprehensively at universal exhibitions con-tributed to thinking about regional characteristics. In that vein, a "Palace of Damas-cus" was included in the Ottoman village at the World's Columbian Exposition in Chicago in 1893. The pavilion displayed an amalgam of Damascus's public and pri-vate architecture, with its monumental entrance quoting the great khans. A richly decorated room, surrounded by a wide divan on all sides and with a marble-paved

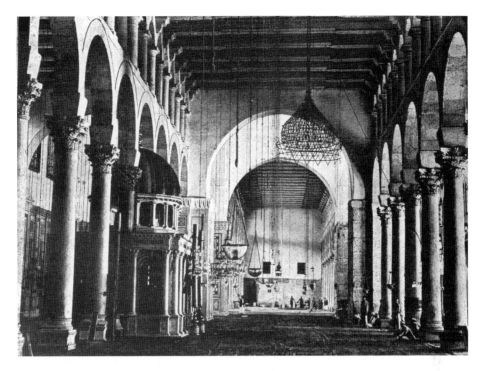

4.56 Damascus, Great Mosque of Damascus, interior view after restorations
(*Servet-i Fünun*, no. 597 [1318/1902]).

vestibule with a fountain, brought the most admired features of the city's mansions
to the new world. The main Ottoman pavilion in the same exhibition, a strikingly
modern building in its massing and overall composition, presented a more synthe-
sized vision of Syria: the wood panels of its façades, "carved in arabesques and tracer-
ies," were fabricated in Damascus by local artisans.[97]

In accord with these developments, the late-nineteenth-century Ottoman archi-
tectural discourse expressed sensitivity toward regional expressions while searching
for a modern language that would embrace the historic and geographic multiplicity
of the empire. This was a new genre, struggling with birth pains and dealing with
difficult issues. Fragmented and often inconsistent with each other, the debates were
spread over reports to the government and articles in periodicals of general interest
(*Mecmua-yı Ebuziya* and *İkdam*) and specialized ones (*Revue technique d'Orient*), as
well as in a few books. An undated document from the Hamidian period, titled
"Unsigned Summary Report on the Development of National Fine Arts and the Pro-
vision of Opportunities," crystallized two trends that pertain to my inquiry in this
chapter: the definition of Ottoman architecture and an understanding of regional
differences.[98] With the disappointing current state of Ottoman fine arts as its depar-
ture point, the exposé investigated the "national fine arts in Ottoman lands" and,
briefly surveying the development phases of each branch (architecture, painting,

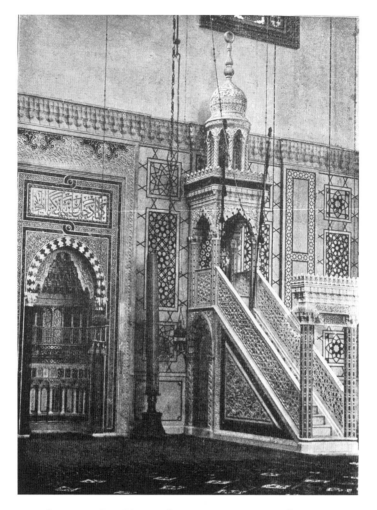

4.57 Damascus, Great Mosque of Damascus, interior view after restorations
(*Servet-i Fünun*, no. 597 [1318/1902]).

carving, pottery, tile making, etc.), offered venues to rejuvenate them. The Ottoman
"science of architecture" (*fenn-i mimari*) was considered a synthesis of Roman and
Byzantine structural experiments (construction of domes and large arches) and Arab
and Persian decorative ingenuity—the associations characteristically mirroring the
European discourse. Scrutinizing recent buildings in the capital led to the conclu-
sion that their overwhelming hybridity was nothing to be desired. Being "neither
Turkish nor Arab nor Gothic," they exemplified an era completely lacking in charac-
ter. The alternative was some kind of purity, dependent on local architecture.

In an 1896 article, titled "Old Ottoman Style Decoration and Contemporary Deco-
ration," Ebuziya Tevfik also argued for regionalism in architecture: "different peoples
have different architectural styles in harmony with their specific taste and aesthet-
ics." The differences applied to history, as well as to current architecture—as best

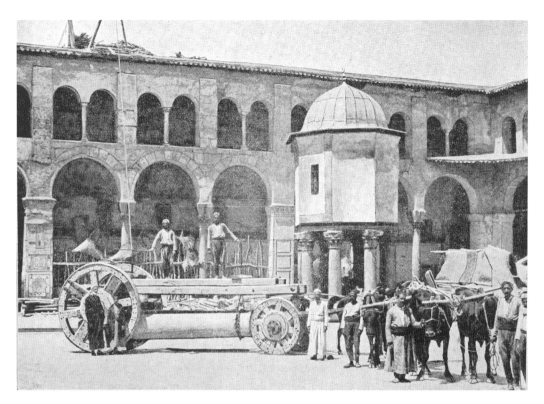

4.58 Damascus, Great Mosque of Damascus, view of the courtyard during restorations, showing the transportation of columns (*Servet-i Fünun*, no. 598 [1318/1902]).

illustrated in Europe by the multiple Gothic traditions developed by Germans, Italians, French, and English. In his survey of historic styles, the author listed the "Oriental" one (*Şark uslubu*), collapsing into it Arab, Persian, Indian, and Central Asian cultures, and, echoing the previous document, attributed its originality to interior treatments. He noted that in the late nineteenth century, the Oriental style had been revived in the "Moresk," an interpretation of the forms developed by the "conquerors of Andalusia" to suit new tastes.[99]

Celal Esad, arguably the first Ottoman "art historian," offered a more systematic view, first in a series of articles, then in his books. Concerned also with the state of the art, his goal was to retrieve the legacy of Ottoman architecture and to revive it in contemporary practice. He began by criticizing the reductive European assumption that made no distinction between Persian, Arabic, and Ottoman art.[100] Focusing on "Arab art," he deconstructed the contradictions in the European discourse that denied artistic creativity and originality to Arabs on the one hand and maintained on the other that Arabs were superior to Romans in their artistic and scientific achievements—opinions expressed in Gustave Le Bon's *Civilisation des Arabes*. Esad showed that, regardless of their different positions, European authors agreed on the derivative

nature of Arab art, seeing it as an imitation of Syrian Byzantine and Coptic forms. This was a major error, based on a general misunderstanding of all artistic formations, because the arts of all peoples developed in response to each other, revealing "profound and continuous influences." He asked: "Can there be an art with no parentage?" Yet, the character of each culture manifested itself in its own synthesis. For example, even a quick comparison of Arab and Ottoman buildings revealed significant differences in the forms of columns, arches, capitals, and domes, as well as the ensemble of compositions: the "severe simplicity" of Ottoman architecture distinguished it from Arab precedents and owed something to the Byzantine tradition. As to the decoration, the Ottoman examples were a great deal more "somber" and not a literal imitation of Arab forms.[101]

Celal Esad elaborated further on "national styles" (*milli üslub*) in the introduction to his *Mimari Tarihi* (History of Architecture) and attributed their genesis to the climatic and natural conditions of the place, the material and spiritual needs of the people, as well as their specific tastes—all interconnected. To explain cross-cultural influences, he made an analogy to plants that transformed their shapes from one climate to another and argued that wars, artists imported from other countries, and slave workers brought new forms and interpretations, contributing to the "national culture" of a particular place. Using "national style" synonymously with "style of the race" (*ırkın üslubu*), he gave it a dynamic character that stemmed from the changing times and the individuality of the artists.[102]

The debate on the character of Ottoman architecture continued up until the eve of World War I, pursuing similar arguments—as manifested by several articles in *Revue technique d'Orient*. Ottoman architecture had interpreted the "svelte" lines of Byzantine monuments but received its inspiration for details and decoration from "Arab buildings of the Umayyads and Fatimids, notably in Damascus and Cairo," to create an effect of "marvelous delicacy." In short, "Ottoman architecture was the quintessence of Byzantine architecture Islamized in its ensemble and dematerialized in its details."[103] The Arab and Persian influences had shaped the essence of Ottoman architecture, as revealed in the new Central Post Office in Istanbul by Vedad Bey (pl. 29), which attested to the complexity of Ottoman "national character" in architecture. In this important building, Vedad Bey did not present his references literally but explored the ideas behind them. The Central Post Office thus served as a corrective to the buildings produced by the current *"écoles de Moghreb"* and implicitly urged comparison with the post office in Algiers.[104]

Fragmented, repetitive, brief, incomplete, and often derivative, such arguments help explain the regionalism observed in the public architecture of the Ottoman Arab provinces. Thus, for example, the Ionic columns of the governor's palace in Jaffa and of the monument to the Hijaz Railroad and telegraph in Haifa embraced the region's Greco-Roman history; the medieval towers that adorned the roof of the police station

in Aleppo and the Government Palace in Beirut incorporated the crusader castles into the imperial repertoire; the Hospital for the Poor and the military high school in Sana acknowledged and claimed the beauty of the Yemeni vernacular. Collectively, they drew an image of the Ottoman Empire that was dynamic, rich, and varied in its historic and cultural resources, while remaining respectful of regional differences.

5

AFFIRMING EMPIRE: PUBLIC CEREMONIES

Public ceremonies have a long history of establishing and asserting authority by taking "symbolic possession of their realm." The nation- and empire-building enterprises of the nineteenth century transformed them into new phenomena. The previous chapters examined some of these "invented traditions" that encompassed urban spaces and built forms. Hobsbawm has argued that such inventions happened more frequently "when a rapid transformation of society weakens or destroys the social patterns for which 'old' traditions had been designed."[1] The French and Ottoman empires were both experiencing intensive transformations during the time period covered in this study. To register and legitimize the changes, they capitalized on the support of recently formulated "traditions" or created them on the spot. Paris and Istanbul staged the lion's share of public ceremonies, but I would argue that the effects were even more pronounced in France's colonies and the Ottoman provinces, where the ruptures were more extreme because they were imposed on "indigenous" populations.

Public ceremonies celebrated jubilees, days of religious importance, official visits, the inauguration of infrastructure projects and monuments, and the laying of cornerstones and foundations of buildings. They could include speeches, temporary structures, military presence, flags, coats of arms, and music, coalescing into an amalgam of symbolic forms that expressed the "political center."[2] They reveal much about

the idea of empire, complementing the main themes of this book. In her remarkable study of the festivals of the French Revolution, Mona Ozouf pointed to the uniformity of public celebrations, which distinguished them from earlier examples. She gave the sequence: "A procession of national guardsmen and regular troops, marching, often outside the town, to attend an open-air mass, stopping for speeches, . . . for the blessing of the flags, for the taking of an oath. The procession would then come back to the Municipal Building. . . . This was often followed by the lighting of a bonfire, and sometimes, in the evening, . . . a ball and fireworks."[3] The format seems to have acquired a significant authority thereafter, shaping public ceremonies regardless of ideological and cultural differences. Their "undefined universality," again to quote Hobsbawm, united them across huge territories, but their adaptations to regional conditions explained their manipulative potential. Their repetition in various formats reinforced the imperial message; their recording and wide dissemination by means of publications carried the impact beyond those present at the events to a much larger public.

The symbolism of the ceremonies cannot be separated from their locales. Open-air spaces that could hold large crowds were essential and could be transformed by temporary structures, as well as the order of the parades, the regimented grouping of the troops and the students from local schools, and miscellaneous paraphernalia. Permanent celebratory monuments enhanced the messages. Public buildings provided excellent backgrounds with their impressive symmetrical masses, axial orientations, architectural decoration, and symbolic associations. Furthermore, they often defined newly opened public squares, which were complemented by wide and straight thoroughfares, all accommodating processional movements.

The universal character of the public ceremonies did not prevent historic, social, and cultural differences from lending them local color. The systematic "official feasts" that celebrated the French Revolution and that were used as "didactic instruments to create desirable attitudes" had their background in the *fêtes des rois* going back to the fifteenth century.[4] When the French ceremonies crossed the Mediterranean to Algeria and Tunisia, their didacticism shifted to address colonial conditions. The late-nineteenth-century Ottoman ceremonies may have been shaped to a great extent by the new European traditions, but they also incorporated elements (such as prayers) from their own history, for example, from the yearly repetition of the *cülus* (celebrations on the anniversary of the sultan's ascension to the throne, a tradition established in 1862) and the public celebration of religious holidays (Eid al-Fitr and Eid al-Adha) that historically united the empire. In turn, the older ceremonies were transformed by elements from the new traditions. Prior to the establishment of telegraph lines, the completion of *cülus* ceremonies throughout the empire could take as long as one month due to delays in communication of documents from Istanbul, but they clearly targeted the entire population in an attempt at unification: *firmans* (imperial

decrees) were opened and read in public, often following the Friday prayers and accompanied by prayers for the health of the sultan.[5] Technology synchronized the delivery of the *firman*s, and the use of similar paraphernalia (temporary structures, flags, etc.) homogenized the celebrations. However, nineteenth-century Ottoman ceremonies maintained another historic continuity: they were all-male affairs, a phenomenon paralleled in North Africa, where Muslim women did not attend public French ceremonies. This chapter will discuss a selection of ceremonies from both empires, ranging from the sumptuous to the vernacular.

THE EMPEROR AND THE SULTAN: "UNDER THE WINGS OF AN EAGLE" / "PADİŞAHIM ÇOK YAŞA"

Napoléon III's second visit to Algiers in 1865 lasted 40 days and prompted a series of public ceremonies choreographed to support his policies of an "Arab kingdom." If Viollet-le-Duc's attempt to translate the emperor's vision into architecture did not materialize, temporary structures that dotted the processional routes he followed throughout the country recycled its main theme of synthesis between French and Arab architecture. The triumphal arch, a Roman building type, was refashioned to symbolize the French conquest of Algeria. In Algiers it took the form of an elaborately domed pavilion carried on four pairs of classical columns and lobed arches, with all surfaces carved in arabesque patterns. A spire topped with a crescent rose above the dome and terminated the structure with another "Islamic" touch, but the four open-winged eagles on the four corners indicated the French presence.[6] The arch in Mostaganem, a coastal town between Algiers and Oran, used a tripartite model, keeping the classical round arches on two sides but transforming the central one into a large triangle, divided into smaller, playfully hanging arches; again, a crescent defined the highest point (fig. 5.1). Blida's arch had two openings and was decorated with bas-relief laurels and topped with an open-winged eagle.[7] In Oran the Spanish and Italian communities built separate arches on the same thoroughfare, the former neoclassical with a flat roof, the latter an "Islamic" dome sitting on lobed arches (fig. 5.2).[8] The *"arc de triomphe des indigènes"* in el-Kantara was a vernacular affair: a single arch was covered with a colorful fabric, and a French flag was placed at its peak (fig. 5.3). But it was Constantine's grain merchants who built the most idiosyncratic of the arches for the emperor: it was composed of sacks of their products (fig. 5.4).[9]

Ceremonies began in Algiers with the disembarkation of the emperor from his boat, *L'aigle* (the Eagle), onto an "elegant" platform designed for the purpose. An illustrated book, published on the occasion and itself representing another invented tradition, described the event. In addition to over two thousand cavalry and Arab *goums* (irregular indigenous soldiers in the French army) lined up neatly on the embankments below the boulevard de l'Impératrice, a mixed crowd of more than

5.1 Mostaganem, triumphal arch for Napoléon III erected by Muslims
(Pharaon, *Voyage en Algérie*, GRI).

twenty thousand people met Napoléon. The crowd was composed of "two perfectly distinct elements, the Europeans and the *indigènes*." The former included all nationalities of Europe, not in their uniform, black "boulevard" costumes, but wearing their original and "often picturesque" outfits. The indigenous population was "remarkable in type and bizarre in costume." At the sight of the emperor, the crowd exploded into

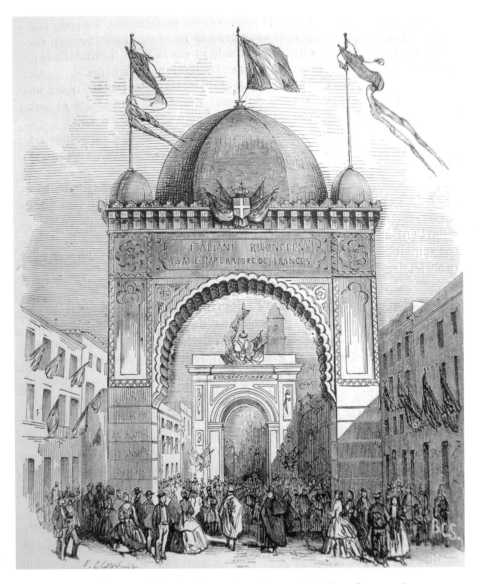

5.2 Oran, triumphal arches for Napoléon III erected by Italians (foreground)
and the Spanish (background) (*L'illustration* 45, no. 1163 [1865]).

cheers. The emperor responded with his famous speech that addressed the settlers, assuring them protection and asking them to treat the Arabs as their compatriots, and that ended with a salute to "the French flag and the Cross, where the sign of civilization, peace, and charity [were] harbored." The emperor then proceeded on his horse across the ramp that took him to the place du Gouvernement.[10]

The ideological dimensions of Napoléon's visit were evident at many venues, and great weight was placed on the favorable Muslim reception, described colorfully in text and image. In a blatant act of manipulation, a long poem by an Arab poet

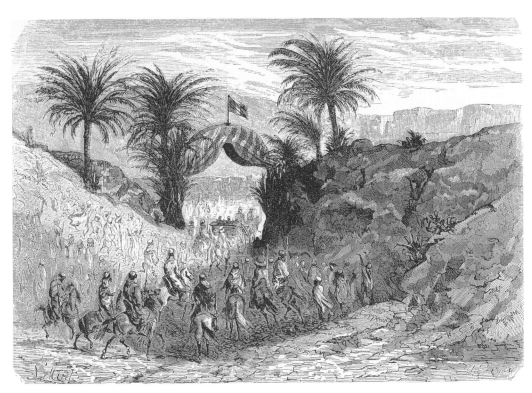

5.3 El-Kantara, triumphal arch for Napoléon III erected by the "indigenous" inhabitants (Pharaon, *Voyage en Algérie*).

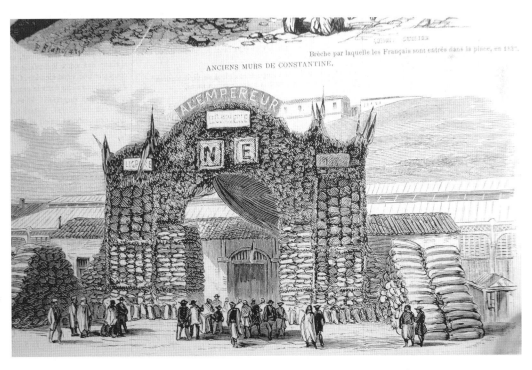

5.4 Constantine, triumphal arch for Napoléon III constructed by the grain merchants from sacks of grain (*L'illustration* 45, no. 1195 [1865]).

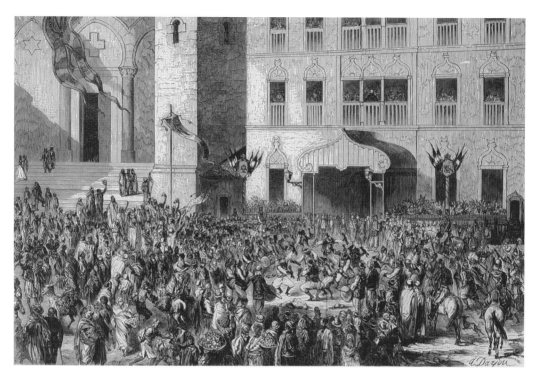

5.5 Algiers, "indigeneous" performances for Napoléon III
(Pharaon, *Voyage en Algérie*, GRI).

applauded the idea of the *royaume arabe:* "The Arabs said to the emperor: 'May God keep you victorious! We submitted ourselves to your government, and the love we have for you will never be erased from our hearts." As though expressing the wishful thoughts of the French authorities, who were faced with recurring insurgencies, the poem continued a few pages later, "I want to live in tranquility under his law, to be under his wings of an eagle";[11] the reference to the eagle illustrates the strategy of reinforcing the symbol from yet another perspective. Performances that accompanied the innumerable ceremonies supported Napoléon's mission (fig. 5.5). They included music; for example, a piece titled "Les enfants de l'Algérie" was composed for the occasion and played by the "Orphéon d'Alger" (the band of Algiers), which included the French, Muslims, "indigenous Israelites," Italians, and the Spanish in a representation of the entire colony.[12]

The coverage of Napoléon III's trip to Algeria in the immensely popular periodical *L'illustration* reveals the event's importance for the metropole.[13] Seven sequential issues, from 13 May to 24 June 1865, gave day-by-day accounts, accompanied by many drawings. The descriptions were typically in a matter-of-fact tone, reporting on the emperor's daily schedule, but every now and then diverged into detailed descriptions of his reception by Algerians. This was an assertion of the completed conquest of the

colony and the *royaume arabe* policies, as clearly stated in the pages of the journal that called its readers to pay attention to the "political importance of the excursion and the hopes that it raised." According to *L'illustration*, both the European and the indigenous people in the colony appreciated the presence of the emperor, because everybody understood that the situation in Algeria had to change; Napoléon III's policies aimed to correct the "tremendous errors" committed so far.[14] The emperor's proclamation to Arabs, posted on all major street corners in French and Arabic, thus produced a "profound sensation." Without referring to the enormous public-relations campaigns (as well as promises and bribes) to entice Arabs to the celebrations, the journal stated that "the emperor's presence in Algiers had made Arab chiefs of all ranks from the tribes in the provinces run [to the capital]," creating a colorful temporary tent city outside Algiers. Algiers was suddenly "full of Arabs of all classes and occupations," gathered to see "the *Sultan* of the French."[15] The periodical maintained that the same enthusiasm accompanied the emperor throughout his voyage—as expressed, for example, by the tribal chiefs who met him outside Médéa with their horsemen and escorted him to the city.[16] *L'illustration* used the occasion of the emperor's visit to describe Algeria to its readers. Algiers dazzled with its public spaces (brightly lit at night), quays, and impressive buildings. The Mitidja Plain boasted several factories. From Blida to Médéa, the emperor's route followed "the most picturesque countryside in the world," passing "perfumed gardens," orchards, fertile plains, and marvelous gorges and waterfalls.[17]

The images told the same stories even more vividly. The facts of the trip were conveyed by scenes such as the departure of the imperial yacht from Marseilles, the arrival of the emperor on the quays of Algiers, his procession to the place du Gouvernement on the same day, his arrival in and departure from other cities, and his visits to agricultural areas. Depictions of Arabs involved in various ceremonies occupied ample space in the pages of the journal and gave the impression of a uniformly enthusiastic welcome, extending from the capital to smaller towns and villages in the mountains and the plains. While these images served as evidence of the acceptance of Napoléon III by the Arabs, myriad drawings of "indigenous types" attempted to familiarize the metropole with the local population, and city and landscape views helped turn Algeria into a concrete reality through visual representations.

Ottoman sultans did not visit the Arab provinces; the nineteenth-century ceremonies where they appeared in person remained limited to the capital. Some of these elaborate affairs, such as the one-time *kılıç kuşanma* ("swording"; literally, being equipped with the sword, which represented imperial power) and the *muayede* to celebrate the two yearly religious holidays (*bayrams*), went back centuries but acquired new elements. Others, notably the weekly *selamlık* following the Friday prayer, originated in the nineteenth century.[18] Upon imperial orders, the important ceremonies in Istanbul were to be matched by similar ones in the provinces: official holidays

would be declared, cannons fired, and cities embellished with flags and banners. The establishment of telegraph lines facilitated communication between the capital and the provinces, allowing for synchronized celebrations that contributed further to the unity of the empire. The growing number of periodicals enabled the dissemination of news on various celebrations throughout Ottoman lands.[19]

Servet-i Fünun's "Padişahım Çok Yaşa" (Long Live the Sultan) issue on Abdülhamid's jubilee is a striking example (pl. 30). The cover page itself marked the special nature of the event by switching from its usual format of a black-and-white photograph and typography to an image in color. Framed by an Ottoman arch, it showed Istanbul's famous skyline in gold, with paper lamps in different shapes and colors in the foreground, evoking the festive decoration of the city. Above the arch, red writing on a black background described the occasion and dominated in its boldness the title of the journal below. Inside, the main topic was the Hijaz Railroad, a project that had become an essential aspect of the sultan's image. The photographs presented the inauguration of the Damascus–Maan line and depicted the visit of the "honorable committee" from Istanbul, but more significantly, the journal gave a detailed financial account of the project from its initiation to the date of the jubilee, taking the enterprise beyond the ceremonial to its monetary reality and emphasizing imperial bounty.[20]

Abdülhamid may have never traveled to Syria, but the visit of his imperial guest Wilhelm II in 1898 echoed the format of the Hamidian ceremonies, as well as those held for Napoléon in Algeria. *Servet-i Fünun* gave a detailed account of the activities of the German emperor and his wife, from their departure from Istanbul on their imperial yacht to their visits to various sites, including the Haram al-Sharif in Jerusalem and the Great Mosque and Azem Palace in Damascus. The processional routes they followed were decorated with flags and banners, as well as occasional arches. The triumphal arch in Jerusalem had a minaret on each side (fig. 5.6). Two structures became permanent memorials of the imperial voyage: the German church in Jerusalem opened by Wilhelm II and a richly decorated marble tablet set up in Baalbek, a gift from the sultan bearing inscriptions that commemorated the visit (fig. 5.7).[21] The range of ceremonies in Damascus alone attested to the multiplicity of the Ottoman image presented to the German emperor: at one end of the spectrum, Governor Nazım Pasha hosted a reception in his salon, which was decorated in the latest European style; at the other, Bedouins engaged in ritual performances with swords on the backs of horses and camels (*cirid*).[22]

Postcards also served as effective means to commemorate imperial rulers and ceremonies. This visual genre had been exploited in its full potential in France, as evident in the sheer quantity of postcards of Napoléon III. It also penetrated the late Ottoman Empire. Despite Abdülhamid's ban on his image appearing in public spaces, the sultan entered the public realm on several postcards: his frontal photograph

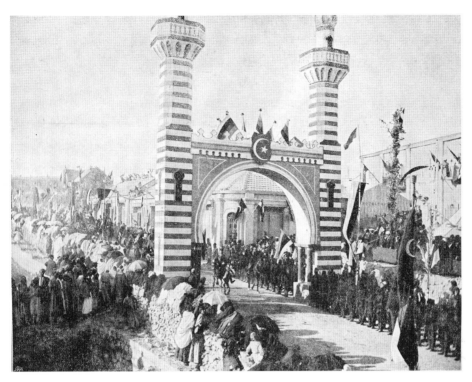

5.6 Jerusalem, triumphal arch erected for Wilhelm II's visit (*Servet-i Fünun*, no. 403 [1314/1898]).

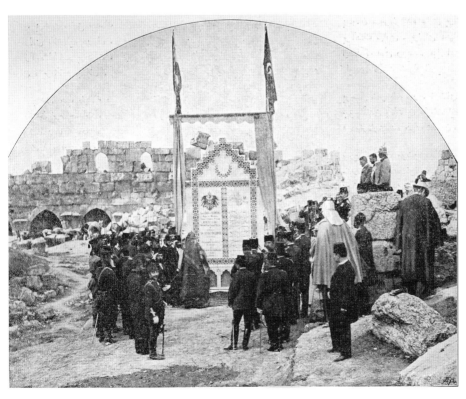

5.7 Baalbek, marble tablet erected on the occasion of Wilhelm II's visit
(*Servet-i Fünun*, no. 403 [1314/1898]).

framed by flags, with his *tuğra* at the bottom, his semiprofile paired with Wilhelm II to commemorate the kaiser's visit, and in his carriage on the streets of Istanbul to celebrate the proclamation of the 1908 constitution. Sultan Reşad appeared much more frequently, with postcards that depicted his *cülus* celebrations, his carriage rides on Hagia Sophia Square, outings on the imperial boat on the Bosporus, as well as many frontal portraits, some with his sons.[23]

<div align="center">

CELEBRATING THE HIJAZ RAILROAD:
"ANNOUNCE TO THE UNIVERSE"

</div>

The innumerable occasions for celebration offered by the Hijaz Railroad reinforced its unique status among the imperial projects, and press coverage kept interest in its progress alive over the years and across long distances. The start and completion of any given stretch, any bridge and tunnel, and any station created another chance to affirm the greatness and benevolence of Abdülhamid, his commitment to the Arab provinces, as well as the unification of the empire and its new identity that blended modernity and technological advancement with tradition. The systematic recording of the construction in the press and in photography albums, in addition to memorabilia such as medals and stamps, carried the message far and wide. A random selection of moments from the process will aid in understanding the images, discourse, and complex agendas of the "holy line." The mixture of secular and religious elements, observed not only in the case of the Hijaz Railroad but also in all other ceremonies during this time, was a hallmark of the late Ottoman Empire. A similar coexistence had also marked the French context, extending as far as the secular festivals of the Revolution that became associated with religious ceremonies.[24] The uniqueness of the Ottoman case was in combining Islam with modernization in the public realm.

On the stretch of railway from Mezeirib to Dara (south of Damascus) two events were highlighted. The first was the completion of the piers of a stone bridge: under a temporary wooden arch decorated with flags and branches, Nazım Pasha, the governor of Syria, and Kazım Pasha, in charge of the construction administration, delivered speeches. The second was the decision to build a station in Dara, marked on the spot by speeches by the same pashas and prayers.[25] A few months later, the completion of the Dara–Zerka branch was celebrated by another temporary structure, similarly adorned, in front of the new Dara Station, as well as a speech by Kazım Pasha and prayers by the *müftü* (chief of religious affairs) of Damascus (fig. 5.8).[26] The modern uniforms of the high officers, medals crowding their vests, the traditional garb of the religious leaders, and the flags on high poles reinforced the idea of the empire (fig. 5.9). In two years, the Maan branch came into focus, with inaugural ceremonies

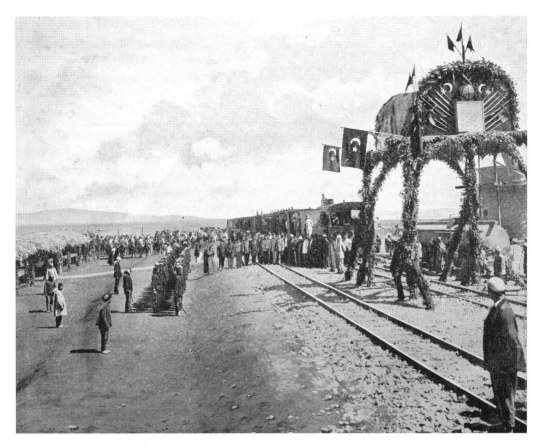

5.8 Dara, temporary structures to celebrate the completion of the Dara–Zerka branch
of the Hijaz Railroad (*Servet-i Fünun*, no. 599 [1318/1902]).

attended by members of the high committee from Istanbul, prominent local officers
(among them Nazım and Kazım Pashas and Halil Pasha, the governor of Beirut),
zevat-ı kiram (illustrious individuals, who had arrived from Medina on horses), Syr-
ian notables, and local residents, including Bedouins and elementary school stu-
dents. Speeches were made, prayers said, and medals distributed.[27] The ceremonies
marking the arrival of the line to Medina in 1907 "announced [the event] to the uni-
verse" with permanent records: the poems and prayers recited on the occasion were
carved on marble plaques and placed in appropriate places in Medina and Damascus
and on the façades of certain buildings, including the entrances to train stations.
They also were disseminated by means of the press. Along with Koranic verses, the
poems composed for the occasion emphasized the imperial goal behind the project
as being "nothing else but charity." One summarized the enterprise: "Hamidiye
Hijaz Railroad is excellent news for pilgrims / Sultan Abdülhamid succeeded in this
holy way." Pilgrims would now be able to reach their destination in security.[28]

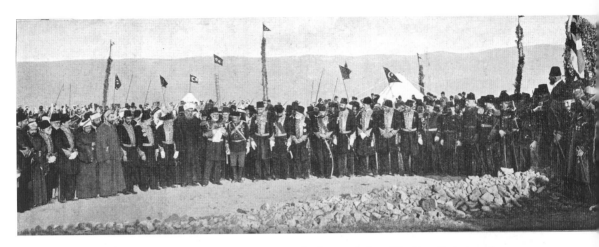

5.9 Dara, inauguration ceremonies for the completion of the Dara–Zerka branch
of the Hijaz Railroad (*Servet-i Fünun*, no. 599 [1318/1902]).

INAUGURATING THE MONUMENTS TO MODERNITY:
"THE TRIUMPH OF CIVILIZATION OVER BARBARY"/
"THE MARVELS WILL LAST"

The series of celebrations that marked episodes in the construction process of the
Hijaz Railroad followed formats already established. Inaugurations of official build-
ings provided convenient occasions to map out the broader modernization agendas
and connect them to the specific structure and the specific region. Prior railroad
construction had exploited similar techniques. Lectures, prayers, the slaughtering of
animals, flags, and often temporary arches accompanied all new rail lines (such as
the Jerusalem–Jaffa line), train stations (such as Jerusalem's new station; fig. 5.10),
and bridges (such as the Meskene Bridge on the Havran–Damascus line).[29] The
beginnings and ends were hailed. Foundation-laying ceremonies were commonly
held in prominent centers, such as Damascus, where structures that directly repre-
sented imperial authority (e.g., government palaces) or that showed its benevolence
(e.g., orphanages) were brought to public attention by the inauguration of their con-
struction sites.[30] Some were more memorable than others: Beirut's clock tower was
represented by sticks decorated with flags, the temporary skeleton conveying a clear
idea of the footprint of the final monument (fig. 5.11).[31] The completed projects, rang-
ing from telegraph lines (between Bengazi and Sert in Libya), to bridges (fig. 5.12),
public parks (in Aleppo; fig. 5.13), hospitals large and small (in Damascus, Trablus-
garb, and el-Deir; figs. 4.34 and 4.35), and schools (fig. 4.41), created opportunities for
state affirmation, symbolized by the sultan.[32] Even school examinations were enlisted
in the effort to publicize the imperial investment in modern education and were
turned into official events. For example, the governor of Sana, accompanied by his

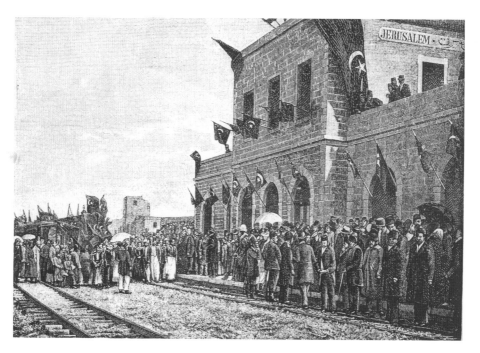

5.10 Jerusalem, inauguration ceremonies for the completion of the Jerusalem–Jaffa line and the Jerusalem Station (*Servet-i Fünun*, no. 95 [1308/1893]).

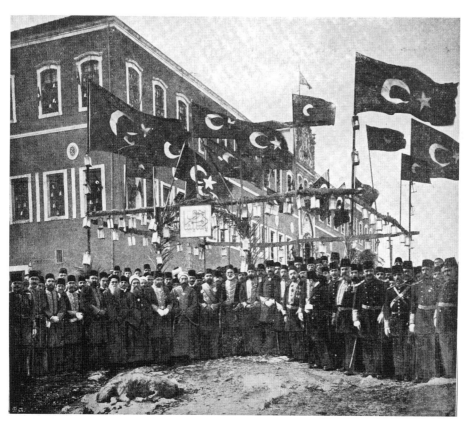

5.11 Beirut, ceremony for the laying of foundation stones for the clock tower
(*Servet-i Fünun*, no. 395 [1314/1898]).

5.12 Near Museirib, ceremony for the completion of the stone piers of a bridge on the Hijaz railroad (*Servet-i Fünun*, nos. 593–94 [1318/1902]).

5.13 Aleppo, inauguration ceremonies for a new public park (*Servet-i Fünun*, no. 396 [1314/1898]).

staff, other officials, and religious leaders attended the end-of-the-year examinations of the local middle school, after which an award ceremony was held outside. The governor distributed the diplomas to music played by the army band. The events culminated in a military parade.[33] Banners in Arabic were hung across the streets of Damascus for the inauguration of an orphanage in 1880. For the occasion, Governor Midhat Pasha penned the following verses regarding imperial benevolence:

Thanks to generous hands, among which are those of Abdülhamid, our sultan,

the most generous of the Osmanlı family.

His work stands as witness to his generosity, the marvels will last.

Rise and enter in security to this house built for success.[34]

The army parades that accompanied the inauguration of military structures (e.g., the vast new barracks in Bengazi and Trablusgarb) were consummate displays of imperial might.[35] The domineering scale and architectural grandeur of the military structures served as impressive backgrounds for these expressions of power. Another type of official public event—the reading of imperial orders (*firmans*) by provincial governors—also used the modern architecture of administrative buildings as stages and background props. The new governors of Aleppo and Beirut, Osman Pasha and Reşid Bey respectively, read the sultan's statements announcing their appointments at the monumental entrance gates of the new city halls.[36]

Descriptions of two military ceremonies in 1881 and 1882, in Yemen and Trablusgarb, reveal the order, format, and pomp of a set of shared conventions in different parts of the empire, where reiteration strengthened the imperial image and identity. In Sana in 1881, the sultan's birthday celebrations began with the recently established Hamidiye artillery's drill exercises. The audience consisted of the governor-general, other officials, the entire military force, and a large crowd. A local newspaper gave a detailed account:

> After the . . . guns had been fired, everyone present expressed his good wishes by shouting repeatedly: "Long live the sultan!" Thereafter they performed a meticulous and orderly parade with, as order requires, the Hamidiye band taking the lead, the trumpeters behind them, then the Hamidiye battalions and the gunners at the far end, while the musicians of the band played alternately at special places, and during this parade the gunners marched by with extraordinary speed. The overall view of these heroes displayed the form of a most orderly and perfect unit and the agitation of the banners in various colors in their midst with the exalted line "Asakir-i Hamidiye" (Abdülhamid's soldiers) written on them presented another pleasant picture to the eyes of the onlooker.[37]

The inaugural ceremonies for a fort outside Trablusgarb, again recorded by a local newspaper, repeat the same features (see fig. 5.14 for a similar event):

> All civil and military officials and the infantry battalion took part in the inauguration, with the army band leading. A great sector of the population attended this festival. The governor-general, the chief commander of the troops in the province, the government officials, and all city officers and notables first visited the fort, then

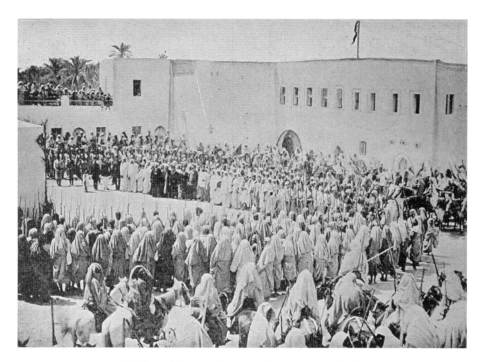

5.14 Trablusgarb Province, inauguration ceremonies for the new
government palace in Zaviye (*Malumat*, no. 100 [1313/1897]).

gathered at the foot of the flagpole to hear the prayers recited by the *ulema*. Immedi-
ately after, the flag, a present from the corporation of silk merchants, was raised
to enthusiastic acclamations of the crowd, which later sacrificed animals. Mustafa
Efendi, imam of the troops, then recited a long prayer to the glory of the govern-
ment and the life of the caliph [the sultan] and all Muslims. The crowd retired,
while shouting "Padişahım çok yaşa!"[38]

Step-by-step accounts of inauguration ceremonies provide useful information
on the decorum and the use of space. The Beirut yearbook of 1908/1909 described
the opening day of the Commercial and Agricultural School, a large complex consist-
ing of two main structures and other buildings in large gardens (see fig. 4.40). A
distinguished crowd, consisting of Governor Halil Pasha, the highest military and
governmental officers, business elites, religious leaders, foreign councils and their
translators, and directors and officers responsible for commercial and financial
affairs, crowded the premises, their uniforms and medals contributing to the pres-
tige of the event. The ceremonies began with prayers led by the chief of religious
affairs in front of the main entrance. Next came the official salute from the army
band, followed by the call "Padişahım çok yaşa." The governor then opened the door,
adorned with ribbons, accompanied by further prayers. The crowd moved to the audi-

torium, impressive with its marble columns, where the chief of the municipality, a local businessman, and a religious notable delivered speeches, in that order. Finally, the guests were taken through the entire complex to admire the "perfection" and construction ingenuity of the architecture, as well as the design of the garden.[39]

Despite the similarity in the format of the ceremonies, their photographic documentation highlighted the regional differences in the architecture of the inaugurated buildings and the composition of the crowds gathered for the events. The whitewashed, cubical mass of the government palace in Zaviye, in Trablusgarb Province, clearly differs from the large neoclassical, symmetrical, and axial school building in Beirut. The uniforms of the government representatives may have been the same in both places, but the overwhelming number of administrative and military officers in Beirut attested to its greater importance. The costumes of the local participants further underlined the cultural multiplicity of the empire and possibly conveyed the understanding that this richness contributed to imperial power.

Inaugural ceremonies in French North Africa displayed a similar mixture of personalities and showcased the local people while broadcasting the mission behind the occupation. When the statue of Jules Ferry was made available to public viewing on 24 April 1899 (see chapter 3), Resident-General René Millet delivered the first speech, hailing Ferry as "a founder . . . just like Roman consuls." Camille Krantz, the minister of public works, then reminded the crowd of Ferry's belief that the "Tunisian expedition [represented] the triumph of civilization over Barbary, the only kind of conquest mentality that modern ethics could accept." Following these blatant statements and ideologically transparent lectures, "our beautiful troops of Africa, *zouaves*, indigenous infantry, *lignards* in their campaign outfits, and an artillery battery" paraded in front of the statue. Officers saluted it with their swords and flags were waved while the spectators stood with "eyes fixed on the bronze."[40]

While representative of the nature of the ceremonies, the dedication of Ferry's statue was a small affair compared to the opening of the new port of Tunis a few years earlier. The festivities occupied an entire week from 21 May to 28 May 1893, and invitations were sent to a large group of high-level bureaucrats and businessmen in France and North Africa. A detailed timetable specified all events. For example, at 8:00 A.M. on 21 May, artillery salvos would open the ceremonies on the avenue de la Marine, the wide spine of the European quarter that linked the old city to the waterfront. From 9:00 to 11:00 A.M., speeches would be delivered. At 11:00 A.M., an "Arab camp," inspired by "the indigenous village of universal expositions" would open its gates to the public and continue to accept guests every day until the end of the week. In the evening, a French and an Arab procession would parade along the avenue de France (the continuation of the avenue de la Marine), the French in front of the Arabs; they would split at the Porte de France. The French would march along the rue el-Djezira and the Arabs along the rue des Maltais and, circling the old city from two

sides, would unite at the place de la Casbah. The procession thus brought together the port, the European town, and the Arab town (pl. 18). The range of participants and the music played acknowledged the sociocultural plurality of the protectorate. The French band played the music of the *zouaves* and the fanfare of the cavalry while the *zouaves* and the cavalry paraded on horseback, carrying torches. The Arab procession was composed of cavalries, lanterns in their hands, and the band playing the *"musique du Bey."* A public ball was held at the Grain Market on the waterfront.[41]

Ceremonies with similar themes filled the rest of the week. To refer to a few, on 11 May, an "Arab fantasia" took place at 5:00 P.M. On 25 May, the Arab camp held a *"dance des Chevaux"* performance in the afternoon; at night, belly dancers entertained the public—again recalling the staged activities of indigenous peoples at world's fairs. The evening of 27 May began with the illumination of the suqs in the medina. A cortège of Arabs carrying lanterns accompanied the ministers through the markets to the place du Dar el-Bey, the square in front of the bey's palace, where the military band played *musique Beylicale.*[42] Speeches filled the days, reinforcing the importance of the unity of the residents and celebrating colonization. For example, M. Terras, the president of the Chamber of Commerce, addressed the indigenous residents by arguing that they had "everything to win from contact with the settlers" and that they should engage in an "intelligent collaboration."[43] Four years later, the opening ceremonies of the port of Sfax repeated the format set by those of the port of Tunis, again spreading over an entire week, 20–28 April 1897.[44]

Metropolitan celebrations were transported across the Mediterranean as well. Among them, Bastille Day, officially declared as a national festival in 1880, occupied a privileged place.[45] The centennial of the commemorated event was particularly important. French communities throughout North Africa attended festivities, but it was the participation of the indigenous people that seemed to matter a great deal. In Bizerte, the entire French population gathered for lunch at the headquarters of the Office of Civilian Affairs, and the chief of the office asserted that "the [indigenous] notables came to me to give assurances of their devotion to France." In Nabeul, the indigenous authorities expressed their "sympathies," even though they were not invited to the celebrations. A similar spontaneous reaction was reported in Souk el-Arba, where "a crowd of *indigènes*" joined the festivities.[46]

Bastille Day turned into a major affair in the larger cities (fig. 5.15). In Tunis in 1909, it involved a complicated series of regimented processions, starting with the resident-general and the bey passing in front of all troops and detachments stationed in the city and nearby Manouba, as well as the Beylical Guard, gathered on the avenue Jules Ferry (formerly the avenue de la Marine). The general and the bey then were escorted by the squadron of Chasseurs d'Afrique to the official tribune, which was set in front of the Gare du Nord. At the foot of the tribune, forty *zouaves* with drums and bugles stood guard. After the distribution of the honors, the *zouaves*

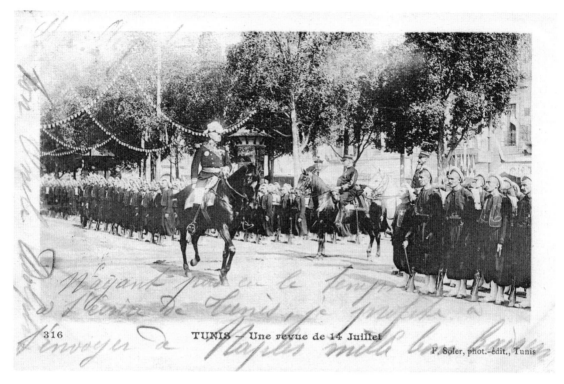

5.15 Tunis, Bastille Day celebrations (postcard).

played the "Marseillaise" and the "Beylical Hymn." The *général de division,* accompanied by officers of the Central Administration of the Tunisian Army, *spahis,* and three squadrons of the Chasseurs d'Afrique, marched to the tribune along the avenue Bab-Djedid, rue es-Sadikia, rue d'Autriche, and rue de la Grèce. The Chasseurs d'Afrique then joined their regiment, whereas the *spahis* retreated to the rue de la Grèce. Beylical officers, reserves, gendarmerie, and firemen filled the nearly streets in geometric order, all the way to the avenue Jules Ferry (see fig. 1.26). After the distribution of medals, a highly choreographed procession commenced. Music, French and *Beylicale,* accompanied the prescribed movements of the regiments. At the end of the ceremonies, the dispersal followed a strict order paralleling that of the gathering.[47] These ceremonies turned the European section of Tunis into a stage where the military power of the occupier was prominently displayed; the bey's presence, as a symbol of the colonized society, only confirmed the colonial order. With its emphasis on military pomp, the celebration diverged from the many "festivals" of the French Revolution, analyzed by Ozouf. The events that the holiday was supposed to commemorate were hardly acknowledged and did not matter in North Africa's Bastille Days, which had become opportunities to confirm and exhibit French domination. The

new quarters accommodated the ceremonies well, with their grid street patterns, large avenues, and open squares; the orderly movements of the armed forces were congruent with the urban forms.

Repetition was the key element of the ceremonies. They took place throughout the empire, followed regular intervals, relied on the same rituals, and used the same paraphernalia—notably, music played by the army bands, flags, and imperial signs (such as "N," which stood for Napoléon III, and the sultan's *tuğra*). The effect was enhanced by the multiplication of individual units, that is, the soldiers, and, to a lesser degree, the students, both groups in uniforms; they created a differentiation among the human fabric between the "official" participants and the crowds. Temporarily transforming urban spaces visually and functionally, the paraphernalia imposed another layer of regularization on the ceremonies, unmistakably associated with the central authority. The photographs reveal the military units' visual contribution to the authority of the events. A quick look at a photograph by Moulin that shows a brigade marching on el-Kantara Bridge of Constantine (see chapter 1) makes the case for the French colonial context (fig. 5.16). The newness of the construction is clear in the crisp stone details of the upper level, while the lower parts recall the bridge's long history. The uniforms turn the troops into a homogeneous unit. The knowledge that the soldiers were marching toward the gate through which the French army had first entered the city charged the image with political meaning.

The different uniforms of the army units served as statements about the complex character of the empire, as well as its goals. After the occupation of Algeria, the uniform occupied a special place in French popular culture, to the degree that it became a shorthand for identifying the colony, in accord with the emergence of a new type of military officer and soldier. The marines and the troops of the Armée d'Afrique, inevitably in contact with different languages and sociocultural customs, were given greater initiative, authority, and responsibility than troops at home. They were seen, not simply as fighters, but also as teachers, negotiators, administrators, and builders— a phenomenon that owed a great deal to the visual culture that disseminated their image widely and effectively. The addition of "indigenous" soldiers, the *zouaves* (autochthonous infantry regiments) and the *spahis* (autochthonous cavalry units), distinguished by their colorful uniforms, enriched the iconography and ensured its colonial specificity.[48]

In the Arab provinces of the Ottoman Empire, the presence of army units went back to the sixteenth century. However, the nineteenth century brought a change to

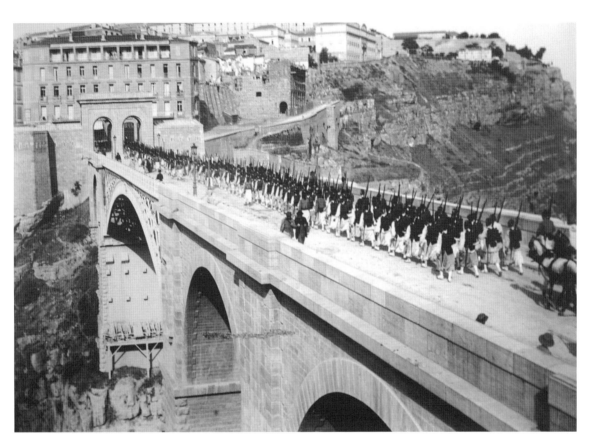

5.16 Constantine, el-Kantara Bridge (Défense, Départment de Terre, Fonds Moulin, fol. 660, 1893).

the image of the Ottoman military presence, as another reminder of the broader modernization initiatives. Modernization of the Ottoman military forces went hand in hand with a "uniform reform" code in 1826 under Sultan Mahmud II, when European-style tunics and trousers, as well as the North African fez, were accepted. This was, of course, only a general formula. A variety of uniforms were devised for different ranks and divisions, inspired by European military fashions. For example, the trumpeters of the marine and artillery forces had comparable, but distinct, outfits (fig. 5.17).[49] Soldiers recruited from local populations had their specific uniforms, reflecting their regional origins, and again with parallels to French practices. Indeed, the word Ottomans used to describe these units was *"sarıklı zühaf"* (*zouaves* with turbans).[50] An analysis of French and Ottoman uniforms remains beyond the framework of this book. What matters, however, is the impact made on the public realm by their high visibility, primarily due to the parades and ceremonies in public spaces.

Publications were another powerful venue for enhancing the visibility of military uniforms because they transported images beyond their actual locales to the entire

5.17 A *zühaf* in the Ottoman army (*Servet-i Fünun*, no. 56 [1308/1893]).

empire. They had several forms: albums of photographs or drawings that documented the variety of uniforms,[51] single photographs showing a specific uniform, and photographs of ceremonies and parades published in newspapers and journals. In several issues in 1892, *Servet-i Fünun* presented a collection of Ottoman military costumes: marine, marine trumpeter, turbaned *zühaf*, artillery soldier, and artillery trumpeter.[52] Postcards popularized the army and its components further, showing one type (the *zouave*), a specialized unit (the Hamidiye band in Damascus), or the different ranks and units present during the celebration of a special historic occasion (the declaration of the constitutional regime in 1908). Postcards also offered narrative drawings, for example, of Sultan Reşad, with a cavalry battalion in the background.[53] They dramatized the army in action, which the French exploited in the colonial context—as illustrated, for example, by a postcard showing the *chasseurs d'Afrique* attacking on horseback, their swords drawn and their blue, white, and red uniforms flowing in the wind, with the palm trees of Algeria in the background (pl. 31). Among the postcards that depicted the French army, three categories made specific references to North Africa: *chasseurs d'Afrique*, *battalions d'Afrique*, and *zouaves*.

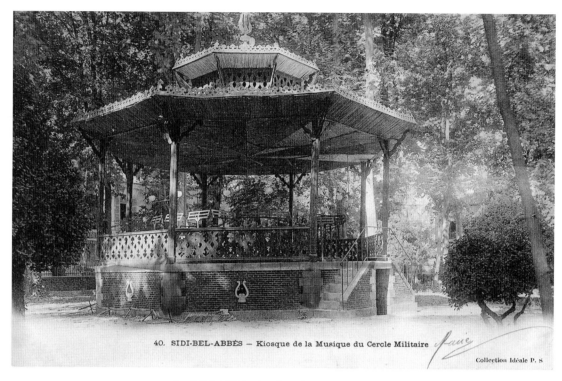

5.18 Sidi Bel Abbès, bandstand (postcard, GRI).

Music, performed by military bands, was an indispensable component of the ceremonies. In France, army units with bands dated from the eighteenth century, but regimental bands were established in 1860. Eugen Weber argues that the French lyrics served as an effective tool to teach the language to many patois speakers of the metropole. He also cites the quick success of the "Marseillaise," born as a battle song on 25 April 1792, officially played the next evening, printed within a few days, immediately followed by other printings on separate broadsheets, and sung throughout France by the autumn.[54] Undoubtedly, the French army exploited military music in North Africa for glorifying the occupation and marking its difference from local art forms, but it may also have served to consolidate the multiethnic European population of Algeria and Tunisia around music and to help teach them French. Not restricted to ceremonies, military bands brought music to civilians and gave regular concerts in public spaces, for example in the place du Gouvernement in Algiers. Bandstands were erected in the midst of squares, wide avenues, and parks. Many of them, such as those on the place Bresson in Algiers, place d'Armes in Blida, avenue Jérôme Fidèlle in Sfax, cours Bertagna in Bône, and place de la Marine in Philippeville, were playful circular structures with teasing references to "Islamic" forms (fig. 5.18).

There is nothing comparable on the Ottoman front to the phenomenal popularity of the "Marseillaise," but there are parallels in the creation of regimental bands and

promotion of an "official" music. The post-Tanzimat military music was modeled after European precedents, and an imperial music school (*musiki-yi hümayun*) was opened in 1831, in accord with the modernization of the army. Giuseppe Donizetti, Gaetano Donizetti's less famous brother, was invited to become the director. During his two-decade career in Istanbul, "Donizetti Pasha" trained many musicians and composed important pieces for the Ottoman rulers. As the ceremonies in all parts of the empire testify, army bands multiplied quickly during the last decades of the century. By the end of it, they were everywhere—in the port of Beirut saluting the boats that brought rails for the construction of the Hijaz Railroad (fig. 5.19) and waiting for the arrival of Ottoman dignitaries at the Damascus train station (fig. 5.20). Like their French counterparts, they performed for civilian populations as well. For example, on every Friday and Sunday, the army band performed in Beirut's Burj Square in a kiosk designed for the event.[55]

Military music underwent a fundamental change after the 1830s with the direct engagement of European musicians and a new generation of local ones, products of modernized education, as composers of Ottoman marches. The post-Tanzimat period generated a surprisingly high number of marches, exploiting any occasion for new compositions. The sultans commissioned many, but even more were composed by musicians at home and abroad on their own initiative, no doubt with hopes of future commissions or, at least, an imperial medal. Marches that marked the beginning of the rule of a sultan constituted a genre. Starting with Donizetti Pasha's 1829 "Mahmudiye Marşı," for Mahmud II, every sultan received his own piece: "Mecidiye" for Abdülmecid (by Donizetti), "Aziziye" for Abdülaziz (by Callisto Guatelli), "Hamidiye" for Abdülhamid (by Necip Pasha; the first to have lyrics), and "Reşadiye" for Reşad (by Italo Selveli). Each served as the "national march" during the reign of the particular sultan. Wars (from the Balkans to Sebastopol) and the declaration of the 1908 constitution were commemorated by marches. Even an international exhibition in Istanbul in 1863 led to a special composition. Two popular tunes on which information is scarce, the "March for Algeria" and the "March of the Arab," invite further speculation. The first was produced in 1830, a highly significant date, perhaps in a sad acknowledgment of the French occupation—a topic that is glaringly absent in Ottoman discourse (see the epilogue). The second may have been linked to Abdülhamid's change in policy toward the Arab provinces. Even without any knowledge of the conditions that framed their production, the associations they made and their widespread reception, undoubtedly due to their musical appeal, kept Algeria and the Arab provinces alive in public memory.[56]

A glance at the Ottoman press of the period gives some insight into the reception of this musical genre. The journal *Malumat* (mimicking *L'illustration,* which periodically published scores and lyrics) published the music and lyrics of two pieces, a "Grande Marche" dedicated to the sultan and a "Chant Turc," as a supplement in

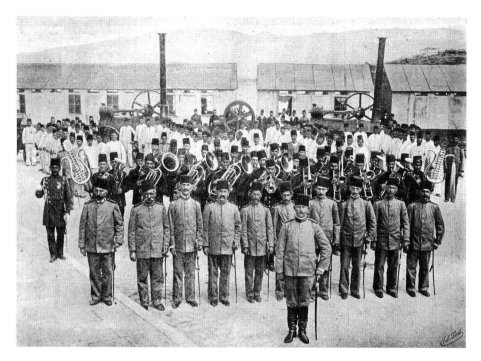

5.19 Beirut, Ottoman military band (*Servet-i Fünun*, nos. 593–94 [1318/1902]).

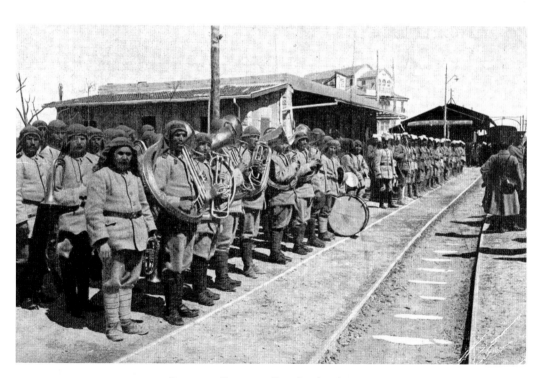

5.20 Damascus, Ottoman military band at the train station

(Dr. Jean-Alexandre Otrakji, www.mideastimage.com).

1898. They were presented with elaborate covers in green and red (pl. 32).[57] The cover images brought together various imperial symbols (crescent and star, flags, weapons, globe) with references to music and the arts in general. The words reflected the message shared with other compositions in expressing the universal might of the sultan and the dedication of his subjects. A few lines will convey the overall message and the simplicity of the language of the "Chant Turc," which celebrated the *cülus:*

> O my sultan, thanks to your sense of justice the world found happiness
> Thanks to Your Majesty people found security and peace
> Thanks to Your Majesty all hearts rejoiced
> Your Majesty endowed the state with grandness.[58]

The "Grande Marche" addressed the "dear soldiers of the sultan," calling them to "Raise his fame . . . our sultan is glorious / Your fame will surely rise with the fame of the state."[59] After the declaration of the constitutional regime, lyrics were dominated by words such as "motherland" (*vatan*), "nation" (*millet*), and "freedom" (*hürriyet*).

The words to the marches of the French army in North Africa, in addition to the formulaic verses on courage and might, were usually more specific. For example, the march of the Chasseurs d'Afrique referred to the violence, the people they were fighting, and particularly battlefields:

> We must punish
> The Arab and the Kabyle
> And hundred against thousand
> Charge without fear
> Soldiers, officers,
> Our ardor is the same
> To the bloody baptism
> We run the first
>
>
>
> Our bodies are strong
> Our swords are sharp
> Bône and Constantine
> Still remember them.[60]

It was common in the French tradition to produce a specific composition for the inauguration ceremonies of an important project. The Grand Theater in Algiers was opened on 29 September 1853 with great pomp to "Alger en 1830 et en 1853," a *"pièce lyrique"* that was the result of a collaboration between a former army officer and a high bureaucrat.[61] While I was not able to locate the lyrics and the music, the title tells

the story in a concise manner. The march written for the opening of the port of Tunis fills in the colonial rhetoric:

> On this hillside which became the land of the French
> the memories of our St. Louis crusades
>
>
>
> progress advances every day . . .
> and the sons of the Gauls, raising Carthage again
> gently to follow its path
> we will rebuild the Roman Empire.
>
>
>
> O France, it is toward you at this blessed hour
> turns the new Tunis, girl of your genius
> and shows her treasures
>
>
>
> It is only you we love
> under this ardent sun that burns our skin
> and our only love
> and our unique emblem
> it is you, France, it is your flag.[62]

Postcards came in handy for the distribution of military music as well. The march of the Chasseurs d'Afrique discussed above was published on a postcard, with the music on the top half, verses on the lower, the latter separated by a drawing of a cavalryman in full uniform and carrying a sword (fig. 5.21). The Ottoman postcard industry, on a par with the European scene, produced its own series. One example featured a photograph of Donizetti Pasha in his Ottoman uniform, complete with fez and medals, and two lines of music (fig. 5.22).[63] Another printed the music and verses of the "National Ottoman March" (Milli Osmanlı Marşı) and gave contextual information: the piece was received to great acclaim by the Ottomans, as well as the French and the English, and accepted as the "national" march by the "Ottoman School." The result of cooperation between an Ottoman composer, Vedii Subra Efendi, and the revolutionary poet Tevfik Fikret, it expressed the spirit of the new era marked by the constitution. The verses were very different from those of the earlier "national" marches: the sultan was not mentioned at all; instead, the "nation" and the "motherland" were glorified. "We are a sacrificing nation," Fikret wrote, "we are heroic, we are proud. . . . We acknowledge one motherland and one justice." He ended: "You are life, you are honor . . . oh the motherland . . . live a thousand times, sacred motherland."[64] It is difficult to estimate the target audience for these serious, almost scholarly, postcards, which do not even bear populist drawings in the style of the soldier in the Chasseurs

5.21　March of the Chasseurs d'Afrique
(postcard, Défense, Département de Terre, Fonds Michat).

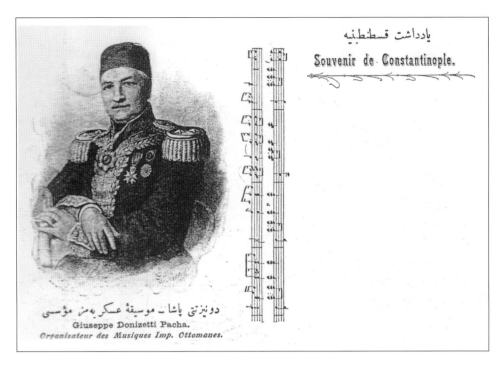

5.22 Postcard showing Donizetti Pasha (Mert Sandalcı collection, Istanbul).

d'Afrique example. However, it may be safe to speculate that they were not printed in large numbers, and the circulation must have been restricted to a learned group of locals and foreigners. Still, the choice of marches as postcard themes sheds light on their importance and popularity as imperial symbols.

Public spaces that imprinted the image of modernity on the cities of the Middle East and North Africa in the nineteenth century and that expressed the symbolic order of the Ottoman and French empires could not convey their messages through their physical character alone. To assert the ideas behind them effectively, they needed to be enriched with a glorified life imposed on the daily human activity that they supported naturally. Ceremonies that established links to imperial events mapped a veneer of spatial and temporal order upon the random traffic and ordinary transactions. Interwoven with a rich array of accoutrements, ceremonies were held frequently to remain fixed in collective memory, in association with the central authority. The portals of the Ottoman government palaces, reached by stairs, were the platforms where the sultan's declarations were read; the statues in the *places d'armes* marked the sites where military bands performed; and the insertion of regimented groups of uniformed bodies, flags, garlands, and temporary pavilions and arches left the traces of imperial references behind after they were gone. Print media enhanced the archiving of the ephemeral aspects of public spaces (including music) and transported them over long distances.

EPILOGUE

IN 1885, JULES FERRY FORMULATED
his colonial policy based on three themes: economic, humanitarian, and political.
Ferry's coherent and clearly articulated vision looked to the future and expressed the
essence of France's *idée coloniale* in reference to practices developed since the Alge-
rian occupation. The economic rationale, simple and transparent, revolved around
providing French industry with primary materials so that it could compete with other
industrialized nations. It extended and manipulated the earlier Saint-Simonian asso-
ciation of colonial expansion with "global economic unity," a necessary step toward
the achievement of "social harmony." The argument for a humanitarian order was
based on the premise that "superior races" that had reached a high degree of techni-
cal development and moral integrity had the right and the responsibility to bring
progress, and through it liberation, to "inferior races." Colonization thus had an
emancipatory mission, which was entangled with a Christian agenda to "establish on
this still infidel earth, a hardworking, ethical, Christian" community, in the words of
Lavigerie, archbishop of Algiers. The political justification addressed power relations
in the changing global order. Its goal was to ensure France's place among other "civ-
ilized" nations by increasing its territory and its population. This political agenda,
expressed in the 1860s, was deemed necessary in order to maintain the country's
"legitimate pride."[1]

To search for an absolute congruence between France's meticulously articulated *idée coloniale* and an Ottoman ideological agenda would be a misleading exercise. Confronted by grave economic, political, and military difficulties, the Ottoman Empire did not possess a growing colonial power comparable to the French, and the legacies of its centuries-long practices in Arab lands continued to shape the relationship between the center and the periphery to some degree. Nevertheless, the nineteenth-century shifts in Ottoman policies and discourse have some affinities with European concepts regarding colonies and the "indigenous" populations. Browsing through publications of the time, whether daily newspapers, journals, works of literature, or translations makes it clear that the Ottoman elites followed European political, social, and cultural events closely and interpreted them through their own critical filters. Ideas about cultural and social differences, as well as patterns of governance, acquired priority and especially affected the thinking about the Arab provinces. At the 1884–85 Berlin Conference, which "scrambled" Africa, the Ottomans began to use the term "colony" (*müstemleke*), albeit infrequently, to identify their territories in the continent.[2] This change in terminology should perhaps be read as an attempt to carve a position for the Ottoman Empire among other powers by showing that, just like them, it had colonies. However, it also implied a change in thinking about the relationship of the center to the periphery.

The dominant themes of Ferry's French colonial policy, which had some echoes on the Ottoman scene, provide a useful comparative frame for examining the Ottoman concepts and practices. Of course, there were no monolithic Ottoman and French discourses, only prominent tendencies. These form the backbone of my concluding inquiry, with which I hope to shed some light on the "colonial" visions of both empires, pointing to their affinities and their divergences. My emphasis will be on the Ottoman Empire because of its ambiguous status among the late-nineteenth-century powers and the nature of its much debated, idiosyncratic modernity. I use the commonly accepted norms that define a modern and colonial empire, as represented by France. Ultimately, the question I would like to reflect upon (if not provide an answer to) is the nature of nineteenth-century "colonialism." Was the Ottoman Empire "colonial" in the way the French Empire was? Do the French and Ottoman perceptions of modernity explain their specific notions about their respective "colonies"? How were the specificities maintained at a time of intense cross-fertilization? Does acknowledging the interconnected nature of empire building lead to homogenization or the emergence of different ideologies and discourses of governance?

ECONOMIC BENEFITS: "POTENTIAL OF THE LAND"

Studies on the nineteenth-century Ottoman Empire unanimously agree on the gravity of its financial problems and Europe's growing economic control over it. The reori-

entation toward the Arab provinces carried an economic agenda. The resources of certain regions singled them out as especially beneficial for the empire, leading to considerations about their development. For example, a report by Governor Midhat Pasha on Syria (1879), written upon his arrival in Damascus, made the argument that, because of its geographic setting, considerable size, large population, and the "potential of the land for all kinds of agricultural production and of its location for trade," the province should have enjoyed a "most developed and happy" status. For various reasons, not the least of which were the 1860s uprisings in Mount Lebanon, provoked by foreigners who "spoiled" certain ethnic groups (such as the Druze), positive development had been hindered. The government's reform and reorganization programs would change the situation.[3] Midhat Pasha's position reflects a newfound awareness of the potential for economic gains from the provinces, echoing the blatantly stated exploitation policies of European colonial empires.

In his long account of Abdülhamid II's reign, written in the heat of the constitutional era, Osman Nuri cast a critical look at the fact that the sultan "boasted of the territories he regained in Asia to make up for his losses in Rumeli." However, these successes were short-lived, as new waves of insurrections against Ottoman sovereignty swept Arab lands.[4] Controlled by European enterprises, the Ottoman reformers did not and could not make radical moves to reorganize the economic structure of the Arab provinces and tap their resources. There were no initiatives comparable to those of the French in North Africa, where mines were heavily exploited, the scale of agriculture increased tremendously, and carefully devised engineering projects connected the ports to the central zones of production. Furthermore, the French infrastructure projects supplemented other investments, and French colonial policy relied on European settlers to initiate and carry out the economic ventures. As we have seen throughout this study, the Ottoman state directed considerable resources to Arab provinces, ranging from regional transportation networks to urban improvements, public buildings, and education. Nevertheless, the older Ottoman patterns of governance affected the modernization programs, which did not match the scale of French interventions in the Maghrib.

THE CIVILIZING MISSION: "BRIGHT ERA OF PROSPERITY AND PROGRESS"

In Ferry's words, the humanitarian premise meant "the triumph of civilization over barbarism, the unique form of the spirit of conquest that modern ethics can accept."[5] The infamous *mission civilisatrice* of French colonialism had intriguing corollaries in Ottoman discourse. With a certain confidence in the tangible results of modernization achieved at the center, the state could now extend its reform programs to the Arab provinces. Leading political figures announced the agendas. When he took

office in the 1890s, the governor of Beirut, İsmail Kemal Bey, stated that his goal was "to accelerate the progress of civilization and to disseminate the light and knowledge of this epoch."[6] The *salname*s, representing the official perspective, often framed the issue of civilization in reference to history and made a case that contemporary reforms were reviving the long-lost past glamor of the Arab provinces. They expressed a consensus, an official self-criticism, that the previous Ottoman centuries had failed to bring development to these lands, an opinion endorsed by a tireless critic, Ahmed Şerif. To him, the roots of the Arab-Ottoman conflict lay in the fact that "the history of the past centuries left no trace of Ottoman civilization, no civilized works [in Arab lands]. Ottoman history, developed by Turks, always remained foreign to this land, and the Ottoman state maintained the status of a guest while centuries rolled on."[7]

According to the 1898 *salname*, Iraq, especially Mesopotamia, occupied a special place in world history as the center of "the most developed and foremost civilizations," with its Assyrian, Babylonian, Roman, Persian, and Arab layers. While the Muslim civilization had reached a "supreme level," careless interior management and cruel rulers such as Hulagu and Tamerlane had destroyed the land. The Ottomans, infected with conflict and shortsightedness, had not been able to bring Iraq back to a level of civilization compatible with its past. Nevertheless, all efforts were now put into creating a new order that reformed the administration of the province and the justice system and invested heavily in the education of the "sons of the country" by establishing many schools in urban centers and in other "works of civilization" (*asar-ı medeniyet*) such as modern transportation systems (e.g., tramways). A "bright era of prosperity and happiness" had opened up for the land of Iraq.[8] Similarly, Syria, historically "extraordinarily prosperous and master of a perfect civilization," had perished prior to the Ottoman conquest. Ottomans, while committed to "genuine" and "sincere" initiatives, had failed to attend to its development due to "constant interior and exterior problems." It was only recently that the government had registered improvements in civil service and completed many "benevolent works," and was engaged in more. Among them, schools of different levels, for Muslims and non-Muslims, were particularly important.[9] Even in Yemen, which did not boast the complex historic traditions of Iraq and Syria, the people had begun to appreciate the "ways of civilization" in response to recent imperial investments in bringing order to the province, and the results were beginning to be registered in agricultural and commercial progress. The new schools had helped the locals to understand the benefits of these Ottoman initiatives.[10]

Visual culture conveyed straightforward and easily legible messages, summarizing the Ottoman civilizing mission. Two examples, an undated architectural drawing labeled "Military Barracks in Bengazi" and the cover image of a special double issue of *Servet-i Fünun* dedicated to the Hijaz Railroad in 1902, reveal the associations with different formal conventions, manipulated to serve the particular agen-

das.[11] The perspective watercolor drawing shows the immense barracks, whose U-shaped mass encloses a parade ground (pl. 33). The symmetry, regularity, and uniformity of the design are emphasized by the continuous two-story mass, delineated by a horizontal row of stones and picked up on the roofline by another horizontal line, as well as by the repetition of the windows. The only break in the façade is the projecting entrance pavilion, which climbs up into a tower, topped by a flagpole. An arch marks the doorway; decorative niches pick up the arch form on two sides. The entrance pavilion establishes the axiality of the project, with a paved path directly connecting it to the main gate into the compound, a monumental arch bordered by pilasters and displaying an inscription and guard posts. The massive size of the barracks is emphasized by the human figures in front, which, at the same time, summarize the human scene: soldiers in uniforms, locals in their "native" costumes, a foreigner couple, and Bedouins with a horse and two camels. The contrast to the background imposes the authority of the imperial presence, with its monumental and modern forms, over the irregular, delicately scaled, and whitewashed fabric of the "indigenous" settlement. The parade ground is vast and bare, suitable for military exercises; its landscaped areas are limited to small manicured gardens in the "French" style on two sides and a straight row of trees along the front wall; the low railing enables unobstructed views into the large open space from the front. The natural landscape of trees behind the barracks contrasts with the sparse and regimented planting in the compound, in another gesture that acknowledges the authority of the new enclave. Rendered according to the conventions of an architectural drawing, the perspective-view emphasizes the imperial messages behind the architecture, reinforced by the depiction of the surroundings and the people, assembled from familiar Orientalist representations.

The watercolor was most likely a presentation drawing for approval and funds. In contrast to the small number of its viewers, the cover of *Servet-i Fünun* (fig. E.1) appealed to a much larger audience—not only the readers of the journal but also those who must have caught a glimpse of it in the sales stands. The image is framed by an arch adorned with motifs derived from Ottoman tile designs and crowned by the crescent and star; the composition evokes European drawings of "Islamic" art forms, notably designs by Owen Jones. The figure of the arch is also reminiscent of nineteenth-century publications on Ottoman art and architecture that presented detail drawings from canonical monuments: *Usul-i Mimari-yi Osmani* (1873) and Léon Parvillée's *Architecture et décoration turques* (1874).[12] The drawing shows a train crossing a modern bridge, the kind that *Servet-i Fünun* had familiarized its readers with by many photographs, through a typically "Arab" landscape, evoked by barren mountains in the background and palm trees. Locals crowd the foreground, some in their tribal costumes, others distinguished by their religious attire. They welcome this feat of civilization with open arms, seemingly expressing their gratitude with prayer.

E.1 *Servet-i Fünun*, cover (*Servet-i Fünun*, nos. 592–93 [1318/1902]).

Among the crowd, one figure in European civilian costume and wearing a fez, unmistakably a high Ottoman officer, represents the imperial administration. The camels, peacefully resting, complete the blissful scene. The whole picture may be an ironic commentary on the real state of affairs, that is, the widespread hostility to the project, but also expresses the Ottoman enterprise of bringing civilization to the Arabian Peninsula. In this respect, it recalls the myriad images depicting the enthusiastic Arab welcome of Napoléon III in Algeria in 1865 that filled the pages of *L'illustration*, among other publications, and glossed over the brewing hostilities, which exploded five years later in mass uprisings against French rule.

RACE-THINKING: "LAZY, CONSERVATIVE, IGNORANT PEOPLE OF THE EAST" / "NEED TO BE EDUCATED AND REFORMED"

Civilizing the Arab provinces meant fighting the backwardness of the region. In addition to centuries-long Ottoman neglect, it was agreed, certain characteristics of Arabs formed the roots of the problem. Race-thinking thus entered the Ottoman discourse, fueled by European notions on the topic that linked race to morality and looked at both through the framework of social conditions. Ottomans twisted this line of analysis (which ultimately reinforced European superiority) to align themselves with the "civilized" world and take on the responsibility of disseminating contemporary civilization throughout their empire. They hence appropriated a position that European discourse unanimously denied to them—as voiced strongly by Gustave Le Bon. Le Bon had argued that "the end of the history of Arab civilization in the Orient originated the day [Arabs] fell into the hands of the Turks." Turks had excelled only in military affairs and failed to create a civilization. Investing all their effort into exploiting what they had in hand, they had borrowed "everything, sciences, arts, industry, commerce," from Arabs. In these areas, where "Arabs shined, Turks did not register any progress; and, like people who do not progress, moved backward fatally." At the end of the nineteenth century, they had finally reached their "hour of decadence."[13] Ironically, Le Bon's opinions enjoyed great popularity among Ottomans.[14]

The French discourse on the Maghrib had developed on the oppositional formula "Arab versus Kabyle (or Berber)." Reductive and clearly constructed for political reasons (in brief, "divide and conquer"), it explained the difference in the interpretation of Islam. Studies on Kabyle society had drawn the conclusion that, while Arabs accepted Muslim law, Kabyles had developed their own customary law, and that brought them closer to the "civilized" societies dominated by secular law.[15] Le Bon underlined this division, basing it on an inquiry into the "psychology of races." He argued that in Kabyle society, the political unit was the village (not the tribe, as among the Arabs), and each village was "a small independent republic, administered by an elected chief," and the simple penal code was so effective that crime was very rare. In

short, "in these microscopic republics, where everybody knew each other, the impact of opinion dominated." Furthermore, Berbers were monogamous, their family structure hence bringing them closer to Europeans.[16] In contrast, the Arabs of Algeria bore all the "inferior qualities of crossbreeds" as the "degenerated products of all the dominations that had weighed on them." They were united by a hatred of Europeans who ruled them. "Indolent, contemplative, not very industrious, living day by day, humble or arrogant depending on the circumstance," they would not hesitate to engage in insurrections against their occupiers. The difference between Europeans and Algerian Arabs was so dramatic that the French would never succeed in assimilating them.[17]

In a rare moment of critical reflection on French policies in Algeria among Ottoman intellectuals, Ahmed Rıza, editor of the Young Turk journal *Méchveret* (published from exile in Paris), argued that the Arabs of Algeria had not been successfully "assimilated by their conquerors" and hence remained "resistant to modern ideas." Ahmed Rıza attributed the root of the problem to bad French governance and persistent ignorance of the "customs and character" of Arabs, provoked by the work of missionaries who "hurt [the Arabs'] religious sentiments by considering their beliefs errors." He first offered advice: "In order to govern well and morally win over a people with a past and with glorious traditions, it is essential to love them, and to love them, it is essential to know them." He then reverted to the philosophy of the *mission civilisatrice*: "He [the Algerian Arab] needs to be educated and reformed. . . . It is necessary to use indulgence and tolerance, the way they are used with the weak and the strayed. In one word, they must be enlightened and not contradicted."[18]

The Ottoman discourse on race was not uniform and alternated between French positions and Ibn Khaldun's writings on "sedentary people" and Bedouins (which situated the former at a higher level of civilization), but often collapsing Arabs and Bedouins into a single category. Echoing the French thesis on Algeria that Kabyles were amenable to European civilization while Arabs were unsalvageable, Ahmed Midhat wrote that the Bedouin in Iraq was a kind of noble savage compared to the corrupt and ignorant townspeople.[19] Osman Hamdi shared the sentiment in a series of letters written to his father from Baghdad. He argued that the Ottomans should not concern themselves with the residents of large cities, especially Baghdad, because despite having abandoned their tents and acquired "some cachet of the men of the nineteenth century," they were "in reality a thousand times below the Bedouin." Corruption was so widespread that, "in all of Baghdad and especially among those in the service of the government," it was impossible to find "one honest person." Bedouins, in comparison, were "virgins." Listing their positive traits as intelligence and courage, Osman Hamdi offered this group as the target for Ottoman civilization attempts. He criticized government officers of all ranks for persecuting and oppressing them and tied the fact that the "Arab had not taken a single path toward civilization and

progress" to the failure of the Ottoman governors of Iraq, who had not put any effort into industrial and commercial development but collected higher and higher revenues from the local populations.[20] Three decades later, Hakkı Bey's evaluation pointed to a change in the situation. Hakkı Bey agreed with Osman Hamdi that the Ottomans had left Iraq to its fate until the late nineteenth century, but then certain governors, most notably Midhat Pasha, carried out the necessary modernization projects to finally give the Ottoman state the right to declare: "Iraq belongs to me."[21]

Le Bon's set of qualifiers that defined Algerian Arabs had precedents. Notably, in a lecture in 1842, Maréchal Bugeaud had characterized the race as fanatic, elusive, and unreliable.[22] Based on their "general psychological traits," Le Bon had divided the human races into four categories: primitive, inferior, average, and superior. "Primitive" displayed no evidence of culture; "inferior" had only some rudiments of it; "average" had created "high types of civilization" but were surpassed by European people, the superior. Arabs, together with the Chinese, Japanese, and Mongolians, belonged to the "average" category.[23]

Ottoman terminology was also abundant with reductive terms that assigned a lower rank to Arabs, justifying the right to rule. Nevertheless, it was not entangled with the politics of conquest as in the case of the French but was linked to rejuvenating imperial authority in the provinces by reforms, which translated to "civilization." One of the words most frequently used to describe the Arabs was "ignorance" (cehalet).[24] Evaluating the underdeveloped status of Yemen in 1909–10, Abdülgani Seni linked it to the cehalet of Yemeni people.[25] Mehmed Refik and Mehmed Behçet made the same reference several times: they attributed the terrible state of Syrian antiquities to the "ignorance of Syrian people," in addition to wars; they sympathized with the teachers of a high school in the vicinity of Haifa in their struggle against the "lazy, conservative, and at the same time ignorant people of the East."[26] Reporting on the poverty of the Syrian countryside near Dara, Ahmed Şerif would even argue that the miserable conditions were a matter of choice, dictated by habits and traditions, and that the villagers were "content in their ways, happy in their lifestyle."[27] It is perhaps not surprising that Le Bon's verdict on Syrian Arabs was along similar lines. He divided them into nomads and urban settlers, maintaining that the former had not changed for the past three thousand years and had a curious double character distinguished by rapacity and generousness. The urban Arabs, on the other hand, had mixed with other races and were "intelligent enough, but supple, sly, and treacherous"; they were lazy and spent their energy only on religious conflicts.[28]

The historic cores of cities, especially the residential neighborhoods, seemed to Ottoman observers to reflect the character of the residents. The houses of Baghdad were small and decrepit, lining narrow, disorderly streets, and were proof of the fact that "the people did not appreciate the pleasures of civilization and prosperity."[29] The Muslim quarter of Haifa, "the lowest and poorest from the point of view of public

social life," had steep, narrow, crooked, and dirty streets that were truly shameful. The garbage thrown from the houses mixed with water from laundry and cluttered all thoroughfares, where children played. The houses were small, packed together, and humid; their windows were covered with sheets of tin, pieces of wood, and dirty rags. Even the streets in front of the large houses of the wealthy displayed the same level of dirt.[30] The streets of Damascus did not fare better. Irregular and narrow, they had many segments that had not seen sunlight for centuries because of the "umbrellas" formed by the eaves of houses on opposite sides. Dirty, muddy, and old, they "moaned" with every carriage passing through. Their state could be summarized in a few words: "no light, no air, no cleanliness, no order." Ahmed Şerif maintained that the residents of Damascus "accepted with complete pleasure this life that seems miserable to us." The interiors of the houses were inexplicably spacious and beautifully decorated, resulting in a contrast that pointed to extremes of taste (an unbalance) from the austere to the ostentatious. The preference for old age in everything reflected the conservative spirit of the Damascene. In effect, the historic city, viewed from Salihiye, recalled a ruin from the past; it evoked associations with "a place of prayer, a Sufi convent, a mausoleum"—totally distanced from modern times.[31] Hakkı Bey seconded Şerif's verdict, attributing to the city a frozen status and repeating the rhetoric of European Orientalism: "Ancient . . . Damascus is an entirely Oriental and Arab city, with its covered bazaars, narrow streets and dead ends [defined] by houses whose walls look like those of a fortress without any openings or windows looking at the streets, similar to streets of six centuries ago."[32]

Other prominent Ottoman voices expressed high appreciation for Arab culture and people. It was common to acknowledge the past achievements of Arabs—as, for example, in the *salnames*, which singled out the Umayyad and Abbasid eras as among the highest points in the history of the region. Several books published during Abdülhamid's reign focused on the importance of Islamic civilization. For example, Ahmed Rasim's *Arapların Terakkiyat-ı Medeniyesi* (1887–88) studied Arab civilization until the end of the Abbasid period and traced continuities to late-nineteenth-century society, using Le Bon's *Civilisation des arabes* as its main reference. Characterizing the Arabs as a "noble nation," the periodical *Tercüman-ı Hakikat* dedicated articles in the late 1870s to Islamic civilization and argued for its distinguished aspects and especially its role in philosophy and sciences during the Middle Ages that enabled European "regeneration and progress."[33]

Seemingly objective accounts contributed to the hierarchical thinking about race. Mehmed Tevfik Bey, the governor of Yemen between 1904 and 1906, gave a straightforward description of "races and castes" in the province:

> There are at least two races here. The difference between them surfaces in the
> lighter skin color of one group. These go around with a shawl thrown on their

costumes. The attires of shopkeepers, merchants, and workers indicate their social status. The clothes of Jews distinguish them immediately from everybody else. Therefore, one quickly realizes the presence of a caste system here. The population is divided into many social classes, from the Seyyidi aristocracy to slaves.[34]

In a series of articles reporting on his trip to Iraq in the periodical *Tasvir-i Efkar* in 1914, poet Cenab Şahabettin saluted the Arabs with genuine emotion and appreciation: the Tigris was "as vast as Arab intelligence, as sound as Arab soul." Şahabettin had a highly critical position toward European racism, specifically British racism, which he had encountered in Port Sudan:

> In all cities that fell under the British flag, there is one rule: black humanity must salute white humanity! . . . The British see the world's people in three large categories: the first is themselves, the second the other white people, and the third consists of the yellow, the red, and the black. They do not believe that the people of the universe come from the same root; they doubt that the black man has a heart, a brain, feelings, and ideas like a lord; they therefore believe in one kind of administration of nonwhites: power.

The overt hierarchies of the British system may have sensitized the poet toward Arabs, but his descriptions still carried the tone of European discourses and implicitly reconstructed them. He appreciated Arabs' love of life, even when confronted with miserable conditions. Their joyfulness and their passion for words were among their endearing qualities; their overall composure conveyed a serene approach to life: "in a beautiful climate I want a beautiful life." Şahabettin's admiration did not conceal his superior tone as he claimed to detect a "child's spirit" in Arabs, who took "important things lightly and unimportant things as important." Şahabettin, opposing Osman Hamdi's vision, considered Bedouins "worthless, decayed, and primitive," lacking serious minds and relegated to a "vegetative" lifestyle—in striking opposition to "city Arabs." Mistaking "vagabondism" (*başıbozukluk*) for "freedom" (*hürriyet*), Bedouins had "slept for centuries lost in their fearful dreams in the desert." Like others, Şahabettin explained the backwardness of the country as the result of historical Ottoman neglect, pointing out that "what the gun captured, the plough should have conquered; it has not been so."[35] *Başıbozuk* (vagabond) became a term to denote the revolting tribes in the years preceding World War I. Hakkı Bey attributed their widespread *başıbozuk* behavior to the "total disorganization" of the army and the state of the soldiers, who had lost their "morale and entire military spirit." In his opinion, Arab revolts resulted, not from a "superior courage," but from the "weakness of the army and governmental anarchy." Yet it was only the "tribes [that] escaped all

legal disposition" and broke "civil and criminal laws." The urban dwellers, in contrast, were "submissive, calm, and willing to obey the law."[36]

Race-thinking was omnipresent in the culture of the late Ottoman Empire and peaked in unexpected places. It may be worthwhile to refer to what is still one of the most popular novels in Turkish literature, Reşat Nuri Güntekin's *Çalıkuşu* (originally serialized in 1922—the year before the empire was abolished), which situated the childhood years of the protagonist, Feride, in Iraq. The daughter of a military officer and an Istanbul aristocrat, Feride is reared "as a child of the desert," first by Fatma, a young woman from an Arab village, then by Hüseyin, a soldier from Baghdad. The loving relationship between Feride and her caretakers, as well as the personalities of Fatma and Hüseyin, is developed with great sympathy, against rough but appealing landscapes. Yet Cenab Şahabettin's general characterization of Arabs colors Fatma and Hüseyin: they are like children. The "strange" local customs make their way into the background, for example, when Hüseyin dances while carrying the child in a basket. The power relationship is also present: Hüseyin receives "two horrendous blows" on the face when Feride's father finds out about their secret horseback trips. Feride's behavior at her grandmother's mansion in Istanbul repeats a formulaic picture: "in the manner that she learned from Arab beggars, opening her hands and bending her neck, [the little girl] pleaded in Arabic."[37] A drawing from the fourth edition of the novel points to racial differences: it depicts fair Feride in the arms of dark-skinned and full-lipped Hüseyin. Together with Feride, Fatma, and Hüseyin endure as familiar references in Turkish culture, saluting the imperial social structure, long gone.

REPRESENTING RACE IN VISUAL CULTURE: *"TYPES ET MÉTIERS"*

Visual media complemented racial discourse. *Servet-i Fünun* periodically published photographs that showed the colorful difference of Arabs as indicated by their attire and manners. A father carrying a child, wearing a tall headdress, adorned with "feathers of a rooster and blue beads in a bizarre manner" in el-Deir,[38] three Bedouins of Baghdad in long robes of different styles and carrying spears, a dervish from the same city with his unique costume and accouterments, citizens of Trablusgarb in their white robes and matching turbans, a fellah from Damascus, a composition of two "indigenous" men and a child from Yemen seated in front of a mud-brick wall, and two children of Trablusgarb in long white cloaks next to an unusually big turnip (exoticizing the land) enabled some visualization of the diversity of the people living in the empire (fig. E.2).[39] In an unusual turn from the format, "types" were presented in a *salname* on Yemen in two drawings of Yemeni men, perhaps triggered by the unfamiliarity and particular exoticism of their physical appearance (fig. E.3a–b). If

E.2 Trablusgarb, children with a big turnip (*Servet-i Fünun*, no. 617 [1318/1903]).

E.3 Yemeni "types," drawings (Veli, *Yemen Salnamesi*, 1298/1880).

C. PORTIER

E.4 Algerian "type," *carte de visite* (GRI, ZCDV2). E.5 Algerian "type," *carte de visite* (GRI, ZCDV2).

these images recall the familiar category of "types" in French visual discourse (figs. E.4 and E.5), the *"métiers"* (professions) that accompany the types also emerge in the pages of *Servet-i Fünun*: for example, street merchants in Damascus and jewelers and coral workers in Jerusalem (fig. E.6).[40] It should be noted, however, that the norms, reiterated in postcards, were not limited to the representation of people in the Arab provinces but were used for all parts of the empire, including the capital. The types included a religious teacher (*hoca*), a Greek priest, a rabbi, Kurds, Laz (people living in the eastern Black Sea region), and gypsies; the professions ranged from firefighters to shoe-shiners, water sellers, and tin workers—echoing the French *types et métiers* that presented the different regions of the metropole, as well as the colonies.

Universal expositions served as memorable platforms to display the racial diversity of empires in "real life." The sequence of great exhibitions in Paris during the second half of the nineteenth century (in 1867, 1878, 1889, and 1900) brought the

E.6 Jerusalem, coral workers (*Servet-i Fünun*, no. 96 [1308/1892]).

colonies to the metropole in complete packages of architecture, products, and, most importantly, people. In compounds carefully designed to evince the colonies, "natives" in "authentic" costumes were made to perform their "authentic" activities. Algerian cobblers, carpet weavers, and ironsmiths and Tunisian weavers, jewelers, embroiderers, and carpenters concentrated on their crafts in stagelike settings while watched by the visitors. Merchants sold "authentic" products in the shops fashioned after suqs; barbers and coffee shops infused the fair markets with further local color. Music and dance (famously, the belly dance) contributed to the exotic atmosphere.[41]

The presence of the "natives" enabled concrete references in debates on race. In 1867 a certain Doctor Warnier compared the physiology and character of the Arab and the Berber. The Arab was tall and thin, with a "pyramid" skull, a narrow forehead, an arched and bony nose, and black eyes, hair, and beard; the Berber was of medium height, with a large round skull, broad straight forehead, fleshy nose, and eyes, hair, and beard varying from black to red. Whereas the Arab was a warrior and an undisciplined "enemy of work," the Berber was docile, worked hard, and because of his intelligence promised to "become a devoted auxiliary of European and Christian colonization." The Arab looked Asiatic, the Berber European.[42] The arguments were picked up in the following exhibitions. Hence, the Tunisian musicians in 1878, of a *"type bien africain,"* revealed the characteristics of a "beautiful race, indolent,

sleepy, but with features not lacking nobility or energy," while the Arabs of the Algerian theater in 1889 were "generally handsome, having preserved the nervous grace and pride of nomadic races."[43]

Although not accompanied by an explicit rhetoric on race, the Ottomans staged the Arab provinces and their people with increasing visibility in the world's fairs. Two pavilions brought Damascus to the 1893 World's Columbian Exposition: a palace and a tent. The marble palace, reduced to one luxurious room, opened onto a court with a fountain and represented the residential domain of Ottoman officials. The tent, shorthand for "native" lifestyle, exhibited the "simple furnishings and necessary utensils of a camp life." Both were used as theater sets: while the "palace" served as the stage for a daily "oriental wedding ceremony," the tent was permanently peopled with Arabs in "traditional" costumes, "squatting about as at home" and smoking their narghiles.[44] Bedouin scenes, conceived specifically to bring the "nomadic Ismaelites of the Syrian desert" to exhibition grounds, were completed by a troop of forty Arab horsemen, who were transported to Chicago together with their "pure Arab steeds." They held races on the hippodrome, another component of the Ottoman exhibits.[45] Extensive and international, the publications that covered all aspects of the fairs contributed to the dissemination of race-thinking in different contexts (including the Ottoman one) and recorded it visually into history.

The significant distance between the Ottoman and French visual discourses emerged in images of women. Entangled in Orientalist fascination, images of women in the colonies constituted a prolific field of visual culture, extending from the "high" art of academic painting to photographs in popular journals and a large postcard industry. The "living samples" brought from the lands of Islam to exhibition settings and made to perform lucrative activities such as singing, belly dancing, and acting in wedding ceremonies completed the image. There are no Ottoman parallels to the familiar French scene, which has been an intensive site of interdisciplinary inquiry during the past two decades. This could be explained by the social and religious norms of Ottomans regarding the privacy of women. In general, the Ottoman discourse on the people of the Arab provinces remained silent on women. Accordingly, visual representation of women was rare and sporadic, with, for example, exceptional images of colorful Bedouin women posed in front of their cooking utensils for an Ottoman officer traveling in the Sahara or sitting on the ground and fortune-telling (fig. E.7). Photographs of urban spaces occasionally showed city women, such as a photograph of a street in el-Deir that included several women entirely covered in veils and long robes—in contrast to Bedouins (fig. E.8).[46] The image recalls innumerable French colonial photographs that show women against exotic urban scenes (fig. E.9). Interest in urban women would peak in the media every now and then, as witnessed, for example, by a photograph in the periodical Şehbal that depicted the "street clothes" they wore in Hijaz: a figure entirely covered by a black robe and a white veil.[47]

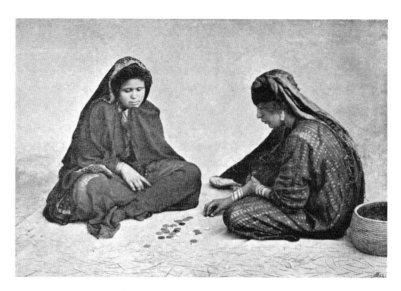

E.7 Bedouin fortune-tellers (*Servet-i Fünun*, no. 435 [1315/1900]).

E.8 El-Deir, street scene (*Servet-i Fünun*, no. 316 [1313/1898]).

The ethnic diversity of the Ottoman Empire that included women formed the topic of an important study, conducted under the leadership of Osman Hamdi on the occasion of the 1873 Universal Exposition held in Vienna. Titled *Les costumes populaires de la Turquie en 1873*, this work documented the costumes of all regions of the empire in a systematic format with photographs taken against the same neutral background by the famous Istanbul atelier Sébah. The book began with an argument that differentiated "clothing" (*vêtement*) from "costume." The former, following the "caprices of fashion" and subjected to perpetual changes, had become uniform throughout the world, erasing the diversity not only between social classes but also between nations. In contrast, costume responded to the specific demands of climate and regional cus-

E.9 Algiers, street scene, c. 1890 (GRI, Special Collections, 94.R.51).

toms, offering a wealth of information for ethnographic and social studies. The cur-
rent study presented a spectacle of costume types that ranged from those worn by
"the *sakka* (water seller) to *caïkdji* (boatman), *hamal* (porter), Bulgarian peasant, and
the Arab or Syrian tribal chief" and were shaped by climate, profession or occupation,
or social position. The costumes stood for all that was "beautiful and good," and the
overall portrayal depicted "the variety in unity" (*la varié dans l'unité*, italicized in the
text), the phrase conjuring an image of the underlying unity of the empire.[48]

The book was organized geographically, starting with the capital and moving to
European provinces, Anatolia, Asia, and, finally, Africa. The Arab provinces were
covered in the order of their proximity to the capital: Aleppo, Syria, Baghdad, Hijaz,
Yemen, and Trablusgarb; Syria was given the most extensive analysis due to its com-
plex population structure. After a description of the geographic and built environ-
ments of each region, photographs and texts presented the costumes, the texts often
including some information on human "types." For example, the Bedouins of Aleppo

were "skillful breeders and vigilant guards of numerous cattle, equipped with arms"; the Christians of Mount Lebanon, the Maronites, were "industrious and rich, . . . remarkably intelligent and proud," although difficult to control—just like their Druze neighbors; in contrast, the Muslim of Mount Lebanon pursued "calm and quiet customs" and concentrated on farming and animal husbandry, "lived modestly with his family, never mixing in the armed struggles of the Druze and the Maronite"; the fellah of the Damascus region, engaged in farming, was "rich," disputing the attribution of the word "fellah" to "misery" elsewhere; the Jews of Jerusalem engaged in "lucrative small local industries," such as souvenirs for pilgrims; the inhabitants of Djèaddèlè (near Mecca) were "great hunters"; the bourgeois of Hudeida spent his days peacefully at his shop but also helped to maintain order in his town as a high military officer.[49]

Descriptions of the costumes, keyed to photographs of two or three figures grouped together, were intended to illustrate these traits, as well as the geographic characteristics of the particular region. They gave information on the fabrics, colors, headdresses, shoes, jewelry, and other paraphernalia such as knives and guns. To cover one example in some detail, a photograph on Yemen showed the "*alim* (scholar) of Hudeida," "the bourgeois of Hudeida," and "the woman of Sana" (fig. E.10). The *alim*'s white calico shirt, voluminous with long and full sleeves, was suitable for the very hot climate of Yemen. The headwear consisted of a huge *dulbend*, rolled in several layers to provide enough shade for the face. *Muda'i*s, or thongs, helped keep the feet cool. The bourgeois wore a "semi-warrior" costume. The lower part of his body was covered by a *foutah*, a blue apron, held at the waist by a silk *kèfiè* (belt); however, when he served as a "national guard," he replaced the *kèfiè* by a red leather *silahlık* for carrying his weapons. His chest was covered by a *djourda*, a light, red silk vest, ornately embroidered; he wore a majestic turban on his head and leather *tcharyks* (sandals) on his feet. As to the woman of Sana, her attire consisted of a long sleeveless shirt of blue with red and blue stripes. In general, women did not wear anything on their feet, although some liked very light white socks. To go out, they wore flat leather shoes and covered their heads with a *yéméni* bordered by lace that revealed only their eyes.[50]

The presentation of women's costumes, neutralized from the conventions of sexually charged European images, was scholarly and respectful. To emphasize this, women were placed next to men in the photographs, in the same standing position, facing the camera (fig. E.11). The language and the associations slipped to Orientalism only slightly and only on rare occasions, for example, in the case of the "women of Damascus": "Sheltered in the shade of the perfumed cradle of jasmines, dark alleys of orange and lemon trees that create cool vaults in gardens, or reclining on large and soft sofas in salons paved by mosaics, equipped in the center with marble basins where water jets murmur, the woman of Damascus, away from the gazes that

E.10 Yemeni costumes from *Costumes populaires*
(Library of Congress, Prints and Photographs Division).

force her [to wear] annoying veils, uncovers her face and poses only with a transparent muslin [scarf]."[51]

Images of the "indigenous people" of Algeria, with an emphasis on women, had formed a large category in European visual culture since the 1830s—as observed in books such as Fl. Vaccari's *Album africain: Collection de 24 costumes lithographiés au trait, d'après nature* (Algiers: Daboussy et Guende, 1831), Claude-Antoine Rozet's *Voyage dans la régence d'Alger* (Paris: A. Bertrand, 1833), Champain and H. Walter's *Souvenirs de l'Algérie: Vues et costumes* (Paris: Wild Éditeur; Algiers: Dubos Frères, 1837), Robert Jungmann's *Costumes, moeurs et usages des Algériens* (Strasbourg: J. Bernard, 1837), and Adolphe Otth's *Esquisses africaines* (Berne: J. F. Wagner, 1839) (figs. E.12 and E.13). By the 1870s, photographs fed the market with albums of *cartes-de-visite* and

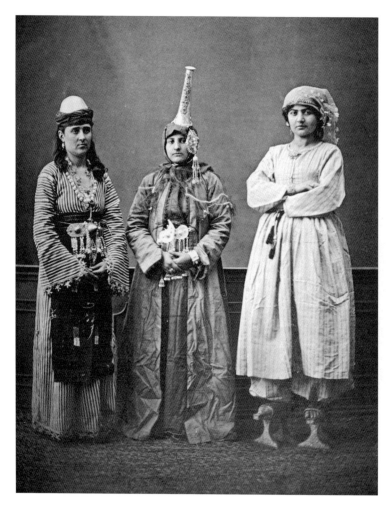

E.11 Damascene costumes from *Costumes populaires*
(Library of Congress, Prints and Photographs Division).

larger size photographs.⁵² Narratives had embellished these images with associations about harem life, constructing an entire genre on Muslim women. During the heyday of the European obsession with Muslim women, *Costumes populaires*, factual, serene, and scholarly, seems to be offered to an international audience with a corrective agenda regarding Ottoman women of different ethnicities and classes. But, more importantly, the book aimed to expose the diversity of the empire in a legible manner, ultimately showcasing the impressive coexistence of different ethnic groups—albeit freezing them into a timeless stasis in an affirmation of Ottoman superiority. This attitude in *Costumes populaires*, it should be noted, went beyond racial thinking and applied to class as well, whether in the capital or in the periphery.

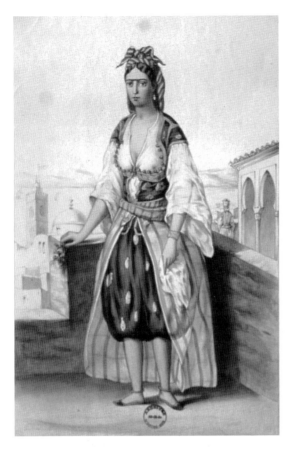

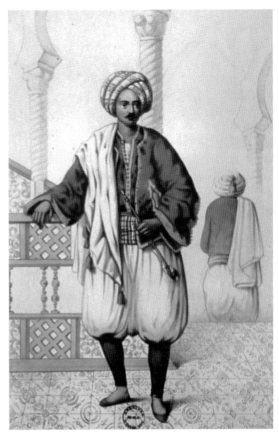

E.12 Algerian "type"
(Champain and Walter, *Souvenirs de l'Algérie*).

E.13 Algerian "type"
(Champain and Walter, *Souvenirs de l'Algérie*).

THE PATHS TO CIVILIZATION: "DECLARE WAR AGAINST THE ARABIC LANGUAGE" / "THE LANGUAGE OF THE RULER OPENS ACCESS TO A GREAT MODERN CIVILIZATION"

To create the intellectual and mental framework that would help root modern civilization in Arab provinces, Ottoman officials and intellectuals concentrated on the intertwined arenas of education, language, and Ottomanization. The post-Tanzimat education reform, glimpsed in the construction of school buildings, was not unique to the Ottoman Empire, and as argued by Benjamin Fortna, many countries embraced "modern-style" education, including France, Germany, Persia, Russia, and Japan.[53] The programs varied according to social and cultural conditions, but they all centered on the importance of public education. In France, Jules Ferry's reforms of 1881–82 were crucial: in addition to abolishing tuition for public elementary education, they

made elementary education mandatory and stipulated the creation of a school in every settlement that had more than twenty school-age children. The project was so vast that financially it matched the sums spent on road construction—another path to civilization and unification of the empire.[54]

Ottoman education reforms took a crucial step with a regulation (Maarif-i Umumiye Nizamnamesi) passed in 1869 that mandated a new, three-tiered system. The regulation stipulated the establishment of primary schools (sıbyan mektebi or ibtidai) in villages and urban neighborhoods, middle schools (rüşdiyes) in all towns with a population of five hundred to a thousand families, and high schools (idadis) in urban areas where more than one thousand families resided. Provisions were also made for girls' schools and men's and women's teaching colleges. Provincial capitals would be endowed with special imperial high schools (sultanis—based on the Galatasaray Sultani in Istanbul). An administrative unit in each province would organize and supervise education, working under the Ministry of Education. The ministry would regulate the teaching methods and course contents, issue textbooks and classroom equipment, and appoint the teachers.[55]

This regulation formed the foundation of educational reform during the reign of Abdülhamid, when the numbers of establishments operating according to the "new manner" (usul-u cedide) in the Arab provinces underwent an unprecedented increase. For example, Baghdad obtained 10 ibtidais, 3 rüşdiyes, and 2 idadis (1 military); Syria, 79 ibtidais (12 for girls), 3 rüşdiyes, and 2 idadis; Beirut, 182 ibtidais (14 for girls), 11 rüşdiyes, and 5 idadis; and Mosul, 41 ibtidais, 3 rüşdiyes, and 1 idadi.[56] However, the numbers and the construction activity did not translate into immediate success. Focusing on Beirut, seemingly the province with the most invested in it, Ahmed Şerif scrutinized the absence of comprehensive and systematic planning and of funds, which had resulted in a random distribution of schools—not sufficient to educate "a new generation bearing an Ottoman identity."[57] As a quick comparison of the two empires shows, elementary schools were especially insufficient; there were 10 times more French schools than Ottoman ones.[58] Despite its commitment to modern education throughout the empire, many grand Hamidian projects and decisions remained on paper, albeit preparing the way for later applications.

Ottoman reformers and intellectuals agreed on the importance of education and attached all failures to lack of it. Mehmed Tevfik Bey, the governor of Yemen between 1904 and 1906, looked back at the mistakes the Ottoman government made in the province, including, above all, the absence of schools committed to the "new sciences." He argued that modern education would "enable the security of the state's influence in a fundamental way. . . . The people of the country would gradually accept the state and hence become civilized."[59] Ahmed Şerif, like many others, attributed the indifference toward an imperial identity among the residents of Beirut to the clear domination and superiority of foreign schools over Ottoman ones: "Because the young

acquire all the needs of their conscience and soul from teachers from America, England, France, and who knows where else, . . . naturally they cannot occupy places in national life and, on the contrary, they turn into unnecessary and harmful creatures . . . who serve other interests." The American College, known locally as the *külliye*, posed a special threat because of its missionary goals and teachers who talked only of "humanity, civilizing undeveloped lands and decorating them with the light of knowledge," and who in reality were "enemies of our Ottomanism and Islamism."[60]

Language was considered key to unifying the empire, and one of the primary goals of the new schools was Turkish instruction, articulated as early as 1858 on the occasion of the inauguration of a middle school in Trablusgarb: "education in sciences and literature and teaching the Turkish language . . . in all corners of the protected domains."[61] The schools had to compete with foreign institutions, especially in the provinces of Beirut and Syria: teaching Turkish to Arabs was "a vital question."[62] As argued by Eugene Rogan in reference to Mekteb-i İdadiye-yi Mülkiye (civil preparatory school, also known as Maktab Anbar) in Damascus and Aşiret Mektebi (School for Tribes) in Istanbul, higher education may have produced a cosmopolitan elite group that mixed "Arabic. . . with Turkish, Persian, and French," forging a "common Ottoman identity," but the impact remained limited, essentially training students for prestigious careers in the Ottoman state.[63]

The Ottoman commentaries consistently deplored the limited knowledge of Turkish in the Arab provinces. Mağmumi stated that in Beirut, Turkish was confined to government offices, whereas even "boatmen and shoe-shiners understood French and English, in addition to their native Arabic."[64] Ahmed Şerif, in reference to the growing national consciousness among Arabs, argued that the residents of Beirut were under the false belief that learning the "official language of the state" would "suppress their origins, make them forget their mother tongues, . . . in summary, exert bad effects on their national identity." Arabic and French had become intermixed, and among the upper classes French had replaced Arabic. It was commonplace to hear people, including shopkeepers, carriage drivers, and boatmen, start in one language and shift to the other, creating an unusual mixture of words and phrases. The situation was not much better in Damascus, where the teaching of French and English by far preceded the teaching of Turkish, with teachers not even knowing the "common language of Ottomans."[65] Noting yet again that French had been embraced by all sectors of the society in Beirut while Turkish was spoken very rarely, Hakkı Bey claimed there was only one solution: "Turks must declare war against the Arabic language."[66]

At first glance, the desire to promote the speaking of Turkish throughout the empire by means of modern and uniform education seems similar to the French position that acknowledged the "need to teach exclusively in French" in order to make French citizens of people who spoke "Basque, Breton, Flemish, German patois, etc."

However, a closer look opens up a range of differences. In France, schooling was considered "a major agent of acculturation" used to shape individuals into a broader entity, to create a nation—and language was the first indispensable step. As one anonymous writer put it in 1861, "instructing the people is to condition them to understand and appreciate the beneficence of the government."[67] Frustratingly slow in the beginning, the efforts were successful in the metropole but had more complicated results in North Africa, where the "linguistic superstructure of colonialism" was nevertheless developed patiently and systematically.[68]

Two years after the French conquest, Anne-Jean-Marie-Renée Savary, the duc de Rovigo, governor of Algeria (1832–33), had declared the central role of language in colonization: "I consider the propagation of instruction and our language as the most efficient means to register progress for our domination of this country. The real wonder would be to replace Arabic little by little with French."[69] At the time of the centennial of the occupation, William Marçais, ironically the great scholar of Arab culture and language, would repeat the same notion:

> It is not practical, it is not reasonable, and, in effect, it is rare that two idioms of civilization coexist for very long in the same country. When the concurrent [languages] enjoy similar prestige, . . . the struggle between them may be prolonged. But when one of the languages is that of the rulers, opens access to a great modern civilization, [and] it is clear that the written and spoken expression share a maximum proximity, while the other is the language of the ruled, expresses medieval ideals in its best writings, is ambiguous, [and] displays difference when written and spoken, the situation is unequal: the first must fatally diminish the second.[70]

In accord with the "trial and error" methods applied in the majority of colonial projects in Algeria, the French first established about 40 bilingual elementary and secondary schools in major cities between 1836 and 1870, with the number of Muslim students jumping from 75 in 1851 to 159 in 1852. Nevertheless, this practice found strong opposition among those who did not favor the mixing of races and called for "separate French schools . . . for Europeans and Africans."[71] The *Arabo-française* schools gradually declined in number, disappearing altogether in 1898. Meanwhile, the systematic appropriation of the *habous* (*waqf*, or religious endowment) by the army continued to reduce the number of "indigenous" schools: during the first two decades of the occupation, half of the existing schools and madrasas had disappeared; in comparison to 2,000 in 1863, about 700 indigenous schools remained in the 1880s. Schooling of Arab children was limited, with only 2 percent in 1890 and 6 percent in 1914 attending school.[72] In the framework of the turbulent history of the French occupation and the recurrent insurrections, this phenomenon could be understood as one of the mechanisms of Algerian resistance. Two prominent Algerian his-

torians interpreted local responses to colonial education. Mohammed Harbi argued that Algerians were reluctant to send their children to French schools because they did not care to "learn the secrets of the conquerors," and that the majority looked down upon those who attended French schools as renegades fallen into the "trap set for their ethnic group and their religion."[73] For Mostefa Lacheraf, Algerians' use of the French language was limited to the world of the quotidian and the profane, whereas Arabic became the "spiritual language of another life," which resulted in Arabic's loss of dynamism.[74]

Schools in the Maghrib had another important mission: to teach French to children of recent immigrants from Spain, southern Italy, Sicily, and Malta and impart the body of knowledge that would make them French citizens in Algeria. Language and education were primary in the creation of a culturally uniform settler society out of a complex mosaic. This aspect of the educational enterprise was very successful. The education system worked like a well-greased machine to turn southern European "peasants into Frenchmen."[75] Other initiatives reinforced the emphasis placed on the French language in education—among them the gradual replacement of Muslim courts by French ones and the renaming of towns and villages in a "policy of instinctive Frenchification."[76]

The Ottoman scene differed owing to the long history of control of Arab lands with a decentralized administration and to the special place occupied by Arabic as the language of the Koran, the language of Islam. The goal was never to replace Arabic but to disseminate Turkish widely as the official language. Hacı İbrahim Efendi, a defender of Arabic studies, considered Arabic as part of the Ottoman identity. Arabic, he maintained, "is the center of Arabism [Arabiyet]; a cultural, religious and moral heritage from which the Turks cannot detach themselves."[77] There were even some initiatives that promoted local cultural characteristics and Arabic as the language of administration. If not in a systematic and comprehensive manner, certain imperial orders and laws, among them the 1858 Land Law (Arazi Kanunnamesi), were translated into Arabic. Arabic was also integrated into education as a second language, most prominently in the Imperial High School in Istanbul (Galatasaray), opened in 1868. Although taken seriously, the debates on instruction in Arabic and the use of Arabic textbooks in Ottoman public schools in the provinces (especially during Midhat Pasha's tenures in Syria and Iraq) yielded few results.[78] Ahmed Şerif made an urgent call for the instruction of Arabic among Turkish speakers as a valuable service to Ottomanism. While endorsing the impetus to learn European languages in order to study European civilization and "take solid and free steps, . . . to be successful . . . in the life struggle," he pointed to the negligible number of young men who knew Arabic and underlined its importance for "private and public benefit," for the good of the country (vatan). The problems with Syria stemmed from lack of communication, and media had a responsibility to improve the situation. He therefore proposed that

his own journal publish an edition in Arabic.[79] In the end, Turkish remained the only official language, its limited accessibility contributing to the distancing of the state from the residents in the Arab provinces.

Ottomanism, an ideological position reflecting the cosmopolitan culture of the empire, was born during the era that marked the birth of nationalism throughout the world. However, it differed from the ideologies that supported the emerging "nation-states," as its goal was to coalesce the multiple ethnic and religious groups in the empire into a single entity. It was shaped under the impact of the Tanzimat principle of equality and strengthened by an 1869 law that acknowledged all Ottoman subjects as Ottoman citizens. Abdülhamid's shift to the caliphate and his emphasis on Islamism embraced the notion but refocused it now on loyalty to the Ottoman sultan. It became further crystallized by the Young Turks, who called for an Ottoman society that identified itself with the state and the country through the sultan and the representative government. Thus, they envisioned an Ottoman political community that would integrate non-Muslims and Muslims.[80] Adapting to changing positions, Ottomanism attempted to complement and facilitate its overarching ideology with projects that ranged from infrastructure to public squares surrounded by new buildings and dotted with iconographic monuments.

There is some affinity between Napoléon III's *royaume arabe* and the Ottoman efforts to create a new understanding of citizenship that would contain diversity under an umbrella identity, that of the empire. With the emperor and the sultan at the summit, both proposals capitalized on the power of the center and hierarchical political and cultural relations and approached their respective "colonies" with more tolerance. Nevertheless, the French colonial policies (of assimilation and association) kept the colonized society socially, culturally, and spatially apart from Europeans. Granted that the Ottoman imperial system was not based on settler colonialism as in the French case, Ottomanist ideology still pointed to a different kind of imperial identity, one that aimed at an integrated heterogeneity—albeit regulated by the institutions of the Ottoman state.

By the 1910s, the problems in the Arab provinces would be explained by the failure of Ottomanism. Ahmed Şerif observed it everywhere: in Beirut he was saddened that the "Ottomanist sentiment was very weak"; in Damascus, he highlighted the main conflict as "Ottomanism versus Arabism," maintaining that the two cultures did not know and understand each other and that the population was united around their identity as Arabs—whether they were Muslim, Christian, or Jewish. Furthermore, Arabs bore strong anti-Ottoman sentiments. For example, Syrian notables took delight in the weaknesses and failures of the state—as observed in their sympathies with the uprisings in Yemen, reported in the local papers in exaggerated emotional tones. Syrian journalists seemed to provoke a collective campaign against Ottomanism: according to them, Ahmed Şerif went on, "Ottomanism is like a treacherous dream. For them,

there is only Arabism, Albanianism, Hellenism, Armenianism, and Turkism."[81]

The failure of Ottomanism to plant widespread sentiments of unity and empire has been widely acknowledged by later historians. Nevertheless, to paraphrase İlber Ortaylı, the attempt to define an Ottoman identity that included Muslims and non-Muslims gave a special "hue" to scholarship, arts, politics, and publishing life during the closing era of the empire.[82] The themes covered in this book attest to this phenomenon, powerfully reflected, for example, in the efforts to relate to the specific characteristics of various cities when introducing new urban forms and the development of architectural languages that responded to local fabrics and heritage.

HAUNTING QUESTIONS

I have left to the very end the old and difficult question that still matters the most: the meaning of history for the world we live in today. I researched and wrote this book against the background of the U.S. occupation of Iraq and the Second Gulf War. As I tried to understand the Ottoman empire-building mechanisms and their urban and architectural manifestations, working with reports, descriptions, plans, and photographs of places such as Baghdad and Mosul, the daily news conveyed fragments of the horror their inhabitants were experiencing. I followed the bloody events in Falluja and studied the map of the city printed over and over in the *New York Times* against a map of the area I had obtained from the Prime Minister's Archives in Istanbul. My map depicted the strategic points for the establishment of an Ottoman military presence and for building a series of barracks on a land marked by palm tree orchards, whereas the *New York Times* maps outlined the latest armed struggles in a heavily built urban area. The bend of the river remained the same, making the unique physical link between the past and the present; the different agendas expressed by the maps, separated by over a century, pointed to the changed notions and mechanisms of territorial control, power relations, and, ultimately, empire building. I studied the photographs of the government offices in Mosul that attempted to bring modernity to the late nineteenth century as I was bombarded by contemporary media on the urgency of modernizing the region.

The tensions between France and its past colonies also hit a moment of crisis during work on this book. The uprising that exploded in November 2005 in the suburbs of the French cities did not happen in abstraction from the history of the French colonial empire and, significantly, its urban practices. At the risk of making an enormous generalization, I suggest that the origins of today's desolate segregated housing projects can be associated with the cutting and piercing of cities in Algeria and the creation of distinct European settlements that separated the colonized from the colonizer. Thinking about nineteenth-century empire-building processes may offer some insight into the burning *banlieues*.

Having read parts of the manuscript, a friend remarked on the value of rethinking the locations recent events have familiarized us with in fresh terms, other than those imposed by contemporary conflict. To begin to understand their histories, including the dynamics of their complex relationship to what it meant to be "modern," would help break through our received one-dimensional and frozen images.[83] As involved as I was in figuring out certain themes in the late-nineteenth- and early-twentieth-century history of the Middle East and North Africa, their implications for today haunted me continuously. This book is not written with an explicit agenda to make sense of today's politics, but to explore certain developments prior to World War I in a cross-cultural framework. My perspective is very different from Rashid Khalidi's in his remarkable *Resurrecting Empire*, which was conceived specifically to fill a gap in American readers' knowledge by contextualizing current events with historic analysis of the struggle for hegemony in the Middle East.[84] However, I share Khalidi's concerns wholeheartedly and hope that my study makes the geographies and cities it deals with historically more accessible and meaningful.

NOTES

INTRODUCTION

1. I borrow the phrase "connected world of empires" from C. A. Bayly and Leila Tarazi Fawaz. See their "Introduction: The Connected World of Empires," in Bayly and Fawaz, eds., *Modernity and Culture: From the Mediterranean to the Indian Ocean* (New York: Columbia University Press, 2002). The essays in that volume cast a new look at the intellectual and political culture of modernity in the Middle East and South Asia, focusing on the Ottoman and British empires. The use of the word "empire" needs some explanation at the outset. After all, during the time period covered in the present book, France was first an empire, then a republic (Second Republic, 1848–52), empire (Second Empire of Napoléon III, 1852–70), and republic again (Third Republic, 1870–1940). "Empire" is understood here in its broader meaning, closer to the definition "a group of nations or states under a sovereign power" in *Webster's Dictionary*. The sovereign power hence may or may not be an emperor; the issue is sovereignty of the metropole over geographically distant lands and culturally different societies. The Ottomans referred to their territories, not as an "empire," but as a "sultanate" and, in a better description for my purposes, as *memalik-i mahsura* (well-protected domains).

2. Marshall Berman, *All That Is Solid Melts into Air: The Experience of Modernity* (New York: Penguin Books, 1982), 1–2. In this study, I kept the references to theoretical sources to a minimum, not because I disown the myriad influences that shaped my thinking (they will be obvious to many of my readers), but because I did not want to burden the text with transparent reminders that often risk turning into repetitive lists of familiar names and texts.

3. I will use the Ottoman names for the two Tripolis to avoid confusion: Trablusgarb (Tripoli of the West) for Tripoli, Libya; and Trablussam (Tripoli of Bilad al-Sham) for Tripoli, Lebanon.

4. Historians have begun to question these bilateral models. Most significantly, see Julia Clancy-Smith, "Migrations, Legal Pluralism, and Identities in Pre-colonial Tunisia," in Patricia Lorcin, ed., *Identity, Memory, and Nostalgia: France and Algeria, 1800–2000* (Syracuse, NY: Syracuse University Press, 2006).

5. I, too, have contributed to the tendency to see only the influences extending from Europe to the Ottoman Empire and not the two-way flow of ideas: see my *The Remaking of Istanbul: Portrait of an Ottoman City in the Nineteenth Century* (Seattle: University of Washington Press, 1986; paperback, Berkeley and Los Angeles: University of California Press, 1993).

6. Jens Hanssen, "Practices of Integration—Center-Periphery Relations in the Ottoman Empire," in Jens Hanssen, Thomas Philipp, and Stefan Weber, *The Empire in the City: Arab Provincial Capitals in the Late Ottoman Empire* (Würzburg: Ergon in Kommission, 2002), 57–58. Isa Blumi also argues the case in his study of Albania and Yemen, which he sees as "a departure from more conventional methods of narration." By considering the "two edges" of the empire, he aims to bring to light "the role of the province, its peoples, its socioeconomic links to the world around it to affect change in the Empire," and to deconstruct the perspective that focuses on the "ideological *raison d'être* of the métropole" for its "oversight of the nuanced local reactions to these attempts to impose imperial power." Isa Blumi, *Rethinking the Late Ottoman Empire: A Comparative Social and Political History of Albania and Yemen, 1878–1918* (Istanbul: Isis Press, 2003), 14, 17.

7. My study is inspired by and indebted to many scholars whose work has dealt with aspects of late Ottoman cities and visual culture, including Isa Blumi, Selim Deringil, Jens Hanssen, Thomas Kühn, Ussama Makdisi, İlber Ortaylı, and Stefan Weber. Historians of colonialism in North Africa are also beginning to look at the "other" perspective. See, e.g., Isabelle Grangaud, "Masking and Unmasking the Historic Quarters of Algiers: The Reassessment of an Archive," in Zeynep Çelik, Julia Clancy-Smith, and Frances Terpak, eds., *Walls of Algiers: Narratives of the City through Text and Image* (Seattle: University of Washington Press; Los Angeles: Getty Research Institute, 2009).

8. Armand Mattelart, *Mapping World Communication: War, Progress, Culture*, trans. Susan Emanuel and James A. Cohen (Minneapolis: University of Minnesota Press, 1994), 4.

9. W. P. Andrew, *Memoir on the Euphrates Valley Route to India* (London, 1857), quoted in Yakup Bektaş, "The Sultan's Messenger: Cultural Constructions of Ottoman Telegraphy, 1847–1880," *Technology and Culture* 41, no. 4 (October 2000): 669.

10. Quoted in Armand Mattelart, *The Invention of Communication*, trans. Susan Emanuel (Minneapolis: University of Minnesota Press, 1996), 52.

11. Ibid., 11.

12. Mattelart, *Mapping World Communication*, 7–8.

13. Mattelart, *Invention of Communication*, 104, 105. On Chevalier, see also Michel Lavallois, "Essai de typologie des orientalistes saint-simoniens," in Michel Lavallois and Sarga Moussa, eds., *L'orientalisme des saint-simoniens* (Paris: Maisonneuve & Larose, 2006), 121–23.

14. Bektaş, "Sultan's Messenger," 670, 676; Roderick H. Davison, *Essays in Ottoman and Turkish History, 1774–1923: The Impact of the West* (Austin: University of Texas Press, 1990), 137–38. It should be added that efficient communication networks, especially the telegraph,

endowed subjects with "a political voice" by making it possible to reach all levels of government easily. Eugene Rogan makes the case convincingly: Eugene Rogan, "Instant Communication: The Impact of the Telegraph in Ottoman Syria," in Thomas Philipp and Birgit Schaebler, eds., *The Syrian Land: Processes of Integration and Fragmentation; Bilad al-Sham from the 18th to the 20th Century* (Stuttgart: Franz Steiner, 1998), 113–28.

15. For a reproduction of the "Map of the New Regime," dating from 1790, see Roland Schaer, Gregory Claeys, and Lyman Tower Sargent, eds., *Utopia: The Search for the Ideal Society in the Western World* (New York: New York Public Library/Oxford: Oxford University Press, 2000), 198.

16. On local administrations see İlber Ortaylı, *Tanzimattan Sonra Mahalli İdareler (1840–1876)* (Ankara: Sevinç Matbaası, 1974).

17. Hüseyin Tosun, ed., *Midhat Paşa'nın Suriye Lahiyası* (Istanbul: Cihan Matbaası, 1324/1906), 7–9.

18. S. John Summerson, "Urban Forms," in Oscar Handlin and John Burchard, eds., *The Historian and the City* (Cambridge, MA: MIT Press, 1963), 165–66. I use Summerson's definition of an architectural historian's "urban history," to which I was first drawn in my dissertation (1984, revised as *Remaking of Istanbul*; the reference to Summerson is on p. xvii). It continues to explain the essence of my approach to built forms.

19. Literature on French rule in Algeria is extensive. For this brief introduction, I relied mainly on Ch.-Robert Ageron, *Histoire de l'Algérie contemporaine* (Paris: Presses Universitaires de France, 1964); and Benjamin Stora, *Histoire de l'Algérie coloniale (1830–1954)* (Paris: Éditions La Découverte, 1991). The quotations are from Ageron, 7–8, 17–18; and Stora, 21.

20. Quoted in Ageron, *Histoire de l'Algérie contemporaine*, 28.

21. Ibid., 31.

22. Leon Carl Brown, *The Surest Path* (Cambridge, MA: Harvard University Press, 1967), 23–24, 151, 81 (quotation), 115.

23. Ahmad ibn Abi Diyaf, *Consult Them in the Matter: A Nineteenth-Century Islamic Argument for Constitutional Government,* trans. L. Carl Brown (Fayetteville: University of Arkansas Press, 2005), 104.

24. Brown, *Surest Path*, 116. On Khayr al-Din's commitment to Tanzimat reforms, see also Julia Clancy-Smith, "Khayr al-Din al-Tunisi and a Mediterranean Community of Thought," in her *Migrations: Trans-Mediterranean Settlement in Nineteenth-Century North Africa, 1820–1881* (forthcoming), chap. 8.

25. William L. Cleveland, "The Municipal Council of Tunis, 1858–1870: A Study in Urban Institutional Change," *International Journal of Middle Eastern Studies* 9 (1978): 39–40.

26. Quoted in *La Tunisie: Terre française* (Paris: Société Française d'Éditions, 1930), 49, 55–56.

27. Abdallah Laroui, *L'histoire du Maghreb* (Paris: François Maspero, 1976), 2:88.

28. Ussama Makdisi, *The Culture of Sectarianism: Community, History, and Violence in Nineteenth-Century Ottoman Lebanon* (Berkeley and Los Angeles: University of California Press, 2000), 11.

29. Ussama Makdisi, "Ottoman Orientalism," *American Historical Review* 107, no. 3 (June 2002). Accessed online at http://www.historycooperative.org/journals/ahr/107.3/ aho30200076 (quotation from paragraph 7).

30. See Ortaylı, *Tanzimattan Sonra Mahalli İdareler*. For a summary of the development of the municipal code, see Michael J. Reimer, "Becoming Urban: Town Administration in Transjordan," *International Journal of Middle East Studies* 37 (2005): 191–92.

31. Quoted in Edmond Bernet, *En Tripolitaine* (Paris: Fontemoing, 1912), 242–43.

32. Quoted in Selim Deringil, "'They Live in a State of Nomadism and Savagery': The Late Ottoman Empire and the Post-colonial Debate," *Comparative Studies in Society and History* 45, no. 2 (April 2003): 327. Deringil summarizes a report from 1885 in the Başbakanlık Osmanlı Arşivi, Istanbul (BOA): Y.EE 14/292/126/8.

33. "Introduction: Towards a New Urban Paradigm," in Hanssen, Philipp, and Weber, *Empire in the City*, 6–10.

34. Deringil, "'They Live in a State of Nomadism and Savagery,'" 311–13; Edhem Eldem, "Istanbul from Imperial to Peripheralized Capital," in Edhem Eldem, Daniel Goffman, and Bruce Masters, eds., *The Ottoman City between East and West* (Cambridge: Cambridge University Press, 1999), 200.

35. An important report that summarized the achievements during the ten-year tenure of Ahmed Rasim Pasha, the governor of Trablusgarb, serves as a good indicator of the specific rapport between the Ottoman reformers and the locals. The lists that itemize the buildings and infrastructure work classify the funding sources: in addition to the municipal budget, they cite construction financed by "the commercial sectors and the people" (*tüccar ve ahali*), including not only commercial establishments but also mosques and madrasas. BOA, Y.EE (1308/1890–91).

36. "Introduction: Towards a New Urban Paradigm," in Hanssen, Philipp, and Weber, *Empire in the City*, 7–8.

37. Deringil, "'They Live in a State of Nomadism and Savagery,'" 312.

38. Makdisi, "Ottoman Orientalism," paragraphs 1–2.

39. Quoted in Engin D. Akarlı, "Abdülhamid II's Attempt to Integrate Arabs into the Ottoman System," in David Kushner, ed., *Palestine in the Late Ottoman Period: Political, Social, and Economic Transformations* (Jerusalem: Yad Izhak Ben-Zvi Press; Leiden: E. J. Brill, 1986), 75. For the first Ottoman constitutional period and the parliament of 1877–78, see Robert Devereux, *The First Ottoman Constitutional Period* (Baltimore, MD: Johns Hopkins Press, 1963).

40. Midhat, "The Past, Present, and Future of Turkey," *The Nineteenth Century*, no. 16 (June 1878): 986, 992–93.

41. Enver Ziya Karal, *Osmanlı Tarihi* (Ankara: Türk Tarih Kurumu, 1962), 8:331; François Georgeon, *Abdulhamid II: Le sultan calife* (Paris: Fayard, 2003), 184.

42. Hasan Kayalı, *Arabs and Young Turks: Ottomanism, Arabism, and Islamism in the Ottoman Empire, 1908–1918* (Berkeley and Los Angeles: University of California Press, 1997), 32. The Young Turks, who had forced Abdülhamid to declare a constitutional government in 1908, formulated their policies in response to Hamidian policies. In their concern to build a "nation-state," they confronted center-periphery relations, prominent among which was the integration of the Arab provinces into a modern political entity. Through identification with the state and the country (through the sultan, but now in a constitutional monarchy/representative government), they aimed to create a "civic-territorial" Ottoman political community. Ibid., 9. Their urban policies followed the aready established models.

43. The Great Britain Foreign Office report (1920) is quoted in Ruth Kark, *Jaffa: A City in Evolution, 1799–1917* (Jerusalem: Yad Izhak Ben-Zvi Press, 1990), 39–40.

44. To refer to a few examples, the new neighborhoods of Aleppo designed on grid plans have been ignored by those scholars who propose that regularity was paramount in urban design during the French mandate period; the *extra-muros* development of Trablusgarb is still attributed to Italian planners in recent studies of Italian colonial cities; and even the Hijaz Railroad was presented in an exhibition recently as a German project. These case studies will be explored in detail later.

45. *Servet-i Fünun*, no. 153 (1309/1894): 359–60; and no. 145 (1309/1894): 231. This should be situated in the context of the Ottoman culture of photography, the combined work of travel photographers, foreign and Ottoman commercial photographers (including regional ones), and Ottoman military photographers—as pointed out by Wolf-Dieter Lemke. Ottoman photography has recently been a popular topic of study. See, e.g., Wolf-Dieter Lemke, "Ottoman Photography: Recording and Contributing to Modernity," in Hanssen, Philipp, and Weber, *Empire in the City*, 237–44; and Engin Çizgen [Özendeş], *Photography in the Ottoman Empire, 1839–1919* (Istanbul: Haşet Kitapevi, 1987).

46. For Moulin, see "La photographie en Algérie," *La lumière* 6, no. 12 (22 March 1856): 45. The Abdülhamid collection is housed in the Istanbul University Central Library (Istanbul Üniversitesi Merkez Kütüphanesi, IÜMK).

47. Gilbert Beaugé and Engin Çizgen and Suraiya Faroqhi also remarked on this difference. See Gilbert Beaugé and Engin Çizgen, *Images d'empire, aux origines de la photographie en Turquie, Türkiye'de Fotoğrafın Öncüleri* (Istanbul: Institut d'Études Françaises d'Istanbul, n.d.), 200–211; Suraiya Faroqhi, *Subjects of the Sultan: Daily Life in the Ottoman Empire* (London and New York: I. B. Tauris, 2000), 259.

48. Christoph Herzog and Raoul Motika, "Orientalism *alla turca*: Late 19th/Early 20th Century Ottoman Voyages into the Muslim 'Outback,'" *Die Welt des Islams* 40, no. 2 (July 2000): 141–51.

49. Ahmet Şerif, *Anadolu'da Tanin*, ed. Mehmet Çetin Börekçi (Ankara: Türk Tarih Kurumu, 1999), 1:197.

50. Çelik, *Remaking of Istanbul*, 168n34.

51. IÜMK, album 90598.

52. Şerif, *Anadolu'da Tanin*, 2:257.

53. Another difficulty stemmed from the fact that I have not been to Iraq, Libya, Yemen, and Hijaz. However, examining recent photographs and plans, I realize that the cities I discuss have lost much of their nineteenth-century development. Hence, I was restricted to cartographic and photographic reconstructions.

1 IMPERIAL INFRASTRUCTURES

1. Quoted in Narcisse Faucon, *La Tunisie avant et depuis l'occupation française* (Paris: Augustin Challamel, 1893), 2:150.

2. Ibid., 138–39, 147.

3. Quoted in Mohamed Lazhar Gharbi, *Impérialisme et réformisme au Maghreb: Histoire d'un chemin de fer algéro-tunisien* (Tunis: Cérès, 1994), 139.

4. Eugen Weber, *Peasants into Frenchmen: The Modernization of Rural France, 1870–1914* (Stanford, CA: Stanford University Press, 1976), 197; Faucon, *La Tunisie*, 2:151.

5. Gharbi supports this interpretation in detail in reference to the Bône–Guelma line. See Gharbi, *Impérialisme et réformisme au Maghreb*.

6. Faucon, *La Tunisie*, 2:191.

7. See Alice L. Conklin, *A Mission to Civilize: The Republican Idea of Empire in France and West Africa, 1895–1930* (Stanford, CA: Stanford University Press, 1997), 53, 56. Conklin examines the *mise-en-valeur* of the colonies in specific reference to West Africa.

8. This regulation, titled Yolların Umur-u Tesviyesi ve Ahalinin Suret-i İstihdamı Hakkında Talimatname (The Ordering Operations of Roads and the Conditions of Public Employment), also enforced public participation in the work. For example, men between the ages of 16 and 60 had to work a minimum of four hours per year or 20 days every five years in the construction of roads and bridges in the areas where they lived; monetary compensation could be substituted. These regulations were translated into Arabic in 1878. See Jens Hanssen, *Fin de Siècle Beirut: The Making of an Ottoman Provincial Capital* (Oxford: Oxford University Press, 2005), 115.

9. Musa Çadırcı, *Tanzimat Döneminde Anadolu Kentlerinin Sosyal ve Ekonomik Yapısı* (Ankara: Türk Tarih Kurumu, 1900), 300; Stanford Shaw, "The Nineteenth Century Ottoman Tax Reforms and Revenue System," *International Journal of Middle East Studies* 6 (1975): 433.

10. Hanssen, *Fin de Siècle Beirut*, 39.

11. Mehmed Refik and Mehmed Behçet, *Beyrut Vilayeti* (Beirut: Vilayet Matbaası, 1333/1917), 1:148–49.

12. This was a widely acknowledged fact, as illustrated by high school history textbooks: "The province has many more roads than other provinces." See Cevad Ibn ün-Nüzhet, *Haritalı Musavver Memalik-i Osmaniye Coğrafyası* (Istanbul: Osmaniye Matbaası, 1327/1909), 109.

13. Engin Deniz Akarlı, *The Long Peace: Ottoman Lebanon, 1861–1920* (London and New York: I. B. Tauris, 1993), 113.

14. Refik and Behçet, *Beyrut Vilayeti*, 1:148; Şerafettin Mağmumi, *Seyahat Hatıraları* (Cairo, 1909), 288; *Salname-yi Vilayet-i Beyrut, 1311–1312* (Beirut: Vilayet Matbaası, 1315/1897), 25. On the completion of the Jaffa–Jerusalem road, which extended to Babü'l Vadi Boğazı, in 1864, see BOA, A.MKT.MHM 395/92 (1284); Kark, *Jaffa*, 220; and Yasemin Avcı, *Değişim Sürecinde bir Osmanlı Kenti: Kudüs (1890–1914)* (Ankara: Phoenix, 2004), 182–83. The Jaffa–Nablus road, completed in 1888, boasted a bridge with stone piers and an iron superstructure; its iron bars were imported from France. See Kark, *Jaffa*, 223.

15. Refik and Behçet, *Beyrut Vilayeti*, 1:65–66.

16. "10,000 kilomètres des Ponts et Chaussées," *Revue technique d'Orient* 1, no. 1 (15 September 1910): 1–2.

17. *Yemen Salnamesi* (Sana: Vilayet Matbaası, 1313/1895), 353.

18. Osman Nuri, *Abdülhamid ve Saltanatı: Hayat-ı Hususiye ve Siyasiyesi* (Istanbul: Kütüphane-yi İslam ve Asker—İbrahim Hilmi, 1327/1909), 948.

19. Engin Deniz Akarlı, ed., *Belgelerle Tanzimat: Osmanlı Sadrazamlarından Ali ve Fuad Paşaların Siyasi Vasiyetnameleri* (Istanbul: Boğaziçi Üniversitesi Yayınları, 1978), 25.

20. [Sultan] Abdül Hamid, *Siyasi Hatıralarım*, 2nd ed. (Istanbul: Dergah Yayınları, 1975), 94.

21. *Salname-yi Vilayet-i Beyrut* (Beirut: Matbaa-yı Vilayet, 1324/1908–9), 55.

22. Murat Özyüksel, *Hicaz Demiryolu* (Istanbul: Tarih Vakfı Yurt Yayınları, 2000), 9–11.

23. Michael E. Bonine, "The Introduction of Railroads in the Eastern Mediterranean: Economic and Social Impacts," in Philipp and Schaebler, *Syrian Land*, 59.

24. Özyüksel, *Hicaz Demiryolu*, 33; Avcı, *Değişim Sürecinde bir Osmanlı Kenti*, 188–90.

25. On the construction of the Berede Boğazı, Sofer, and Araya tunnels and the Zerzer viaduct, see *Servet-i Fünun*, no. 241 (1311/1893–94); Özyüksel, *Hicaz Demiryolu*, 32; Bonine, "Railroads in the Eastern Mediterranean," 59.

26. Bonine, "Railroads in the Eastern Mediterranean," 59; Refik and Behçet, *Beyrut Vilayeti*, 1:170–71.

27. Refik and Behçet, *Beyrut Vilayeti*, 1:171.

28. Özyüksel, *Hicaz Demiryolu*, 35.

29. Refik and Behçet, *Beyrut Vilayeti*, 1:169–70.

30. Özyüksel, *Hicaz Demirolu*, 42.

31. An article in *Le tour du monde* underlined the commercial advantages Germany would gain from this line and reported that Germans were in the process of "preparing the land for German colonization." It urgently called for French "participation in this gigantic work." See H. Hauser, "Le chemin de fer de Bagdad," *A travers du monde*, appendix to *Le tour du monde* 3, no. 3 (20 January 1900): 21–22.

32. Özyüksel, *Hicaz Demiryolu*, 22–24; Bonine, "Railroads in the Eastern Mediterranean," 57–58.

33. *Actes de la Société du Chemin de Fer Ottoman de la Syrie, Akka à Damas* (Pera, Constantinople: Imprimerie du journal "Stamboul," 1891); IÜMK 79296, arts. 19, 22, 25, and 26 (Convention), and art. 16 (Cahier des charges), pp. 12–14, 24.

34. Literature on the Hijaz Railroad is extensive. Among the most insightful publications on the topic are two books offering new interpretations based on hitherto-untapped sources: Ufuk Gülsoy's *Hicaz Demiryolu* (Istanbul: Eren, 1994), which uses Ottoman archival documents, and Özyüksel's *Hicaz Demiryolu*, which relies primarily on German material. William Ochsenwald's *The Hijaz Railroad* (Charlottesville: University Press of Virginia, 1980) is a comprehensive study that stands out in its exhaustive use of French and English sources. Jacob M. Landau's *The Hejaz Railway and the Muslim Pilgrimage: A Case of Ottoman Political Propaganda* (Detroit: Wayne State University Press, 1971) is the translation of a text in Arabic by Muhammed Arif and constitutes an important source. A recent exhibition, titled "Bagdadbahn und Hedjazbahn," was organized by Deutschebundesbahn Museum Nürnberg (28 September 2003–15 February 2004) and also shown in Pergamonmuseum in Berlin (8 October 2004–9 January 2005). Looking at railroad construction in the Ottoman Empire exclusively from the German point of view and using only German documents, this large exhibition covered the construction of the two lines up to the present day and complemented the historic documents with a series of photographs by Helmut Dollhopt, shot in 2000, along the two lines.

35. Özyüksel, *Hicaz Demiryolu*, 41.

36. BOA, MV 140/51 (1328/1910).

37. Half of the income from the Jidda customs was designated for the emirs of Mecca. See Özyüksel, *Hicaz Demiryolu*, 45.

38. Ibid., 70–75. Gülsoy argues that there were economic reasons as well and they involved potential mining, establishment of small industries, animal husbandry, and increase in trade. See Gülsoy, *Hicaz Demiryolu*, 51. A 1906 report by an anonymous Ottoman official argued for the religious, economic, and military need for the project. The economic benefit would derive from the fact that the line would be operated by the Ottoman state, which would thus gain the profits from it—in contrast to all other rail lines in the empire, the income from which "entered the pockets of foreign companies." The military aspect of the project derived from its construction by Ottoman soldiers. In fact, this provided a significant economic gain and the work would proceed in "a short time and [spending] little money." Furthermore, the report asserted that construction in the desert, where water and people were scarce, could be achieved only by military troops. See BOA, Y.PRK.TNF 8/37 (1323).

39. Gülsoy, *Hicaz Demiryolu*, 34–39.

40. Özyüksel, *Hicaz Demiryolu*, 81–117; Gülsoy, *Hicaz Demiryolu*, 57–104. During Eid al-Adha the tradition is to sacrifice animals and distribute their meat to the needy.

41. Özyüksel, *Hicaz Demiryolu*, 118–35, 107–16.

42. *Servet-i Fünun*, nos. 592–93 (1318/1902): 310–11.

43. Gülsoy, *Hicaz Demiryolu*, 255–56.

44. See, for example, an album on the tunnels and bridges along the Hijaz Railroad (Atatürk Kütüphanesi, Istanbul [AK], 136) and another dedicated to bridges between Haifa and Akka (IÜMK 90860/26–27).

45. *Servet-i Fünun*, nos. 592–93 (1318/1902): 311.

46. The photographs in *Servet-i Fünun* were almost exclusively presented without accompanying text except for captions. The memorable exception was the special issue.

47. *Servet-i Fünun*, nos. 688, 689, 696, 701, 703, 705–9, and 713 (1320/1904).

48. Özyüksel, *Hicaz Demiryolu*, 182–96; Gülsoy, *Hicaz Demiryolu*, 134–39. On measures against the attacks, see BOA, DH.MUI 1-1/37 (1327/1909) and DH.MUI 1-3/25 (1327/1909).

49. "Ligne Hodeïdah-Hadjela (Yémen)," *Revue technique d'Orient* 1, no. 3 (15 November 1910): 1–2.

50. Şerif, *Anadolu'da Tanin*, 1:207, 191–94.

51. For plans and sections of the stations, see François Lantz, *Chemins de fer et perception de l'espace dans les provinces arabes de l'Empire ottoman* (Paris: L'Harmattan, 2005), 264–65. The drawings are taken from *Revue générale des chemins de fer*, no. 6 (June 1896).

52. Şerif, "Anadolu'da Tanin," 193–94.

53. Cengiz Orhonlu and Turgut Işıksal, "Osmanlı Devrinde Nehir Nakliyatı Hakkında Araştırmalar: Dicle ve Fırat Nehirlerinde Nakliyat," *Tarih Dergisi*, nos. 17–18 (1963): 100–139.

54. *Seyahat: İstanbul'dan Samsun, Diyarbekir Tarikiyle Bağdad, Basra ve Oradan Halep, İskenderun Tarikiyle İstanbul'a Seyahat-ı Mutazammın Mektuplarından Müteşekkildir* (Istanbul: Aşaderyan Matbaası, 1311/1893), 118.

55. BOA, DH.ID 130/6 (1331/1912).

56. "Fırat ve Dicle Nehirlerinin etrafındaki şehir ve köylerin haritası," IÜMK 93163.

57. *Seyahat*, 14.

58. Hakkı-Bey [Babanzade], *De Stamboul à Baghdad: Notes d'un homme d'État turc* (Paris: Ernest Leroux, 1911), 37–38.

59. *Servet-i Fünun*, no. 338 (1313/1897): 408.

60. *Servet-i Fünun*, no. 475 (1316/1899): cover page shows the inauguration ceremonies.

61. See, e.g., Ali Tevfik, *Memalik-i Osmaniye Coğrafyası* (Istanbul: Bab-ı Ali Matbaası, 1307/1887), 312.

62. Laila Fawaz, "The Changing Balance of Forces between Beirut and Damascus in the Nineteenth and Twentieth Centuries," *Revue du monde musulman et de la Méditerranée* 55–56, nos. 1–2 (1990): 209–10.

63. BOA, I.MVL 242/8719 (1268/1851); BOA, I.MVL 299/12165 (1270/1853). Both documents discuss the reorganization of the Beirut harbor.

64. For a discussion of attempts to build the Beirut port between the 1850s and 1888, including those of Governor Midhat Pasha, see Hanssen, *Fin de Siècle Beirut*, 85–89.

65. Julius Löytved, Plan de Beyrouth dedié a S. M. I. Le Sultan Abdul Hamid II, 1876, IÜMK 93158.

66. Mağmumi, *Seyahat Hatıraları*, 285.

67. Hanssen, *Fin de Siècle Beirut*, 89.

68. "Beyrut Limanı İnşaatına Müteallik Projeler," 1888, IÜMK 92301. I could not decipher the name of the engineer.

69. Service hydrographique de la Marine, "Baies de Beyrouth et de St. Georges d'après les levés anglais de 1859," Paris, 1888 (inset: "Port de Beyrouth levé en 1908"); American University in Beirut, University Libraries, Archives and Special Collections (AUB), Mp 912.56925 BEI 1888.

70. *Salname-yi Vilayet-i Beyrut* (Beirut: Vilayet Matbaası, 1321/1903), 68.

71. Lewis Gaston Leary, *Syria: The Land of Lebanon* (New York: McBride, Nast & Co., 1913), 35–36.

72. Refik and Behçet, *Beyrut Vilayeti*, 1:170; *Salname-yi Vilayet-i Beyrut 1311–1312* (Beirut: Vilayet Matbaası, 1315/1897) 438.

73. BOA, Y.PRK.TNF 6/3 (1316).

74. Refik and Behçet, *Beyrut Vilayeti*, 1:243.

75. Şerif, *Anadolu'da Tanin*, 1:207.

76. Karl Baedecker, *Palestine and Syria*, 5th ed. (Leipzig: Karl Baedecker; London: George Allen & Unwin; New York: Chas. Scribner's Sons, 1912), 229.

77. Ochsenwald, *Hijaz Railroad*, 132–33; Refik and Behçet, *Beyrut Vilayeti*, 1:242. The authors of *Beyrut Vilayeti* give several figures to show the increase in customs income: between 1310 (1892) and 1329 (1911), it had increased almost twentyfold.

78. BOA, I.MVL 531/23824 (1281/1864).

79. Kark, *Jaffa*, 64 (see the map by Theodor Sandel).

80. BOA, Y.MTV 35/79 (1306/1888) and Y.MTV 36/91 (1306/1888).

81. Mehmet Tevfik [Biran], *II. Abdülhamid, Meşrutiyet ve Mütareke Devri Hatıraları*, ed. F. Rezan Hürmen (Istanbul: Arma Yayınları, 1993), 1:76–77.

82. BOA, DH.ID 74/19 (1329/1911). The fact that the report was written by the Financial Bureau of the Navy (Bahriye Mesarifat Dairesi) and addressed to the Ministry of the Interior (Dahiliye Nezaret-i Celilesi) presents the building of Jaffa's port as a broader imperial project, not one relegated to local authorities.

83. BOA, DH.ID 59/72 (1332/1913).

84. Avcı, *Değişim Sürecinde bir Osmanlı Kenti*, 185.

85. Gülsoy, *Hicaz Demiryolu*, 213n2.

86. *Hicaz Vilayeti Salnamesi* (Mecca: Vilayet Matbaası, 1309/1891), 272.

87. *Trablusgarb Vilayeti Salnamesi* (Tripoli: Vilayet Matbaası, 1305/1887), 124.

88. BOA, DH.TMIK.S 18/80 (1315/1898).

89. BOA, Y.EE 109/22 (1307/1889).

90. Deringil, "'They Live in a State of Nomadism and Savagery,'" 319. The document is titled "Directions Given by His Imperial Majesty the August Personage and Caliph regarding the Prosperity, Progress, and Reinforcement of the Province of Trablusgarb." Deringil speculates that the undated report must have been prepared in the 1890s. In the light of the port project, the date may be pushed back by a few years. I consulted this document as well. For the items related to my discussion, see BOA, Y.EE 3/68, arts. 8–10).

91. Deringil, "'They Live in a State of Nomadism and Savagery,'" 320. For the work done under Ahmed Rasim Pasha, see BOA, Y.EE 7/13 (1308/1890–91).

92. İbrahim Paşa, "Trablusgarb Kasabası ile Civarı Haritası," Donanma-yı Osmani Muavenet-i Milliye Cemiyeti, 1327, AK 912-612 IBR 1237/*harita* 1335/1917 (the date is wrong in the catalog: it should be 1327/1909).

93. Faucon, *La Tunisie*, 2:139.

94. I will not analyze these documents, which are in the archives of the Service Historique de la Défense, Armée de Terre, Château de Vincennes, Paris (hereafter Défense); they do not pertain to my main arguments.

95. *La Province de Constantine en 1839 et 1840* (Paris: Félix Locquin, 1843), 9–12.

96. Défense, Génie, Constantine, 1H 830, art. 8, no. 19.

97. Louis Piesse, *Algérie et Tunisie*, Collection des guides-Joanne (Paris: Librairie Hachette, 1888).

98. Ibid., 255, 265–66.

99. Défense, Génie, Constantine, 1H 289, art. 8, no. 24 (8 January 1862).

100. This suspended bridge was one of the rare projects in Algeria that was reported in the Ottoman press. See *Revue technique d'Orient* 2, no. 18 (February 1912): 12–13.

101. "Travaux publics," *Tunis: Journal de l'Afrique française* 2, no. 3 (5 January 1891).

102. Piesse, *Algérie et Tunisie*, 373–74; Faucon, *La Tunisie*, 2:140–41, 146.

103. Gharbi, *Impérialisme et réformisme au Maghreb*, 135–38: M. Forestier, *Notice sur les chemins de fers algériens* (Alger-Mustapha: Girault, 1900), 5–6.

104. Quoted in Pascal Bejui, Luc Raynaud, and Jean-Pierre Vergez-Larrouy, *L'Afrique du nord, le Transsaharien* (Chanac: La Régordane, 1992), 11.

105. Gharbi, *Impérialisme et réformisme au Maghreb*, 146.

106. Levallois, "Essai de typologie des orientalistes saint-simoniens." 121–23. The quotation from Chevalier is on 122–23.

107. Annie Rey-Goldzeiguer, "Le projet industriel de Paulin Talabot," in Magali Morsy, ed., *Les Saint-Simoniens et l'Orient: Vers la modernité* (Aix-en-Provence: Édisud, 1989), 104–6. Examining the Talabot family's projects, Rey-Goldzeiguer provides a focused case study that sheds much light on Saint-Simonian activities in the region.

108. Gharbi, *Impérialisme et réformisme au Maghreb*, 142–43.

109. Ibid., 151–53. *Spahi* refers to "indigenous" troops in the French army. It was common practice to employ military prisoners in construction projects. Clancy-Smith examines coerced labor in detail in her forthcoming book, *Migrations*.

110. Défense, Génie, Souk-Arhas, 1H 874 (11 March 1881).

111. Défense, Génie, Souk-Arhas, 1H 874, art. 3, no. 14, "Frontière tunisienne," scale: 1/400,000.

112. Robert Schemama, *La Tunisie agricole et rurale et l'oeuvre de la France* (Paris: Librairie Générale de Droit et de Jurisprudence, 1938), 64–65; Faucon, *La Tunisie*, 2:152–53; Clancy-Smith, "Khayr al-Din al-Tunisi and a Mediterranean Community of Thought," in *Migrations*, chap. 8.

113. Faucon, *La Tunisie*, 2:159.

114. Ibid., 159–60.

115. Gharbi, *Impérialisme et réformisme au Maghreb*, 307.

116. Quoted in Jacques Marseille, *Empire colonial et capitalisme français: Histoire d'un divorce* (Paris: Albin Michel, 1984), 229.

117. "Les chemins de fer," *Tunis: Journal de l'Afrique française* 2, no. 15 (30 March 1891).

118. Archives Diplomatiques de Nantes (ADN), Tunisie, 943A, "Extension rationelle du Réseau des Chemins de fer Tunisiens," Paris (20 September 1898).

119. Jean Despois, *La Tunisie* (Paris: Librairie Larousse, 1930), 130.

120. *Tunis: Journal de l'Afrique française* 1, no. 2 (1890). The construction of this line went back to 1881, when it was conceived as a *decauville* (horse-drawn system) for the needs of the army. See Faucon, *La Tunisie*, 2:173.

121. "Le développement industriel et commercial de la Tunisie," *Le tour du monde* 5, no. 27 (8 July 1899): 205; Faucon, *La Tunisie*, 2:172. For detailed information on the operations of the Companie de Chemins de Fer Bône-Guelma in Tunisia (e.g., schedules, fees, and maps showing the network), see ADN, Tunisie, 941A and 941B.

122. Philippe Berger, *La Tunisie ancienne et moderne* (Paris: Ernest Leroux, 1907), 47.

123. With the growth of cities, the old train stations would be replaced with new ones, and sometimes additional stations would be constructed. For example, in the light of Bône's economic development, a project, endorsed by the mayor, was proposed in 1890 to build a new station in the port area and to connect it to the old one. However, the plan was opposed by the army because the site fell into the "zone de servitudes" (zones under army control). See Défense, Génie, Bône, 1H 867, art. 8/8, no. 102 (7 August 1890).

124. The following discussion on the port of Algiers is derived largely from René Lespès, *Alger: Étude du géographie et d'histoire urbaines* (Paris: Librairie Félix Alcan, 1930). See also Yves Laye, *Le port d'Alger* (Algiers: L. Rives, 1951).

125. Lespès, *Alger*, 315–24; Federico Cresti, "The Boulevard de l'Impératrice in Colonial Algiers (1860–1866)," *Environmental Design* 1 (1984): 54–95.

126. E. Déchaud, *Oran, son port, son commerce* (Oran: Chambre de Commerce, 1914), 51–56.

127. Piesse, *Algérie et Tunisie*, 149.

128. Défense, Génie, Bône, 1H 866, art. 8, no. 1 (4 January 1845); 1H 866 (31 December 1861).

129. Piesse, *Algérie et Tunisie*, 335–36.

130. For example, one scheme expanded the north and west quays to 35 meters, with 5-meter sidewalks lined by arcaded structures. See Défense, Génie, Bône, 1H 866, art. 8, no. 18 (22 March 1869).

131. Défense, Génie, Bône, 1H 866, art. 9, no. 323 (13 April 1872).

132. Défense, Génie, Bône, 1H 867, art. 96, no. 47 (28 November 1896).

133. "Discours de M. René Millet," in *À Jules Ferry, Tunis 24 avril 1899* (Paris, 1899), 31.

134. Eugène Résal, "Notes sur le port de Bizerte," *Le nouveau port de Bizerte: Bulletin de la Companie du Port de Bizerte* 1, no. 1 (14 July 1893): 9.

135. Louis Boudenoot, *La Tunisie et ses chemins de fer* (Paris: Librairie Arman Collin, 1902), 6–7.

136. François Ricard, "Les transformations de Tunis sous le protectorat français," *Le tour du monde*, n.s., 16 (5 November 1910): 534, 536–37.

137. ADN, Tunisie, 1268, "Port de Tunis." For a discussion of the inauguration ceremonies of the port of Tunis, see chapter 5.

138. Despois, *La Tunisie*, 134; Armand Megglé, *La Tunisie: Terre française* (Paris: Société Française d'Éditions, 1930), 127.

139. ADN, Tunisie, 1268, "Plans d'agrandissements successifs" (22 August 1907).

140. Despois, *La Tunisie*, 134–35.

141. ADN, Tunisie, 1268, "Port de Sfax: Plan d'ensemble" (26 January 1893).

142. "Le développement industriel et commercial de la Tunisie," *Le tour du monde* 5, no. 27 (8 July 1899): 206.

143. Résal, "Notes sur le port de Bizerte," 8–9. For a discussion of the "French city" in Bizerte, see chapter 3.

144. Louis Olivier, ed., *La Tunisie* (Paris: Librairie Ch. Delagrave, 1895), 315.

145. "Bizerte et Ferryville: La création d'une ville en Tunisie," *Le tour du monde*, no. 28 (15 July 1899): 218.

146. İlber Ortaylı, "19. Yüzyıl Sonunda Suriye ve Lübnan Üzerine Bazı Notlar," in İlber Ortaylı, *Osmanlı İmparatorluğu'nda İktisadi ve Sosyal Gelişim: Makaleler I* (Ankara: Turhan Kitabevi, 2000), 146 (first published in *Osmanlı Araştırmaları*, no. 4, 1984).

147. Özyüksel, *Hicaz Demiryolu*, 274–75.

148. Linda S. Schilcher, "Railways in the Political Economy of Southern Syria, 1890–1925," in Philipp and Schaebler, *Syrian Land*, 105, 109.

1. The Ottoman presence, which went back to the sixteenth century, had made its mark on all the cities included in this study. While certain tendencies dominated all Ottoman interventions (such as not interfering with the existing urban fabrics), there were considerable differences that stemmed from the specific conditions of each city. This topic, although bearing on the changes I examine, is too large and complicated to be discussed in depth here. I refer readers to the classic text on the subject: André Raymond's *Grandes villes arabes à l'époque ottomane* (Paris: Sindbad, 1985).

2. I discussed the transformations to Algiers in *Urban Forms and Colonial Confrontations: Algiers under French Rule* (Berkeley and Los Angeles: University of California Press, 1997), chap. 1. What follows is a summary of the executed operations and does not include the unrealized projects.

3. Archives Nationales d'Outre-Mer, Aix-en-Provence (ANOM), "Rapport fait au Ministre de l'Intérieur" (8 January 1834).

4. Lespès, *Alger*, 213–21.

5. ANOM, "Extraits des registres des délibérations du Conseil Municipal de la ville d'Alger: Session extraordinaire; Séance du 26 novembre 1859."

6. Jean-Jacques Deluz, *L'urbanisme et l'architecture d'Alger* (Algiers: Office des Publications Universitaires; Liège: Pierre Mardaga, 1988), 13.

7. ANOM, "Rapport" addressed to M. Le Maréchal Comte Randon, gouverneur général d'Algérie (5 May 1858).

8. Défense, Génie, Bône, 1H 866, art. 2 (15 November 1851).

9. Piesse, *Algérie et Tunisie*, 337.

10. Ibid., 253–56.

11. Ghanima Meskaldji, "De la ville unique à la ville duale: Constantine, au contact de la colonisation," in F. Z. Guechi, ed., *Constantine: Une ville, des héritages* (Constantine: Éditions Média-Plus, 2004), 137.

12. Défense, Génie, Constantine, 1H 807 (21 September 1840).

13. Meskaldji, "De la ville unique à la ville duale," 138; Salwa Boughaba, "L'architecture de la ville comme lieu de l'affrontement et du dialogue culturels: Les transformations coloniales de Constantine et d'Alger" (PhD diss., École des Hautes Études en Sciences Sociales, Paris, 1999), 266.

14. Défense, Génie, Constantine, 1H 829, art. 8, no. 18 (18 March 1861).

15. Défense, Génie, Constantine, 1H 829, art. 8, no. 18 (5 September 1861).

16. Piesse, *Algérie et Tunisie*, 261.

17. Défense, Génie, Constantine, 1H 829; 1H 830, art. 8, no. 19 (4 July 1879).

18. Défense, Génie, Constantine, 1H 830, art. 8, no. 19 (21 March 1879).

19. Défense, Génie, Constantine, 1H 830, art. 8, no. 18 (4 April 1881).

20. Défense, Génie, Tlemcen, 1H 756, art. 1, no. 4 (12 July 1842).

21. Défense, Génie, Tlemcen, 1H 756, art. 1, no. 5 (1 January 1843).

22. Défense, Génie, Tlemcen, 1H 758, art. 3, no. 2 (1843).

23. Défense, Génie, Tlemcen, 1H 756, art. 1, no. 5 (1 January 1843).

24. Défense, Génie, Tlemcen, 1H 756, art. 1, no. 5 (1 January 1843). *Koulouglu* refers to Muslims of mixed marriage between Turks and locals.

25. Défense, Génie, Tlemcen, 1H 758, art. 3, no. 2 (1843).

26. Cevdet Baysun, "Mustafa Reşit Paşa'nın Siyasi Yazıları," *Istanbul Üniversitesi Edebiyat Fakültesi Tarih Dergisi*, no. 111 (September 1960): 15.

27. I analyzed these laws and regulations and their impact on the transformation of Istanbul's urban fabric in *Remaking of Istanbul*, chap. 3.

28. Stefan Weber, "Reshaping Damascus: Social Change and Patterns of Architecture in Late Ottoman Times," unpublished paper. Weber's work on Damascus has been published in several venues in English. It has recently appeared in German. See Stefan Weber, "Zeugnisse kulturellen Wandels: Stadt, Architektur und Gesellschaft des Osmanischen Damaskus im 19. und frühen 20. Jahrhundert," *Electronic Journal of Oriental Studies* 9, no. 1 (2006): i–xi, 1–1014.

29. Mağmumi described the Suq Midhat Pasha as "a market covered with iron arches, large, long, and with many streets [branching off it]" (*Seyahat Hatıraları*, 293). For an analysis of the suqs of Damascus in reference to regulations, see Frank Fries, "Damas (1860–1946): La mise en place de la ville moderne, des réglements au plan" (PhD diss., Université de Paris VIII, 2000), 48–55.

30. Stefan Weber, "Reshaping Damascus," 49–50. Weber states that Suq el-Hamidiye was longer than any arcade in Europe.

31. Dorothée Sack, "The Historic Fabric of Damascus and Its Changes in the 19th and the Beginning of the 20th Century," in Philipp and Schaebler, *Syrian Land*, 193.

32. "Resimlerimiz: Haleb'de Yeni Cadde," *Servet-i Fünun*, no. 153 (1309/1894): 359–60.

33. May Davie, "Beyrouth au temps de la visite de Guillaume II en 1898," in Hélène Sader, Thomas Scheffler, and Angelika Neuwirth, eds., *Baalbek: Image and Monument, 1898–1998* (Beirut: Beiruter Texte und Studien; Stuttgart: Franz Steiner Verlag, 1998), 104–5.

34. *Salname-yi Vilayet-i Beyrut, 1311–1312*, 385–86.

35. Quoted in Jens Hanssen, "'Your Beirut Is on My Desk': Ottomanizing Beirut under Sultan Abdülhamid II (1876–1909)," in Peter G. Rowe and Hashim Sarkis, eds., *Projecting Beirut: Episodes in the Construction and Reconstruction of a Modern City* (Munich and New York: Prestel, 1998), 52.

36. *Salname-yi Vilayet-i Beyrut, 1311–1312*, 386–87.

37. Mehmed Refed, *Seyahatname-yi Arz-ı Filistin* (Damascus: Suriye Matbaası, 1305/1888), 34; Richard Coke, *Baghdad: The City of Peace* (London: Thornton Butterworth, 1927), 274.

38. Mehmed Hurşid [Paşa], *Seyahatname-i Hudud*, ed. Alaattin Eser (1852; Istanbul: Simurg Kitapçılık, 1997), 56.

39. Mehmed Tevfik, "Hatt-ı Irakiye'de bir Cevelan," *Servet-i Fünun*, no. 333 (1313/1897): 333; *Bağdad Vilayet-i Celilesine Mahsus Salname, 1316–1317* (Baghdad: Vilayet Matbaası, c. 1317/1898–99), 411; Yaşar Yücel, "Midhat Paşa'nın Bağdad Vilayetindeki Alt Yapı Yatırımları," in *Uluslararası Midhat Paşa Semineri* (Ankara: Türk Tarih Kurumu Basımevi, 1986), 180–81.

40. Mehmed Tevfik, "Hatt-ı Irakiye'de bir Cevelan," 333–34; *Seyahat*, 113; Yücel, "Midhat Paşa'nın Bağdad Vilayetindeki Alt Yapı Yatırımları," 180–81.

41. *Servet-i Fünun*, no. 616 (1318/1903): 273.

42. According to a French observer, in 1917 there were no quays in Baghdad and streets simply ended on the river's banks, cluttered with piers. See Émile Aublé, *Baghdad: Son chemin de fer, son importance, son avenir* (Paris: Éditions Librairie, 1917), 28.

43. *Bağdad Vilayet-i Celilesine Mahsus Salname*, 412.

44. Cenap Şahabettin, *Afak-ı Irak: Kızıldeniz'den Bağdad'a Hatıralar*, ed. Bülent Yorulmaz (Istanbul: Dergah Yayınları, 2002), 98.

45. Mehmed Tevfik, "Hatt-ı Irakiye'de bir Cevelan," 334.

46. Hakkı-Bey, *De Stamboul à Bagdad*, 33–34. For electricity and electric tramways, see also BOA, DH.ID 130/6 (1331/1912).

47. Vigouroux and Caillat, *Alger: Projet d'une nouvelle ville* (Algiers: Lith. Mme Philippe, 1858). Copy of handwritten report (Algiers, 30 April 1858), Bibliothèque Nationale de France; Frédéric Chassériau, *Étude pour l'avant-projet d'une cité Napoléon-Ville à établir sur la Plage de Mustapha à Alger* (Algiers: Dubois Frères, 1858).

48. Vigouroux and Caillat, *Alger*.

49. Chassériau, *Étude*.

50. Vigouroux and Caillat, *Alger*.

51. Ibid.

52. Chassériau, *Étude*.

53. Chassériau's schematic design does not reflect the detailed articulation of the accompanying document but shows only the grid, defined by perimeter blocks with interior green spaces and broken by public squares. For example, on the plan it is not possible to see the street system that Chassériau so carefully described in words, or the placement and scale of the public monuments. If the tone of the report evokes Adolphe Alphand's work in Paris at the time, the plan leaves much to the imagination.

54. Xavier Malverti, "Les officiers du Génie et le dessin de villes en Algérie (1830–1870)," in C. Bruant, S. Leprun, and M. Volait, eds., "Figures de l'orientalisme en architecture," special issue, *Revue du monde musulman et de la Méditerranée*, nos. 73–74 (1996): 234–38.

55. A. Lenoir and Pierre Landry, "Théories des villes," *Revue générale d'architecture et des travaux publics* 12 (1854): column 295.

56. See Çelik, *Urban Forms*, chap. 2.

57. Zahia Meghnous Driss, "L'espace de la Brèche entre coupure et suture," in Guechi, *Constantine*, 150, 176n6; Bernard Pagand, *La Médina de Constantine (Algérie): De la ville traditionelle au centre de l'agglomération contemporaine*, Études Méditerranéennes 14 (Poitiers: Université de Poitiers, 1989), 20.

58. Défense, Génie, Constantine, 1H 807, art. 3, no. 64 (14 June 1852).

59. Défense, Génie, Constantine, 1H 829, art. 8 (4 June 1864).

60. Driss, "L'espace de la Brèche entre coupure et suture," 152.

61. Défense, Génie, Constantine, 1H 807, art. 2, no. 100 (18 May 1899); Défense, Génie, Constantine, 1H 807, art. 9, no. 784 (30 October 1900). For many projects and reports on Coudiat-Aty, see the documents in Défense, Génie, Constantine, 1H 807.

62. Driss, "L'espace de la Brèche entre coupure et suture," 155.

63. Pagand, *La Médina de Constantine*, 28.

64. Défense, Génie, Tlemcen, 1H 756, art. 2, no. 17 (30 June 1850).

65. Défense, Génie, Tlemcen, 1H 756, art. 2, no. 17 (1853).

66. Piesse, *Algérie et Tunisie*, 171–78. The church was built in 1855 by the architect Lefèvre, using porphyry and onyx stones from the ruins of the Mansoura Mosque in the basin and the paving of the baptistery.

67. "Discours de M. René Millet," in *À Jules Ferry*, 39.

68. Ibid.

69. Ricard, "Les transformations de Tunis sous le protectorat français," 529–31.

70. Piesse, *Algérie et Tunisie*, 384.

71. "Édilité," *Tunis: Journal de l'Afrique française* 1, no. 1 (22 December 1890): n.p.

72. Serge Santenelli, "Tunis la blanche," in Maurice Culot and Jean-Marie Thiveaud, eds. *Architectures françaises outre-mer* (Liège: Pierre Mardaga, 1992), 79.

73. *La Tunisie: Terre française*. Christophe Giudice argues that the regularity of this municipal network was broken by private streets integrated into the municipal domain. At a recent conference, he demonstrated the irregularities by a careful analysis of the negotiations between the municipality and the property owners. See Christophe Giudice, "Le plan, le quartier, la rue à Tunis, des objets de colonisation," paper presented at the symposium "Moyens de connaissance et outils d'intervention: Les villes du Maghreb entre réformes et colonisation," Institut de Recherche sur le Maghreb Contemporain, Tunis, 17–18 June 2005.

74. Eugène Résal, "Note sur le port de Bizerte," *Le nouveau port de Bizerte: Bulletin de la Companie du Port de Bizerte* 1, no. 1 (14 July 1893): 12.

75. Ibid.

76. "Bizerte et Ferryville: La création d'une ville en Tunisie," *Le tour du monde*, no. 28 (15 July 1899): 217–20.

77. The large-scale projects carried out in Istanbul around the same time had a direct impact on projects in the provinces. For a detailed account of the scene in Istanbul, see Çelik, *Remaking of Istanbul*.

78. For a meticulously detailed survey of this area, see Stefan Weber, "Der Marga-Platz in Damaskus," *Damaszener Mitteilungen* 10 (1998).

79. Quoted in Gérard Degeorge, *Damas des Ottomans à nos jours* (Paris: L'Harmattan, 1994), 145.

80. *Salname-yi Vilayet-i Suriye* (Damascus: Vilayet Matbaası, 1300/1883), 299; *Salname-yi Vilayet-i Beyrut, 1311–1312*, 385–86.

81. Cemal Paşa, *Hatıralar*, ed. Behçet Cemal (Istanbul: Selek Yayınları, 1959), 328.

82. Stefan Weber, "Der Marga-Platz in Damaskus," 340–41.

83. Ibid., 341; Jean-Luc Arnaud, *Damas: Urbanisme et architecture, 1860–1925* (Arles: Actes Sud/Sindbad, 2005), 162–68; Sack, "Historic Fabric of Damascus," 192–93. Max Zürcher, a Swiss architect, was in charge of the "Embellishment of the Cities" program.

84. BOA, DH.UMVM 102/52 (1336).

85. Stefan Weber, "Reshaping Damascus."

86. Ali Tevfik, *Memalik-i Osmaniye Coğrafyası*, 307; Mağmumi, *Seyahat Hatıraları*, 292; Hakkı-Bey, *De Stamboul à Baghdad*, 12.

87. *Servet-i Fünun*, no. 186 (1310/1892): 60.

88. Hakkı-Bey, *De Stamboul à Baghdad*, 12; A. Leroux, *Le Liban et la mer, Beyrouth, Balbek, Damas* (Nantes, 1881), 68 (quoted in Degeorge, *Damas*, 139).

89. Hakkı-Bey, *De Stamboul à Baghdad*, 11–13.

90. Şerif, *Anadolu'da Tanin*, 1:109, 111, 179–80, 185.

91. Refed, *Seyahatname-yi Arz-ı Filistin*, 74.

92. Mağmumi, *Seyahat Hatıraları*, 295.

93. Fries, "Damas (1860–1946)," 64. On the redesign of this neighborhood, see Çelik, *Remaking of Istanbul*, 53–55.

94. Arnaud, *Damas*, 168–77; Michael Meinecke, "The Old Quarter of as-Salihiyya, Damascus: Development and Recent Changes," *Les annales archéologiques arabes syriennes* 35 (1985): 31–33; Degeorge, *Damas*, 147.

95. See, e.g., Mia Fuller, "Preservation and Self-Absorption: Italian Colonisation and the Walled City of Tripoli, Libya," in Susan Slyomovics, ed., *The Walled Arab City in Literature, Architecture, and History* (London and Portland, OR: Frank Cass, 2001), 121–54; and Krystna von Henneberg, "Tripoli: Piazza Castello and the Making of a Fascist Colonial Capital," in Zeynep Çelik, Diane Favro, and Richard Ingersoll, eds., *Streets: Critical Perspectives on Public Space* (Berkeley and Los Angeles: University of California Press, 1994), 135–50; Brian L. McLaren, *Architecture and Tourism in Italian Colonial Libya: An Ambivalent Modernism* (Seattle: University of Washington Press, 2006). Fuller alludes to "a certain sprawl" outside the walls but does not attempt to situate the Italian interventions in reference to Ottoman modernization initiatives.

96. Mehmed Nuri and Mahmud Naci, *Trablusgarb* (Istanbul: Tercüman-ı Hakikat Matbaası, 1330/1911), 156; Charles Féraud, *Annales tripolitaines* (Tunis: Librairie Tournier, 1927), 421; Nora Lafi, *Une ville du Maghreb entre ancien régime et réformes ottomanes* (Paris: L'Harmattan, 2002), 213–19; Mehmed Süreyya, *Sicill-i Osmani* (1889; Istanbul: Sebil Yayınevi, 1996), 3:674.

97. For a reference to the map of the province assigned to Mazhar Bey, an engineer trained at the Military School (Mekteb-i Harbiye), see BOA, I.DH 39506 (1284/1867). I have not been able to locate this map, but even the fact that making a map was considered points to the importance of maps in modernization projects.

98. BOA, I.DH 40035 (1285/1868).

99. Suq Aziziye is reminiscent, at the same time, of another hybrid construction, Suq Ali Pasha in Damascus.

100. Ettore Rossi, *Storia di Tripoli e della Tripolitania* (Rome: Istituto per l'Oriente, 1968), 321.

101. Paul Radiot, *Tripoli d'Occident et Tunis* (Paris: E. Dentu, 1892), 52.

102. Nuri and Naci, *Trablusgarb*, 158–60. For the work done during Ahmed Rasim Pasha's tenure, see BOA, Y.EE 7/13.

103. *Trablusgarb Vilayeti Salnamesi*, 124.

104. Ali Tevfik, *Memalik-i Osmaniye Coğrafyası*, 438.

105. IÜMK 92310; and AK, *harita* 1335.

106. Bernet, *En Tripolitaine*, 12.

107. Hanssen, "'Your Beirut Is on My Desk,'" 51–52; Hanssen, *Fin de Siècle Beirut*, 214–21.

108. Mağmumi, *Seyahat Hatıraları*, 285, 289; *Salname-yi Vilayet-i Beyrut, 1311–1312*, 385.

109. Hanssen, *Fin de Siècle Beirut*, 143.

110. *Beyrut Vilayeti Salnamesi (Trablusşam Vilayeti)* (Beirut: Vilayet Matbaası, 1332–33/1914), 243, 247.

111. BOA, Y.PRK.UM 80/22 (1323/1905). Although the document mentions an attached plan for the new neighborhood, it was not included in the folder.

112. *Musul Vilayeti Salname-yi Resmiyesi* (Mosul: Matbaa-yı Vilayet, 1325/1909), 108, 129.

113. Baedecker, *Palestine and Syria*, 379; Keith David Watenpaugh, *Being Modern in the Middle East: Revolution, Nationalism, Colonialism, and the Arab Middle Class* (Princeton, NJ: Princeton University Press, 2006), 47–48.

114. Mağmumi, *Seyahat Hatıraları*, 265.

115. Fries, "Damas (1860–1946)," 83.

116. Hakkı-Bey, *De Stamboul à Bagdad*, 35.

117. Malverti, "Les officiers du Génie et le dessin de villes en Algérie," 230–31.

118. Quoted in Malverti, "Les officiers du Génie," 235.

119. Défense, Génie, Orléansville, 1H 667, art. 2, no. 5 (22 February 1845).

120. Défense, Génie, Orléansville, 1H 667, art. 2, no. 5 (25 April 1845).

121. See "Plan du territoire de colonisation de Sidi Bel-Abbès" (1849), in Malverti, "Les officiers du Génie," 239.

122. Féraud, *Annales tripolitaines*, 422.

123. Deringil, "'They Live in a State of Nomadism and Savagery,'" 334.

124. Cemal Paşa, *Hatıralar*, 324–25. On Beersheba, see also Filiz Yenişehirlioğlu, "Bir Çöl Kenti: Béer-Sheva," in *Ortadoğu'da Osmanlı Dönemi Kültür İşleri Uluslararası Bilgi Şöleni Bildirileri* (Ankara: Atatürk Kültür Merkezi Başkanlığı Yayınları, 2002), 2:627–28; Nimrod Luz, "The Re-making of Beersheba: Winds of Modernization in Late Ottoman Sultanate," unpublished paper, 2004. I am grateful to Dr. Luz for giving me a copy of his paper.

3 NEW PUBLIC SPACES

1. The most prominent of imperial ceremonial squares was the Hippodrome in Istanbul; also, open-air markets were common places for public gatherings.

2. Maurice Agulhon, *Marianne into Battle: Republican Imagery and Symbolism in France, 1879–1880*, trans. Janet Lloyd (Cambridge: Cambridge University Press, 1981), 70.

3. Défense, Génie, Alger, 1H 508, art. 8, section 6 (1831).

4. For a reconstruction of this area before the French interventions, see André Raymond, "Le centre d'Alger en 1830," *Revue de l'Occident musulman et de la Meditérranée* 31, no. 1 (1981): 73–81.

5. Défense, Génie, Alger, art. 8, section 1, carton 2, "Place d'Alger, 1831," feuille no. 1.

6. Defense, Génie, Alger, art. 8, section 6 (11 November 1831).

7. Défense, Génie, Alger, art. 8, section 1, carton 2 (1833).

8. Défense, Génie, Alger, art. 8, section 1, carton 3 (1834).

9. The duc d'Orléans died in a carriage accident in Neuilly in 1842, without making it to the throne.

10. For a reading of this square and the monument as a *lieu de mémoire* in the colonial and postcolonial eras, see Zeynep Çelik, "Colonial/Postcolonial Intersections: *Lieux de Mémoire* in Algiers," *Third Text* 49 (Winter 1999–2000).

11. Lespès, *Alger*, 336.

12. Jean-Jacques Jordi and Jean-Louis Planche, "1860–1930: Une certaine idée de la construction de la France," in Jean-Jacques Jordi and Jean-Louis Planche, eds., *Alger, 1860–1919: Le modèle ambigu du triomphe colonial* (Paris: Éditions Autrement, 1999), 45–46.

13. Charles Dubois, *Alger en 1861* (Algiers: Imprimerie de A. Bourget, 1861), 11.

14. Lespès, *Alger*, 130, 251–57.

15. *Le Moniteur algérien*, 21 July 1832, quoted in Henri Klein, ed., *Souvenirs de l'ancien et du nouvel Alger*, Feuillets d'El-Djezaïr, vol. 5 (Algiers: Imprimerie Orientale Fontana Frères, 1913), 24.

16. The lyricist was M. Descous, a former officer, and the composer was Baron Bron, president of the mayor's council. The theater burned down in 1882 and was rebuilt in a manner faithful to the original scheme. See Klein, *Souvenirs*, 26–27.

17. For the boulevard de l'Impératrice, see Cresti, "The Boulevard de l'Impératrice in Colonial Algiers."

18. Fromentin quoted in Fernand Arnaudiès, *Esquisses anecdotiques et historiques du Vieil Alger* (Avignon: Éditions A. Bathélemy, 1990), 205.

19. Piesse, *Algérie et Tunisie*, 336–37.

20. André Raymond, "Les caractéristiques d'une ville arabe 'moyen' au VIIIe siècle: Le cas de Constantine," *Revue de l'Occident musulman et de la Méditerranée* 44 (1987): 136–38, 140.

21. Défense, Génie, Constantine, 1H 808, art. 3, no. 95 (14 November 1860).

22. Défense, Génie, Constantine, 1H 830, art. 8, no. 19 (11 May 1859).

23. Défense, Génie, Constantine, 1H 830, art. 8, no. 19 (9 January 1880); Défense, Génie, Constantine, 1H 809, art. 3, no. 256 (1887). For a survey of the transformations to the Palace of Ahmed Bey between 1837 and 1984, see Hafiza Azazza, "Un palais, des fonctions," in Guechi, *Constantine*, 203–30.

24. Défense, Génie, Constantine, 1H 830, art. 8, no. 19 (11 May 1859); Piesse, *Algérie et Tunisie*, 257–58, 260, 263–64.

25. Défense, Génie, Constantine, 1H 830, art. 8, no. 19 (11 May 1859).

26. For related projects that eventually created the place Nemours, see Défense, Génie, Constantine, 1H 830, art. 8, no. 16 (15 May 1879); art. 8, no. 17 (15 May 1879); art. 8, no. 52 (27 November 1879).

27. Défense, Génie, Constantine, 1H 830, art. 8, no. 55 (1 May 1880).

28. Défense, Génie, Constantine, 1H 829, art. 9, no. 917 (12 July 1905).

29. Driss, "L'espace de la Brèche entre coupure et suture," in Guechi, *Constantine*, 158–59. This essay gives an overview of the development of the place Nemours and its environs from the French occupation to 1980.

30. Piesse, *Algérie et Tunisie*, 257–58.

31. Ibid., 175, 178–79.

32. Çelik, *Remaking of Istanbul*, 59–62. The official penchant for monumental Parisian squares emerged in the positive acclaim for Joseph-Antoine Bouvard's projects at the end of the century. See ibid., 110–25.

33. Kark, *Jaffa*, 47.

34. Davie, "Beyrouth au temps de la visite de Guillaume II en 1898," 106–7.

35. Mağmumi, *Seyahat Hatıraları*, 281.

36. Ibid., 281–82.

37. Jens Hanssen, "'Your Beirut Is on My Desk'," in Rowe and Sarkis, *Projecting Beirut*, 63.

38. Mağmumi, *Seyahat Hatıraları*, 281–82.

39. For a comprehensive history of Marja Square, its development, and the buildings on and around it, see Stefan Weber, "Der Marga-Platz in Damaskus."

40. Boughaba, "L'architecture de la ville," 305.

41. "Discours de M. René Millet," in *À Jules Ferry*, 13.

42. Ibid., 38.

43. Ibid.

44. ADN, Tunisie, 1434.

45. "Inauguration du monument Philippe Thomas," *Revue tunisienne* 20, no. 100 (July 1913): 388, 392, 402.

46. Klaus Kreiser, "Public Monuments in Turkey and Egypt, 1840–1916," *Muqarnas* 14 (1997): 103–5. Şehbal revived the story of this unrealized monument in no. 83 (1329/1913) and published a drawing of the project, 210–11.

47. "Le premier monument statuaire turc," *Revue technique d'Orient* 4, no. 38 (April 1914). The monument (memorializing the battle of Çatalca) was received by *Revue technique d'Orient* as a testament to Enver Pasha's liberalism. The Ottoman resistance to erecting statues of rulers and leading politicians even after the shift to the constitutional regime forms an intriguing contrast to Egyptian practice. In Cairo, the erection of an equestrian statue of Khedive Ibrahim Pasha on Azbakiyya Square in 1868 was followed by others. See Kreiser, "Public Monuments," 107–8.

48. *Salname-yi Vilayet-i Beyrut* (Beirut: Vilayet Matbaası, 1319/1901), 72.

49. Hanssen, "'Your Beirut Is on My Desk,'" 62. This monument was taken down in 1957. See ibid., 41. It has been transported to Sanayeh Public Gardens.

50. Kreiser describes the Haifa monument on the basis of a contemporary photograph and gives a translation of one of the inscriptions. See Kreiser, "Public Monuments," 110–11.

51. Selim Deringil, *The Well-Protected Domains: Ideology and Legitimation of Power in the Ottoman Empire, 1876–1919* (New York and London: I. B. Taurus, 1998), 23–24.

52. For discussions of the Telegraph Tower, see Stefan Weber, "Der Marga-Platz in Damaskus," 316–17; Diana Barillari, *Raimondo D'Aronco* (Rome: Laterza, 1995), 49; and Kreiser, "Public Monuments," 111–12.

53. For another version of this discussion, see Zeynep Çelik, "Commemorating the Empire: From Algiers to Damascus," in Jocelyn Hackforth-Jones and Mary Roberts, eds., *Edges of Empire: Orientalism and Visual Culture* (Oxford: Blackwell, 2005), 20–37.

54. On Thomas Ismail Urbain, see Edmund Burke III, "Two Critics of French Rule in Algeria: Ismail Urbain and Frantz Fanon," in L. Carl Brown and Matthew S. Gordon, eds., *Franco-Arab Encounters* (Beirut: American University of Beirut, 1996), 329–44; and Michel Levallois, "Ismayl Urbain: Éléments pour une biographie," in Morsy, *Les Saint-Simoniens et l'Orient*, 53–82. Literature on Napoléon's notion of "Arab kingdom" is extensive. For concise discussions, see Charles-Robert Ageron, "Peut-on parler d'une politique des 'royaumes arabes' de Napoléon III," in Morsy, *Les Saint-Simoniens et l'Orient*, 83–96; and Stora, *Histoire de l'Algérie coloniale*, 21–22.

55. Stora, *Histoire de l'Algérie coloniale*, 21–22.

56. Octave Teissier, *Napoléon III en Algérie* (Paris: Challame, Ainé; Algiers: Bastide; Toulon: J. Renoux, 1865), 14, 19.

57. On 10 May 1865, Napoléon III watched a performance of *Rigoletto* in this building. See Klein, *Souvenirs*, 26.

58. Monuments Historiques et des Sites (MHS), Fonds Viollet-le-Duc, no. 1444, "2ᵉ esquisse d'un monument à élèver à Alger sour le règne de l'empereur," 1864. The document shows a site plan on a scale of 1/1,000. Another sketch plan on trace paper is of the "palais impérial." The idea for a Palace of Justice survived from Viollet-le-Duc's project, and a competition was launched in 1867 by the Gouvernement Général de l'Algérie. According to the competition guidelines, the palace would now be situated on the north side of the square; its main façade would be on the place Napoléon, and a secondary entrance on rue Bab Azzoun. Following the architecture of the neighboring structures, it would incorporate continuous colonnades at its ground level. See "Concours pour la construction d'un Palais de Justice à Alger," *Revue générale de l'architecture et des travaux publics* 25 (1867): columns 41 and 42.

59. MHS, Fonds Viollet-le-Duc, no. 1442, "1ʳᵉ esquisse d'un monument à élèver à Alger sous le règne de l'empereur."

60. Gestère, "Monument à élèver à Alger sur la place Napoléon, *L'illustration*, 1865 (2ᵉ semestre): 189.

61. MHS, Fonds Viollet-le-Duc, no. 1443, "2ᵉ esquisse d'un monument à élèver à Alger sous le regne de l'empereur Napoléon III."

62. For a description of this project, see Gestère, "Monument à élèver à Alger."

63. Ibid., 189.

64. Arnaudiès, *Esquisses anecdotiques et historiques du Vieil Alger*, 107.

65. Nuri and Naci, *Trablusgarb*, 156. The new tower was proposed in an undated document discussed earlier (BOA, Y.EE 3/68, art. 19).

66. *Servet-i Fünun*, no. 395 (1314/1898): 68.

67. Quoted in Hanssen, *Fin de Siècle Beirut*, 243; *Salname-yi Vilayet-i Beyrut* (1319/1901), 72, 243. For a fine description of the tower and the actors involved in the decision-making process, see Hanssen, "'Your Beirut Is on My Desk,'" 57–59; and Hanssen, *Fin de Siècle Beirut*, 243–47.

68. *Malumat*, no. 246 (1318/1316/1900).

69. The architect may have been Raimondo D'Aronco. In 1899, he had designed an unexecuted "monumental fountain" in Damascus with the fountain at the bottom and a

square tower (without a function) on top. He was the architect of the Tophane Fountain (1896) in Istanbul. The *sebil* part of the Hijaz monument shows many similarities with the Tophane Fountain, but the Damascus tower is much simpler. For the Damascus "monumental fountain" and the Tophane Fountain, see *D'Aronco architetto* (Milan: Electra, 1982), 74, 86.

70. BOA, Y.PRK.UM 80/69 (1325/1907).

71. This composite type also became popular in the early years of the Turkish Republic. As argued by Cengizkan, the clock towers played a significant role in the "secularization and democratization" of public space. See Ali Cengizkan, *Modernin Saati* (Ankara: Mimarlar Derneği and Boyut Yayın Grubu, 2002), 17.

72. Gustave Mercier, *Le centenaire de l'Algérie* (Algiers: Éditions P. & G. Soubiron, 1931), 302–6.

73. Anne-Marie Briat et al., *Des chemins et des hommes: La France en Algérie (1830–1962)* (Hélette: Éditions Harriet, 1995), 153–54. Because Colonel Marengo employed prisoners to work on the park, it first came to be known as Parc des Condemnés; the name was changed later to acknowledge its creator.

74. Eduard Dalles, *Alger, Bou-Farik, Blidah* (Algiers: Adolphe Journal, 1888), 33.

75. Naïma Chabbi-Chemrouk, "Jardins et parcs publics d'Alger aujourd'hui," in Jean-Louis Cohen, Nabila Oulebsir, and Youcef Kanoun, eds., *Alger: Paysage urbain et architectures, 1800–2000* (Paris: Éditions de l'Imprimeur, 2003), 302–3.

76. Piesse, *Algérie et Tunisie*, 57.

77. *Alger-Oran-Constantine* (Algiers: Adolphe Jourdan, 1903), 11.

78. For a discussion of Pierre-Auguste Renoir's paintings in reference to the park itself, see Roger Benjamin, *Renoir in Algeria* (New Haven, CT: Yale University Press; Williamstown, MA: Sterling and Francine Clark Art Institute, 2003), 64–71.

79. *Alger-Oran-Constantine*, 12.

80. "Conseil Municipal, séance du 20 janvier 1891," *Tunis: Journal de l'Afrique française* 1, no. 6 (26 January 1891).

81. Graham Petrie, *Tunis, Kairouan and Carthage* (1908; London: Stacey International, 2003), 105–7.

82. "Notre future casino," *Tunis: Journal de l'Afrique française* 1, no. 1 (22 December 1890). For the impact of the architecture of universal exhibitions on the development of a neo-Moorish style in the Maghrib, see chapter 4.

83. *Salname-yi Vilayet-i Beyrut, 1311–1312*, 384, 386.

84. *Salname-yi Vilayet-i Beyrut* (1319/1901), 72; *Salname-yi Vilayet-i Beyrut* (1324/1908–9), 313.

85. Mağmumi, *Seyahat Hatıraları*, 293; *Salname-yi Vilayet-i Suriye*, 299.

86. Stefan Weber, "Der Marga-Platz in Damaskus," 337–38, 340.

87. Hakkı-Bey, *De Stamboul à Bagdad*, 13.

88. Ibid., 14.

89. Şerif, *Anadolu'da Tanin*, 1:179–80.

90. BOA, DH.UMVM 124–64 (1334/1918).

1. As already pointed out in chapter 2, André Raymond studied this phenomenon extensively. See his *Grandes villes arabes*. For a recent detailed study of the transformations of Aleppo's image under Ottoman rule, see Heghnar Zeitlian Watenpaugh, *The Image of an Ottoman City: Imperial Architecture and Urban Experience in Aleppo in the 16th and 17th Centuries* (Leiden and Boston: Brill, 2004).

2. Hamdi Veli, *Yemen Salnamesi* ([Sana: Vilayet Matbaası,] 1298/1880), 67.

3. *Salname-yi Vilayet-i Beyrut* (1319/1901), 243.

4. *Salname-yi Vilayet-i Beyrut* (1324/1908–9), 227.

5. *Salname-yi Vilayet-i Beyrut, 1311–1312,* 384.

6. *Bağdad Vilayet-i Celilesine Mahsus Salname,* 413–14.

7. *Musul Vilayeti Salname-yi Resmiyesi,* 129.

8. *Salname-yi Vilayet-i Suriye,* 299; "Şam Belediye Dairesi," *Servet-i Fünun,* no. 158 (1310/ 1894): 23. *Servet-i Fünun*'s adoption of the same language points to its acceptance beyond official circles.

9. *Trablusgarb Vilayeti Salnamesi,* 124.

10. *Salname-yi Vilayet-i Beyrut* (1324/1908–9), 227, 228.

11. *Salname-yi Vilayet-i Beyrut, 1311–1312,* 385.

12. *Salname-yi Vilayet-i Suriye,* 301.

13. Ali Tevfik, *Memalik-i Osmaniye Coğrafyası,* 329.

14. Mağmumi, *Seyahat Hatıraları,* 285, 286.

15. Quoted in Stéphanie Burth-Levetto, "Le service des bâtiments civils en Algérie (1843– 1872)," in Bruant, Leprun, and Volait, "Figures de l'orientalisme en architecture," 145.

16. Quoted in Malverti, "Les officiers du Génie et le dessin de villes en Algérie (1830– 1870)," 235.

17. Ch. Géniaux, quoted in François Béguin, *Arabisances* (Paris: Dunod, 1983), 25.

18. Vigouroux and Caillat, *Alger.*

19. Stora, *Histoire de l'Algérie coloniale,* 20.

20. Stanford J. Shaw and Ezel Kural Shaw, *History of the Ottoman Empire and Modern Turkey* (Cambridge: Cambridge University Press, 1977), 1:85.

21. "Lettre de Constantinople (24 mars 1901)," *Méchveret* 6, no. 113 (15 April 1901): 3. Critical of the Ottoman policies in Yemen, *Méchveret,* the publication of Young Turks based in Paris, argued that this increase would not result in the defeat of the tribes, who now had modern guns.

22. Georgeon, *Abdulhamid II,* 189.

23. Leclerc, *Fenn-i Mimari,* trans. Mehmed Rıfat (Istanbul, 1291/1874–75). I have not been able to find the French original. There are several Leclercs who have written on military engineering and architecture. However, the books I consulted did not correspond to the Ottoman translation.

24. Ibid., 90.

25. Ibid., 86–96.

26. For the barracks in Felluja, see BOA, PPK 899.

27. See drawings in BOA, Y.PRK.ASK 120/120 (1314).

28. *Servet-i Fünun*, no. 144 (1309/1893): 267.

29. *Salname-yi Vilayet-i Beyrut, 1311–1312*, 385.

30. Another sizable guesthouse, constructed inside the military zone in Sana, showed similar characteristics. See the drawing: BOA, PPK 90661.

31. "Resimlerimiz: Haleb'te Selimiye Karakolhanesi," *Servet-i Fünun*, no. 211 (1311/1895): 40.

32. Charles Féraud, "Visite au palais de Constantine," *Le tour du monde* 32 (1887, 1e semestre): 225.

33. For a brief mention of the projects dating from 1848 and 1862, see H. Azazza, "Un palais, des fonctions," in Guechi, *Constantine*, 207.

34. Défense, Génie, Constantine, 1H 808, art. 3, no. 169 (17 February 1870); Défense, Génie, Constantine, 1H 809, art. 3, no. 256 (1887).

35. Badia Belabed-Sahraoui, "Institution coloniale et architecture de pouvoir: L'histoire de l'hôtel de ville," in Guechi, *Constantine*, 180.

36. For the Islamic pavilions at universal exhibitions, see Zeynep Çelik, *Displaying the Orient: Architecture of Islam at Nineteenth-Century World's Fairs* (Berkeley and Los Angeles: University of California Press, 1992), especially chap. 3.

37. "Lettre de Constantinople," *Méchveret*, 3.

38. Mağmumi, *Seyahat Hatıraları*, 285.

39. *Salname-yi Vilayet-i Beyrut, 1311–1312*, 385.

40. Baedeker, *Palestine and Syria*, 323.

41. "Resimlerimiz: Yafa'da Hükümet Konağı," *Servet-i Fünun*, no. 335 (1313/1897): 362.

42. A. J. B. Wavell, *A Modern Pilgrim in Mecca and a Siege in Sana* (London: Constable, 1912), 242.

43. Défense, Génie, Blida, 1H 619, art. 3, no. 9 (14 September 1840). This appropriation was challenged by the Muslim community in 1861, which demanded that the army return the building to the community to be used as a mosque again. See Défense, Génie, Blida, 1H 619, art. 3, no. 104 (23 October 1861).

44. Défense, Génie, Oran, 1H 76, dossier 2 (23 April 1841).

45. Défense, Génie, Tlemcen, 1H 758, art. 3, no. 60 (12 January 1863); Défense, Génie, Tlemcen, 1H 758, art. 3, no. 75 (28 June 1872).

46. "Un hôpital à Tunis," *Tunis: Journal d'Afrique française* 1, no. 4 (12 January 1891).

47. Ibid.

48. Mağmumi, *Seyahat Hatıraları*, 286.

49. Stefan Weber, "Der Marga-Platz in Damaskus," 327.

50. See plan: BOA, DH.ID 14/13, 17 r. 1329.

51. Benjamin Fortna, *Imperial Classroom* (Oxford: Oxford University Press, 2000), 21. See also Eugen Weber, *Peasants into Frenchmen*, chap. 18; and François Furret and Jacques Ozouf, *Reading and Writing: Literacy in France, from Calvin to Jules Ferry* (Cambridge: Cambridge University Press, 1982).

52. Briat et al., *Des chemins et des hommes*, 127–30.

53. Béchir Tlili, *Les rapports culturels et idéologiques entre l'Orient et l'Occident, en Tunisie, au XIX^e siècle (1830–1880)* (Tunis: Publications de l'Université de Tunis, 1974), 429–30, 611–12. See also Clancy-Smith's chapter "Khayr al-Din al-Tunisi and a Mediterranean Community of Thought, c. 1820–1890," in her *Migrations* (forthcoming).

54. Mehmed Kamil Pasha, quoted in Fortna, *Imperial Classroom*, 57.

55. Georgeon, *Abdulhamid II*, 251.

56. BOA, Y.MTV 73–80 (1308/1892).

57. Küçük Said Paşa, *Hatırat* (Istanbul: Sabah Matbaası, 1328/1910–11), 1:156, quoted in Burcu Özgüven, "İdadi Schools: Standard Secondary School Buildings in the Ottoman Empire (1884–1908)" (MA thesis, Boğaziçi University, Istanbul, 1989), 10, 15. See also Fortna, *Imperial Classroom*, 139. Commissioning the embassy to find French plans that could be used in the empire happened in other instances as well. A memorable example is the project designed by Joseph-Antoine Bouvard to renovate the image of Istanbul according to modern standards. See Çelik, *Remaking of Istanbul*, 110–11.

58. Mağmumi, *Seyahat Hatıraları*, 270.

59. Fortna, *Imperial Classroom*, 142.

60. Mağmumi, *Seyahat Hatıraları*, 270.

61. Veli, *Yemen Salnamesi*, 84.

62. Piesse, *Algérie et Tunisie*, 264.

63. Mağmumi, *Seyahat Hatıraları*, 285.

64. I have explored this issue in *Remaking of Istanbul*, chap. 5, and in *Displaying the Orient*, especially in chap. 3.

65. For a detailed analysis of Ravoisié's work in Algeria, see Nabila Oulebsir, *Les usages du patrimoine: Monuments, musées et politique coloniale en Algérie (1830–1930)* (Paris: Éditions de la Maison des Sciences de l'Homme, 2004), 48–74.

66. Çelik, *Urban Forms*, 37–39.

67. Çelik, *Displaying the Orient*, 90–93, 125–31.

68. Oulebsir, *Usages du patrimoine*, 149–52.

69. For example, in 1905 two small mosques (Safir and Mohammed Cherif), a *marabout* (Hassan Pasha), a tomb ("of the queen," in Jardin Marengo), and two fountains were classified as historic. See MHS, Algérie, Alger, Fonds 81/99-01, carton 002, dossier 027 (22 February 1905). Three years later, Jonnard himself demanded the preservation of a group of houses, "precious specimens that adorned old Algiers." See MHS, Algérie, Alger, Fonds 81/99-01, carton 002, dossier 023 (16 March 1908).

70. For a discussion of museums in Algeria, see Oulebsir, *Usages du patrimoine*, 184–95.

71. Quoted in ibid., 252.

72. L. Michel, *Tunis* (1883), quoted in Béguin, *Arabisances*, 37.

73. Saladin quoted in Béguin, *Arabisances*, 38.

74. Charles Edmond, *L'Égypte à l'Exposition Universelle de 1867* (Paris: Dentu, 1867), 196.

75. Eugène-Emmanuel Viollet-le-Duc, preface to Jules Bourgoin, *Les arts arabes* (Paris: Vve A. Morel, 1874), n.p.

76. MHS, Algérie, Alger, Fonds 81/99-01, carton 002, dossiers 021 (6 May 1876), 029 (5 February 1904), and 028 (6 July 1883).

77. Gülru Necipoğlu-Kafadar, "Plans and Models in 15th- and 16th-Century Ottoman Architectural Practice," *Journal of the Society of Architectural Historians* 45, no. 3 (September 1986): 243.

78. The 1318/1900 *salname* on Syria provides a detailed list of the religious buildings constructed and restored in the province of Syria and in Beirut and Jerusalem, specifying the functions (mosque, Sufi convent, school), locations, and even styles ("new style," "elegant style"). See *Suriye Vilayeti Salnamesi* (Damascus: Vilayet Matbaası, 1318/1900), 131–38.

79. Münif Pasha, minister of education in 1880, quoted in Wendy M. K. Shaw, *Possessors and Possessed: Museums, Archaeology, and the Visualization of History in the Late Ottoman Empire* (Berkeley and Los Angeles: University of California Press, 2003), 93. *Possessors and Possessed* is the authoritative work on the topic. The organization of the Imperial Museum, divided into six sections, echoed the European examples: Greek/Roman/Byzantine, Assyrian/Egyptian/Phoenician/Hittite, Islamic, coins, natural history, and a library. See "Müze-yi Hümayun Nizamname-yi Dahilisi," art. 2 (13 Ramazan 1306/1 Mayıs 1305/13 May 1889), in *Düstur*, Birinci Tertip, vol. 6 (Ankara, 1939), 344. For a critical evaluation of the Ottoman appropriation of Saidon for the imperial image, see Jens Hanssen, "Imperial Discourses and an Ottoman Excavation in Lebanon," in Sader, Scheffler, and Neuwirth, *Baalbek*, 157–72.

80. Ussama Makdisi, "Rethinking Ottoman Imperialism," in Hanssen, Philipp, and Weber, *Empire in the City*, 40. For an inquiry that focuses on Baalbek, see Makdisi, "The 'Re-discovery' of Baalbek: A Metaphor for Empire in the Nineteenth Century," in Sader, Scheffler, and Neuwirth, *Baalbek*, 137–56.

81. The first part of the museum was designed by Alexandre Vallaury; the Sarcophagus Museum, so named because of the sarcophagi Osman Hamdi had transported there from Saidon, was completed in 1891. Two wings were added in 1903 and 1908.

82. Wendy Shaw points to *Servet-i Fünun*'s coverage of archaeological activities as well. See Shaw, *Possessors and Possessed*, 115.

83. Refik and Behçet, *Beyrut Vilayeti*, 1:81–84.

84. Ibid., 84.

85. Aziz Ogan, "Th. Makridi'nin Hatırasına," *Belleten* 5 (1941): 163–69.

86. Wendy Shaw, *Possessors and Possessed*, 171–76. The quotation is from Halil Edhem, the assistant director of the museum (1895), and is on 175–76.

87. The Great Mosque of Damascus had undergone major restorations throughout its long history. For earlier repairs, see Doris Behrens-Abouseif, "The Fire of 1479 at the Great Mosque of Damascus and the Chronicle of the Following Restoration Works," *Mamluk Studies Review* 8 (2004): 279–97; and Finbarr Barry Flood, "Umayyad Survivals and Mamluk Revivals: Qalawunid Architecture and the Great Mosque of Damascus," *Muqarnas* 14 (1997). For nineteenth-century repairs, see BOA, A.MKT.MHM 271/97 (1280/1864), I.DH 661/46025 (1289/1873), and I.DH 47365 (1291/1874). The last document, for example, is a demand for government funds for "necessary repairs" to parts of the mosque, as well as for some proposed additions.

88. BOA, Y.PRK.AZJ 27-79 (1311/1894).

89. BOA, Y.PRK.EV 2/22 (1310/1893).

90. I am making this assumption based on the favorable reception of Viollet-le-Duc's arguments among Ottoman intellectuals. See Celal Esad's writings and the following discussion.

91. BOA, Y.PRK.EV 2/22 (1310/1893).

92. BOA, I.HUS 17/1311 R-112 (1311/1894).

93. BOA, I.HUS 30/1312 R-100 (1312/1895).

94. BOA, Y.MTV 105/16 (1312/1895). Unfortunately, I have not been able to locate either the drawings or the name of the architect. A document reports the sending of the model of the mosque to the palace in 1910. See BOA, Y.EE 144/29 (1328/1910). It is likely that Raimondo D'Aronco, Abdülhamid's chief architect, was commissioned or at least asked to supervise the project.

95. *Servet-i Fünun*, no. 597 (1318/1902): 377, 380, 381, 384, 385, 388, 389, 392; and *Servet-i Fünun*, no. 598 (1318/1902): 401, 404.

96. *Servet-i Fünun*, no. 615 (1318/1903): 261.

97. Çelik, *Displaying the Orient*, 87–88, 107–8.

98. BOA, Yıldız, kısım 14, evrak 2022, zarf 126, kutu 10. I first introduced this document, in another context, in *Remaking of Istanbul*, 149–50.

99. Ebuziya Tevfik, "Osmanlıların tarz-ı kadim tefrişleriyle şimdiki usul-u tefriş," *Mecmua-yı Ebuziya*, Rebiülahir 1314/September 1896, 652–53.

100. Celal Esad, "Osmanlı Sanayi-yi Nefisesi," *İkdam*, 13 December 1906.

101. Djelal Essad [Celal Esad], *Constantinople, de Byzance à Stamboul* (Paris: H. Laurens, 1909).

102. Celal Esad, *Mimari Tarihi* (Istanbul: Devlet Matbaası, 1928), 1:2–3.

103. Alex. M. Raymond, "Renaissance ottomane," *Revue technique d'Orient* 1, no. 6 (15 February 1911): 15.

104. E. M., "Du caractère nationale en architecture: Le style turc à l'École des Beaux-Arts," *Revue technique d'Orient* 4, no. 36 (February 1914): 5; and E. Manass, "Du 'caractère' en architecture: Le style turc," *Revue technique d'Orient* 3, no. 27 (November 1912): 5.

5 AFFIRMING THE EMPIRE: PUBLIC CEREMONIES

1. Eric Hobsbawm, "Introduction: Inventing Traditions," in Eric Hobsbawm and Terence Ranger, eds., *The Invention of Tradition* (Cambridge: Cambridge University Press, 1983), 4.

2. Clifford Geertz, *Local Knowledge: Further Essays in Interpretive Anthropology* (New York: Basic Books, 1983), 124. For a description of the Ottoman coat of arms, see Deringil, *Well-Protected Domains*, 26.

3. Mona Ozouf, *Festivals and the French Revolution*, trans. Alan Sheridan (Cambridge, MA: Harvard University Press, 1987), 41.

4. Eugen Weber, *Peasants into Frenchmen*, 387.

5. Hakan T. Karateke, *Padişahım Çok Yaşa: Osmanlı Devletinin Son Yüz Yılında Merasimler* (Istanbul: Kitap Yayınevi, 2004), 39. For an overview of Ottoman court ceremonies in urban settings prior to the period studied in this book, see Faroqhi, *Subjects of the Sultan*, 164–82.

6. For a photograph of this pavilion, see Béguin, *Arabisances*, 31.

7. *L'illustration* 45, no. 1161 (27 May 1865): 324.

8. *L'illustration* 45, no. 1163 (10 June 1865): 364.

9. *L'illustration* 45, no. 1165 (24 June 1865): 404.

10. Florian Pharaon, *Voyage en Algérie de sa Majesté Napoléon III* (Paris: Plon, 1865), 5–7.

11. *Félicitations et allègresse au sujet d'entrée de S. M. Napoléon III à Alger: Poème composé par M'hammed el-Ouennas* (Algiers: Imprimerie Typographique Bouyer, 1867), 18, 26.

12. Pharaon, *Voyage en Algérie*, 10.

13. *L'illustration*'s popularity was uncontested in France, and it also enjoyed a wide international reception. It had a considerable readership in Istanbul, and several Ottoman periodicals, including *Servet-i Fünun* and *Malumat*, had fashioned themselves after it.

14. "Corréspondence algérienne," *L'illustration* 45, no. 1163 (10 June 1865): 362.

15. "Voyage de l'empereur en Algérie," *L'illustration* 45, no. 1160 (20 May 1865): 306.

16. "Voyage de l'empereur en Algérie," *L'illustration* 45, no. 1162 (3 June 1865): 353.

17. "Voyage de l'empereur en Algérie," *L'illustration* 45, no. 1160 (20 May 1865): 306; "Voyage de l'empereur en Algérie," *L'illustration* 45, no. 1162 (3 June 1865): 353.

18. For a comprehensive analysis of nineteenth- to early-twentieth-century imperial ceremonies in Istanbul, see Karateke, *Padişahım Çok Yaşa*.

19. Ibid., 38.

20. *Servet-i Fünun*, no. 670 (1320/1904): 323–26.

21. Thomas Scheffler, "The Kaiser in Baalbek: Tourism, Archaeology, and the Politics of Imagination," in Sader, Scheffler, and Neuwirth, *Baalbek*, 27–28.

22. For Wilhelm II's visit, see *Servet-i Fünun*, nos. 398–405 (1314/1898–99). For an album of photographs of the visit, see IÜMK, album 90621.

23. For an overview of postcards, I browsed the auction catalog of Istanbul Filateli ve Kültür Merkezi A.Ş. (ISFILA), *Ephemera Postcards Object Book Auction*, Istanbul, August 2004. A useful reference for postcards of the post-1908 era is Sacit Kutlu, *Didar-ı Hürriyet: Kartpostallarla İkinci Meşrutiyet (1908–1913)* (Istanbul: Bilgi Üniversitesi, 2004).

24. On the topic of the association of French revolutionary festivals with religious ceremonies, see Ozouf, *Festivals and the French Revolution*, chap. 10.

25. *Servet-i Fünun*, no. 582 (1318/1902): 145, 148.

26. *Servet-i Fünun*, no. 599 (1318/1902): 1, 4, 5.

27. *Servet-i Fünun*, no. 670 (1320/1904): 385, 388, 389; no. 702 (1320/1904): 404; no. 708 (1320/1904): 84.

28. BOA, Y.PRK.ASK 248/47 (1325/1907). The Turkish verses read "Hamidiye Hicaz Demiryolu tam müjde hecaca / Muvaffak oldu han-ı Abdülhamid bu ulvi minhaca."

29. *Servet-i Fünun*, no. 95 (1308/1893): 76–79; no. 118 (1309/1893): 213.

30. *Servet-i Fünun*, no. 450 (1315/1899): 113; no. 427 (1315/1899): 161.

31. *Servet-i Fünun*, no. 366 (1314/1898): 17.

32. *Servet-i Fünun*, no. 691 (1320/1904): 228; no. 695 (1320/1904): 289; no. 183 (1310/1894): 1, 4, 12; no. 337 (1314/1898): 388; no. 363 (1313/1898): 385; no. 311 (1312/1897): 385; no. 450 (1315/1899): 113; no. 670 (1320/1904): 327.

33. Thomas Kühn, "Ordering Urban Space in Ottoman Yemen, 1872–1914," in Hanssen, Philipp, and Weber, *Empire in the City*, 338.

34. BOA, Y.EE 79/87 (1297/1880).

35. *Servet-i Fünun*, no. 259 (1311/1896): 388; no. 349 (1313/1897): 161, 164.

36. *Servet-i Fünun*, no. 105 (1308/1892): 1; no. 345 (1313/1897): 176.

37. *Sana*, no. 43 (22 Temmuz 1297/3 August 1881), quoted in Kühn, "Ordering Urban Space in Ottoman Yemen," 337–38.

38. *Stamboul* (4 July 1882), quoted in Lafi, *Une ville du Maghreb*, 160.

39. *Salname-yi Vilayet-i Beyrut* (1324/1908–9), 97–101.

40. *À Jules Ferry*, 14, 22, 28, 37.

41. ADN, Tunisie, 1270 (1893).

42. ADN, Tunisie, 1270 (1893).

43. "Inauguration du Port du Tunis," *Journal officiel tunisien*, *Supplément*, no. 22 (1 June 1893): 193.

44. On the ceremonies for the inauguration of the port of Sfax, see ADN, Tunisie, 1271 (1897).

45. Eugen Weber, *Peasants into Frenchmen*, 389.

46. ADN, Tunisie, 1434 (1889).

47. Division d'Occupation de Tunisie, État-Major, "Ordre particulier no. 8," ADN, Tunisie, 1438 (11 July 1909).

48. Raoul Girardet, *L'idée coloniale en France* (Paris: Pluriel, 1972), 32–35. *Zouaves* were first recruited from the Berber tribe Zouaoua in Algeria; they later consisted mainly of conscripts from European settlers in Algeria and Tunisia.

49. See *Servet-i Fünun*, no. 54 (1308/1892); no. 57 (1308/1892); and no. 81 (1308/1892).

50. Deringil, "'They Live in a State of Nomadism and Savagery,'" 319.

51. From the collections of Atatürk Library see, e.g., *Istanbul'a ve Geçit Törenlerine ait Fotoğraflar*, album 18, and *Osmanlı Askeri Kıyafetlerine ait Renkli Resimler Albümü*, album 266.

52. *Servet-i Fünun*, no. 54 (1308/1892): 71, 23; no. 56 (1308/1892): 49; no. 57 (1308/1892): cover, p. 74.

53. See ISFILA, *Ephemera Postcards*, 15, 26, and 73 for the examples mentioned in the text.

54. Eugen Weber, *Peasants into Frenchmen*, 438–40.

55. Mağmumi, *Seyahat Hatıraları*, 286.

56. These two marches are still played in Turkey. For the information on Ottoman marches, I relied on *Osmanlı Marşları*, a recording of twenty-one pieces, as well as the accompanying booklet written by Muammer Karabey.

57. *Malumat*, no. 120 (1313/1898), supplement. This was not a one-time affair. A few years later, it published "Hamidiye Marşı." See *Malumat*, no. 251 (1318/1900).

58. "Padişahım saye-yi adlinde alem kamuran / buldu alem emn-ü rahat zat-ı şahanen ile / her dile geldi setaret zat-ı şahanen ile / etti devlet kesb-i şevket zat-ı şahanen ile."

59. "Namını ila edin şanlıdır sultanımız / şan-ı devletle beraber artar elbet şanınız."

60. ADN, Tunisie, postcard collection, "Marche célèbre des Chasseurs d'Afrique," by Alphonse Plouchart. "Faut-il chatier / L'Arabe ou le Kabyle / Et cent contre mille / Charger sans effrayer, / Soldats, Officiers, / Notre ardeur est la même / Au sanglant baptême / Nous courons le premier. . . . Notre bras est fort / Et notre lame est fine / Bône et Constantine / S'en souvient encore."

61. Henri Klein, *Feuillet d'El-Djezaïr* (Algiers: L. Chaix, 1937), 138. I was not able to locate the music and the lyrics.

62. ADN, Tunisie, 1270, "A la France—à l'occasion de l'inauguration du Port de Tunis," lyrics by F. Huard, music by E. Bourget, Tunis, 26 April 1893. "La bas sur ce côteau qui fit terre française / Le souvenir de nos croisés St. Louis / . . . / le progrès chaque jour avançant d'avantage / et les fils des Gaulois, en relevant Carthage / lentement poursuivent son chemin / referons l'empire romain / . . . / France c'est vers toi qu'à cette heure bénie / la nouvelle Tunis fille de ton génie se tourne / pour montrer ses trésors / c'est toi seule qu'on aime / sous ce soleil ardent qui nous brûle la peau / et notre seul amour / et notre unique emblème / c'est toi la France, c'est ton Drapeau."

63. I am deeply grateful to Mehmet Sandalcı for copies of these postcards.

64. "bir fedai milletiz / . . . / kahramanız şanlıyız / bir vatan bir hak tanır / . . . / can da şan da sen / hepsi sensin yaşa ey vatan / ey mübarek vatan bin yaşa."

EPILOGUE

1. Literature on France's colonial policies is extensive. For the discussion above, I relied on Girardet, *L'idée coloniale en France*, chaps. 1–3.

2. Deringil, "'They Live in a State of Nomadism and Savagery,'" 323.

3. Tosun, *Midhat Paşa'nın Suriye Lahiyası*, 5. As shown in the introduction, Ahmed Cevdet Pasha had articulated the same notion around the same time.

4. Osman Nuri, *Abdülhamid ve Devr-i Saltanatı*, 948.

5. *À Jules Ferry*, 28.

6. Quoted in Hanssen, "Your Beirut Is on My Desk," 52.

7. Şerif, *Anadolu'da Tanin*, 1:128.

8. *Bağdad Vilayet-i Celilesine Mahsus Salname*, 30.

9. *Suriye Vilayeti Salnamesi*, 243.

10. *Yemen Salnamesi* (1313/1895), 353.

11. IÜMK, no. 93139; *Servet-i Fünun*, nos. 592–593 (1318/1902). The similarities between the perspective drawing in IÜMK and a photograph published during the inauguration ceremonies of the Military Barracks in Bengazi (*Servet-i Fünun*, no. 259 [1311/1896]: 189, 288) show that the barracks were in Bengazi, in the province of Trablusgarb.

12. Marie de Launay, Montani Efendi, and Boghos Efendi Chachian, *Usul-i Mimari-yi Osmani (L'architecture ottomane)* (Istanbul: Sebah, 1873). For Parvillée, see Çelik, *Displaying the Orient*, especially 96–98 and 155–56.

13. Gustave Le Bon, *La civilisation des arabes* (Paris: Librairie de Firmin-Didot, 1884), 640.

14. Among Gustave Le Bon's books, *Les lois psychologiques de l'évolution des peuples* (1884) was particularly influential. It was eventually translated into Turkish by Abdullah Cevdet in 1907. (An English translation appeared in 1899.)

15. For a summary of "Arab versus Kabyle" construction, see Patricia M. E. Lorcin, "The Soldier-Scholars of Colonial Algeria, Arabs, Kabyles and Islam: Military Images of France in Algeria," in Brown and Gordon, *Franco-Arab Encounters*, 128–50.

16. Le Bon, *Civilisation des arabes*, 251–53.

17. Ibid., 53–54. Le Bon continued, speculating that perhaps the French could "method-ologically destroy the Arab of Algeria by a manner analogous to that used by Americans to exterminate the Red-Skins. . . . Two races so different from each other could never live in peace on the same land."

18. Ahmed Rıza, "Tolerance musulmane," *Méchveret* 2, no. 27 (15 January 1897): 7.

19. Christoph Herzog, "Nineteenth Century Baghdad through Ottoman Eyes," in Hanssen, Philipp, and Weber, *Empire in the City*, 324–36.

20. Edhem Eldem, "Quelques lettres d'Osman Hamdi Bey à son père lors de son séjour en Irak (1869–1870)," *Anatolia Moderna/Yeni Anadolu* 33, no. 1 (1991): 130. Deringil and Herzog also elaborate Osman Hamdi's views on civilization and Arabs. See Deringil, "'They Live in a State of Nomadism and Savagery,'" 331–33; Herzog, "Nineteenth Century Baghdad through Ottoman Eyes," 325.

21. Hakkı-Bey, *De Stamboul à Baghdad*, 84–85.

22. Lorcin, "Soldier-Scholars of Colonial Algeria," 136–37.

23. Gustave Le Bon, *The Psychology of Peoples* (London: Fisher Unwin, 1899), 26–28. The original French edition appeared in 1884. See n. 14.

24. Analyzing the Ottoman contempt for Bedouins, Deringil points to the choice of vocabulary (words such as "ignorant") and states that he kept a "data base" on terminology used to describe nomadic populations. See Deringil, "'They Live in a State of Nomadism and Savagery,'" 317–18. I also kept a log; mine includes "Arabs" in general. Makdisi argues for Ottoman "modernization" as an antidote to the "backwardness" of the people of Mount Lebanon. See Makdisi, "Ottoman Orientalism," paragraphs 20–27.

25. Klaus Kreiser, "Abdülgani Seni (1871–1951) comme observateur de l'Administration Ottomane au Yémen," *Revue d'histoire maghrebine* 31/32 (1982): 317. According to Abdülkadir Cami Bey, reporting on his travels from Trablusgarb toward the Sahara (*Trablusgarb'dan Sahra-yı Kebir'e Doğru*, 1908), the Tuareg tribes of the Sahara were savages who could not even be civilized; they could only be "objects of colonial rule." See Herzog and Motika, "Orientalism *alla turca*," 192–93.

26. Refik and Behçet, *Beyrut Vilayeti*, 1:81, 248.

27. Şerif, *Anadolu'da Tanin*, 1:104.

28. Le Bon, *Civilisation des arabes*, 47–49.

29. Herzog, "Nineteenth Century Baghdad through Ottoman Eyes," 317.

30. Refik and Behçet, *Beyrut Vilayeti*, 1:258–59.

31. Şerif, *Anadolu'da Tanin*, 1:178–79, 184, 186–87.

32. Hakkı-Bey, *De Stamboul à Bagdad*, 12.

33. S. Tufan Bozpınar, "Abdülhamid II, Islam and the Arabs: The Cases of Syria and Hijaz, 1842–1918" (PhD diss., University of Manchester, 1991), 31.

34. Mehmet Tevfik [Biran], *II. Abdülhamid, Meşrutiyet ve Mütareke Devri Hatıraları*, ed. F. Rezan Hürmen (Istanbul: Arma Yayınları, 1993), 277.

35. Şahabettin, *Afak-ı Irak*, 21, 43–44, 70, 71, 81, 95–96.

36. Hakkı-Bey, *De Stamboul à Baghdad*, 85–86, 89.

37. Reşat Nuri [Güntekin], *Çalıkuşu*, 4th ed. (1923; Istanbul: Amedi Matbaası, 1928), 14–18, quotation from 23.

38. *Servet-i Fünun*, no. 316 (1313/1897): 50.

39. *Servet-i Fünun*, no. 316 (1313/1897): 52; no. 366 (1314/1898): 25; no. 347 (1313/1897): 137; no. 311 (1312/1897): 393; no. 361 (1313/1898): 353; no. 391 (1314/1898): 5; no. 617 (1318/1903): 301. The major photography studios in Istanbul also produced a remarkable number of Ottoman "types." On Ottoman "type photographs" (of men) from the 1870s and the 1880s, see Ayshe Erdoglu, "Picturing Alterity: Representational Strategies in Victorian Type Photographs of Ottoman Men," in Eleanor M. Hight and Gary D. Sampson, eds., *Colonialist Photography: Imag(in)ing Race and Place* (New York and London: Routledge, 2002), 107–25. I deliberately omit studio photographs from my discussion, as they targeted above all foreign customers and accommodated their expectations. *Servet-i Fünun*'s audience was, of course, local, and the reliance on similar categories helped punctuate the differences in the human landscapes between the Arab provinces and the center.

40. *Servet-i Fünun*, no. 304 (1312/1897): 276; no. 96 (1308/1892): 276; no. 99 (1308/1892): 328, 329, 332.

41. For the representation of "natives" in world's fairs, see Çelik, *Displaying the Orient*, 17–32.

42. Docteur Warnier, "Exposition de l'Algérie," in *L'Exposition universelle de 1867 illustrée* (Paris: E. Dentu & P. Petit, 1867), 182–83.

43. *L'illustration*, 18 May 1878, and *Paris illustrée*, 1889, 449, quoted in Çelik, *Displaying the Orient*, 30.

44. *Vanishing White City* (Chicago: Peacock Publishing, 1894), captions to "Palace of Damascus" and "Camp of Damascus."

45. The Istanbul-based *Levant Herald and Eastern Express* reported on the decision to send the horses and riders to Chicago (16 January 1893) and on their transport on a large steamer from Beirut (27 March 1893).

46. *Servet-i Fünun*, no. 360 (1313/1898): 340; no. 431 (1315/1899): 293; no. 316 (1313/1897): 52. Ottoman literature on Arab provinces very rarely provides information and commentary on women, and even when it does, it remains fragmented and schematic. For example, Şahabettin states that, with the exception of Europeans, all Muslim and non-Muslim women in Baghdad were "covered." He does not appreciate the "Keldani" women, famous for their beauty, because they are too slow and heavy for his taste, and he finds "the bedouin woman, with her lively eyes, sunburned face, agile arms, and bare feet, following her donkey and crossing the desert like a mystery of nature, a thousand times more elegant." See Şahabettin, *Afak-ı Irak*, 100–101. Writing on Aleppo, Mağmumi also focuses on the dress codes, noting that Christian and Jewish women wear the black *çarşaf* but not veils. However, they sit on the terraces of cafés outside the city, mixing with men and smoking *nargile*s—behaviors that alienate the author. Aleppo's women surprise him by riding donkeys and mules in the narrow streets. See Mağmumi, *Seyahat Hatıraları*, 271, 273.

47. *Şehbal*, no. 85 (1 Teşrin-i sani 1329/14 November 1913).

48. Hamdy Bey and Marie de Launay, *Les costumes populaires de la Turquie en 1873* (Constantinople: Imprimerie du Levant Times & Shipping Gazette, 1873), 5–6.

49. Ibid., 245, 265, 267, 275, 284, 309, 315.

50. Ibid., 314–16.

51. Ibid., 280.

52. See, for example, a *cartes-de-visite* album produced by the photography studio of Alary and Geiser (c. 1865): Getty Research Institute, Los Angeles (GRI), Special Collections, 91. R.6. For an album with larger, hand-colored cabinet photographs, see GRI, Special Collections, 95.R.68.

53. Fortna, *Imperial Classroom*, 21.

54. Eugen Weber, *Peasants into Frenchmen*, 308–9.

55. Özgüven, "İdadi Schools," 7.

56. Bayram Kodaman, *Abdülhamid Devri Eğitim Sistemi* (Ankara: Türk Tarih Kurumu Basımevi, 1988), 89–90, 103, 128. A unique and doomed experiment was the Aşiret Mektebi-i Hümayunu, or the School for Tribes (1892–1907), established to educate the sons of Arab tribal notables and thereby draw them to "the benefits of civilization" and instill Ottoman values through education. For a detailed study of this school, see Eugene L. Rogan, "Aşiret Mektebi: Abdülhamid II's School for Tribes (1892–1907)," *International Journal of Middle East Studies* 28 (1996): 83–107.

57. Şerif, *Anadolu'da Tanin*, 1:150–51.

58. Compare the total of 3,338 *ibtidais* in the Ottoman Empire in 1905 with the 17,320 new elementary schools, the 5,428 enlarged ones, and the 8,381 repaired ones in the French Empire. See Kodaman, *Abdülhamid Devri*, 90; and Eugen Weber, *Peasants into Frenchmen*, 309.

59. Mehmet Tevfik [Biran], *II. Abdülhamid, Meşrutiyet ve Mütareke Devri Hatıraları*, 369.

60. Şerif, *Anadolu'da Tanin*, 1:108, 155. The attribution of the word *külliye* to the American College is likely because the campus recalled the Ottoman complexes that combined religious and educational functions.

61. BOA, I.MVL 415/18147 (1875/1858).

62. Hakkı-Bey, *De Stamboul à Baghdad*, 18.

63. Eugene Rogan, "The Political Significance of Ottoman Education: Maktab 'Anvar Revisited," in Thomas Philipp and Christoph Schumann, eds., *From the Syrian Land to the States of Syria and Lebanon* (Würzburg: Ergon in Kommission, 2004), 80–81, 93.

64. Mağmumi, *Seyahat Hatıraları*, 287.

65. Şerif, *Anadolu'da Tanin*, 1:107, 128, 151.

66. Hakkı-Bey, *De Stamboul à Baghdad*, 7, 16.

67. Quoted in Eugen Weber, *Peasants into Frenchmen*, 315, 330–31.

68. Louis-Jean Calvet, *Linguistique et colonialisme* (Paris: Payot, 1974), 71.

69. Quoted in ibid., 68–69.

70. Quoted in ibid., 124–25.

71. Ibid., 69–70.

72. Mohamed Benrabah, *Langue et pouvoir en Algérie* (Paris: Séguier, 1999), 48–52.

73. Mohammed Harbi, *La guerre commence en Algérie* (Brussels: Éditions Complexe, 1984), 79.

74. Mostefa Lacheraf, *Nation et société* (Paris: F. Maspero, 1965), 324.

75. Although well beyond the time period of this study, Albert Camus's posthumous memoirs explain the remarkable success of colonial education in creating Frenchmen. See Albert Camus, *Le premier homme* (Paris: Gallimard, 1994).

76. Ageron, *Histoire de l'Algérie contemporaine*, 62.

77. Quoted in Bozpınar, "Abdülhamid II," 30–31.

78. İlber Ortaylı, *Osmanlı Barışı* (Istanbul: Ufuk Kitapları, 2004), 148–54.

79. Şerif, *Anadolu'da Tanin*, 1:145–46.

80. Kayalı, *Arabs and Young Turks*, 9, 31; Şerif Mardin, "Center-Periphery Relations: A Key to Turkish Politics?" in S. N. Eisenstadt, ed., *Post-traditional Societies* (New York: Norton, 1972), 175.

81. Şerif, *Anadolu'da Tanin*, 1:109, 110, 127, 128, 133, 134.

82. İlber Ortaylı, *İmparatorluğun En Uzun Yüzyılı* (Istanbul: İletişim Yayınları, 1999), 241. An excellent example of an Ottomanist intellectual is the prolific and complicated Khalil al-Khuri (1836–1907). Fruma Zachs studied his interweaving of four identities (Eastern, Ottoman, Arab, and Syrian) within the framework of Ottomanism in "Building a Cultural Identity: The Case of Khalil al-Khuri," in Philipp and Schumann, *From the Syrian Land*, 27–39.

83. I thank Jayne Merkel for her comments.

84. Rashid Khalidi, *Resurrecting Empire: Western Footprints and America's Perilous Path in the Middle East* (Boston: Beacon Press, 2004).

BIBLIOGRAPHY

ARCHIVES

Atatürk Kütüphanesi, Istanbul (AK)
Başbakanlık Osmanlı Arşivi, Istanbul (BOA)
 Sadaret (A)
 Bab-ı Asafi, Mektubi Kalemi (A.MKT)
 Mektubi Mühimme Kalemi Evrakı (A.MKT.MHM)
 Dahiliye (DH)
 İdare (DH.ID)
 Muhaberat-ı Umumiye İdaresi (DH.MUI)
 Teşr-i Muamelat ve İslahat Komisyonu (DH.TMIK)
 Umur-i Mahalliye ve Vilayet Müdürlüğü (DH.UMVM)
 İrade (I)
 Dahiliye (I.DH)
 Hususi (I.HUS)
 Meclis-i Vala (I.MVL)
 Meclis-i Vala (MV)
 Plan, Proje ve Krokiler (PPK)
 Yıldız (Y)
 Esas Evrakı (Y.EE)
 Mütenevvi Mazurat Evrakı (Y.MTV)
 Perakende Evrakı (Y.PRK)
 Arzuhal Jurnal (Y.PRK.AZJ)
 Askeri Maruzat (Y.PRK.ASK)

Evkaf Nezareti Maruzatı (Y.PRK.EV)

Ticaret ve Nafıa Nezareti Maruzatı (Y.PRK.TNF)

Umumi (Y.PRK.UM)

Istanbul Üniversitesi Merkez Kütüphanesi, Istanbul (IÜMK)

Osmanlı Bankası Arşivi, Istanbul (OBA)

Archives Diplomatiques de Nantes, Nantes (ADN)

 Tunisie

Archives Nationales d'Outre-Mer, Aix-en-Provence (ANOM)

Bibliothèque Nationale de France (BNF)

Monuments Historiques et des Sites, Paris (MHS)

 Fonds Viollet-le-Duc

 Fonds 81/99-01 (Algeria)

Service Historique de la Défense, Paris (Défense)

 Génie:

 Alger

 Blida

 Bône

 Constantine

 Oran

 Orléansville

 Sidi Bel Abbès

 Souk-Arhas

 Tlemcen

 Département de Terre

Getty Research Institute, Los Angeles (GRI)

American University in Beirut, University Libraries, Archives and Special Collections
(AUB)

PERIODICALS

Bulletin de la Companie du Port de Bizerte

L'illustration

Journal officiel tunisien, Supplément

Malumat

Méchveret

Mecmua-yı Ebuziya

Revue technique d'Orient

Revue tunisienne

Şehbal

Servet-i Fünun

Le tour du monde

Tunis: Journal de l'Afrique française

SALNAMES

Province of Baghdad

Bağdad Vilayet-i Celilesine Mahsus Salname, 1316–1317. Baghdad: Vilayet Matbaası, c. 1317/
 1898–99.

Province of Beirut

Salname-yi Vilayet-i Beyrut, 1311–1312. Beirut: Vilayet Matbaası, 1315/1897.
Salname-yi Vilayet-i Beyrut. Beirut: Vilayet Matbaası, 1319/1901.
Salname-yi Vilayet-i Beyrut. Beirut: Vilayet Matbaası, 1321/1903.
Salname-yi Vilayet-i Beyrut. Beirut: Matbaa-yı Vilayet, 1324/1908–9.
Salname-yi Beyrut. Beirut: Vilayet Matbaası, 1326/1910–11.
Beyrut Vilayeti Salnamesi (Trablusşam Vilayeti). Beirut: Vilayet Matbaası, 1332–33/1914.

Province of Hijaz

Hicaz Vilayeti Salnamesi. Mecca: Vilayet Matbaası, 1309/1891.

Province of Mosul

Musul Vilayeti Salneme-yi Resmiyesi. Mosul: Matbaa-yı Vilayet, 1325/1909.

Province of Syria

Salname-yi Vilayet-i Suriye. Damascus: Vilayet Matbaası, 1300/1883.

Suriye Vilayeti Salnamesi. Damascus: Vilayet Matbaası, 1318/1900.

Province of Trablusgarb (Tripoli, Libya)

Trablusgarb Vilayeti Salnamesi. Tripoli: Vilayet Matbaası, 1305/1887.

Province of Yemen

Veli, Hamdi. *Yemen Salnamesi.* [Sana: Vilayet Matbaası,] 1298/1880.
Yemen Salnamesi. Sana: Vilayet Matbaası, 1313/1895.

BOOKS, ARTICLES, AND DISSERTATIONS

Abdül Hamid [Sultan]. *Siyasi Hatıralarım.* 2nd ed. Istanbul: Dergah Yayınları, 1975.
Actes de la Société du Chemin de Fer Ottoman de la Syrie, Akka à Damas. Pera, Constantino-
 ple: Imprimerie du journal "Stamboul," 1891.

Ageron, Ch.-Robert. *Histoire de l'Algérie contemporaine*. Paris: Presses Universitaires de France, 1964.

Agulhon, Maurice. *Marianne into Battle: Republican Imagery and Symbolism in France, 1879–1880*. Trans. Janet Lloyd. Cambridge: Cambridge University Press, 1981.

À Jules Ferry, Tunis 24 avril 1899. Paris, 1899.

Akarlı, Engin Deniz, ed. *Belgelerle Tanzimat: Osmanlı Sadrazamlarından Ali ve Fuad Paşaların Siyasi Vasiyetnameleri*. Istanbul: Boğaziçi Üniversitesi Yayınları, 1978.

———. *The Long Peace: Ottoman Lebanon, 1861–1920*. London and New York: I. B. Tauris, 1993.

Alger-Oran-Constantine. Algiers: Adolphe Jourdan, 1903.

Arif, Muhammed. *The Hejaz Railway and the Muslim Pilgrimage: A Case of Ottoman Political Propaganda*. Trans. Jacob M. Landau. Detroit: Wayne State University Press, 1971.

Arnaud, Jean-Luc. *Damas: Urbanisme et architecture, 1860–1925*. Arles: Actes Sud/Sindbad, 2005.

Arnaudiès, Fernand. *Esquisses anecdotiques et historiques du Vieil Alger*. Avignon: Éditions A. Bathélemy, 1990.

Aublé, Émile. *Baghdad: Son chemin de fer, son importance, son avenir*. Paris: Éditions Librairie, 1917.

Avcı, Yasemin. *Değişim Sürecinde bir Osmanlı Kenti: Kudüs (1890–1914)*. Ankara: Phoenix, 2004.

Babanzade. *See* Hakkı-Bey [Babanzade].

Baedecker, Karl. *Palestine and Syria*. 5th ed. Leipzig: Karl Baedecker; London: George Allen & Unwin; New York: Chas. Scribner's Sons, 1912.

Barillari, Diana. *Raimondo D'Aronco*. Rome: Laterza, 1995.

Bayly, C. A., and Leila Tarazi Fawaz, eds. *Modernity and Culture: From the Mediterranean to the Indian Ocean*. New York: Columbia University Press, 2002.

Baysun, Cevdet. "Mustafa Reşit Paşa'nın Siyasi Yazıları." *Istanbul Üniversitesi Edebiyat Fakültesi Tarih Dergisi*, no. 111 (September 1960).

Beaugé, Gilbert, and Engin Çizgen. *Images d'empire, aux origines de la photographie en Turquie, Türkiye'de Fotoğrafın Öncüleri*. Istanbul: Institut d'Études Françaises d'Istanbul, n.d.

Béguin, François. *Arabisances*. Paris: Dunod, 1983.

Behrens-Abouseif, Doris. "The Fire of 1479 at the Great Mosque of Damascus and the Chronicle of the Following Restoration Works." *Mamluk Studies Review* 8 (2004).

Bejui, Pascal, Luc Raynaud, and Jean-Pierre Vergez-Larrouy. *L'Afrique du nord, le Transsaharien*. Chanac: La Régordane, 1992.

Bektaş, Yakup. "The Sultan's Messenger: Cultural Constructions of Ottoman Telegraphy, 1847–1880." *Technology and Culture* 41, no. 4 (October 2000).

Benjamin, Roger. *Renoir in Algeria*. New Haven, CT: Yale University Press; Williamstown, MA: Sterling and Francine Clark Art Institute, 2003.

Benrabah, Mohamed. *Langue et pouvoir en Algérie*. Paris: Séguier, 1999.

Berger, Philippe. *La Tunisie ancienne et moderne*. Paris: Ernest Leroux, 1907.

Berman, Marshall. *All That Is Solid Melts into Air: The Experience of Modernity*. New York: Penguin Books, 1982.

Bernet, Edmond. *En Tripolitaine.* Paris: Fontemoing, 1912.

Biran. *See* Tevfik, Mehmet, [Biran].

Blumi, Isa. *Rethinking the Late Ottoman Empire: A Comparative Social and Political History of Albania and Yemen, 1878–1918.* Istanbul: Isis Press, 2003.

Boudenoot, Louis. *La Tunisie et ses chemins de fer.* Paris: Librairie Arman Collin, 1902.

Boughaba, Salwa. "L'architecture de la ville comme lieu de l'affrontement et du dialogue culturels: Les transformations coloniales de Constantine et d'Alger." PhD diss., École des Hautes Études en Sciences Sociales, Paris, 1999.

Bourgoin, Jules. *Les arts arabes.* Paris: Vve A. Morel, 1874.

Bozpınar, S. Tufan. "Abdülhamid II, Islam and the Arabs: The Cases of Syria and Hijaz, 1842–1918." PhD diss., University of Manchester, 1991.

Briat, Anne-Marie, et al. *Des chemins et des hommes: La France en Algérie (1830–1962).* Hélette: Éditions Harriet, 1995.

Brown, L. Carl, and Matthew S. Gordon, eds. *Franco-Arab Encounters.* Beirut: American University of Beirut, 1996.

Brown, Leon Carl. *The Surest Path.* Cambridge, MA: Harvard University Press, 1967.

Bruant, C., S. Leprun, and M. Volait, eds. "Figures de l'orientalisme en architecture." Special issue, *Revue du monde musulman et de la Méditerranée,* nos. 73–74 (1996).

Çadırcı, Musa. *Tanzimat Döneminde Anadolu Kentlerinin Sosyal ve Ekonomik Yapısı.* Ankara: Türk Tarih Kurumu, 1990.

Calvet, Louis-Jean. *Linguistique et colonialisme.* Paris: Payot, 1974.

Camus, Albert. *Le premier homme.* Paris: Gallimard, 1994.

Çelik, Zeynep. "Colonial/Postcolonial Intersections: *Lieux de Mémoire* in Algiers." *Third Text* 49 (Winter 1999–2000).

———. "Commemorating the Empire: From Algiers to Damascus." In Jocelyn Hackforth-Jones and Mary Roberts, eds., *Edges of Empire, Orientalism and Visual Culture.* Oxford: Blackwell, 2005.

———. *Displaying the Orient: Architecture of Islam at Nineteenth-Century World's Fairs.* Berkeley and Los Angeles: University of California Press, 1992.

———. *The Remaking of Istanbul: Portrait of an Ottoman City in the Nineteenth Century.* Seattle: University of Washington Press, 1986; paperback, Berkeley and Los Angeles: University of California Press, 1993.

———. *Urban Forms and Colonial Confrontations: Algiers under French Rule.* Berkeley and Los Angeles: University of California Press, 1997.

Çelik, Zeynep, Julia Clancy-Smith, and Frances Terpak, eds. *Walls of Algiers: Narratives of the City through Text and Image.* Seattle: University of Washington Press; Los Angeles: Getty Research Institute, 2009.

Çelik, Zeynep, Diane Favro, and Richard Ingersoll, eds. *Streets: Critical Perspectives on Public Space.* Berkeley and Los Angeles: University of California Press, 1994.

Cemal Paşa. *Hatıralar.* Ed. Behçet Cemal. Istanbul: Selek Yayınları, 1959.

Cengizkan, Ali. *Modernin Saati.* Ankara: Mimarlar Derneği and Boyut Yayın Grubu, 2002.

Chassériau, Frédéric. *Étude pour l'avant-projet d'une cité Napoléon-Ville à établir sur la Plage de Mustapha à Alger.* Algiers: Dubois Frères, 1858.

Çizgen [Özendeş], Engin. *Photography in the Ottoman Empire, 1839–1919*. Istanbul: Haşet Kitapevi, 1987.

Clancy-Smith, Julia. "Migrations, Legal Pluralism, and Identities in Pre-colonial Tunisia." In Patricia Lorcin, ed., *Identity, Memory, and Nostalgia: France and Algeria, 1800–2000*. Syracuse, NY: Syracuse University Press, 2006.

———. *Migrations: Trans-Mediterranean Settlement in Nineteenth-Century North Africa, 1820–1881*. Forthcoming.

Cleveland, William L. "The Municipal Council of Tunis, 1858–1870: A Study in Urban Institutional Change." *International Journal of Middle East Studies* 9 (1978).

Cohen, Jean-Louis, Nabila Oulebsir, and Youcef Kanoun, eds. *Alger: Paysage urbain et architectures, 1800–2000*. Paris: Éditions de l'Imprimeur, 2003.

Coke, Richard. *Baghdad: The City of Peace*. London: Thornton Butterworth, 1927.

Conklin, Alice L. *A Mission to Civilize: The Republican Idea of Empire in France and West Africa, 1895–1930*. Stanford, CA: Stanford University Press, 1997.

Cresti, Federico. "The Boulevard de l'Impératrice in Colonial Algiers (1860–1866)." *Environmental Design* 1 (1984). Reprinted in Cohen, Oulebsir, and Kanoun, *Alger*.

Culot, Maurice, and Jean-Marie Thiveaud. *Architectures françaises outre-mer*. Liège: Pierre Mardaga, 1992.

Dalles, Eduard. *Alger, Bou-Farik, Blidah*. Algiers: Adolphe Journal, 1888.

D'Aronco architetto. Milan: Electra, 1982.

Davison, Roderick H. *Essays in Ottoman and Turkish History, 1774–1923: The Impact of the West*. Austin: University of Texas Press, 1990.

Déchaud, E. *Oran, son port, son commerce*. Oran: Chambre de Commerce, 1914.

Degeorge, Gérard. *Damas des Ottomans à nos jours*. Paris: L'Harmattan, 1994.

Deluz, Jean-Jacques. *L'urbanisme et l'architecture d'Alger*. Algiers: Office des Publications Universitaires; Liège: Pierre Mardaga, 1988.

Deringil, Selim. "'They Live in a State of Nomadism and Savagery': The Late Ottoman Empire and the Post-colonial Debate." *Comparative Studies in Society and History* 45, no. 2 (April 2003).

———. *The Well-Protected Domains: Ideology and Legitimation of Power in the Ottoman Empire, 1876–1909*. New York and London: I. B. Taurus, 1998.

Despois, Jean. *La Tunisie*. Paris: Librairie Larousse, 1930.

Devereux, Robert. *The First Ottoman Constitutional Period*. Baltimore, MD: Johns Hopkins Press, 1963.

Dubois, Charles. *Alger en 1861*. Algiers: Imprimerie A. Bourget, 1861.

Edmond, Charles. *L'Égypte à l'Exposition Universelle de 1867*. Paris: E. Dentu, 1867.

Eisenstadt, S. N., ed. *Post-traditional Societies*. New York: Norton, 1972.

Eldem, Edhem. "Quelques lettres d'Osman Hamdi Bey à son père lors de son séjour en Irak (1869–1870)." *Anatolia Moderna/Yeni Anadolu* 33, no. 1 (1991).

Eldem, Edhem, Daniel Goffman, and Bruce Masters. *The Ottoman City between East and West*. Cambridge: Cambridge University Press, 1999.

Esad, Celal. *Mimari Tarihi*. Vol. 1. Istanbul: Devlet Matbaası, 1928.

———. "Osmanlı Sanayi-yi Nefisesi." *İkdam*, 13 December 1906.

Essad, Djelal [Celal Esad]. *Constantinople, de Byzance à Stamboul*. Paris: H. Laurens, 1909.

L'exposition universelle de 1867 illustrée. Paris: E. Dentu & P. Petit, 1867.

Faroqhi, Suraiya. *Subjects of the Sultan: Daily Life in the Ottoman Empire*. London and New York: I. B. Tauris, 2000.

Faucon, Narcisse. *La Tunisie avant et depuis l'occupation française*. Vol. 2. Paris: Augustin Challamel, 1893.

Fawaz, Laila. "The Changing Balance of Forces between Beirut and Damascus in the Nineteenth and Twentieth Centuries." *Revue du monde musulman et de la Méditerranée* 55–56, nos. 1–2 (1990).

Félicitations et allègresse au sujet d'entrée de S. M. Napoléon III à Alger: Poème composé par M'hammed el-Ouennas. Algiers: Imprimerie Typographique Bouyer, 1867.

Féraud, Charles. *Annales tripolitaines*. Tunis: Librairie Tournier, 1927.

———. "Visite au palais de Constantine." *Le tour du monde* 32 (1887, 1ᵉ semestre).

Flood, Finbarr Barry. "Umayyad Survivals and Mamluk Revivals: Qalawunid Architecture and the Great Mosque of Damascus." *Muqarnas* 14 (1997).

Forestier, M. *Notice sur les chemins de fers algériens*. Alger-Mustapha: Girault, 1900.

Fortna, Benjamin. *Imperial Classroom*. Oxford: Oxford University Press, 2000.

Fries, Frank. "Damas (1860–1946): La mise en place de la ville moderne, des réglements au plan." PhD diss., Université de Paris VIII, 2000.

Furet, François, and Jacques Ozouf. *Reading and Writing: Literacy in France, from Calvin to Jules Ferry*. Cambridge: Cambridge University Press, 1982. Originally published as *Lire et écrire* (1977).

Geertz, Clifford. *Local Knowledge: Further Essays in Interpretive Anthropology*. New York: Basic Books, 1983.

Georgeon, François. *Abdulhamid II: Le sultan calife*. Paris: Fayard, 2003.

Gharbi, Mohamed Lazhar. *Impérialisme et réformisme au Maghreb: Histoire d'un chemin de fer algéro-tunisien*. Tunis: Cérès, 1994.

Girardet, Raoul. *L'idée coloniale en France*. Paris: Pluriel, 1972.

Giudice, Christophe. "Le plan, le quartier, la rue à Tunis, des objets de colonisation." Paper presented at the symposium "Moyens de connaissance et outils d'intervention: Les villes du Maghreb entre réformes et colonisation," Institut de Recherche sur le Maghreb Contemporain, Tunis, 17–18 June 2005.

Guechi, F. Z., ed. *Constantine: Une ville, des héritages*. Constantine: Éditions Média-Plus, 2004.

Gülsoy, Ufuk. *Hicaz Demiryolu*. Istanbul: Eren, 1994.

[Güntekin], Reşat Nuri. *Çalıkuşu*. 4th ed. Istanbul: Amedi Matbaası, 1928.

Hakkı-Bey [Babanzade]. *De Stamboul à Baghdad: Notes d'un homme d'État Turc*. Paris: Ernest Leroux, 1911.

Hamdy Bey, and Marie de Launay. *Les costumes populaires de la Turquie en 1873*. Constantinople: Imprimerie du Levant Times & Shipping Gazette, 1873.

Handlin, Oscar, and John Burchard, eds. *The Historian and the City*. Cambridge, MA: MIT Press, 1963.

Hanssen, Jens. *Fin de Siècle Beirut: The Making of an Ottoman Provincial Capital*. Oxford: Oxford University Press, 2005.

Hanssen, Jens, Thomas Philipp, and Stefan Weber, eds. *The Empire in the City: Arab Provincial Capitals in the Late Ottoman Empire*. Würzburg: Ergon in Kommission , 2002.

Harbi, Mohammed. *La guerre commence en Algérie*. Brussels: Éditions Complexe, 1984.

Herzog, Christoph, and Raoul Motika. "Orientalism *alla turca*: Late 19th/Early 20th Century Ottoman Voyages into the Muslim 'Outback.'" *Die Welt des Islams* 40, no. 2 (July 2000).

Hight, Eleanor M., and Gary D. Sampson, eds. *Colonialist Photography: Imag(in)ing Race and Place*. New York and London: Routledge, 2002.

Hobsbawm, Eric, and Terence Ranger, eds. *The Invention of Tradition*. Cambridge: Cambridge University Press, 1983.

Hurşid, Mehmed. *Seyahatname-i Hudud*. Ed. Alaattin Eser. Istanbul: Simurg Kitapçılık, 1997. First published in 1852.

Hüseyin Tosun, ed. *Midhat Paşa'nın Suriye Lahiyası*. Istanbul: Cihan Matbaası, 1324/1906.

Ibn Abi Diyaf, Ahmad. *Consult Them in the Matter: A Nineteenth-Century Islamic Argument for Constitutional Government*. Trans. L. Carl Brown. Fayetteville: University of Arkansas Press, 2005.

Ibn ün-Nüzhet, Cevad. *Haritalı Musavver Memalik-i Osmaniye Coğrafyası*. Istanbul: Osmaniye Matbaası, 1327/1909.

Jordi, Jean-Jacques, and Jean-Louis Planche, eds. *Alger, 1860–1919: Le modèle ambigu du triomphe colonial*. Paris: Éditions Autrement, 1999.

Karal, Enver Ziya. *Osmanlı Tarihi*. Vol. 8. Ankara: Türk Tarih Kurumu, 1962.

Karateke, Hakan T. *Padişahım Çok Yaşa: Osmanlı Devletinin Son Yüz Yılında Merasimler*. Istanbul: Kitap Yayınevi, 2004.

Kark, Ruth. *Jaffa: A City in Evolution, 1799–1917*. Jerusalem: Yad Izhak Ben-Zvi Press, 1990.

Kayalı, Hasan. *Arabs and Young Turks: Ottomanism, Arabism, and Islamism in the Ottoman Empire, 1908–1918*. Berkeley and Los Angeles: University of California Press, 1997.

Khalidi, Rashid. *Resurrecting Empire: Western Footprints and America's Perilous Path in the Middle East*. Boston: Beacon Press, 2004.

Klein, Henri, ed. *Feuillets d'El-Djezaïr*. Algiers: L. Chaix, 1937.

———. *Souvenirs de l'ancien et du nouvel Alger*. Feuillets d'El-Djezaïr, vol. 5. Algiers: Imprimerie Orientale Fontana Frères, 1913.

Kodaman, Bayram. *Abdülhamid Devri Eğitim Sistemi*. Ankara: Türk Tarih Kurumu Basımevi, 1988.

Kreiser, Klaus. "Abdulgani Seni (1871–1951) comme observateur de l'Administration Ottomane au Yémen." *Revue d'histoire maghrebine* 31/32 (1982).

———. "Public Monuments in Turkey and Egypt, 1840–1916." *Muqarnas* 14 (1997).

Kushner, David, ed. *Palestine in the Late Ottoman Period: Political, Social, and Economic Transformations*. Jerusalem: Yad Izhak Ben-Zvi Press; Leiden: E. J. Brill, 1986.

Kutlu, Sacit. *Didar-ı Hürriyet: Kartpostallarla İkinci Meşrutiyet (1908–1913)*. Istanbul: Bilgi Üniversitesi, 2004.

Lacheraf, Mostefa. *Nation et société*. Paris: F. Maspero, 1965.

Lafi, Nora. *Une ville du Maghreb entre ancien régime et réformes ottomans*. Paris: L'Harmattan, 2002.

Lantz, François. *Chemins de fer et perception de l'espace dans les provinces arabes de l'Empire ottoman*. Paris: L'Harmattan, 2005.

Laroui, Abdallah. *L'histoire du Maghreb*. 2 vols. Paris: François Maspero, 1976.

Launay, Marie de, Montani Efendi, and Boghos Efendi Chachian. *Usul-i Mimari-yi Osmani (L'architecture ottomane)*. Istanbul: Sebah, 1873.

Laye, Yves. *Le port d'Alger*. Algiers: L. Rives, 1951.

Leary, Lewis Gaston. *Syria: The Land of Lebanon*. New York: McBride, Nast & Co., 1913.

Le Bon, Gustave. *La civilisation des arabes*. Paris: Librairie de Firmin-Didot, 1884.

———. *The Psychology of Peoples*. London: Fisher Unwin, 1899. Originally published as *Les lois psychologiques de l'évolution des peuples* (1884).

Leclerc. *Fenn-i Mimari*. Trans. Mehmed Rıfat. Istanbul: 1291/1874–75.

Lenoir, A., and Pierre Landry. "Théories des villes." *Revue générale d'architecture et des travaux publics* 12 (1854).

Lespès, René. *Alger: Étude du géographie et d'histoire urbaines*. Paris: Librairie Félix Alcan, 1930.

Levallois, Michel, and Sarga Moussa, eds. *L'orientalisme des saint-simoniens*. Paris: Maisonneuve & Larose, 2006.

Luz, Nimrod. "The Re-making of Beersheba: Winds of Modernization in Late Ottoman Sultanate." Unpublished paper, 2004.

M., E. "Du caractère nationale en architecture: Le style turc à l'École des Beaux-Arts." *Revue technique d'Orient* 4, no. 36 (February 1914).

Mağmumi, Şerafettin. *Seyahat Hatıraları*. Cairo, 1909.

Makdisi, Ussama. *The Culture of Sectarianism: Community, History, and Violence in Nineteenth-Century Ottoman Lebanon*. Berkeley and Los Angeles: University of California Press, 2000.

———. "Ottoman Orientalism." *American Historical Review* 107, no. 3 (June 2002). http://www.historycooperative.org/journals/ahr/107.3/ah0302000076.

Manass, E. "Du 'caractère' en architecture: Le style turc." *Revue technique d'Orient* 3, no. 27 (November 1912).

Marseille, Jacques. *Empire colonial et capitalisme français: Histoire d'un divorce*. Paris: Albin Michel, 1984.

Mattelart, Armand. *The Invention of Communication*. Trans. Susan Emanuel. Minneapolis: University of Minnesota Press, 1996. Originally published as *L'invention de la communication* (1994).

———. *Mapping World Communication: War, Progress, Culture*. Trans. Susan Emanuel and James A. Cohen. Minneapolis: University of Minnesota Press, 1994. Originally published as *La communication-monde* (1991).

McLaren, Brian L. *Architecture and Tourism in Italian Colonial Libya: An Ambivalent Modernism*. Seattle: University of Washington Press, 2006.

Megglé, Armand. *La Tunisie: Terre française*. Paris: Société Française d'Éditions, 1930.

Meinecke, Michael. "The Old Quarter of as-Salihiyya, Damascus: Development and Recent Changes." *Les annales archéologiques arabes syriennes* 35 (1985).

Mercier, Gustave. *Le centenaire de l'Algérie*. Algiers: Éditions P. & G. Soubiron, 1931.

Midhat. "The Past, Present, and Future of Turkey." *The Nineteenth Century*, no. 16 (June 1878).

Morsy, Magali, ed. *Les Saint-Simoniens et l'Orient: Vers la modernité*. Aix-en-Provence: Édisud, 1989.

Necipoğlu-Kafadar, Gülru. "Plans and Models in 15th- and 16th-Century Ottoman Architectural Practice." *Journal of the Society of Architectural Historians* 45, no. 3 (September 1986).

Nuri, Mehmed, and Mahmud Naci. *Trablusgarb*. Istanbul: Tercüman-ı Hakikat Matbaası, 1330/1911.

Nuri, Osman. *Abdülhamid ve Saltanatı*. Istanbul: Kütüphane-yi İslam ve Asker—İbrahim Hilmi, 1327/1909.

Ochsenwald, William. *The Hijaz Railroad*. Charlottesville: University Press of Virginia, 1980.

Ogan, Aziz. "Th. Makridi'nin Hatırasına." *Belleten* 5 (1941).

Olivier, Louis, ed. *La Tunisie*. Paris: Librairie Ch. Delagrave, 1895.

Orhonlu, Cengiz, and Turgut Işıksal. "Osmanlı Devrinde Nehir Nakliyatı Hakkında Araştırmalar: Dicle ve Fırat Nehirlerinde Nakliyat." *Tarih Dergisi*, nos. 17–18 (1963).

Ortaylı, İlber. *İmparatorluğun En Uzun Yüzyılı*. Istanbul: İletişim Yayınları, 1999.

———. *Osmanlı Barışı*. Istanbul: Ufuk Kitapları, 2004.

———. *Osmanlı İmparatorluğu'nda İktisadi ve Sosyal Gelişim: Makaleler I*. Ankara: Turhan Kitabevi, 2000.

———. *Tanzimattan Sonra Mahalli İdareler (1840–1876)*. Ankara: Sevinç Matbaası, 1974.

Oulebsir, Nabila. *Les usages du patrimoine: Monuments, musées et politique coloniale en Algérie (1830–1930)*. Paris: Éditions de la Maison des Sciences de l'Homme, 2004.

Özgüven, Burcu. "İdadi Schools: Standard Secondary School Buildings in the Ottoman Empire (1884–1908)." MA thesis, Boğaziçi University, Istanbul, 1989.

Ozouf, Mona. *Festivals and the French Revolution*. Trans. Alan Sheridan. Cambridge, MA: Harvard University Press, 1987. Originally published as *La fête révolutionnaire, 1789–1799* (1976).

Özyüksel, Murat. *Hicaz Demiryolu*. Istanbul: Tarih Vakfı Yurt Yayınları, 2000.

Pagand, Bernard. *La médina de Constantine (Algérie): De la ville traditionelle au centre de l'agglomération contemporaine*. Études Méditerranéennes 14. Poitiers: Université de Poitiers, 1989.

Petrie, Graham. *Tunis, Kairouan and Carthage*. London: Stacey International, 2003. First published in 1908.

Pharaon, Florian. *Voyage en Algérie de sa Majesté Napoléon III*. Paris: Plon, 1865.

Philipp, Thomas, and Birgit Schaebler, eds. *The Syrian Land: Processes of Integration and Fragmentation; Bilad al-Sham from the 18th to the 20th Century*. Stuttgart: Franz Steiner, 1998.

Philipp, Thomas, and Christoph Schumann, eds. *From the Syrian Land to the States of Syria and Lebanon*. Würzburg: Ergon in Kommission, 2004.

Piesse, Louis. *Algérie et Tunisie*. Collection des guides-Joanne. Paris: Librairie Hachette, 1888.

La Province de Constantine en 1839 et 1840. Paris: Félix Locquin, 1843.

Radiot, Paul. *Tripoli d'Occident et Tunis*. Paris: E. Dentu, 1892.

Raymond, Alex. M. "Renaissance ottomane." *Revue technique d'Orient* 1, no. 6 (15 February 1911).

Raymond, André. "Le centre d'Alger en 1830." *Revue de l'Occident musulman et de la Méditerranée* 31, no. 1 (1981). Reprinted in Cohen, Oulebsir, and Kanoun, *Alger.*

———. "Les charactéristiques d'une ville arabe 'moyen' au VIII^e siècle: Le cas de Constantine." *Revue de l'Occident musulman et de la Méditerranée* 44 (1987).

———. *Grandes villes arabes à l'époque ottomane.* Paris: Sindbad, 1985.

Refed, Mehmed. *Seyahatname-yi Arz-ı Filistin.* Damascus: Suriye Matbaası, 1305/1888.

Refik, Mehmed, and Mehmed Behçet. *Beyrut Vilayeti.* 2 vols. Beirut: Vilayet Matbaası, 1333/1917.

Reimer, Michael J. "Becoming Urban: Town Administration in Transjordan." *International Journal of Middle East Studies* 37 (2005).

Ricard, François. "Les transformations de Tunis sous le protectorat français." *Le tour du monde,* n.s., 16 (5 November 1910).

Rogan, Eugene L. "Aşiret Mektebi: Abdülhamid II's School for Tribes (1892–1907)." *International Journal of Middle East Studies* 28 (1996).

Rossi, Ettore. *Storia di Tripoli e della Tripolitania.* Rome: Istituto per l'Oriente, 1968.

Rowe, Peter G., and Hashim Sarkis, eds. *Projecting Beirut: Episodes in the Construction and Reconstruction of a Modern City.* Munich and New York: Prestel, 1998.

Sader, Hélène, Thomas Scheffler, and Angelika Neuwirth, eds. *Baalbek: Image and Monument, 1898–1998.* Beirut: Beiruter Texte und Studien; Stuttgart: Franz Steiner Verlag, 1998.

Şahabettin, Cenap. *Afak-ı Irak: Kızıldeniz'den Bağdad'a Hatıralar.* Ed. Bülent Yorulmaz. Istanbul: Dergah Yayınları, 2002.

Schaer, Roland, Gregory Claeys, and Lyman Tower Sargent, eds. *Utopia: The Search for the Ideal Society in the Western World.* New York: New York Public Library; Oxford: Oxford University Press, 2000.

Schemama, Robert. *La Tunisie agricole et rurale et l'oeuvre de la France.* Paris: Librairie Générale de Droit et de Jurisprudence, 1938.

Şerif, Ahmet. *Anadolu'da Tanin.* Ed. Mehmet Çetin Börekçi. 2 vols. Ankara: Türk Tarih Kurumu, 1999.

Seyahat: Istanbul'dan Samsun, Diyarbekir Tarikiyle Bağdad, Basra ve Oradan Halep, İskenderun Tarikiyle Istanbul'a Seyahat-ı Mutazammın Mektuplarından Müteşekkildir. Istanbul: Aşaderyan Matbaası, 1311/1893.

Shaw, Stanford. "The Nineteenth Century Ottoman Tax Reforms and Revenue System." *International Journal of Middle East Studies* 6 (1975).

Shaw, Stanford J., and Ezel Kural Shaw. *History of the Ottoman Empire and Modern Turkey.* Vol. 1. Cambridge: Cambridge University Press, 1977.

Shaw, Wendy M. K. *Possessors and Possessed: Museums, Archaeology, and the Visualization of History in the Late Ottoman Empire.* Berkeley and Los Angeles: University of California Press, 2003.

Slyomovics, Susan, ed. *The Walled Arab City in Literature, Architecture, and History.* London and Portland, OR: Frank Cass, 2001.

Stora, Benjamin. *Histoire de l'Algérie coloniale (1830–1954)*. Paris: Éditions La Découverte, 1991.

Süreyya, Mehmed. *Sicill-i Osmani*. Ed. Nuri Akbayar. 6 vols. Istanbul: Sebil Yayinevi, 1996. First published in 1889.

Teissier, Octave. *Napoléon III en Algérie*. Paris: Challame, Ainé; Algiers: Bastide; Toulon: J. Renoux, 1865.

Tevfik, Ali. *Memalik-i Osmaniye Coğrafyası*. Istanbul: Bab-ı Ali Matbaası, 1307/1887.

Tevfik, Ebuziya. "Osmanlıların Tarz-ı Kadim Tefrişleriyle Simdiki Usul-u Tefriş." *Mecmua-yı Ebuziya*, Rebiülahır 1314/September 1896.

Tevfik, Mehmet, [Biran]. *II. Abdülhamid, Meşrutiyet ve Mütareke Devri Hatıraları*. Ed. F. Rezan Hürmen. 2 vols. Istanbul: Arma Yayınları, 1993.

Tlili, Béchir. *Les rapports culturels et idéologiques entre l'Orient et l'Occident, en Tunisie, au XIXᵉ siècle (1830–1880)*. Tunis: Publications de l'Université de Tunis, 1974.

Tosun, Hüseyin, ed. *Midhat Paşa'nın Suriye Lahiyası*. Istanbul: Cihan Matbaası, 1324/1906.

La Tunisie: Terre française. Paris: Société Française d'Éditions, 1930.

Vanishing White City. Chicago: Peacock Publishing, 1894.

Vigouroux and Caillat. *Alger: Projet d'une nouvelle ville*. Algiers: Lith. Mme Philippe, 1858. Copy of handwritten report (Algiers, 30 April 1858), Bibliothèque Nationale de France.

Watenpaugh, Heghnar Zeitlian. *The Image of an Ottoman City: Imperial Architecture and Urban Experience in Aleppo in the 16th and 17th Centuries*. Leiden and Boston: Brill, 2004.

Watenpaugh, Keith David. *Being Modern in the Middle East: Revolution, Nationalism, Colonialism, and the Arab Middle Class*. Princeton, NJ: Princeton University Press, 2006.

Wavell, A. J. B. *A Modern Pilgrim in Mecca and a Siege in Sana*. London: Constable, 1912.

Weber, Eugen. *Peasants into Frenchmen: The Modernization of Rural France, 1870–1914*. Stanford, CA: Stanford University Press, 1976.

Weber, Stefan. "Der Marga-Platz in Damaskus." *Damaszener Mitteilungen* 10 (1998).

———. "Reshaping Damascus: Social Change and Patterns of Architecture in Late Ottoman Times." Unpublished paper.

———. "Zeugnisse kulturellen Wandels: Stadt, Architektur und Gesellschaft des Osmanischen Damaskus im 19. und frühen 20. Jahrhundert." *Electronic Journal of Oriental Studies* 9, no. 1 (2006): i–xi, 1–1014.

Yenişehirlioğlu, Filiz. "Bir Çöl Kenti: Béer-Sheva." In *Ortadoğu'da Osmanlı Dönemi Kültür İşleri Uluslararası Bilgi Şöleni Bildirileri*, vol. 2. Ankara: Atatürk Kültür Merkezi Başkanlığı Yayınları, 2002.

Yücel, Yaşar. "Midhat Paşa'nın Bağdad Vilayetindeki Alt Yapı Yatırımları." In *Uluslararası Midhat Paşa Semineri*. Ankara: Türk Tarih Kurumu Basımevı, 1986.

INDEX

Illustrations are indicated with *f*.

boulevard de la'Impératrice, Algiers, 60, 73*f*, 74, 121, 144, 218

boulevard de la Victoire, Algiers, 73*f*

boulevard Gambetta, Algiers, 73*f*, 74

boulevard l'Ouest, Constantine, 77

boulevard National, Tlemcen, 94

boulevard Valée, Algiers, 73*f*, 74

Boutin, General, 151–53

Bouvard, Joseph-Antoine, 299*n57*

bridges, French colonies: Bizerte, 67, 68*f*; Constantine, 52*f*, 53, 236, 237*f*

bridges, Ottoman Empire: Baghdad, 44*f*, 45, 83; Damascus, 100; Hijaz Railroad, 32–33*f*, 37, 38*f*, 226, 228, 230*f*; Mosul, 45

British companies, transportation concessions: railroads, 30, 31, 36, 55; river highways, 42, 44

British racism, Şahabettin's charge, 256

British Tunisian Railroad Company, 55

Bugeaud, Thomas-Robert, 25, 121, 254

Bulgaria, independence, 15

Burj Square, in Beirut, 82, 129–30, 203, 240, pl. 5

Bursa, theaters, 201

Café des Platanes, Hamma, 155

Caillat (clerk), 86–89, 90–91

Çalıkuşu (Güntekin), 257

Caracalla statue, Philippeville, 132, 133*f*

Casbah, French colonies: Algiers, 72, 88, 89, 95, 119, 121; Bône, 75; Constantine, 76, 92; Oran, 186

Caserne Lambert, Bizerte, 164–65

casinos, 129, 155–56

Castello Mosque, Trabusgarb, 104

cathedrals, French colonies, 89, 95–96, 123, 159–60, 160

Cemiliye quarter, Aleppo, 84*f*, 108

Cengizkan, Ali, 296*n71*

Cermal Pasha, 81, 99

Cermal Pasha Avenue, Damascus, 99, 100

Cermal Pasha Gardens, Bir-i-Şebi, 115

Chabaud-La Tour, François-Ernest-Henri, 54

"Chant Turc," 240, 242, pl. 32

Chartier, Charles, 109

Chassériau, Charles-Frédéric, 60–61, 86–87, 89–91, 120–21

Chasseurs d'Afrique, 234–35, 238, 242, 243–44, pl. 31

Chesney, F. R., 30, 42, 44

Chevalier, Charles, 206

Chevalier, Michel, 7, 54

China, Hijaz railroad financing, 36

churches, French colonies: Algiers, 89; Bizerte, 98; Bône, 91; Orléansville, 109; Sidi Bel Abbès, 111; Tlemcen, 94

churches, Ottoman Empire, 224

citizenship policies, 15, 272

city halls, French colonies, 124, 127, 151. *See also* government offices/palaces, French colonies

Civilian Hospital, Constantine, 187, 189*f*

civilizing mission, overviews: colonial and imperial policies, 246, 248–52; language and education, 267–73, 307*n56*, *n58*; and race-thinking, 252–57, 305*n17*, *nn24–25*

clock towers, French colonies: overview, 150–51; Algiers, 146, 151; Bizerte, 59, 151; Bône, 121, 146; Oran, 59, 151; Sfax, 151, 175; Sidi Abdellah, 151; Tunis, 146

clock towers, Ottoman Empire: Aleppo, 84*f*, 150, 151*f*; Baghdad, 85*f*, 160; Beirut, 147–49, 160, 228, 229*f*; Haifa, 41; Istanbul, 146, 149–50; Jaffa, 129, 150, 152*f*; Jerusalem, 150, pl. 20; Trablusgarb, 146–47, pl. 9; Trablusşam, 106

clock towers, Turkish Republic, 296*n71*

Collège Sadiqi, 191–93

colonial policy, French overview, 10–13, 246–47. *See also* civilizing mission

Columbian Exposition, Chicago, 210–11, 261

Commercial and Agricultural School, Beirut, 195, 196*f*, 232–33

commercial areas: French colonies, 77, 89,